British Cultural Studies

British Cultural Studies is a comprehensive introduction to the British tradition of cultural studies. Graeme Turner offers an accessible overview of the central themes that have informed British cultural studies: language, semiotics, Marxism and ideology, individualism, subjectivity and discourse.

Beginning with a history of cultural studies, Turner discusses the work of such pioneers as Raymond Williams, Richard Hoggart, E. P. Thompson, Stuart Hall and the Birmingham Centre for Contemporary Cultural Studies. He then explores the central theorists and categories of British cultural studies: texts and contexts; audience; everyday life; ideology; politics, gender and race. The third edition of this successful text has been fully revised and updated to include:

* applying the principles of cultural studies and how to read a text
* an overview of recent ethnographic studies
* a discussion of anthropological theories of consumption
* questions of identity and new ethnicities
* how to do cultural studies, and an evaluation of recent research method-
 ologies
* a fully updated and comprehensive bibliography.

Graeme Turner is Professor of Cultural Studies at the University of Queensland. He is the editor of *The Film Cultures Reader* and author of *Film as Social Practice*, 3rd edition, both published by Routledge.

Reviews of the second edition

'An excellent introduction to cultural studies ... very well written and accessible.'
John Sparrowhawk, University of North London

'A good foundation and background to the development of cultural studies and its associated theories.'
Paul Rixon, Roehampton Institute

'A short and good overview of the history of cultural studies and a useful discussion of central categories and seminal texts.'
Udo Goettlich, Universitaet Duisburg, Germany

'A comprehensive study of the field, easily understood by students ...'
Tom Grainger, Faculty of Sciences of Luminy, Marseille, France

British Cultural Studies

An introduction

Third edition

■ **Graeme Turner**



Routledge
Taylor & Francis Group

LONDON AND NEW YORK

First published 1990
by Unwin Hyman Inc.
Reprinted 1992

Second edition published 1996
Reprinted 1998, 2000, 2002
Third edition published 2003
by Routledge
2 Park Square, Milton Park,
Abingdon, Oxon OX14 4RN

Simultaneously published in
the USA and Canada
by Routledge
270 Madison Avenue, New York, NY 10016

*Routledge is an imprint of the
Taylor & Francis Group*

© 1990, 1992, 1996, 2003 Graeme Turner

Typeset in Times by Taylor & Francis Books Ltd

British Library Cataloguing in Publication Data
A catalogue record for this book is available
from the British Library

*Library of Congress Cataloging in Publication
Data*
A catalog record for this book has been
requested

ISBN 0–415–25227–X (hbk)
ISBN 0–415–25228–8 (pbk)

Contents

CONTENTS

8 Conclusion 225

Introduction

If it had been written thirty years ago, a book with this title would almost certainly have been expected to deal with 'high culture': the elite art forms seen to provide the best that has been written, spoken or performed over the ages. An index of how large a shift has occurred in those thirty years is that I will deal primarily not with elite but with popular culture. This book will chart some of the reasons for this shift, while outlining cultural studies as a set of key sites of investigation, key methodologies and theoretical orientations, and a critical practice.

The term *cultural studies* is now well known as the title for an important set of theories and practices within the humanities and social sciences. As its international journal, *Cultural Studies*, puts it, the field is 'dedicated to the notion that the study of cultural processes, and especially of popular culture, is important, complex and both theoretically and politically rewarding'. While the field has now achieved recognition, it is not a discrete or homogeneous formation, nor is it easy to define. It is not surprising that, although there had been many readers and collections of articles dealing with specific aspects or applications of cultural theory up until 1990, the original edition of this book was the first to attempt to introduce it accessibly and comprehensively. Since this book was published, however, there has been something of an explosion of such attempts – Brantlinger (1990), Gray and McGuigan (1993), Storey (1994), Tudor (1999) and Mulhern (2000) among them. The need, however, for the particular perspective offered by this book remains. While few outside the US would use the term 'British cultural studies' without at least some of the reservations I will go on to make later in this introduction, the label has become more widely used in recent

1

years within the UK. Nothwithstanding its difficulties, it continues to be a useful way of directing attention to the original and fundamental concerns of the broad and changing field of cultural studies. For the third edition, some changes have been made to acknowledge shifts in the field or to implement revisions in the approach. In particular, a new section has been added to Chapter 7, dealing with 'Identity', to reflect the significant shift towards such issues within British cultural studies over the last decade.

As Paul Willis (1979) has said, the 'culture' that is the subject of British cultural studies is 'not artifice and manners, the preserve of Sunday best, rainy afternoons and concert halls. It is the very material of our daily lives, the bricks and mortar of our most commonplace understandings' (pp. 185–6). What we wear, hear, watch and eat; how we see ourselves in relation to others; the function of everyday activities such as cooking or shopping: all of these have attracted the interest of cultural studies. Emerging from a literary critical tradition that saw popular culture as a threat to the moral and cultural standards of modern civilization, the work of the pioneers in cultural studies breaks with that literary tradition's elitist assumptions in order to examine the everyday and the ordinary: those aspects of our lives that exert so powerful and unquestioned an influence on our existence that we take them for granted. The processes that make us – as individuals, as citizens, as members of a particular class, race or gender – are cultural processes that work precisely because they seem so natural, so unexceptional, so irresistible.

The work of Raymond Williams, Richard Hoggart, Stuart Hall and in particular the Birmingham Centre for Contemporary Cultural Studies (CCCS) has established the consideration of popular culture – from the mass media to sport to dance crazes – on an academic and intellectual agenda from which it had been excluded. This exclusion had exacted a great cost; what it regarded as peripheral and meretricious included the most basic and pervasive of social processes, practices and meanings. It is from these 'peripheral' networks of meaning and pleasure that culture is constructed, for

> it is one of the fundamental paradoxes of our social life that when we are at our most natural, our most *everyday*, we are also at our most cultural; that when we are in roles that look the most obvious and given, we are actually in roles that are constructed, learned and far from inevitable.
>
> (Willis 1979: 185)

Willis' concluding phrase is the one that bites: if the roles we take for granted should *not* be taken for granted, then their exclusion from academic inquiry is, at least, unwise. So the focus on popular culture has quickly become a focus on how

our everyday lives are *constructed*, how culture forms its subjects. No idle interest, the aim is to locate the social and political effects of these formations.

The following chapters present a history of the development of these ideas, specifying what seem to me the central principles of British cultural studies. The book is organized in two parts. Part I sets up the basic theoretical principles in Chapter 1, and sketches a history of British cultural studies in Chapter 2. Part II looks more in depth at the central categories within the field: texts, audiences, the social production of everyday life, the problem of ideology, and finally the politics of cultural studies through race, gender and identity. The first chapter, necessarily, has some heavy ground-clearing to do, and those who are already familiar with semiotics and structuralism may wish only to skim through it on their way to Chapter 2. Throughout, I present descriptive accounts of significant contributions to each topic; in many cases, this work is quite daunting to read in its original form, and my account aims to guide both those who intend to seek out the original book or article and those who do not. As often as possible I have chosen to allow the original works to speak for themselves, and I have quoted liberally. For the conceptual organization of the material, of course, I alone am to blame.

Before proceeding with this account, however, there are a number of admonitory points to be made about the 'tradition' constructed through this history, its 'Britishness', and the status of the theoretical formulations made in the process of constructing it. The title *British Cultural Studies* is itself a touch too precise. While I am going to concentrate on British work in the wide and shifting field of cultural studies, and while I am also going to examine some of the British origins of British cultural studies, it is important to recognize that this tradition is not sealed off from other influences. As Adrian Mellor (1992: 664) has said, 'the Brits don't *own* cultural studies'. While I may argue that the role of Williams and other British researchers is seminal, the work of the European structuralists – Lévi-Strauss, Saussure, Lacan, Barthes, Foucault – and certain inflections of European Marxism – Althusser, Gramsci – are also central to the formation of what is now recognized as British cultural studies. Further, although I will not deal with these corollary movements, readers should be aware that there are other important, non-British, traditions in cultural studies: the work emanating from the sociology of Bourdieu or de Certeau in France, for instance, or the American anthropological tradition James Carey (1989: 61) identifies with Clifford Geertz and calls 'cultural science'. This book is not aimed at appropriating the whole of the field and incorporating it into the category of British cultural studies; rather, it looks at one, relatively discrete but particularly influential, corner of this emerging intellectual terrain.

The distinctiveness and usefulness of the British tradition of cultural studies for those working in other contexts could be said to lie in its relatively accessible

applications of European theoretical models to specific cultural formations. It is unusual in the degree of emphasis it has given to 'concrete' or applied studies – applying complex social theory to, say, the process of leaving school or organizing a lift home from the local dance. Richard Harland (1987) may be too sweepingly dismissive, but he is also roughly correct when he claims that 'Anglo-Saxon Semioticians are largely indifferent to matters of philosophy; their interests are more practical, focusing upon various specific studies in various specific fields of communication' (p. 4). Far from limiting the tradition's appeal, this practicality has expanded its usefulness and contributed to the influence it has enjoyed. If such an attribute enhances the desirability of constructing an introduction to the British tradition of cultural studies, it must also be admitted that this very particular focus is maintained at some cost. This book necessarily omits detailed discussion of some work which has had an influence on cultural studies in Britain but which comes from elsewhere: examples which come to mind would be Ien Ang (1985), Meaghan Morris (1988) and Janice Radway (1987). Further, my approach implicitly aligns this tradition with an idea of the nation that many within British cultural studies would resist. Paul Gilroy (1993), for instance, has criticized British cultural studies for its 'morbid celebration' of national characteristics (p. 10). However, it is worth pointing out that for many this 'morbid celebration' was made possible by the implicit universalization of (white) British cultural experience, accompanied by a slightly disingenuous disavowal of any interest in 'the national'. A significant feature of British cultural studies over the latter half of the 1990s is the explicit focus on British national identities and their complex relation to issues of ethnicity, gender and class.

A further reason for caution in writing such a book as this is that cultural studies is pre-eminently a critical field: many have warned against the dangers of an orthodoxy developing. When the Birmingham Centre for Contemporary Cultural Studies launched its journal, *Working Papers in Cultural Studies*, it 'refused' to define the field, choosing instead to embark on what Hall (1980a) calls a 'sustained work of theoretical clarification' (p. 15). While not every product of the Centre could be said to achieve this objective (and resisting an orthodoxy can certainly limit the achievement of clarity), such work continues, and it would be wrong to see these pages as describing a stable, fixed field of theory or practice. This book, I hope, offers instead a kind of narrative in progress, proposing ways of conceptualizing where the field of study has been and where it might be now.

This dogged and perhaps slightly curious resistance to the establishment of a theoretical orthodoxy in cultural studies is a product of two of its defining characteristics: the complexity and comprehensiveness of the theoretical issues it has confronted in order to deal with the problem of culture, and its commitment to

critical, political objectives. The first characteristic creates real problems in a book such as this, since the issues dealt with are genuinely complex and difficult to simplify for the purposes of an introduction without sacrificing accuracy or comprehensiveness. This is also a problem for the tradition itself, and has led to accusations of 'theoreticism', an elitist fondness for the intricacies of theory for their own sake. Such theoreticism is seen to produce a particularly self-regarding kind of writing, couched in an exclusive and intimidating jargon that is deployed as proof of the academic seriousness of the field of study and its objects. Readers of this book will have to judge for themselves how successfully I have compromised between the demands of simplicity of expression and an appropriate complexity of conceptualization.

The second issue, however, is more substantive. Work in cultural studies has consistently addressed itself to the interrogation of society's structures of domination. It has focused most particularly on the experience of the working class and, more recently, on that of women as locations where the action of oppressive power relations can be examined. In its theoretical tradition it is inextricably linked with a critical European Marxism that seeks to understand how capitalist societies work and how to change them. This means that, while cultural studies' subject matter may be popular culture, and while this may even be dealt with in ways that involve an element of nostalgia, for instance, the objective of cultural studies is not simply to recover aspects of social experience that were dear to the researchers' own hearts. It is all too easy to characterize work on the media, or on youth cultures, or on the music industry, as a kind of 'slumming' by middle-aged academics who want to legitimate the activities of their youth. Such motivations are at odds with the basic enterprise of British cultural studies. As Richard Johnson (1983) says, it is important to recognize the inadequacy of studies of popular culture that occur for 'purely academic purposes or when enthusiasm for popular cultural forms is divorced from the analysis of power and of social possibilities' (p. 9). Popular culture is a site where the construction of everyday life may be examined. The point of doing this is not only academic – that is, as an attempt to understand a process or practice – it is also political, to examine the power relations that constitute this form of everyday life and thus to reveal the configuration of interests its construction serves.

This political dimension is one legitimate reason there is concern about the establishment of a cultural studies orthodoxy, about cultural studies' inclusion within the traditional academy, or about the incorporation of its work and its challenges within more conventional academic discourses. Cultural studies defines itself in part through its disruption of the boundaries between disciplines, and through its ability to explode the category of 'the natural' – revealing the history behind those social relations we see as the products of a neutral

evolutionary process. It is understandably worried at the prospect of becoming a 'natural' discipline itself.

Nevertheless, a book like this is necessary to provide an accessible introduction to an important body of theory that is in many cases unavailable outside journal articles and that is not easily assimilable by undergraduates. So, while I am under no illusions as to what the fate of a book like this might well be – it *could* support the installation of an orthodoxy within teaching programmes if not in research – there seems no alternative if I want the material it contains to gain a wider currency. Therefore, I offer what must look like something of a ritual disclaimer: this book does not set out to offer *the* definitive account of the tradition, nor do I feel we need such an account. The aim of this book is to provide a guide for students entering this important and complicated field to enable them to search out the appropriate primary sources relevant to their interests or needs.

There could be substantially different accounts of this tradition from what follows. While I have dealt with all aspects of the field that seem most significant, I am aware of placing some emphasis on the textualist/structuralist aspects; those who work in, say, history and use cultural studies theory may feel that my literary and media studies background has skewed my definition of the field in this direction. I would acknowledge that possibility, and invite alternative accounts. Nor is the British tradition the only way into an understanding of, or engagement with, cultural studies. Cultural studies is a variously and vigorously contested field, yet this very fact makes it necessary for students to have some kind of map that will organize the territory at least provisionally so that they may then begin to explore it and reframe it in their own ways. This book is intended to be that map.

For permission to use illustrations, I would like to thank the BBC, AAP, AFP, AP, Methuen/Routledge and *The Australian*. For their part in the production of the first edition of the book, through conversation, comments or encouragement, I would like to thank John Hartley, Richard Johnson, Philip Nielsen, Lisa Freeman and, most particularly, my editor, David Thorburn. For their part in the production of the revised editions, I would like to thank Christopher Cudmore, Rebecca Barden, Tony Bennett, Frances Bonner, Paul Du Gay, John Frow, John Hartley, John Storey and the many students in the US, Canada and Australia who have offered appreciative and helpful advice towards improving the original edition.

Part I
FIRST PRINCIPLES

The idea of cultural studies

Writing in 1983, Richard Johnson, a former director of the Birmingham Centre for Contemporary Cultural Studies, revised the grammar in the title of his paper 'What Is Cultural Studies Anyway?' to read 'What *are* cultural studies anyway?' (p. 1). It is a significant shift. There are many ideas about what constitutes the centre of cultural studies. Seemingly, many of the arguments about the shape of the field and the appropriateness of specific practices within it are driven by the original disciplinary orientation of individual contributors. Thus, historians tend to be suspicious of the textual analysis practised by those who originally trained as literary critics; the literary critics in turn are often suspicious of the way in which sociologists or ethnographers accept statements from their subjects without sufficient analysis and interpretation. Recently, some sociologists have been broadly critical of humanities-based cultural studies research that over-looks the usefulness of political economy. It would be a mistake to see cultural studies as a new discipline, or even a discrete constellation of disciplines. Cultural studies is an interdisciplinary field where certain concerns and methods have converged; the usefulness of this convergence is that it has enabled us to understand phenomena and relationships that were not accessible through the existing disciplines. It is not, however, a unified field, and much of this book will be taken up with mapping lines of argument and division as well as of convergence.

All of that said, cultural studies *does* contain common elements: principles, motivations, preoccupations and theoretical categories. In this chapter I will outline the most basic of these at an introductory level. I will return to develop them more fully in later chapters.

LANGUAGE AND CULTURE

In Chapter 2 I will sketch out the beginnings of British cultural studies within English literary studies, looking at the contributions of Raymond Williams and Richard Hoggart in some detail. At this stage only a couple of points need to be made about the way in which this tradition began.

Customarily, cultural studies is seen to begin with the publication of Richard Hoggart's *The Uses of Literacy* (1958) and Raymond Williams' *Culture and Society 1780–1950* (1966; first published in 1958) and *The Long Revolution* (1975; first published in 1961). Both Hoggart and Williams can be placed within a tradition of English literary criticism generally identified with F. R. Leavis and noted for its concentration on the forms of literary texts and on their moral/social significance. What was impressive about both Hoggart and Williams was their ability to mobilize their methods of textual criticism so as to 'read' cultural forms other than literature: popular song, for instance, or popular fiction. But there were clear limits: both writers suffered from the lack of a method that could more appropriately analyse the ways in which such cultural forms and practices produced their *social*, not merely their aesthetic, meanings and pleasures. To reconnect the texts with society, with the culture and the individuals that produced and consumed them, involved a fundamental reorientation. One was required to think about how culture was structured as a *whole* before one could examine its processes or its constitutive parts.

As Iain Chambers (1986: 208) has suggested, 'Explanations based on the idea of totality, on the rational frame that connects the most distant and complex parts, are characteristic of the great Continental schools of thought': Marxism, classical sociology, psychoanalysis, structuralism, semiotics. The European influence on British cultural studies largely came, in the first instance at least, from structuralism. Structuralism has many variants, but its common characteristic is an interest in the systems, the sets of relationships, the formal structures that frame and enable the production of meaning. The original structuralist stimulus registered within British cultural studies was not, however, a theory of culture, but rather a theory of language. Within most of what follows, language looms as the most essential of concepts, either in its own right or through being appropriated as a model for understanding other cultural systems.

Saussure

Ferdinand de Saussure's theory of language is our starting point.[1] Common-sense understandings of the function of language would see it as a system for naming things; seemingly, an object turns up in the material world, we apply a name to it and communicate this to others, and the word enters into usage. Saussure sees it

differently. For him, language is a mechanism that determines how we decide what constitutes 'an object' in the first place, let alone which objects might need naming. Language does not name an already organized and coherent reality; its role is far more powerful and complex. The function of language is to organize, to construct, indeed to provide us with our only access to, reality.

This distinction might become clearer if we refer to Saussure's proposition that the connection between a word and its meaning is not inherent, or natural, but, in most instances, quite arbitrary; the word *tree* means what it does to us only because we agree to let it do so. The fact that there is no real reason *this* word should mean what it does is underlined by the fact that there are different words to express the same concept in different languages. Further, there is no 'natural' reason the concept itself should be expressed at all. There is no universal law that decrees we should distinguish between trees and, say, flowers, or between trees and grass; that we do so is a matter of convention. Australian Aboriginal cultures discern a multitude of differences among various conditions of what white Australian culture sees as empty desert; their language has many words differentiating what whites simply call 'bush' or 'scrub'. Even the way we 'see' the world is determined by the cultural conventions through which we conceptualize the images we receive. When the first colonists arrived in Australia, their early paintings of the indigenous peoples resembled current European aesthetic conventions of 'the noble savage'. They bore little resemblance to what we now see as the 'real' characteristics of Australian Aborigines. Those early painters represented what they saw through the *visual* 'languages' of their time. So, even our idea of the natural world is organized, constituted, through the conventions of its representation: through languages.

When Saussure insists that the relation between a word and its meaning is constructed, not given, he is directing us to the cultural and social dimensions of language. Language is cultural, not natural, and so the meanings it generates are too. The *way* in which language generates meaning, according to Saussure, is important. Again, he insists that the function of language is not to fix intrinsic meanings, the *definitions* of those things it refers to, as we might imagine it should. Language is a system of relationships; it establishes categories and makes distinctions through networks of difference and similarity. When we think of the word *man* we attribute meaning by specifying the concept's similarity to, or difference from, other concepts; crucially, we will consider what such a word tells us this object is *not*: not boy, not girl, not woman, and so on. Cultural relations are reproduced through the language system: to extend the previous example, the word *man* might also generate its meaning in opposition to other concepts – not weak, not emotional, not sensitive, for example – that go to build up a particular cultural definition of the male role within gender relations.

11

The insights contained within Saussure's theory of language have a relevance beyond linguistics because they reveal to us the mechanisms through which we make sense of our world. Specific social relations are defined through the place language allocates them within *its* system of relations. Such an explanation of language endows it with enormous determining power. Reality is made relative, while the power of constructing 'the real' is attributed to the mechanisms of language within the culture. Meaning is revealed to be culturally grounded – even culturally specific. Different cultures may not only use different language systems but they may also, in a definitive sense, inhabit different worlds. Culture, as the site where meaning is generated and experienced, becomes a determining, productive field through which social realities are constructed, experienced and interpreted.

The central mechanism through which language exercises its determining function is explained through the notions of *langue* and *parole*. Saussure divides the structure of a language system into two categories: *langue* is the full repertoire of possibilities within a language system – all the things that can be thought and said; *parole* refers to the specific utterance, composed by selection from the *langue*. Although *langue* is an enormous system, it is also a determining, limiting system in that it sets up specific sets of relations that are impossible for any one speaker alone to change (although, as we shall see, the system does contain the potential for change). Any utterance composed within the system is also constrained by it, restricted to the categories it recognizes, the conventions it establishes. In speaking a language we find it immensely difficult not to reproduce its assumptions, its version of the world:

> The individual absorbs language before he can think for himself: indeed the absorption of language is the very condition of being able to think for himself. The individual can reject particular knowledges that society explicitly teaches him, he can throw off particular beliefs that society forcibly imposes upon him – but he has always already accepted the words and meanings through which such knowledges and beliefs were communicated to him. ... They lie within him like an undigested piece of society.
>
> (Harland 1987: 12–13)

The great contribution of Saussure's theory is that it directly relates language and culture; some may say it works too well, making it difficult to separate them.

Other signifying systems

Saussure's next step is outside the specific domain of linguistics. He argues that the principles which structure the linguistic system can also be seen to organize other

kinds of communication systems – not only writing, but also non-linguistic systems such as those governing images, gestures or the conventions of 'good manners', for instance. Saussure proposes an analogy between the operation of language and the operation of all other systems that generate meaning, seeing them all as 'signifying systems'. This analogy has been widely accepted and adopted. The reasons for its attraction are pretty clear. Language is a signifying system that can be seen to be closely ordered, structured, and thus can be rigorously examined and ultimately understood; conversely, it is also a means of 'expression' that is not entirely mechanistic in its functions but allows for a range of variant possibilities. Saussure's system thus acknowledges or recognizes the power of determining, controlling structures (analogous to *langue*), as well as the specific, partly 'free', individualized instance (analogous to *parole*). It offers enormous possibilities for the analysis of cultural systems that are not, strictly speaking, languages, but that work like languages. The structuralist anthropologist Claude Lévi-Strauss (1966) adopted Saussure's model to decode the myths, symbolic systems, even the customary practices employed in the preparation of food, of 'primitive' societies; and the French semiotician Roland Barthes (1973) applied it to the analysis of the codes and conventions employed in the films, sports and eating habits (among other topics) of contemporary Western societies in *Mythologies*. For such followers, there was little doubt that 'culture ... was itself a ... *signifying* practice – and had its own determinate product: meaning' (Hall 1980a: 30).

SEMIOTICS AND SIGNIFICATION

That cultural product – meaning – is of crucial importance. If the only way to understand the world is through its 'representation' to us through language(s), we need some method of dealing with representation, with the production of meaning. In his *A Course in General Linguistics* (1960), Saussure suggests the establishment of a 'science which would study the life of signs within society' (p. 16). Semiology 'would teach us what signs consist of, what laws govern them'. Semiology was to be the mechanism for applying the structural model of language across all signifying systems and for providing a method of analysis that would be 'scientific' and precise. While it is not entirely scientific, semiotics – as we shall call it here – has become a most useful method, the terminology of which is basic to cultural studies and needs to be outlined at least briefly in this section.

The sign

Semiotics allows us to examine the cultural specificity of representations and their meanings by using one set of methods and terms across the full range of

signifying practices: gesture, dress, writing, speech, photography, film, television and so on. Central here is the idea of the sign. A sign can be thought of as the smallest unit of communication within a language system. It can be a word, a photograph, a sound, an image on a screen, a musical note, a gesture, an item of clothing. To be a sign it must have a physical form, it must refer to something other than itself, and it must be recognized as doing this by other users of the sign system. The word *tree* is a sign; the photographic image of Brad Pitt is a sign; the trademark of Coca-Cola is a sign, too. Less obviously, when we dress to go out for a drink or to a club, our selection and combination of items of clothing is a combination of signs; our clothes are placed in relation to other signs (the way we do our hair, for instance) that have meaning for those we will meet there. We intend that these signs will determine our meaning for those we meet, and we fear that the meanings we have attempted to create will not be the meanings taken: for instance, instead of being seen as a part of a particular social scene we may be 'read' as *poseurs* or phonies. In this, as in other situations, we signify ourselves through the signs available to us within our culture; we select and combine them in relation to the codes and conventions established within our culture, in order to limit and determine the range of possible meanings they are likely to generate when read by others.

In order to understand the process of signification, the sign has been separated into its constituent parts: the signifier and the signified. It has become conventional to talk of the signifier as the physical form of the sign: the written word, the lines on the page that form the drawing, the photograph, the sound. The signified is the mental concept referred to by the signifier. So the word *tree* will not necessarily refer to a specific tree but to a culturally produced concept of 'tree-ness'. The meaning generated by these two components emerges from their relationship; one cannot separate them and still generate meaning. The relationship is, most often, an arbitrary and constructed one, and so it can change. The mental concept conventionally activated by the word *gay*, for instance, has shifted over the last twenty or so years, articulating an entirely new set of relations. The ways in which such a shift might occur are of crucial importance to cultural studies, because it is through such phenomena that we can track cultural change.

We need to understand the social dimension of the sign: the ways in which culture supplies us with the signifier, the form, and the signified, the mental concept. A conventional system of classification is of some relevance here: the distinction between literal and associative meanings – or denotation and connotation. According to such a system, we have the literal (denotative) meaning of a word, such as *mugging*, and the wider social dimension (connotation), where the accretion of associations around the word extends and amplifies its literal

meaning. Of course, *mugging* is not likely to produce utterly literal meanings, free of connotation; there is really only the theoretical possibility that such a thing as a connotation-free, or unsocialized, meaning might exist. Stuart Hall and a group from the Birmingham Centre for Contemporary Cultural Studies have written a large book devoted almost solely to the public understandings of this one word – *mugging* – in Britain, and the cultural and political means through which those understandings were constructed (Hall *et al.* 1978).

Semiotics in practice

Roland Barthes (1973) has, in effect, extended this system of classification into semiotics. In his essay 'Myth Today', he has outlined an incremental signifying system in which social meanings attach themselves to signs, just as connotations attach themselves to a word. This culturally enriched sign itself becomes the signifier for the next sign in a chain of signification of ascending complexity and cultural specificity. So, for example, the word *outlaw* has acquired social meanings that will be called up and that will acquire further and more specific accretions when used, say, in a western film or in the lyrics of a song played by a heavy metal band. Similarly, the meanings Arnold Schwarzenegger has accrued in his *Terminator* films become part of what he signifies in subsequent performances (even when he plays slightly against them, as in *Kindergarten Cop*). Barthes' particular concern in 'Myth Today' is with the way cultural associations and social knowledge attach themselves to signifieds. He calls these attachments 'myths', not meaning to suggest that they are necessarily untrue, but that they operate, as do myths in what we think of as more primitive societies, to 'explain' our world for us.

It is easier to demonstrate the function of semiotic methods in practice than to explain them in the abstract. The practices of advertising provide a clear demonstration of the processes of signification. Advertising could be said to work by fitting a signifier to a signified, both cooperating with and intervening in the semiotic process. Advertisers typically deploy a signifier, already conventionally related to a mental concept they wish to attach to their product, as a means of providing their product with that meaning. So, the manufacturers of Ski yoghurt in Australia run a series of television ads featuring a particular life-style: sailboarding, hang-gliding, surfing, skiing. The arrangement of signifiers within the images places great emphasis on the natural environment in which these activities take place: water, snow, air. There is no obvious connection with yoghurt, but the life-style shots are intercut with shots of the product being consumed by the same suntanned young things who were sailboarding. The process of semiosis means that we stitch the signs together, connecting the yoghurt with the life-style

depicted. It is similar to the process of metaphor in writing or speech, in which two otherwise unconnected ideas are syntactically linked and thus bleed into each other; each takes on some of the meanings of the other.

The result, for Ski yoghurt, is the product's incorporation into an idea of the natural, into the existing myths of youth, and of a healthy outdoor life-style. As a consequence of advertising like this, yoghurt is now a 'life-style product' as much as a food. This campaign emphasizes the product's place within a set of social, subcultural, fashionable, life-style relations more than it emphasizes Ski's taste as a food – its place within a culinary (if still fashionable) set of relations. Finally, the ads are informed by a myth that links youth, health and nature, as if youth were not only more healthy and vigorous but also more 'natural' than other physical states. This operates in tandem with the apparently unshakeable myth that certain aspects of one's physical appearance are the key to all other states of well-being, from employment to love to personal happiness and success. Such myths may seem transparently false, but they do have surprising explanatory force. Television programmes such as *Lifestyles of the Rich and Famous* reinforce such myths by knitting fame, financial success and glamour together in every segment. To see the successful as exceptionally gifted, and implicitly to see oneself as ordinary and therefore in need of the signifiers of success that life-style products might provide, is to accept the mythic explanation offered for an inequitable and discriminatory economic and social structure.

Textual analysis

These last comments foreshadow the next of the common elements within British cultural studies, its political objectives. But before we leave semiotics, it is important to re-emphasize its usefulness as a methodology. At the most elementary level it supplies us with a terminology and a conceptual frame that enables the analysis of non-linguistic signs. For this reason alone, semiotics has become part of the vocabulary of cultural studies. The method is widely deployed in the analysis of film and television. Clearly, its value lies in its ability to deal with sound, image and their interrelation. In television studies, particularly, semiotics' break with an aesthetic mode of analysis and its relative independence from notions of authorial intention are valuable. There is a link, however, between aesthetic analysis and semiotic analysis: the strategy of calling the object or site of one's analysis *a text*. The term is appropriated from literary studies and depends upon an analogy between the close analysis conventionally applied to literary texts and the close analysis cultural studies applies to popular cultural texts. The objectives of cultural studies' analyses of texts may differ markedly, however, from those of predominantly evaluative modes of literary

studies, such as the tradition associated with F. R. Leavis in Britain. While many individual or groups of cultural texts may be particularly interesting to us – the various formations of the *Big Brother* TV programme, for instance, or the American TV series *Ally McBeal* – the point of textual analysis is not to set up a canon of rich and rewarding texts we can return to as privileged objects. Structuralist influence on the application of semiotics to popular cultural texts has insisted that analysis should not limit itself to the structures of individual texts, but should use such texts as the site for examining the wider structures that produced them – those of the culture itself. As Richard Johnson (1983) has emphasized, while textual analysis is, as we shall see, a major current within cultural studies, the text is still 'only a *means* in cultural study'; it is 'no longer studied for its own sake … but rather for the subjective or cultural forms which it realises and makes available' (p. 35).[2]

Johnson has been sceptical of the value of textual analysis, and arguments around the practice will be taken up in Chapter 3 in greater detail, but he is right to stress the importance of the text as a site where cultural meanings are accessible to us, rather than as a privileged object of study in its own right. The precise nature of cultural studies' interest in these meanings is important, too; at its most distinctive, cultural studies analysis is aimed towards a particular end – that of understanding the ways in which power relations are regulated, distributed and deployed within industrial societies. This introduces the next topic, and I approach it by acknowledging the philosophical and political roots of British cultural studies in British Marxism.

MARXISM AND IDEOLOGY

British Marxist thought underwent radical transformations during the 1960s. When Raymond Williams published *Culture and Society* in 1958, he was able to scoff at English Marxist critics as essentially irrelevant to any wider community of ideas. This attitude was increasingly inappropriate as the 1960s developed and the influence of European Marxist thought provoked a break with traditional Marxism and an embracing of what has been called a 'complex' or a 'critical' Marxism (see Bennett 1981: 7; Hall 1980a: 25).

Stereotyped representations of Marxist thought conventionalize it as a monolithic and revolutionary body of theory. This European tradition is neither of these things; its standard discourse is the critique, and it spends as much time dealing with issues and divisions *within* the field as outside it. The influence of such European theorists as Lukács, Benjamin, Goldmann and Sartre was extended through English translations of their work in the mid-1960s, affecting a large range of academic disciplines and political formations. Crucial for cultural

studies was the way in which this tradition reframed the place and function of culture:

> The Marxism which informs the cultural studies approach is a *critical* Marxism in the sense that it has contested the reductionist implications of earlier Marxist approaches to the study of culture. These, especially in Britain, often tended to view culture – whether we mean this in the sense of works of art or literature, or the ways of life of particular social classes – as being totally determined by economic relationships. The Marxist approaches that have informed the development of the cultural studies perspective, by contrast, have insisted on the 'relative autonomy' of culture – on the fact that it is not simply dependent on economic relationships and cannot, accordingly, be reduced to or viewed as a mere reflection of these, and that it actively influences and has consequences for economic and political relationships rather than simply being passively influenced by them.
>
> (Bennett 1981: 7)

Traditional Marxism had devalued the importance of the idea of culture; culture was part of the 'superstructure' of society, and thus simply a product of the economic and industrial base. Yet, as Saussure's account of the social function of language suggests, this ignores the way in which language exercises a determining influence over the 'real' – including the material bases of capitalism. Historians, too, have argued against such a view as too simple an account of history and its formation. Cultural studies employed critical Marxist theory to launch attacks on the 'economism' in previous explanations of how existing power relations have been instituted and legitimated. Drawing in particular on Louis Althusser's (1971) argument that key 'ideological' apparatuses (the law, the family, the education system, for instance) are every bit as significant as economic conditions, cultural studies insisted that culture is neither simply dependent on nor simply independent of economic relationships. Rather, as Althusser argues, there are many determining forces – economic, political *and* cultural – competing and conflicting with each other in order to make up the complex unity of society.

Marx's aphorism that 'men make their own history, but not in conditions of their own making' has become an oft-repeated dictum in this field. The problem of *how* the conditions in which we make our own history are determined is a central one for Marxist and for cultural studies theory. Althusser's answer is to argue for a network of determinations, differently articulated at different points and for different people, that exercises an overseeing, or 'overdetermining', control over social experience. The mechanism through which the process of overdetermination works is that of ideology.

Ideology, in earlier Marxist formulations, had been seen as a kind of veil over the eyes of the working class, the filter that screened out or disguised their 'real' relations to the world around them. The function of ideology was to construct a 'false consciousness' of the self and of one's relation to history. Althusser's work marks a conclusive break with this way of conceptualizing the term. Just as Saussure had argued that language provides us with access to a *version* of reality, rather than to *the* reality, Althusser's definition sees ideology not as false but as a conceptual framework 'through which men interpret, make sense of, experience and "live" the material conditions in which they find themselves' (Hall 1980a: 33). Ideology forms and shapes our consciousness of reality. For good or ill, the world it constructs is the one we will always inhabit.

Ideology, language and state apparatuses

Clearly, ideology must saturate language. The formation of the categories through which we understand experience, as mentioned above in the quotation from Harland (1987), begins before we can resist them. The language system, with its constitutive ideological frameworks, is always already there waiting for the child to insert him- or herself into it. This is why feminists have been so critical of sexist language – the ways in which ideologies of domination are institutionalized through the use of *Miss/Mrs* or the assumption that every committee must have a 'chairman'. Althusser also insists that ideologies must be examined not only in language and representation, but also in their material forms – the institutions and social practices through which we organize and live our lives. John Fiske (1987a) explains how Althusser's ideological state apparatuses (the media, the legal system, the educational system and the political system) achieve ideological ends by establishing and legitimating social norms:

> These norms are realized in the day-to-day workings of the ideological state apparatuses. Each one of these institutions is 'relatively autonomous', and there are no overt connections between it and any of the others – the legal system is not explicitly connected to the school system or to the media, for example – yet they all perform similar ideological work. They are all patriarchal; they are all concerned with the getting and keeping of wealth and possessions, and they all assert individualism and competition between individuals.
>
> (Fiske 1987a: 257)

Since ideologies are observable in material form only in the practices, behaviours, institutions and texts in society, the need to examine these material forms

seemed to be extremely pressing. There is now a rich literature of inquiry into the material, social and historical conditions of ideological formations. These range from histories of the media to the histories of discourse identified with Michel Foucault, histories of the notion of discipline or of Western sexuality, for instance, that see such concepts as entirely culturally produced.[3] However, within British cultural studies the primary focus of ideological analysis has been on the media, in particular on their definitions of social relations and political problems, and on their implication in the production and transformation of popular ideologies (Hall 1980d: 117). This was a central concern for the Birmingham Centre.

These critical Marxist accounts of ideology insist on culture's determination by specific historical forces, legitimated by specific ideological formations, and in specific material interests. There is nothing natural or inevitable about their view of history. Althusserian Marxism does not stop there, however. Ideology not only produces our culture, it also produces our consciousness of our selves. Another essential category moves into our sights now – the category of the unique individual, possessed of innate, intrinsic qualities expressed and realized in the idea of the self. This category, this romantic idea of the individual, is the next target of cultural studies theory.

INDIVIDUALISM AND SUBJECTIVITY

Marxism has always seen the notion of individualism as a central supporting mythology for capitalism; the placement of the individual at the centre of history has thus been vigorously resisted. Althusser's and, later, Jacques Lacan's critiques of individualism, however, are significantly different from those that preceded them.

Althusser argues that ideology operates not explicitly but implicitly; it lives in those practices, those structures, those images we take for granted. We internalize ideology and thus are not easily made conscious of its presence or its effects; it is unconscious. And yet, the unconscious has, within many philosophical frameworks, been seen as the core of our individuality, a product of our nature. If Althusser is right, then, our unconscious, too, is formed in ideology, from *outside* our 'essential' selves. For Althusser, the notion of an essential self disappears as a fiction, an impossibility, and in its place is the social being who possesses a socially produced sense of identity – a 'subjectivity'. This subjectivity is not like the old unified individual self; it can be contradictory, and it can change within different situations and in response to different kinds of address. We rely, in fact, on language and ideology to instruct us in how we are to conceive our social identities, in how to be a 'subject'.

The post-Freudian psychoanalyst Jacques Lacan takes this notion further. Lacan appropriates the model of structural linguistics from Saussure, and argues that our unconscious is a sign system, too, that functions like a language. (Dreams, for instance, offer an example of this.) The *langue* of our unconscious is not produced by a unique individual, but by culture. Just as we learn to speak in the language and customs of our culture, and are thus in a sense constructed through them, our unconscious too is formed through the perceptions and language of others. Our view of ourselves is composed from a repertoire given to us, not produced by us, and so we are the subjects, not the authors, of cultural processes.

Dizzying as this can seem when first encountered, such perspectives have been extraordinarily productive. For instance, consider how such a view of the individual/subject might have affected the first feminist critiques of the social construction of the feminine. Alibis against accusations of sexual discrimination customarily invoke the problems inherent in 'natural' female attributes: women are not given managerial jobs because they are not 'risk-takers', or they tend to get too 'emotionally involved'. Their consignment to the home and family is justified because these are seen as their 'natural' place, and this is reinforced by their 'natural' interests in children, sewing, homemaking and so on. Even women who might have to admit to such interests, or such personal attributes, could now argue that there is nothing natural about them: they are socially produced. What to do about this is a little more difficult; women cannot be granted an exemption from cultural processes, but they can interrogate their function so that women's subordination no longer has the alibi of being 'natural'. For recent feminist theorists, post-Freudian notions of subjectivity have been widely used to examine the social construction of the feminine and to frame attempts to intervene in that social process.

More widely, the notion of subjectivity has provoked studies into the construction of subjectivities by and within specific historical movements. Media studies and screen theory have looked at the way the medium, and in many cases a particular text, constructs a specific range of subjectivities for the reader or viewer. There is a rich controversy around this work, particularly that published in *Screen* magazine, but it has been useful in underlining the fact that we respond to the invitation of a text by inhabiting a designated or constructed subjectivity. This subjectivity may well be quite different from what we construct for ourselves in reading other texts. Socially produced subjectivities do not need to be consistent (Morley 1986: 42).[4] David Morley's research on people's use of television found that viewers could adopt internally contradictory positions in response, say, to particular items within one television news programme, inhabiting a range of competing and apparently inconsistent subjectivities. Nor would a viewer's

response to a television news programme be framed solely by that programme; clearly a range of social, economic and cultural forces will 'overdetermine' the way in which the viewer sees him- or herself as the subject of that programme's address.

This foreshadows an area that will be followed up in Chapter 3 – the degree to which texts construct the subjectivities of their audiences. Morley's work is opposed to that of the majority of the *Screen* critics in insisting that the reader is a social, as well as a textual, subject; that is, the text is not the only or even the major mechanism producing the reader's subjectivity – even while he or she is reading the text. This debate has wider ramifications, too, which affect discussions about the degree to which subjectivity, in general, is produced by determinants external to the individual self. Michel Foucault's early work, for instance, described subjectivity as an 'effect' of the operation of particular cultural forces. While he acknowledged that individual differences occurred in spite of these forces, his account allowed little actual room for the subject's active participation in the production of their own subjectivity. Consequently, and as is the case with *Screen* theory and (as we shall see in a moment) Althusserian theories of ideology, Foucault's early work has been attacked for subscribing to a monolithic model of cultural process.

TEXTS, CONTEXTS AND DISCOURSES

As will have become plain by now, cultural studies is a complicated field in which the role of theory is crucial. The problem of conceptualizing the social relations that make up our popular cultures defeats small-scale empirical analyses. That is the reason for the commonly held view that one really does have to develop some overarching theoretical position that can organize one's practice coherently. However, the complexity of the field has meant that, while all the variant approaches share a view of culture as a political, historical process constructing everyday life, their specific approaches and their chosen subject matter can look very different.

Current work in cultural studies includes histories of popular movements, particularly in the Britain of the nineteenth century, that focus on subcultures and the gaps in official histories; Lacanian studies of subjectivities, particularly the construction of feminine subjectivities in particular contexts and through particular media; 'ethnographic' studies of subcultures within contemporary urban societies, attempting to analyse the subcultures' interpretations of their own cultural experiences; the analysis of specific media, such as television, in an attempt to understand the structure of their 'languages' and their relation to ideologies; the analysis of particular textual forms – from popular fiction to

music video – in order to pin down their formal and ideological characteristics; studies of media economy, drawing on the major traditions of the 1960s and 1970s in Britain, and tracking the production of culture through media institutions and government cultural policy; a combination of textual analysis and ethnographic audience studies that attempt to find out how, primarily, television audiences use the medium; and the continuing enterprise of theoretical clarification of the whole field of study. This is not an exhaustive list, but it at least suggests the breadth and depth of the field.

To see that such diverse activities belong to the same broad enterprise is not easy, but it is important to recognize that, despite this variety of topics and perspectives, the object inspected is the same: culture. The methodologies I have outlined – structuralism and semiotics in particular – and the central terms I have glossed so far – signification, representation, texts, subjectivity, ideology – are applied throughout the field, too. Nevertheless, it was customary for quite some time to perceive cultural studies as split by a broad methodological and theoretical division between structuralists and 'culturalists'.

Structuralism and culturalism

The structuralism/culturalism split will occupy us again later, but for the moment it is worth outlining as a debate. Structuralists saw culture as the primary object of study, and approached it most often by way of the analysis of representative textual forms. The forms and structures that produced cultural meanings were the centre of their attention, and so they tended to be less interested in the culturally specific, the historical or the differences between forms than they were in tracking overarching characteristics and similarities. 'Culturalists', and British historians in particular, resisted structuralism; it was too deterministic, too comprehensive a definition of the force of ideology. Identified particularly with Raymond Williams and E. P. Thompson, culturalism retained a stronger sense of the power of human agency against history and ideology; that is, culturalists argued that determining forces could be resisted, and that history could be affected by radical individual effort. The focus of their work was resolutely parochial – on the 'peculiarities of the English'. Where structuralism took on a particularly European, even 'foreign' image, culturalism seemed to be the home-grown, British alternative.[5]

This structuralism/culturalism split always was a little too neat: it delimited as well as divided the field. It is now a much less applicable distinction, anyway, as Tony Bennett has argued in his introduction to *Popular Culture and Social Relations* (Bennett *et al.* 1986). Since the interest in the work of Italian theorist Antonio Gramsci, the split no longer occupies as important a place as it once did.

23

Gramsci's theories of hegemony will be explored further in later chapters, but suffice to say here that he resolves a number of problems seen to hamper the application of Althusser's theory of ideology. Most important, Gramsci offers a less mechanistic notion of determination and of the domination of a ruling class. Where Althusser's explanation implies that cultural change is almost impossible and ideological struggle futile, Gramsci explains how change is built into the system. He acknowledges the power of the individual human agent within culture by analysing not only the overdetermining structure that produces the individual, but also the range of possibilities produced for the individual. Finally, Gramsci's work is historicized, addressing the construction of cultural power at specific historical moments.

Other approaches

In practical terms, the differences between the major tendencies in cultural studies have revealed themselves in the ways through which individual authors have approached their subject matter. Here, too, we can see two broad, if not always mutually exclusive, categories of approach: one either works through a set of textual formations from which one begins to read constitutive cultural codes or one examines the political, historical, economic or social context in which texts were produced and thus tracks the codes from the culture into the text. These days, neither approach is as discrete as once was the case, but the early days of textual analysis did tend to see texts out of context, to ignore their placement within a specific historical juncture, while contextual studies tended to deny the need to interpret specific representations at all. Now, however, since the active relationship between audiences and texts has been acknowledged, and since the insertion of both within a historical context is regarded as fundamental, the boundary between textual and contextual work, between representation and history, has broken down.

Such generalizations, however, are getting harder to justify as the field expands and diversifies. At this point in time, it is probably more difficult to describe cultural studies as a discrete programme of approaches tied to a relatively fixed theoretical agenda than in any previous period. On the other hand, however, it is not at all difficult to list what are regarded as an agreed-upon set of cultural studies practices and approaches from which analysts may choose. We now have broad agreement on the usefulness of the more sophisticated notions of ideology drawn from Gramsci as well as on the limitations to the usefulness of the category of ideology itself; textual analysis is much more historical, more socially coded, because it now takes account not just of signs and signification, but of their combinations in particular, culturally specific discourses. The development

of the term *discourse* has itself been significant; it refers to socially produced groups of ideas or ways of thinking that can be tracked in individual texts or groups of texts, but that also demand to be located within wider historical and social structures or relations. More crucially, the term has been used increasingly in the Foucauldian sense, as a way of organising (or in some cases regulating) our knowledges about the world.

The range of discursive analyses employed within cultural studies has been wide. Richard Dyer, for instance, has extended his useful work on the semiotic function of film stars – what they signify independently of the characters they might play – to the examination of particular star images and their social meanings. Dyer (1986) looks at Marilyn Monroe and traces her enclosure within discourses of sexuality during the 1950s. These discourses constructed sexuality in what were then new ways: sex was connected with the core of the self; its expression was a mechanism for psychological health and its centrality to life a rebuttal of notions of sexual guilt and prudery. Other examples of discursive analysis, tracking ideological discourses across texts, institutions and history, include Elaine Showalter's (1987) account of the nineteenth-century treatment of madness, which argues that the institutions and technologies employed were a consequence of insanity's construction as a 'female malady', and Angela McRobbie's (1984) analysis of dance clubs and young girls, which examines the way in which the pleasures of dance are set aside as the licensed domain of the female.

Michel Foucault

Probably the key theoretical influence on the application of the notion of discourse within cultural studies generally over the last decade has been the French theorist Michel Foucault. The great benefit of Foucault's work in this regard was its explicit reconnection of texts to history. In *Discipline and Punish* (1979a), for example, Foucault examines the discourses which enabled the establishment of the prison and other prison-like institutions (the military, the hospital, the school) in late eighteenth-century France and which also structured the specific procedures and disciplines which determined how the inmates experienced their incarceration. Rather than focusing on the reproduction of ideologies, Foucault examined how these enabling discourses directed the operation of power: how these institutions established practices and routines which disciplined behaviour, defined space and regulated the experience of time for those placed within their control.

As I read him, Foucault seems more interested in how power worked than in the specific interests it served. As a result, his view of power differed significantly

from that which had emerged from the Marxist tradition described earlier. First, it had no specific class dimension within it; that is, the aim of the exercise was not to demonstrate how class fractions managed to maintain their dominance. Second, Foucault was interested in how power was dispersed into everyday structures of regulation and control that influenced cultural practices rather than cultural meanings. Third, this version of power was not therefore a centralized, repressive structure operating on behalf of a clear set of interests, but also contained the possibilities (muted, admittedly) of being productive, enabling, even liberatory. Given the importance of the examination of power relations to contemporary cultural studies, it is not surprising that Foucault's work has been extremely influential. Foucault used the idea of discourse in adventurous, if not entirely methodologically consistent, ways which have been increasingly taken up in cultural studies and are evident in a widening of the range of texts and formations approached for analysis: institutions, cultural policies (such as for urban planning or heritage management), the cultural definition and regulation of the body and sexuality, the 'fashioning of the self', and so on.

APPLYING THE PRINCIPLES

In this section I want to apply some of the principles I have been summarising, to show them in action in a 'reading' of a text. This will demonstrate some of the kinds of knowledge which are produced through a cultural studies approach, and might reinforce definitions of some basic terms. What follows is not, however, meant to be a definitive reading of its subject; rather, it is a simple set of initial notes that might indicate the shape of further interpretation.

Our topic is not a television programme or a film but an international political figure: Hamid Karzai. Karzai, at the time of writing, was the leader of the interim government of Afghanistan installed through an international agreement after the fall of the Taliban as a result of the American-led 'war on terrorism' in 2001–2. I want to use cultural studies principles to discuss a change in the meanings generated around the figure of Hamid Karzai within the Western media in early 2002. And I stress what follows may have little to do with a *material* Hamid Karzai you could call on the phone; this is a reading of the cultural construction of Hamid Karzai.

We could commence this analysis with an attempt to understand the ideological formations that might organize Western constructions of someone such as Karzai: an Afghan warlord, his ethnicity and value systems categorically outside those of the West. This could involve a history of Afghanistan since the 1970s, mapping Karzai's place within successive waves of invasion and occupation. Or it might involve an account of the Western cultural discourses around Arab,

Middle East and Eastern politics and ethnicities, and their place within Western constructions of race and identity – particularly over the last year or so. But for my purposes here I am content to commence with a text, using it as a means of access to the codes, myths, discourses and ideologies that have contributed to the shift in Karzai's cultural and political meaning I want to discuss. This is only a beginning, but I think we will find it can take us quite some distance.

The photographs in Figure 1.1 (on p. 28) are taken from newspaper coverage of Hamid Karzai's visit to the US in late January 2002. They accompany a report written by journalist Sally Jackson, under the headline 'A unifying thread runs through Karzai's outfit'. Karzai's visit was aimed at securing the commitment of substantial US funds to the reconstruction of Afghanistan, as well as lobbying for a continued US military presence in the country during the reconstruction period. It coincided with George W. Bush's State of the Union address, and Karzai was a high-profile member of the audience of that address. He was seated next to the First Lady, Laura Bush, and in the same row as the wife of the CIA operative killed in Afghanistan as well as relatives of victims of the terrorist attacks on the World Trade Center on 11 September 2001.

Karzai's trip to the US was preceded by reports of his role that provided the conventional geopolitical analysis one might expect. He was not particularly individualized as a personality, his private life and motivations were not implicated in the analysis, and the emphasis was firmly on the political drama within which he was to play a part. Typical, for instance, was a report in *Time* magazine the previous week (28 January 2002); headlined 'So Many Warlords, So Little Time', this report confined itself to speculating on Karzai's chances of bringing the renegade warlords to heel in the time available to him – six months. By the end of Karzai's trip to the US the discursive context within which he was being reported (that is, the discourses characteristically used to frame the reports) had changed dramatically. An article appeared in *The Sunday Times* on 3 February, for instance, headlined 'Not Your Average Warlord', referring to him as the 'most chic man in the world' and describing his personal appeal as well as his political objectives.

In the case of Sally Jackson's story, it is not hard to tell that Karzai is being represented through the *codes* and *discourses* of celebrity as well as those of politics. 'He's wonderful, he's intelligent ... and, yes, he's sexy' is the breakout quote in the middle of the report. The headline, the captions and photos all use the signs of fashion as a means of constructing Karzai's appearance as a spectacular cultural event. Karzai is 'dressed for success', with a 'unifying thread' running through his 'outfit'; Karzai is a 'style icon', his clothes making 'almost as loud a statement as his speeches'. The colourful traditional Afghan cape (the chapan) he wears is offered up as an exotic indigenous fashion item, in a way that is entirely

27

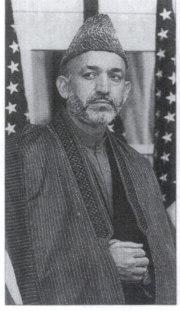
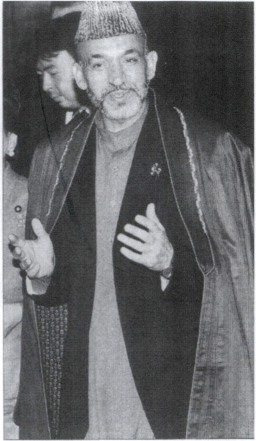

Dressed for
success: Mr
Karzai at the
White House,
above, and in
Tokyo, right,
favours the
traditional
Afghan chapan
Pictures: AP, AFP

A unifying thread runs
through Kazai's outfit

Figure 1.1 **A unifying thread runs through Karzai's outfit (reproduced courtesy of**
The Australian, AP and AFP)

consonant with the appropriating cultural omnivorousness we identify with how
fashion appropriates style.

The comprehensiveness of the operation of the discourses of fashion in the
text of the story must affect how we view the arrangement of *signs* in the photo-
graphs. Where Karzai's appearance may have seemed at best exotic in another
context, here the combination of signs (the text and the images) all contribute
towards supporting the claim that he has become a 'style icon'. The headlines and

the captions tell us that the mix of Western and traditional garments is fashionable; the fact that the photographs were originally printed in colour, exploiting the rich emerald and purple capes as sartorial spectacle, reinforces that reading. As Jackson points out in her report, Karzai is himself 'keenly aware' of this process, and applauds it. It is 'an achievement', he says, that 'wearing the traditional Afghan chapan has become a fashion'.

It is important to remember the discursive context within which it takes place. As Sally Jackson puts it bluntly in her opening paragraphs:

> If your image of the typical Afghanistan male is still a turban-wearing, Kalashnikov-toting, cave-dwelling scruff, prepare to be dazzled by Hamid Karzai, the world's best-dressed warlord.
>
> With his neatly cropped salt-and-pepper beard, sumptuous silk capes and jaunty hats, the interim Prime Minister of Afghanistan proved to be a media sensation – not to mention fashion revelation – during his whirlwind tour of the US this week.
>
> (*The Weekend Australian*, February 2–3, 2002, p. 12)

A set of *intertextual* contrasts are set up, then, between what meanings we take from the signs used to construct Karzai and those conventionally used to construct, say, the representatives of the Taliban. These are relations both of difference and similarity. In comparison to the turbaned, robed, and heavily bearded Taliban officials representing their fundamentalist government, Karzai's appearance is relatively Westernized and familiar (so, by association it would seem, are his politics). His beard is trimmed, he wears a combination of Western and traditional garments (but not a turban), and we are told he speaks fluent English. The photographs present us with a slightly exotic figure, but not excessively 'foreign', and certainly in no way threatening. The two photos appear to play out a narrative of his incorporation into the value systems of the West. In the larger photograph his gesture is accepting, conciliatory, perhaps characteristically 'Eastern'; in the smaller, his face is framed by the most unequivocal *signifier* of Western values – the Stars and Stripes.

His expressions signify as well. In the first image, he is charming, open, at ease; in the second, he is thoughtful, perhaps (we might deduce) borne down by responsibility. In other texts around this time a representational pattern was repeated over and over again. He was photographed in extreme close up, often with his face filling the whole frame. Typically, his face was composed but intense, with his eyes looking away from the camera, out of the frame. ('What is he thinking of?' the reader might ask. 'Is it the enormous political task before him?') The representational *conventions* used here are almost sentimentally sympathetic,

signifying the depths within, his eyes looking off towards responsibilities always lying in wait. The conventional tendency of such a pose is to signify the presence of a higher purpose and a noble calling.

The purpose of such representation

None of this is remarkable, perhaps, except for the fact that we are looking at a contemporary representation of an Afghan warlord, where the more conventional discourses are still those of tribalism rather than internationalism, of militarism rather than politics, and of a threatening and alien foreignness that refuses any identification between the Western reader and the figure depicted. There is a discourse of ethnicity organising such conventions too, which is offered up in the way that Barthes would describe as *myth*: as an explanation of the Afghan's intrinsic difference from Western readers. Shaped by such myths, the fabled treachery of the warlords, the intractability of ancient tribal disputes, the readiness to resolve political differences through military means are all routinely cited in media analysis and grounded in racialized assumptions about the nature of the Afghan culture and the ethnicities in play.

Karzai's representations were initially framed within those discourses too. In many of the stories which appeared before the shift I am describing, the likelihood of his failure was already explained through the mythologies referred to above. However, this representational shift moves him into the orbit of a different set of explanatory myths. On the evidence of the texts we have been examining Karzai becomes a sign for the acceptable face of Afghan politics. Karzai is urbane, sophisticated and dressed in a fashionable style that indicates an internationalist orientation. International fashion is itself a signifier of Western values, as the Taliban themselves recognized. It is informed by myths of individualism as well as the connection between consumption and personal self-realization, which are among the central ideologies behind capitalism. You could not find an ideological context more central to Western mythologies, nor one that was more opposed to the Muslim fundamentalism of the Taliban regime. So this shift in Karzai's representation carries important ideological and practical consequences. Since he is so unlike the media's previous representation of his countrymen in these significant respects, the explanatory myth goes, he is more like 'us'; if he is more like 'us', he is more trustworthy, more responsible, and more 'civilized' (and there is a wealth of assumptions in that description, too) than the 'scruffs' Sally Jackson described as typical. 'The West can work with this person' is the consoling message these representations carry.

Let us widen the frame a little further, to think again of the historical context in which this is happening. This is the point where the so-called 'war against

terrorism' has achieved some objectives – it has overthrown the Taliban – but there is much more to be done. Afghanistan is in ruins, the key suspects have escaped and the search is on for the next target. Politically, certainly for the Western non-Muslim countries, it is important that the reconstruction of Afghanistan proceeds rapidly and successfully. This depends heavily upon the effectiveness and legitimacy of Karzai's leadership. It is, then, in the interests of the Western alliance against terrorism for Karzai to attract support and to succeed. The shift we have been examining can be seen to play its part in the pursuit of this objective.

I am not suggesting there is a media conspiracy to represent this man in partic-ular ways to suit specific political ends (nor am I suggesting there *isn't* either!). Indeed, it is possible to explain the sudden enthusiasm expressed by the Western media for this man through reference, for instance, to the extent to which the media representation of persons of his racial and cultural background had been dominated by the racial and political paranoia provoked (understandably but regrettably) by 11 September 2001. Suddenly, perhaps, a media used to wheeling out the same old racial and political assumptions found itself confronting a person who clearly did not fit these assumptions. At such points the established myths lose their explanatory power, and new ones have to be developed. It is really the mapping of that process which is the primary interest in this short analysis.

What I am suggesting is that the texts before us here provide evidence of a cultural process that operates in more systemic and contingent ways than a media conspiracy might. What we can observe in these representations is the gradual cultural negotiation of an ideological shift, as the Afghan leader becomes *semiot-ically* transformed into something more like what we might expect of a European leader – foreign but non-threatening, foreign but sophisticated – for Western consumption and approbation. Just as the Ski yoghurt was semiotically aligned with a 'youthful' life-style through a visual association, Karzai is semiotically aligned with values close to those of the West through these representations. Where he remains aligned with Afghan values it is through the exotic capes and his loyalty to a traditional culture that the Taliban had attempted to extinguish and that the West is happy to respect. The political equivalent of 'World Music', if you like, the meaning of Hamid Karzai can retain the hint of the exotic because he has now been reprocessed by media representations so that such aspects are easily assimilable.

A disclaimer

All of this has been laid out with the confidence that my analysis will gain my readers' assent. So at this stage we need to recover the notion that messages are

polysemic. The reading I have been presenting is highly specific and clearly contestable; I simply do not know what these images and text might mean to a non-Western or Muslim reader. The historical and political location of the reader is going to affect dramatically what they make of this material. Even those reading from within pro-US Western cultures may well vary in their response to, for example, the mobilization of discourses of celebrity in the representations of such an important political figure, or in their political opinion of Karzai's role within the larger debates about the so-called war on terrorism and the legitimacy of the attacks upon Afghanistan itself. The American media's enthusiasm for Karzai will have been read within a much larger context than that which I have presented here, and readings of that will vary too. Some may regard it as a highly cynical public relations exercise to assist in maintaining international support for American policy; others may see it as a welcome sign that there are limits to the demonizing of Arab or Eastern ethnicities that flourished in the wake of the events of 11 September.

This is a useful reminder. A group of texts such as this always needs to be placed in a historical context. To outline properly the particular historical conjuncture that has produced these texts and given Hamid Karzai his temporary celebrity is beyond my brief here. But it is important to note that a reading of these texts would not be complete without some consideration of such a context. We could not understand the cultural construction of 'Hamid Karzai' without further exploring the sources of the constitutive myths – around his ethnicity, around fashion as a signifier of Western values, and so on – within Western cultures. The texts can help us to understand how these sources are constructed, legitimated and disseminated – as well as to understand something about the construction of the specific historical conjuncture. Ultimately, however, to describe the shift in meaning I have set out to examine would involve the elaboration of a specific history, not just a resonant, but arbitrary, array of texts. Nevertheless, as is the case with cultural studies itself, the close analysis of the texts provides us with a provocative starting point.

The British tradition
A short history

My account of cultural studies' 'first principles' has inevitably foregrounded the European theoretical influence. This should not obscure the fact that British cultural studies has very specific historical roots in postwar Britain, where the revival of capitalist industrial production, the establishment of the welfare state and the Western powers' unity in opposition to Russian communism were all inflected into a representation of a 'new' Britain. This was a culture where class was said to have disappeared, where postwar Britain could be congratulated for its putative discontinuity with prewar Britain, and where modernity and the Americanization of popular culture were signs of a new future. The precise conditions of British or, more particularly, English culture were subjected to especially keen scrutiny in the attempt to understand these changes and their cultural, economic and political effects.

British cultural studies emerged from this context. But it was not the only product. Within the social sciences there was a substantial revival of interest in the nature of working-class culture and communities. Addressing the widely held thesis that the working class had become 'bourgeois' – that is, that their living conditions and their ideologies had become indistinguishable from those of the middle class – were a number of studies of urban working-class life that documented the survival of working-class value systems and social structures. The work of the Institute of Community Studies and a proliferation of participant observer studies of working-class communities attempted to get inside these structures, often abandoning the conventions of scientific objectivity in order to do so (for an outline of this movement, see Laing 1986: ch. 2).

Interest in British popular culture came from other quarters as well; in the

early 1950s the Independent Group (IG) was examining the visual arts, architecture, graphic design and pop art, and establishing itself at the Institute of Contemporary Arts (ICA) in London. This movement, like cultural studies later, was primarily interested in everyday, not elite, culture and focused particularly on the influence of American popular culture on British life – an influence that was largely to the movement's adherents' taste. In fact, as Chambers (1986: 201) points out, 'the very term "Pop Art", coined by the art critic Lawrence Alloway in the early 1950s, was intended to describe not a new movement in painting but the products of popular culture'.

The IG's relish for postwar culture, style and modernity was not, however, widely shared within the British academic world. Indeed, the major academic tradition I will trace into British cultural studies was implacably opposed to popular culture. The so-called 'culture and civilization' tradition was concerned by the development of popular culture and the concomitant decline of more 'organic' communal or folk cultures that proceeded from the spread of industrialization during the late eighteenth and nineteenth centuries. Matthew Arnold's *Culture and Anarchy*, published in 1869, warned of the likely consequences of the spread of this urban, 'philistine culture', which was accelerating with the extension of literacy and democracy. Where class divisions had once been sufficiently rigid to confine political and economic power to one class, industrialization and the growth of the middle class and an urban working class had blurred these divisions. The aesthetic barrenness of the culture of the new 'masses' worried Arnold, who felt that such a culture must necessarily fail to equip its subjects for the social and political roles they would play within democratic society.

The 'culture and civilization' tradition is most clearly defined, however, by its response to the twentieth-century technologies that radically extended the purchase of 'mass culture' – in particular those that enabled the mass distribution of cultural forms such as the popular novel, the women's magazine, the cinema, the popular press, the popular song and, of course, television. Between the wars, general concern about the moral and aesthetic content of culture began to concentrate on its forms of representation (the mass media in particular) and to become identified with the work of a circle around the English literary critical journal *Scrutiny*: F. R. Leavis, his wife Q. D. Leavis, Denys Thompson and L. C. Knights. Relating the 'abuse' of language to specific social and moral effects, the *Scrutiny* group produced some of the earliest critiques of 'mass culture': F. R. Leavis and Denys Thompson's *Culture and Environment* (1933) and Q. D. Leavis' *Fiction and the Reading Public* (1932), which looked at, respectively, advertising and popular fiction. T. S. Eliot, although often an opponent of the *Scrutiny* line in literary criticism, also analysed the forms and content of popular culture in order to attack the classless 'new' culture in *Notes Towards a Definition of Culture* in 1948.

Viewed from this distance, these approaches seem unashamedly elitist;[1] from their perspective, popular culture was to be deplored for its deficiencies – for its lack of 'moral seriousness' or aesthetic value. The mass culture of contemporary England was unfavourably compared to an earlier, albeit mythical, folk culture located in some past formation of the 'garden of England'. Industrialization, mass communication and technology were all seen to be inimical to this earlier, more organic version of British existence; it was as if the entire twentieth century were intrinsically 'anti-British'. The specific concern with mass culture was generalized in order to criticize other popular cultural forms, including many of the forms of everyday life within industrial societies. Within such a critique, the products of popular culture 'existed only in order to be condemned, to be found wanting on one ground or another':

> as corrosive of the capacity for ethical and aesthetic discrimination, or – and most enduringly – as worse than whatever forms of popular culture may have preceded them, a corruption and dilution of an earlier and supposedly, sturdier, more robust and organic phase in the development of the people's culture.
>
> (Bennett 1981: 6)

The account of the everyday life of the ordinary citizen produced by these studies was extremely remote and patronizing. As Bennett (1981) says, it was a discourse of the 'cultured' about the culture of those without 'culture':

> Popular culture was approached from a distance and gingerly, held out at arm's length by outsiders who clearly lacked any fondness for or participation in the forms they were studying. It was always the culture of 'other people' that was at issue.
>
> (Bennett 1981: 6)

This elitism was made to seem more 'natural' and legitimate by the fact that those expressing it had similar class backgrounds; the prewar means of entrance to higher education more or less ensured this. However, the expansion of educational opportunities within Britain after the war and the spread of adult education as a means of postwar reconstruction as well as an arm of the welfare state eventually had an effect on the class origins of those who inherited this intellectual tradition. The 'scholarship boys and girls' (those admitted to universities and colleges on merit, regardless of income or background) included a significant number from the working or lower-middle class. Key figures in the next generation of cultural criticism in Britain – Raymond Williams and Richard

Hoggart, to mention just two – were working class, and had a personal involvement with this despised sphere of culture. As Bennett goes on to point out:

> This has altered the entire tone of the debate as a sense of liking for and, often, deep involvement in the forms studied has replaced the aloof and distant approach 'from above', and as the need to *understand* the effects of popular culture on ourselves has displaced the need to *condemn* it because of what it does to 'other people'.
>
> (Bennett 1981: 6)

Certainly the influence of the scholarship students was important in recasting the examination of popular culture in Britain in the 1950s and 1960s. Even now, many of those working in cultural studies tend to foreground their origins as being in some respects from outside the mainstream of British academic culture. Links with the early foundations of cultural studies in extramural adult education are also relevant here; Williams, Hoggart and Hall all worked as adult education tutors early in their careers. Williams acknowledges debts to this work in *Culture and Society 1780–1950* (1966), *Communications* (1962) and *The Long Revolution* (1975), before arguing in 1989 that the field of cultural studies grew out of the adult education experience (1989). Hall (1990) also notes the importance of developing his ideas in negotiation with 'the dirty outside world' (p. 12) through his adult education experience. Tony Bennett (also an extramural tutor early in his career) throws some cold water on this connection by suggesting that changes in the teaching of history in secondary schools might be just as plausible an institutional origin for cultural studies (1996). However, Ben Carrington's recent account of British cultural studies draws on the significant body of recent research into this history (Steele 1997; Dworkin 1997) in order to argue that 'the formation of cultural studies was, first and foremost, a political project aimed at popular education for working class adults' (Carrington 2001: 278). It certainly seems that working in adult education brought the tutor into touch with a range of subcultural groups not normally encountered at university, whose membership in a popular rather than an elite culture needed to be accepted and understood by their teachers. One can imagine how this might provoke some radical rethinking for a standard Leavisite of the time.

Others were also having to do some rethinking at this time. The cultural and ideological gap between schoolteachers and their pupils was widening as popular culture became more pervasive. The cultural development of the schoolchild became a battleground, defended by the 'civilizing' objectives of the education system but assailed by the illicit pleasures of popular culture. The spread of commercial television across Britain in the late 1950s increased the urgency with

which such concerns were felt. Stuart Laing (1986: 194) suggests that the 1960 National Union of Teachers (NUT) conference, titled 'Popular Culture and Personal Responsibility', was a seminal event at which these debates were aired and structured.

The NUT conference was aimed at finding ways of dealing with popular culture that did not dismiss it out of hand and thus acknowledged its place within the everyday lives of school pupils, but that nonetheless taught some principles of discrimination – the exercise of choice, the 'personal responsibility' of the title – to guide pupils' consumption of cultural forms. This was a liberalization of the Leavis line – it made it possible to argue that certain popular forms (such as jazz, the blues or the cinema) had recognizable aesthetic concerns and traditions. But it was still, residually, a high-culture view of popular culture, interested in aesthetic rather than social pleasures and meanings.

It was, however, an influential conference; Hoggart and Williams both spoke, together with the British Home Secretary, Rab Butler, Stuart Hall, writer Arnold Wesker and film director Karel Reisz. Williams acknowledges the conference's implications in *Communications*, and two books emerged directly out of its deliberations: Hall and Whannel's *The Popular Arts* (1967) and Denys Thompson's *Discrimination and Popular Culture* (1973).[2] Hall and Whannel's book will be dealt with later, but Thompson's collection is a wonderfully clear demonstration of the confusion engendered by the combination of an elite method of analysis and a democratic-humanist interest in the forms of everyday life. The essays in *Discrimination and Popular Culture* adopt extremely varied perspectives on the collective objective of counteracting the debasement of standards resulting from the *misuse* of the press, radio, cinema and television. On the one hand we have the moral panic motivating David Holbrook's literary analysis of the 'dismal' and 'limited world' of popular magazines, while on the other we have Graham Martin's sober institutional study of newspapers, which notes how simplistic and misleading such literary analysis can be when applied to popular culture (D. Thompson 1973: 80). Rather than following Holbrook's lead, Martin relates the styles and contents of the different products of the press to their social roles. Other contributors attempt to legitimate the popular arts by discovering hitherto unnoticed homologies between popular and high art; this effort is almost parodic: 'groups like Pink Floyd and The Who are concerned mainly with instrumental sounds, with developing their music along lines sometimes as abstract as those of the classical symphonist' (p. 144). It is a measure of the distance we have travelled in understanding rock music that this kind of comment rarely appears these days.

Of course, Denys Thompson's introduction is much more sensible than this, and the collection has been influential; it was still supporting courses on popular

culture well into the mid-1970s. But the babble of competing voices it licenses to speak signifies the failure of the analysts of popular culture, in 1964, to articulate a clear sense of their objectives and methods. The NUT conference is a sign of the felt need for more appropriate ways of understanding the problem of culture; *Discrimination and Popular Culture* indicates that, while the culture and civilization tradition may have asked important questions, it lacked the equipment to address them. It is time to begin tracing the development of alternative methodologies and objectives, and my starting points are the conventional but necessary ones: the work of Hoggart, Williams, Hall and the Birmingham Centre for Contemporary Cultural Studies.

HOGGART AND *THE USES OF LITERACY*

Richard Hoggart was born to a working-class family in Leeds in the last year of the Great War, was educated at his hometown university and served in the British Army during the Second World War. From 1946 to 1959 Hoggart was an adult education tutor at the University of Hull, teaching literature. Laing (1986: ch. 7) suggests that this experience was crucial to Hoggart's definition of culture and the place of education within it. The typical participant in adult education (usually an individual who for economic, personal or class reasons was denied or had forgone normal entry into higher education) is also the reader about whom, and to whom, *The Uses of Literacy* (1958) appears to have been written. Certainly there were few opportunities for Hoggart to 'convert' conclusively to another set of class positions; he was teaching those who had come from much the same background as himself and interpreting for them a set of cultural standards that may have seemed foreign but nevertheless prevailed.

More than most academic books, *The Uses of Literacy* invokes the personal experience of the author – not always as direct evidence, it must be said, but often through the admission of a personal partiality, or even a worried ambivalence. This has some benefits; in those chapters that outline the 'full rich life' Hoggart remembers as typical of the working class – in particular the linkages among forms of popular entertainment, the social practices of the neighbourhood, and family relations – Hoggart's personal experience provides a sense of 'authenticity' that is among the book's most distinctive attributes. *The Uses of Literacy* is not primarily confessional, however. The book's method is to employ the analytical skills provided by Hoggart's literary training, often to great effect: the analysis of the discourses and conventions of the performance of popular song, for instance, is interesting and persuasive, and the discussion of popular fiction still repays attention.

It is important to recognize Hoggart's achievement in applying, as successfully

as he did, the analytical protocols of literary studies to a wider range of cultural products: music, newspapers, magazines and popular fiction, in particular. The book's most significant achievement, however, is the demonstration of the interconnections among various aspects of public culture – pubs, working-men's clubs, magazines and sports, for instance – and the structures of an individual's private, everyday life – family roles, gender relations, language patterns, the community's 'common sense'. Hoggart describes working-class life in the prewar period as a complex whole, in which public values and private practices are tightly intertwined. Subsequently, he tends not to separate out specific elements as 'good' or 'bad'; Hoggart acknowledges the social determinants of even the regressive aspects of working-class living, such as domestic and neighbourhood violence. However, while Hoggart's account of traditional urban working-class life is admirable in this sense of its complex interconnectedness, it is nevertheless a nostalgic account of an organic, rather than a constructed, culture. In common with the rest of the culture and civilization tradition, Hoggart looks back to a cultural Fall, when earlier versions of working-class culture were lost. Hoggart differs from Leavis or Eliot only in that his Fall seems to have taken place during the 1930s rather than the nineteenth century, so that his description of the urban working class of this period bears all the attributes of a folk rather than a popular culture.[3]

Nostalgia and critique

Nostalgia is central to the book's project. Hoggart's establishment of the richness of prewar working-class culture in the first half of *The Uses of Literacy* is employed to heighten the second half's contrast with the newer 'mass' popular culture of postwar England. This contrast stresses the latter's lack of organicism, its failure to emerge from specific roots within the lived cultures of ordinary people. In the analysis of *this* version of popular culture, Hoggart is less inclined to suspend aesthetic judgement or to take the culture on its own terms. The book regards modern popular music, American television, the jukebox, popular crime and romance novels, and cheap magazines as intrinsically phoney. They are accused of displacing, but providing no substitute for, a popular culture experientially connected to the social conditions of those who produce and consume it. Not only are the relations of production and consumption a problem, but – almost inevitably – the quality of mass-produced culture is too. Hoggart spends much of the second half of the book invoking Leavisite aesthetic standards against these cultural products. Such a practice is not a significant feature of his portrait of the 'full rich life' of the past, but he clearly feels authorized to criticize the newer, worrying trends. Indeed, Hoggart anticipates the readers' support in this enterprise; he admits to assuming their agreement with his judgement of the

'decent', the 'healthy', the 'serious' and the 'trivial' in his analyses of popular culture texts (p. 344). The result of Hoggart's critical practice is a book about the importance of such distinctions, of standards of discrimination, in the production and consumption of popular cultural forms.

The Uses of Literacy observes conflicting social and theoretical allegiances: to both the culture and civilization tradition from which its ideological assumptions and analytical practices proceed, and to a working-class cultural and political tradition that acknowledges significance in the *whole* of the cultural field. The contradictions thus produced are apparent in the book's method, as it moves from an affectionate account of the social function of popular culture to an evaluative critique of its textual forms, exposing both the author's ambivalence about the class he has left and the limitations of the theoretical tradition he has joined.

These problems are clearest when Hoggart deals with specific examples of this new mass culture. While he well describes the complexity of the constitution of the cultural field of his youth, he is blind and deaf to the complexity of, let alone the functions served by, the 'full rich life' of contemporary working-class youths. A notorious example of his alienation from his subject is his description of 'the juke-box boys':

> Like the cafés I described in an earlier chapter, the milk-bars indicate at once, in the nastiness of their modernistic knickknacks, their glaring showiness, an aesthetic breakdown so complete that, in comparison with them, the layout of the living rooms in some of the poor homes from which the customers come seems to speak of a tradition as balanced and civilized as an eighteenth century townhouse ... the 'nickelodeon' is allowed to blare out so that the noise would be sufficient to fill a good-sized ballroom, rather than a converted shop in the main street. The young men waggle one shoulder or stare, as desperately as Humphrey Bogart, across the tubular chairs.
>
> Compared even with the pub around the corner, this is all a peculiarly thin and pallid form of dissipation, a sort of spiritual dry-rot amid the odour of boiled milk.
>
> (Hoggart 1958: 247–8)

He goes on to describe the young men as 'the directionless and tamed helots of a machine minding class':

> If they seem to consist so far chiefly of those of poorer intelligence or from homes subject to special strains, that is probably due to the strength of a moral fibre which most cultural providers for working-class people are helping to de-nature. ... The hedonistic but passive barbarian who rides in a

fifty-horsepower bus for threepence, to see a five million dollar film for one-and-eightpence, is not simply a social oddity; he is a portent.

(Hoggart 1958: 250)

As one group of critics has said, this prose could almost – 'in its lack of concreteness and "felt" qualities – have been written by one of the new "hack" writers [Hoggart] so perceptively analyses' elsewhere (Hall and Jefferson 1976: 19).[4]

Hoggart's place in cultural studies

The book, nonetheless, has enjoyed substantial influence. Stuart Laing (1986: 184) has referred to Richard Dyer's proposition that Hoggart's construction of working-class life has influenced the long-running TV serial *Coronation Street*, which takes place in a fictionalized northern environment Reyner Banham satirically terms 'Hoggartsborough'. The book's most enduring theoretical value, however, lies in the fact that it reveals, in Critcher's (1979: 19) words, the 'network of shared cultural meanings which sustains relationships between different facets of culture' and the complexity of this network. If some of these meanings are subjected to inappropriate judgements, the book does nevertheless open up culture as a field of forms and practices, and asks us to understand them.

As a result of *The Uses of Literacy* Hoggart became a highly visible contributor to public arguments about the media and popular culture, and is still invoked as an authority in the area. After a period of four years as professor of English at Birmingham, Hoggart became the founding director of the Centre for Contemporary Cultural Studies (CCCS) at the University of Birmingham in 1964.[5] He remained there until 1968, when he left to become assistant director-general at UNESCO. Hoggart's work at the Centre continued, significantly developed and reframed by Stuart Hall, but his own writing since *The Uses of Literacy* has not exercised the same influence on the theoretical development of cultural studies – indeed, Hoggart has pointed to Hall's greater theoretical influence on cultural studies at the Centre (Gibson and Hartley 1998). Steele (1997) presents an account of Hoggart's career which fleshes out the outline given above. With Hoggart's departure from the CCCS (and from debates in cultural studies) the role of the theoretical pioneer passed over to Raymond Williams; it is to his work we turn now.

RAYMOND WILLIAMS

Like Hoggart, Raymond Williams came from a working-class background – in his case, a Welsh village. Also like Hoggart, Williams spent most of his early

career as an adult education tutor, for Oxford University, from 1946 to 1960. The influence of this role was considerable: Williams' involvement in the journal *Politics and Letters*, a journal that aimed at uniting left-wing working-class politics with Leavisite literary criticism, was directed towards an audience of 'adult education tutors and their students' (Laing 1986: 198), and his first book, *Culture and Society* (Williams 1966), came directly out of an adult education class on the idea of culture in T. S. Eliot, F. R. Leavis, Clive Bell and Matthew Arnold. *Communications* (1962) explicitly acknowledges its debt to Williams' time in adult education and this connection is explored at great length in Dworkin's history of adult education and cultural studies (Dworkin 1997).

Culture and Society

Williams' theoretical influence over the development of cultural studies has arguably been more profound than that of any other, and it began with the publication of *Culture and Society* in 1958. *Culture and Society* is a book of literary history, but with a crucial difference; its focus is not on literary texts for their own sake but for their relationship to an idea. Williams follows a thread in English thought and writing through the nineteenth and twentieth centuries in order to establish the cultural grounding of ideas and their representations. The book employs a version of Leavisite close textual analysis, and has certainly had a life on textbook lists as a consequence of that (in fact, that is how I first read the book myself). But its movement is back from the idiosyncrasies of the text to movements within the society, relating specific representations to the culture's ways of seeing. This is the real strength of *Culture and Society*: the reader's continual sense of an entire field of study emerging from the clarity and persistence of the book's pursuit of the connections between cultural products and cultural relations.

To read *Culture and Society* now is to be impressed by its prescience, and by how continually its insights and objectives outrun the supply of available theoretical support. That the book does not actually constitute the field itself should come as no surprise; most of cultural studies' constitutive theoretical positions – from structuralism, from critical Marxism, from semiotics – were simply unavailable to most British readers at the time it was written.[6]

Williams' work in this period enjoys a complicated relationship with the Leavisite tradition. It emphasizes practical criticism and offers a version of English cultural history that in many ways accords with Leavis's, invoking an 'uncertain nostalgia for the "organic", "common culture"' of an England that 'predates and is more "English" than industrialised England' (Eagleton 1978: 40). However, Williams' view of culture cannot be entirely contained within this

tradition; his celebrated opening account of the four meanings of the word *culture* includes that of culture as a 'whole way of life, material, intellectual and spiritual' (Williams 1966: 16). Williams is interested in the whole of cultural experience, its meaning and 'patterning': accordingly, he finds himself interested not just in literary or philosophical uses of language but in 'actual language', 'the words and sequences which particular men and women have used in trying to give meaning to their experience' (p. 18). He is unaware of structuralist explorations of language systems as a means of understanding the workings of culture and so is unable to develop this interest further; as he says, with unconscious understatement, 'the area of experience to which the book refers has produced its own difficulties in terms of method' (p. 17). In *Culture and Society* Williams 'still has to discover the idiom which will allow him to extend "practical criticism" and organicist social positions into fully socialist analysis' (Eagleton 1978: 39). What he *does* discover is that culture is a key category, because it connects his two major interests – literary analysis and social inquiry.

The category of 'culture', however, cannot be said to be fully developed in *Culture and Society*, although it pervades the book's arguments. Williams is still caught among the four definitions the book canvasses. This is most noticeable in the chapters dealing with the twentieth century, where Williams collides head-on with the culture and civilization tradition. His account of Eliot's formulation of culture as 'a whole way of life' is critical, and his discussion of Leavis rejects the text-based approach to the mass media and popular culture upon which most Leavisite critiques depend. 'It is obvious', says Williams, 'that the ways of feeling and thinking embodied in such institutions as the popular press, advertising and the cinema cannot finally be criticised without reference to a way of life' (p. 251). And while he is both critical of and distanced from traditional Marxism in this book, he does admit the relevance of Marxist perspectives:

> The one vital lesson which the nineteenth century had to learn – and learn urgently because of the very magnitude of its changes – was that the basic economic organisation could not be separated and excluded from its moral and intellectual concerns. Society and individual experience were alike being transformed, and this driving agency, which there were no adequate traditional procedures to understand and interpret, had, in depth, to be taken into consciousness.
>
> (Williams 1966: 271)

The economic basis of society, in short, was centrally implicated in any question of culture. Although Williams then moves into a ritual attack on economic

determinism, it is clear that the Arnoldian definition of culture as 'the best that has been thought and said' is subordinated to a more social, historical and materialist view. Culture is talked of both as an idea, its history 'a record of our meanings and our definitions', *and* as sets of material forms, their history that of the 'changed conditions of our common life' (p. 285).

While Williams insists that 'there are in fact no masses; there are only ways of seeing people as masses' (p. 289), his rejection of the mass-culture critique is less than categorical. Like Thompson's contributors, Williams attempts to legitimate certain aspects of mass culture at the expense of others – the 'good' against the 'bad'. The book is dated by this strategy, but to Williams' credit he sees that it is futile to attempt the analysis of a 'whole way of life' with a set of standards and analytical tools developed in order to establish the pre-eminence of one small section of it. Eventually, Williams has to admit that democratic notions of equality are among the casualties of a Leavisite approach to culture: 'An insistence on equality', he says, 'may be, in practice, a denial of value'. Value, the proposition that some things are inherently and permanently better than others, is not an innocent category; Williams warns against its function as dogma, as a means of legitimating existing ideological structures. Most important, he deplores the invocation of value as a means of denigrating the everyday lives of the vast majority of ordinary individuals. He characterizes this as an act of contempt, the sign of a lack of interest in 'men and their common efforts' (p. 306). Such a position is the reverse of Williams' own.

Reading the concluding sections of *Culture and Society*, one can see Williams' own position hardening, focusing on culture as the pre-eminent object of attention, and laying the foundations for the more fully argued and conclusive establishment of the category in *The Long Revolution*. In this next book Williams finally breaks with the literary-moral tradition that inevitably compromises *Culture and Society*.

The Long Revolution

The Long Revolution was published in 1961, a year after the NUT conference, and it reflects the increasing intensity of contemporary debates about the cultural impact of the media[7]. While Williams uses the book to clarify his own interest in culture, and to move further away from the tradition of thought that struggles to contain him in *Culture and Society*, it is, nevertheless, also a book that more closely aligns him with Hoggart's pessimistic accounts of popular culture and, in particular, the media. Unlike Hoggart's, however, Williams' pessimism is not founded entirely on aesthetic grounds, as *The Long Revolution* – significantly – focuses on the cultural institutions, their ideologies and discourses, as well as on

media products. Admittedly, the book is limited by internal contradictions; it lacks a theory of cultural structure and an appropriate method of textual analysis. However, its publication was, as Stuart Hall (1980a) has said, a 'seminal event in English post-war intellectual life':

> It shifted the whole ground of debate from a literary-moral to an anthropological definition of culture. But it defined the latter now as the 'whole process' by means of which meanings and definitions are socially constructed and historically transformed, with literature and art as only one, specially privileged, kind of social communication.
>
> (Hall 1980a: 19)

This shift is the strategic one, making the development of cultural studies possible.

The Long Revolution's opening premise is that British society has been engaged in a progressive and gradual revolution: through industrialization, democratization and cultural transformation. Since the importance of the first two historical movements was generally acknowledged, the book took on the task of establishing the comparable significance of cultural change:

> Our whole way of life, from the shape of our communities to the organisation and content of education, and from the structure of the family to the status of art and entertainment, is being profoundly affected by the progress and interaction of democracy and industry, and by the extension of communications. This deeper cultural revolution is a large part of our most significant living experience, and is being interpreted and indeed fought out, in very complex ways, in the world of art and ideas. It is when we try to correlate change of this kind with the changes covered by the disciplines of politics, economics, and communications that we discover some of the most difficult but also some of the most human questions.
>
> (Williams 1975: 12)

Dealing with these questions occupies the first section of the book, which attempts to set up a theoretical framework for the analysis of culture. This framework is clearly much advanced from that operating in *Culture and Society*. What emerges is an impressive set of definitions of terms and practices:

> Culture is a description of a particular way of life, which expresses certain meanings and values not only in art and learning but also in institutions and ordinary behaviour. The analysis of culture, from such a definition, is the

clarification of the meanings and values implicit and explicit in a particular way of life, a particular culture.

(Williams 1975: 57)

The objects of analysis are also outlined:

Such analysis will include ... historical criticism ... in which intellectual and imaginative works are analysed in relation to particular traditions and societies, but will also include analysis of elements in the way of life that to followers of other definitions are not 'culture' at all: the organisation of production, the structure of the family, the structure of institutions which express or govern social relationships, the characteristic forms through which members of the society communicate.

(Williams 1975: 57)

Williams insists on the need to see the cultural process as a whole, so that the textual analysis of media products (for instance) should be conducted in relation to an analysis of the institutions and social structures producing them. The analysis of culture, then, is 'the study of relationships between elements in a whole way of life', attempting to 'discover the nature of the organisation which is the complex of these relationships' (p. 63).

These definitions are still relevant today. Less enduring, perhaps, are the methods Williams used to carry them out. It is difficult to read the book's focus on the constitutive 'patterns' of cultural relationships, for instance, without regretting the absence of structuralist methodologies. Further, as the book presents its account of contemporary England one notices that the development of analytic methods is subordinated to the development of a particular critique of British culture. The book is not merely an account of the long revolution, but an argument for its continuation. The latter half of *The Long Revolution* is littered with calls for a 'common culture', the rejection of class culture and the conception of a society 'which could quite reasonably be organised on the basis of collective democratic institutions and the substitution of cooperative equality for competition as the principle of social and economic policy' (p. 328). Behind this is a disenchantment with contemporary English life, which stirs up the residue of nostalgic organicism from Williams' first book. The analysis, then, does not establish a methodology.

The book does make a further contribution to a theory of culture, however, in its notion of the 'structure of feeling'. Williams suggests that all cultures possess a particular sense of life, a 'particular and characteristic colour': 'this structure of feeling is the culture of a period' (p. 64). Williams' own description of the term is notoriously slippery; Tony Bennett's is more accessible, if still tentative:

> The general idea ... is that of a shared set of ways of thinking and feeling which, displaying a patterned regularity, form and are formed by the 'whole way of life' which comprises the 'lived culture' of a particular epoch, class or group.
>
> (Bennett 1981: 26)

Even this, as Bennett implies, is too general. One must admit that, while the idea has been influential, it is hard not to sympathize with Eagleton's (1978: 33) view that Williams' description of 'that firm but intangible organisation of values and perceptions' of a culture is little more than a description of ideology.

The concept's function within Williams' theory of culture perhaps explains why it has remained in use for so long despite its lack of clarity. It is important to realize that the structure of feeling of a period can run contrary to the dominant cultural definitions. Thus, British working-class culture survives despite its devaluation within successive dominant constructions of culture. Williams uses the category as a means of insisting on the existence of an *organic* popular spirit, closely linked to lived conditions and values, that may or may not be reflected (and that may be contested or resisted) at other levels of culture. As Anthony Barnett (1976: 62) says, the structure of feeling is 'designed exactly to restore the category of experience to the world, as a part of its mutable and various social history'.[8] As we shall see, this is a strategic move that ultimately connected Williams with the British 'culturalists', distancing him from the European structuralists and from formulations of ideology that tended to subordinate individual experience. The category, and the problems in defining it adequately, proceeds from the conflict between Williams' humanism – his insistence on the free agency of the individual – and his socialism – his awareness of the ways in which individual experience is culturally and politically constrained.

With all its faults, *The Long Revolution* establishes a comprehensive theoretical foundation for cultural studies, ready for the influence of European Marxism and structuralism to provide the methodologies for its further development. Williams' background in literary criticism gives both textual and historical approaches their due; the full range of later applications of cultural studies is foreshadowed at one point or another. Ironically, Williams himself may be said to benefit least of all from this; he founded a tradition that others have largely developed.

Both Hoggart and Williams offer slightly idealized versions of working-class culture as, in a sense, models to be emulated in contemporary British culture. What they value in the 'common culture' of their respective pasts seems to be the complex unity of their everyday lives: the close social relations among work, organized politics, public entertainments and so on. This is what Hoggart believed was threatened by the new mass-produced culture. Williams' argument

for a progressive liberalization of culture and the spread of democracy in *Culture and Society* led him to a more optimistic vision: of the spread of working-class cultural values achieving the common culture of socialism. By the time he wrote *The Long Revolution*, however, this optimism was already fading, and his sense of the danger posed by the structure and practices of media institutions moved him closer to Hoggart's position. Laing (1986: ch. 7) suggests that their positions were finely connected in the NUT conference, and that progressively during the 1960s Williams' position was being revised.

Communications

During this period Williams entered intramural teaching, as a lecturer at Cambridge. Laing suggests that as Williams moved away from adult education he also moved away from an emphasis on 'the lived', everyday culture (pp. 216–17). The 1960s saw an unprecedented explosion of popular cultural forms in Britain: 'swinging Britain', the Liverpool sound of the Beatles and others, and the identification between the nation and a populist modernity are signified through the James Bond movies and the appropriation of the Union Jack as a pop icon on tote bags, T-shirts and even shoes. Substantiated by the widespread adoption of the NUT conference's strategy of centring discussion of class and popular culture on the role of the mass media, such factors all contributed to the establishment of media analysis as 'the central plank of the new field of cultural studies' for Williams as for others (p. 217). In *The Long Revolution*, it is noticeable how the term *communications* competes with *culture*; the first conclusive sign of this shift in attention, however, is the publication of the first edition of *Communications* in 1962.

It is important to stress that Williams' discussion of the functions of modern communication technologies is not separate from the cultural project that informed *Culture and Society* and *The Long Revolution*. The programme of cultural change laid out in *The Long Revolution* reappears in *Communications*. Again, Williams (1962) insists that the cultural revolution is 'part of a great process of human liberation, comparable in importance with the industrial revolution and the struggle for democracy':

> The essential values ... are common to the whole process: that men should grow in capacity and power to direct their own lives – by creating democratic institutions, by bringing new sources of energy to human work, and by extending the expression and exchange of experience on which understanding depends.
>
> (Williams 1962: 138)

The goal of a common culture is still there, shaping the second half of the book. This time, however, the cultural revolution will be accomplished through, rather than in spite of, mass communication technologies and institutions; reforms within the communications sector itself have the potential to democratize society.

Despite its primary focus on technologies and institutions, *Communications* is still caught in the web of complexities and contradictions that ensnares attempts to separate art and culture. On the one hand, Williams defends the permanence of literary value against the variations of history: 'We must not confuse' he says, 'the great works of the past' with the particular 'social minority which identifies itself with them' (p. 110). On the other hand, although he continues to interrogate aspects of popular culture in order to privilege 'only the best work', he is careful to separate himself from Leavisite positions and terminology: 'If we look at what we call "mass culture" and "minority culture" [these are Leavis's terms], I am not sure that we invariably find one on the side of reality and one against it' (p. 113). Indeed, at the end of the revised edition (published in 1975) he concludes that the whole controversy has now been displaced by the development of cultural studies: the 'older kind of defence of "high" culture, with its associated emphasis on minority education and the social privileges needed to sustain it, has not disappeared but is now clearly residual' (p. 183).

In general, the move from the central category of culture to that of communication is potentially quite helpful, since it enables Williams to shed some of the baggage carried from the culture and civilization traditions and to begin to explore other traditions of theory and research. Unfortunately, the strongest influence on the book is from American communications research, primarily empiricist branches of sociology and political economy. The result is a strong collection of content analyses and media history – models for others to follow but almost entirely enclosed within an existing American theoretical tradition. Much of this tradition is now discredited within cultural studies, a casualty of the anti-empiricist cast of structuralist thought, and Williams' dependence on these theoretical models makes *Communications* a dated book. That said, in *Communications* Williams does take a useful strategic step towards understanding the communication industries rather than simply deploring their products, and towards seeing communication as contained within culture rather than as secondary to it. And, possibly most usefully, the 'Proposals' chapter offers sets of suggestions for the study and teaching of communication: these include proposals for the study of media institutions and media production, and for the development of a mode of textual criticism that can deal with *all* cultural forms. As so often with Williams' early work, one is surprised by how closely these proposals describe what has become established practice.

Television: Technology and Cultural Form

Between *Communications* and Williams' next exploration of cultural studies, *Television: Technology and Cultural Form* (1974), Williams returned to literary studies, publishing two studies of drama, *Modern Tragedy* (1966) and *Drama from Ibsen to Brecht* (1968). His more personal account of British culture, *The Country and the City*, was published in 1973. By 1974 the study of the media was well established in British academia through media sociology, media economy and the developing field of cultural studies. The CCCS had been working primarily in media studies for some years, and the Leicester Centre for Mass Communication Research had also produced groundbreaking research. Williams still had new things to offer media and cultural studies, however. *Television: Technology and Cultural Form* is a powerful and original book, and although it offers resistance at strategic points to the influence of structuralism – of which Williams was by now well aware – it marks the beginning of a new breed of British accounts of television.

Television: Technology and Cultural Form breaks with Williams' previous work in two key areas: first, it rejects the accounts of technologies and their social effects produced by American mass communication research, research so influential on *Communications*; second, instead of focusing solely on the content of television programmes it analyses the medium's technological structures and how they work to determine television's characteristic forms. While work of this kind was going on elsewhere, particularly in the CCCS, this was the first book-length study to employ such an approach to the medium.

Possibly the book's most widely quoted passage describes Williams' first experience of American TV, in a hotel in Miami:

I began watching a film and at first had some difficulty in adjusting to a much greater frequence of commercial 'breaks'. Yet this was a minor problem compared to what eventually happened. Two other films, which were due to be shown on the same channel on other nights, began to be inserted as trailers. A crime in San Francisco (the subject of the original film) began to operate in an extraordinary counterpoint not only with the deodorant and cereal commercials but with a romance in Paris and the eruption of a prehistoric monster who laid waste New York. Moreover, this was sequence in a new sense. Even in commercial British television there is a visual signal – the residual sign of an interval – before and after the commercial sequences, and 'programme' trailers only occur between 'programmes'. Here was something quite different, since the transitions from film to commercial and from film A to films B and C were in effect unmarked.

(Williams 1974: 92)

What Williams takes from this is the recognition that, despite TV guides, broadcast TV is not organized around discrete units – programmes. Nor is TV's characteristic form a chain of programme sequences regularly interrupted by advertising. Williams argues that the multiplicity of programme forms within an evening's TV are not disruptive, but are incorporated into its 'flow':

> What is being offered is not, in older terms, a programme of discrete units with particular insertions, but a planned flow, in which the true series is not the published sequence of programme items but this sequence is transformed by the inclusion of another kind of sequence, so that these sequences together compose the real flow, the real 'broadcasting'.
>
> (Williams 1974: 90)

This flow effect is institutionalized in programming policies aimed at keeping the audience with the channel for the whole evening, hence the use of trailers to 'sustain that evening's flow' (p. 93).

Notwithstanding John Ellis's (1982: 117–24) critique in *Visible Fictions*, which points out that the same principles can be used to describe formal patterns *within* television programmes and develops the idea that television works in 'segments' not programmes, Williams' development of the notion of flow and sequence has been significant. Its great advance is that it attempts to understand how television, as a medium, specifically works. 'Flow' and 'sequence' aim to describe a characteristic of the experience of television, a characteristic produced by the complex articulation of production practices, technological and economic determinants, and the social function of television within the home, as well as the formal structures of individual television genres. It is a kind of analysis that is singularly lacking in *Communications*, and in most other full-length studies of the medium produced at the time.

The final section of *Television: Technology and Cultural Form* deals with the effects of the technology of television. It attacks empiricist mass communication research and technological determinism, and concludes by restating Williams' view of what 'determination' is. While he admits the validity of certain forms of American 'effects' research, Williams directs his strongest criticism at developments from such research which argue that the medium of television itself – not even the specific message – has a determining, causal effect on behaviour:

> If the medium – whether print or television – is the cause, all other causes, all that men ordinarily see as history, are at once reduced to effects. Similarly, what are elsewhere seen as effects, and as such subject to social, cultural, psychological and moral questioning, are excluded as irrelevant by

comparison with the direct physiological and therefore 'psychic' effects of the media as such.

(Williams 1974: 127)

In other words, history is the determining force; it produces us *and* the medium of television. Williams offers accounts of the development of radio and television in which he demonstrates the difference between the invention of a technology and its diffusion in a culture. Invention itself does not cause cultural change; to understand any of the mass communication technologies we must 'historicize', we must consider their articulation with specific sets of interests and within a specific social order (p. 128). Consequently, Marshall McLuhan's work is dismissed as 'ludicrous' and Williams treats his privileging of the technologies of television with contempt: 'If the effect of the medium is the same, whoever controls or uses it, and whatever apparent content he may try to insert, then we can forget ordinary political and cultural argument and let the technology run itself' (p. 128).

Williams accuses this tradition of media analysis of 'technological determinism'; that is, of ascribing to a technology a set of intentions and effects independent of history. In place of that relatively crude explanation for the determination of cultural practices, institutions or technologies, Williams offers his own, subtler explanation:

The reality of determination is the setting of limits and the exertion of pressures, within which variable social practices are profoundly affected but never necessarily controlled. We have to think of determination not as a single force, or a single abstraction of forces, but as a process in which real determining factors – the distribution of power or of capital, social and physical inheritance, relations of scale and size between groups – set limits and exert pressures, but neither wholly control nor wholly predict the outcome of complex activity within or at these limits, and under or against these pressures.

(Williams 1974: 130)

This formulation is still useful today.

Marxism and Literature

Williams' work up to this point in his career is marked by the struggle between his humanism and his socialism; none of the works examined so far has accepted the invitation of Marxist thought as a means of resolving the many contradictions

within his thinking about culture, art and communications. In *Marxism and Literature*, published in 1977, we have an extraordinary theoretical 'coming out', as Williams finally admits the usefulness of Marxism and his place within its philosophical traditions.

Marxism and Literature begins with an autobiographical account of Williams' own relationship with and resistance to Marxism. He reveals he had a relatively unsophisticated knowledge of it at the time he wrote *Culture and Society*, but that his gradual acquaintance with the work of Lukács, Goldmann, Althusser and, later, Gramsci had alerted him to a new critical mode of Marxism that was not crudely deterministic or economistic. He discovered a body of Marxist thought that challenged traditional Marxism's division of society into the base (the economic conditions) and the superstructure (the effects of the economic base, including culture). Critical Marxism complicated such a model by, for instance, insisting that culture was not merely a reflection of the economic base but could produce its *own* 'effects'. There Williams (1977: 19) found support for his formulation of culture as a 'constitutive social process, creating specific and different "ways of life" '.

Williams, in effect, announces his conversion, and a whole range of theory becomes available to him that had hitherto been off limits. He admits the value of semiotics as a method of textual analysis (but still sees it as dealing with aesthetics); he notes the importance of Saussure's work (but worries at its rigid determinism); he acknowledges the importance of the economic determinations of culture and outlines the means through which media institutions, for instance, can be studied; he offers a materialist definition of the category of literature, seeing it as a historical category of 'use and condition' rather than as an ideal, essential entity. But the most important development in *Marxism and Literature* is that Williams finally outlines his view of ideology.

When Williams breaks with the traditional Marxist division of base and superstructure he does so in order to foreground the role of culture. He concludes the discussion of this issue in *Marxism and Literature* by saying that it is not the base or the superstructure we should be examining, but rather the processes that integrate them – the processes through which history and culture are determined. The examination of determination leads, inevitably, to an examination of the mechanisms through which it is held to occur: mechanisms variously defined as the working of ideologies.

As Williams says, the problem of determination is the most intractable issue within Marxist thought, but his conclusions are characteristic. Rejecting more mechanistic schemes of determination, he opts for the Althusserian idea of 'overdetermination', a concept encountered briefly in Chapter 1 of this volume. Overdetermination allows for the 'relative autonomy' of cultural forces, and consequently explains the achievement of ideological domination as a struggle

between competing and contradictory forces. For Williams, the virtue of Althusser's view of ideology over earlier versions is that it is able to acknowledge the importance and complexity of individual, 'lived' experience: 'the concept of "overdetermination" is more useful than any other way of understanding historically lived situations and the authentic complexities of practice' (p. 89). However, while this is true, Althusser finds it easier to explain how these relatively autonomous formations are necessarily subject to ideological forces than to explain how these forces can be resisted or dominant ideologies contested. Williams, like many others in the field, found an answer to this in Gramsci's theory of hegemony.

Gramsci's theory of hegemony holds that cultural domination or, more accurately, cultural leadership is not achieved by force or coercion but is secured through the consent of those it will ultimately subordinate. The subordinated groups consent because they are convinced that this will serve their interests; they accept as 'common sense' the view of the world offered them by the dominant group. (Such a process, for instance, might explain how working-class voters in Britain could see Margaret Thatcher as identified with their interests.) Gramsci's insistence on the production of consent implies a cultural field that is composed through much more vigorous and dynamic struggle than that envisaged by Althusser. Cultural domination is the product of complex negotiations and alignments of interests; it is never simply imposed from above, nor is it inevitably produced through language or through ideological apparatuses such as the education system. The achievement of hegemony is sustained only through the continual winning of consent. (Further discussion of hegemony will be presented in Chapter 6.)

For Williams, the attraction of Gramsci's theory is that it both includes and goes beyond two powerful earlier concepts:

> that of 'culture' as a 'whole social process', in which men define and shape their whole lives; and that of 'ideology', in any of its Marxist senses, in which a system of meanings and values is the expression or projection of a particular class interest.
>
> (Williams 1977: 108)

The idea of hegemony connects, in a sense, the theory and practice of social process and provides us with ways of examining how specific formations of domination occur. Again, for Williams the power of the theory is its ability to consider individual experience within history, to talk of culture as 'the lived dominance and subordination of particular classes', thus stitching history, experience, politics and ideology into the study of everyday life.

To develop this position further, and to emphasize the fact that domination is a process rather than a permanently achieved state, Williams identifies three kinds of cultural forces: the *dominant*, *residual* and *emergent* forces discernible at any one point and within any one historical juncture. These terms roughly correspond to the ideological forms of, respectively, the present, the past and the future. These cultural forces may be utterly antipathetic to each other's interests; by incorporating them into his schema Williams is installing the notion of conflict, difference and contradiction as components within a theory of determination. As Williams says, domination must never be seen as total: 'No mode of production and therefore no dominant social order ... ever in reality includes or exhausts all human practice, human energy, and human intention' (p. 125). It is fitting to conclude this necessarily partial survey of Williams' work with his insistence on political possibility, on the power of the human agent to change his or her conditions of existence. This has been the overriding concern in his work from the beginning.

Williams' acceptance of Marxism had an odd effect on his role in cultural studies. It is as if he accepted his place within a Marxist tradition only to disappear into it; his value over the last two decades has been as a pioneer rather than as a leader. Critiques of his work argue that he never came up with a thoroughgoing statement of his position or that he never developed methods for its application. Even the honesty of his work, openly revising his position, has been attacked as a flaw (see Eagleton 1978: 33), although there are more sympathetic treatments (Inglis: 1995). But Williams' work remains strikingly original and compelling reading even now, and his commitment to the political objectives of theoretical work was exemplary. For Williams, cultural studies was a practice not a profession, and his work remains an indispensable guide to the full range of developments to occur within British cultural studies during his lifetime.

E. P. THOMPSON AND CULTURALISM

Raymond Williams is normally, if a little problematically, located in the 'culturalist' tradition within British cultural studies; E. P. Thompson is a less equivocal representative of this tradition. Thompson's importance is not confined only to cultural studies, however. His book *The Making of the English Working Class* (1978a) has had a profound influence on the writing of British social history since its publication (it was first published in 1963) and has also been implicated in explorations of popular culture, class and subcultures from within sociology, anthropology and ethnography.

Unlike Williams, Thompson developed his theory of culture from within Marxist traditions. Although he left the Communist Party around the time of the

Soviet intervention in Hungary, the debates in which he engaged were debates within Marxism itself. However, there are many similarities between his position in 1963 and that of the Raymond Williams of *Culture and Society* and *The Long Revolution*: Thompson resisted simple notions of economic determinism and the traditional base–superstructure model in order to recover the importance of culture; he resisted simple notions of class domination and thus recovered the importance of human agency; he insisted on the importance of 'lived' culture and of subjective experience; and he maintained a basic humanism. Culture, for both men, was a lived network of practices and relationships that constituted everyday life, within which the role of the individual subject had to be foregrounded.

Thompson, more than Williams, developed his theory through practice, through his history of the making of culture by its subjects. A more important difference between the two was the conflict-based view of culture Thompson proposed, in opposition to the consensualizing view Williams offered in *Culture and Society* and *The Long Revolution*. Thompson resisted Williams' definition of culture as 'a whole way of life' in order to reframe it as a struggle between *ways* of life. Thompson's culture was constituted by the friction between competing interests and forces, mostly located in social class. Williams' residually Leavisite view of culture was countered by Thompson's unequivocal definition of culture as popular culture, the culture of 'the people'. The intellectual project for Thompson was to rewrite the history of this culture in order to redress the imbalance of its representation in 'official' histories.

The Making of the English Working Class sets out its agenda explicitly in its opening pages; Thompson attacks orthodox labour and social histories for leaving out the working class, for remembering only the successful – 'those whose aspirations anticipated subsequent evolution': 'The blind alleys, the lost causes, and the losers themselves', he says, 'are forgotten'. Thompson sets out to rescue the casualties of ruling class history, 'the poor stockinger, the Luddite cropper', from 'the enormous condescension of posterity'. His goal is not simply to recuperate the past:

> In some of the lost causes of the people of the Industrial Revolution we may discover insights into social evils which we have yet to cure. Moreover, the greater part of the world today is still undergoing problems of industrialisation, and of the formation of democratic institutions, analogous in many ways to our own experience during the Industrial Revolution.
>
> (Thompson 1978a: 13)

The result is a polemical, imaginative and richly readable account of the formation of a class and the specific discourses that gave its members' lives their meaning.

The immediate beneficiary of this work was not cultural studies; Thompson saw his work as directly examining 'the peculiarities of the English', and as such the project has been accepted and taken on (R. Johnson 1980: 48). There is now a strong tradition of British social history that is shaped by Thompson's work. Although Richard Johnson (1980) has defined the historical and historiographic interests of the CCCS in roughly Thompsonian terms, emphasizing in particular the relevance of historical research to the analysis of the present, cultural studies has had reservations about Thompson's work and the work of historians generally. Furthermore, what reservations cultural studies had about the contribution of history were well and truly reciprocated in historians' distrust of European cultural theory. Thompson (1978b) himself proved to be an enthusiastic controversialist, and engaged in a decade of argument that culminated in *The Poverty of Theory* in 1978. This field of conflict has been conventionalized as one between structuralism and culturalism.

Structuralism encouraged cultural studies theorists to see Thompson's (and for that matter Williams') concentration on individual experience and agency as romantic and regressively humanist. Since consciousness is culturally constructed, why waste time dealing with its individual contents when we can deal with its constitutive processes – language, for instance? Culturalists, on the other hand, saw structuralism as too abstract, rigid and mechanical to accommodate the lived complexities of cultural processes. Structuralists saw culturalists as lacking theory; culturalists saw structuralists as theoreticist. Culturalism was a home-grown movement, while structuralism was foreign. In the discipline of history, the controversy became quite specific: historians claimed, with some justice, that structuralism was ahistorical and thus denied the very processes historians examined; conversely, structuralists saw culturalist historians as theoretically naive in their understanding of cultural processes.

We can see this controversy displayed in the pages of the *History Workshop*, a journal that began in 1976, developing from a series of seminars and meetings that had been held under that title in Ruskin College, Oxford, since 1967. Explicitly socialist, its first issue carried not one but three editorials-cum-manifestos: the first proclaimed the journal's task as that of bringing 'the boundaries of history closer to people's lives' and counteracting the control of the academy over history; the second argued for the importance of feminist histories; and the third announced the end of an informal theoretical treaty by thanking sociology for its assistance in the past and claiming history would provide its own theoretical support in the future. The state of 'theory' within the study of history was thus constructed as an issue and a problem for the journal and the discipline.

By the late 1970s some structuralist work was going on within history: on nineteenth-century popular culture, oral history and some aspects of ethnographic

research. But there were still limits to the acceptability, in particular, of Althusserian notions of ideology. In 1978 Richard Johnson, by then at the CCCS, published an article in *History Workshop* proposing the benefits of structuralism to historians and, among other things, accusing Thompson of 'preferring experience to theory'. The journal was deluged with letters. Johnson was accused of historical illiteracy, a slavish Althusserianism, a barren and empty theoreticism, and an excessive anti-humanism. One of the journal's editors contributed a letter saying he never wanted the article published anyway, while another (affiliated with the Birmingham Centre's work) expressed disgust at the shrillness of the response. While Johnson might have been seen as a champion of history *within* cultural studies, clearly he was still seen as something of a heretic by historians (see *History Workshop* 7, 1979) There was a rematch between Thompson and Johnson at the notorious *History Workshop* conference in 1979, and again the arguments merely exposed the depth of the division between culturalism and structuralism. (Dworkin (1997) presents a detailed account of these debates in his history of British Cultural Marxism.)

A possible effect of this fissure may have been historians' subsequent tendency to avoid analyses of contemporary popular culture and anything that might look like textual analysis. Other consequences have been more worthwhile; the culturalist emphasis on individual experience, the 'making' of culture, fed into ethnographic work on subcultures within the mainstream of cultural studies (examples of this work can be seen in Bennett *et al.* 1981b; Hall and Jefferson 1976). As Hall, Johnson and Bennett have all indicated, however, and as we saw in our account of Williams' theoretical development, Gramsci's theory of hegemony has resolved many of the points at issue between structuralists and culturalists, particularly the sticking points of determination and social change. What Bennett calls 'the turn to Gramsci' effectively consigned the culturalism–structuralism split to the past (see Bennett *et al.* 1986: Introduction) and opened the way for cultural studies to recover the usefulness of history. Nevertheless, disciplinary tensions remain. At the 'Cultural Studies Now and in the Future' conference in Illinois in 1990, Carolyn Steedman (1992) challenged cultural studies to explain why it *wanted* history, implying that this was by no means evident from cultural studies practice. (The most elegant answer to this challenge came from Meaghan Morris, who replied: 'in the culture I live in history is the name of the space where we define what matters' (Grossberg *et al.* 1992: 622).)

STUART HALL

An index of Stuart Hall's importance to contemporary formations of British cultural studies is that the detailed discussion of his work since the mid-1970s

occurs within subsequent chapters rather than within this survey. But some account of Hall's earlier work should be given here, if only because his theoretical history closely parallels that of British cultural studies itself. An early editor of *New Left Review*, and a secondary school teacher before he became an academic, Hall was among the speakers at the 1960 NUT conference on popular culture and the media. His first book, *The Popular Arts* (Hall and Whannel 1967; first published in Britain in 1964), was deeply indebted to Hoggart and Williams; he joined the CCCS as Hoggart's deputy in 1966 and replaced Hoggart as director in 1969. During his decade as director Hall oversaw a tremendous expansion in the theoretical base and intellectual influence of the CCCS. The structuralist enterprise could be said to find its focus there, and the development of both the ethnographic and the media studies strands in cultural studies is clearest there. Cultural studies' development of its distinctive combination of Althusserian and Gramscian theories of ideology and hegemony owes a significant debt to the CCCS and Hall's own work. Hall took up the chair of sociology at the Open University in 1979, a position he held until his retirement in 1999. He remains a major figure in cultural studies, and is currently leading British debates around the character of a multicultural and multi-ethnic 'Britishness'.

Hall has been on quite a theoretical journey. His first book, co-authored with Paddy Whannel, stands in clearest relation to the culture and civilization tradition. There are some key differences, however. *The Popular Arts* is relatively free of the nostalgia and organicism of Leavisite texts, even of the diluted variants found in *The Uses of Literacy* and *Culture and Society*. In fact, Hall and Whannel explicitly reject the conventional contrast between the 'organic culture of pre-industrial England with the mass-produced culture of today':

> This is a perspective that has produced a penetrating critique of industrial society but as a guide to action it is restrictive. The old culture has gone because the way of life that produced it has gone. The rhythms of work have been permanently altered and the enclosed small-scale communities are vanishing. It may be important to resist unnecessary increases in scale and to re-establish local initiatives where we can; but if we wish to re-create a genuine popular culture we must seek out the points of growth within the society that now exists.
>
> (Hall and Whannel 1967: 38)

As a result of this position, Hall and Whannel are much more interested in dealing with popular cultural forms on their own terms than are any of their predecessors. *The Popular Arts* strikes the note taken up eleven years later by Fiske and Hartley in *Reading Television* (1978: 44) that 'the kind of attention we

must pay to [in this case, film's] visual qualities is the equivalent of the attention we give to verbal images, rhythms and so on, in our reading'. This kind of attention alerts Hall and Whannel to properties of popular forms missed by earlier commentators; their analysis of the signifying function of film stars, for instance, predates Dyer's work by many years but comes to very similar conclusions about the contradiction between a star's typicality and individuality (p. 213). (Dyer's work is dealt with in Chapter 3.)

The Popular Arts is still aimed at developing strategies of discrimination, however. Its advance on Hoggart is that it rejects the idea that the media necessarily and inevitably produce rubbish; as a result, Hall and Whannel's aim is to discriminate *among* the products of the media, not *against* them (p. 15). In order to theorize the artistic possibilities provided within various popular forms, Hall and Whannel develop the influential distinction between popular art (which derives from folk cultures) and mass art (which does not): 'The typical "art" of the mass media today is not a continuity from, but *a corruption of* popular art', they say. 'Mass art has no personal quality but, instead, a high degree of personalisation' (p. 68). Although *The Popular Arts* means well and intends to legitimate 'good' popular art by proposing a historic relation between the form and the culture, it does have problems. As frameworks for aesthetic judgement, its formulations are doomed to expose many contradictions and inevitably to discount the specific pleasures offered by popular cultural forms (familiarity and repetition in popular fiction or television, for instance) no matter how good the intentions. Finally, and once again, the book is limited by the lack of more appropriate analytical tools than those provided by Leavisite literary analysis.

Hall spent the next few years revising his position. Evidence of the comprehensiveness of this revision can be found in 'Television as a Medium and Its Relation to Culture'. This article was published as a CCCS stencilled paper in 1975, but it was originally prepared as part of a report on TV for UNESCO in 1971. One has to deduce UNESCO's brief from the discussion, but it seems to have required the consideration of how television might be enlisted to support the popularization or dissemination of high art – 'Culture'. The article makes skilled, confident and early use of semiotics and its various formulations in the work of Barthes, Wollen and Pierce. It also radically rewrites Hall's position from *The Popular Arts*. Rather than arguing for 'better' television through the adaptation of high art, for instance, Hall argues that the UNESCO brief misunderstands the relation between the medium and the culture. *Popular* television is the centre of this relation and to persist in attempting to integrate the domains of art and popular television is 'anachronistic'. He concludes: 'Television invites us, not to serve up the traditional dishes of culture more effectively, but to make real the Utopian slogan which appeared in May 1968,

adorning the walls of the Sorbonne, "Art is dead. Let us create everyday life" '
(1975: 113). This flamboyant final flourish is perhaps a little of its time, but the
deployment of the phrase 'everyday life' is strategic, invoking the enterprise of
cultural studies.

In the same year, 1971, a paper Hall delivered to the British Sociological
Association, 'Deviancy, Politics and the Media', displays the influence of struc-
turalism and semiotics. To support his attack on American media research, Hall
uses the work of Lévi-Strauss, Barthes, Althusser and Gramsci. These two papers
provide evidence of Hall's early interest in European theory, much of it unavail-
able in English translation, and certainly not widely deployed within the
disciplines from which cultural studies was emerging.[9] Indeed, part of Hall's role
within cultural studies has been as a conduit through which European struc-
turalist theory reached British researchers and theorists; in the United States
during the 1990s he was to serve a similar role for British transformations of that
theory.

A substantial proportion of Hall's writings are available as chapters within
readers published through the CCCS and the Open University, or as individual
articles or chapters. He is an editor of many readers, and the co-author of prob-
ably the most thorough and magisterial application of cultural studies theory so
far, *Policing the Crisis: Mugging, the State, and Law and Order* (Hall *et al.* 1978).
In this book, Hall's own background (West Indian) must have played a part in
recovering the issue of race as one of concern to cultural studies. Surprisingly,
perhaps, issues of race and empire were not at the forefront of British cultural
studies work in its early years (see the discussion of this in Chapter 7), nor at the
forefront of Hall's own published work during his time at the CCCS. The analysis
of the media, the investigation of practices of resistance within subcultures, and
the public construction of political power in Britain were his overriding concerns
at that time. More recently, issues of representation and identity in which race
and ethnicity play a prominent role have dominated his published work (Hall and
Du Gay 1996; Morley and Chen 1996).

There is some debate about the political and cultural placement of Hall's
contribution. Jon Stratton and Ien Ang have discussed him as the epitome of the
'diasporic' intellectual (1996), someone capable of interrogating their culture
from positions that are both within and outside their society. On the other hand,
Chris Rojek (1998) has presented an argument which ties Hall's political philos-
ophy to a long-standing stream of British antinomianism and thus to an entirely
'British' intellectual history. Perhaps Stratton and Ang cover both angles with
their argument that Hall problematizes 'Britishness' from within. According to
their reading of Hall's work, he has foregrounded the 'Britishness' of cultural
studies while nevertheless questioning the current definitions of British national

identity. The 'turn towards race' Stratton and Ang (1996: 381) notice in Hall's later career has enabled Hall to speak from a specific ethnicity while problematizing the construction of national identities.

It is difficult for students to form a sense of the body of Hall's work, however; so far he has not been the sole author of a book-length project although collections incorporating many of his key articles have appeared (Hall 1988; Morley and Chen 1996). His work will be further discussed in later chapters, in particular his theories of textual and ideological analysis of the media, his theorizing of the category of ideology, and his contributions to analysis of institutions and their cultural/political effects.

THE BIRMINGHAM CENTRE FOR CONTEMPORARY CULTURAL STUDIES

This is a history not only of individual contributors but also of institutions. While there are now numerous institutions around the world participating in and reshaping the field of cultural studies, the Birmingham Centre for Contemporary Cultural Studies (CCCS) can justifiably claim to be the key institution in the history of the field. There is some concern that such a claim might be overstated or give rise to a simplifying 'myth of origins' that obscures other claims and other contributors (H. Wright 1998). As a result there is a body of work aimed at 'decentring the Centre' by contesting its claims to institutional centrality (McNeil 1998). Nonetheless, it is important to acknowledge that the Centre's publications have made strategic contributions to academic and public awareness, and in sheer volume dominate the field. A high proportion of the authors listed in the bibliography at the end of this book have worked at, studied within, or are in some way affiliated with the Centre and its work; examples of such individuals include Dick Hebdige, Dorothy Hobson, David Morley, Phil Cohen, Chas Critcher, Charlotte Brunsdon, Iain Chambers, Janice Winship, Paul Willis, Angela McRobbie, Richard Hoggart, Richard Johnson, Stuart Laing and Stuart Hall. While the specifics of its definitions of cultural studies might well be (and are) contested, the Centre's claim to a special influence on the field's development is beyond argument.

The CCCS was established at the University of Birmingham in 1964. Hoggart was its first director, and clearly his work was seen as the major focus of its attention. The CCCS was to direct itself to cultural forms, practices and institutions, and 'their relation to society and social change' (Hall *et al.* 1980) (see Figure 2.1). Given such a brief, it is little wonder that both the English and the Sociology Departments at Birmingham saw the CCCS as a potential threat (Hall 1990). In conjunction with history, English and sociology were the two foundational disci-

Figure 2.1 Cover of the first issue of the CCCS journal, *Working Papers in Cultural Studies* (used with permission)

plines cultural studies was to raid for approaches as well as for objects of critique. Perhaps fortunately, given the consequent sensitivities, the CCCS confined itself to postgraduate research for most of its history and only began offering under-graduate degree programmes in cultural studies towards the end of the 1980s.

As the above discussions of the work of Hoggart, Williams and Hall during the 1960s make clear, Hoggart's project of understanding the everyday, 'lived' cultures of particular classes was overtaken by interest in the mass media, which quickly came to dominate the Centre's research and has provided it with its longest-running focus. Initially this work was heavily influenced by American communication research; as with Williams' *Communications*, the existence of a well-developed body of work in the United States encouraged its adaptation to British topics. While this tradition continued to influence another key centre,

Leicester's Centre for Mass Communication Research, the CCCS (like Williams) broke with the American influence, with the culture and civilization tradition, and with the empirical aspects of social science research. It moved towards the analysis of the ideological function of the media; within such analyses, the media were defined as a 'major cultural and ideological force ... standing in a dominant position with respect to the way in which social relations and political problems were defined and the production and transformations of popular ideologies in the audience addressed' (Hall 1980d: 117). The result was a concentration on the ideological 'effectivity' of the media (a more general and indirect idea of the process of determination) rather than on their behavioural 'effects'. This was an inquiry into structures of power, the 'politics' of the media.

Stuart Hall's replacement of Richard Hoggart as director centrally influenced this shift of emphasis. Under Hall's leadership, the relations between media and ideology were investigated through the analysis of signifying systems in texts. Other kinds of work also prospered. Histories of 'everyday life' drew on Thompson's work but also appropriated ethnographic approaches from sociology and anthropology. For some years such interests were focused on subcultures, examining their construction, their relation to their parent and dominant cultures, and their histories of resistance and incorporation. Much of this work examined the rituals and practices that generated meaning and pleasure within precisely that fragment of the cultural field Hoggart had dismissed in *The Uses of Literacy*: urban youth subcultures. Feminist research also benefited from some applications of this subcultural approach, using it to examine aspects of women's cultural subordination. Interaction between research on feminine subcultures and on the ways audiences negotiated their own meanings and pleasures from popular television has provided a platform for revisions of our understanding of 'the feminine' and of television. And concurrent with all this, work on class histories, histories of popular culture, and popular memory also continued.

Hall was succeeded by Richard Johnson in 1979. Johnson (1983) has noted some discontinuities between the principles followed under Hall and under his own directorship. Textual analysis gave way to a sharper focus on history as the centrality of the need to examine everyday life was reaffirmed. Johnson's own interests were focused on the historical construction of subjectivities rather than on media texts. Somewhat paradoxically, Johnson has expressed scepticism about the rich tradition of ethnographic work within the CCCS. While the work of certain individuals (Hebdige and Willis, to name two) is exempted from this scepticism, Johnson (1983: 46–8) has represented ethnography as relatively untheorized, while noting its tendencies towards an elitist paternalism. This latter point derives from what is seen as the arrogance implicit in wandering into

someone else's culture and assuming its transparency before one's own methods of analysis. It is a criticism ethnographers themselves have raised.

Johnson passed the directorship on to Jorge Lorrain, who oversaw a significant change in the CCCS's institutional role from the late 1980s. Under university pressure to be reabsorbed into the Department of English, the CCCS embarked on an international campaign to generate support for its survival. It won the battle but it did not win the war. The Centre became a Department of Cultural Studies, offering undergraduate programmes for the first time. The staff was augmented by the closure and dispersal of the University of Birmingham's Sociology Department; two members joined the Department of Cultural Studies. Now things have turned full circle, as the former CCCS is a Department of Cultural Studies and Sociology, teaching undergraduates and postgraduates in both fields.

The CCCS has exerted an influence far beyond what anyone could have expected. At any one time it had only a handful of staff – never more than three until conversion into a Department. But it adopted a policy of encouraging its students to publish their work rather than produce assignments – or even finish their degrees! While this did little for the Centre's 'academic throughput figures', it did make the work visible, disseminating the fruits of its research and establishing the reputations of its students. The CCCS also operated through reading and research groups rather than through formal courses.[10] Most of its publications bear the marks of this collectivist practice, a practice that clearly served the research function exceptionally well, while presumably making the teaching and assessment of student work something of a problem. The introduction of undergraduate teaching in the late 1980s, as well as its restructuring into a Department with defined and programmed course units, clearly affected the former Centre's research output, and ultimately its influence on the field.

OTHER 'CENTRES'

Birmingham is not the only research centre devoted to cultural studies, of course. At the time it was established a number of other developments also institutionalized an interest in media and popular culture. The Centre for Television Research was set up at Leeds in 1966, and the first chair in film studies in Britain was founded at the University of London in 1967. Possibly of greatest importance was the Centre for Mass Communication Research at the University of Leicester, established in 1966. Halloran *et al.*'s (1970) analysis of the media treatment of the 1968 demonstrations (*Demonstrations and Communications*) was a groundbreaking work and influenced subsequent connections between politics and the media at Birmingham (see Hall *et al.* 1980: 119). The Leicester centre was initially

heavily influenced by empiricist communication theory, and then by media sociology and political economy, so its relation to cultural studies was not systematic.

Work within the Leicester centre and the CCCS helped to revive a strand of British media sociology that dealt with the media institutions. Institutional studies of media production such as Schlesinger's *Putting 'Reality' Together* (1978) appeared during the 1970s, investigating how the industrial production of news is ideologically constrained. Such work was generated by a particular interest in the way politics was represented in the media. Between 1974 and 1982 the Glasgow Media Group, a collective at the University of Glasgow, applied both empirical and interpretative methods to news reports on such topics as the economy, unions and the Labour Party; their analyses appear in *Bad News* (1976), *More Bad News* (1980) and *Really Bad News* (1982).

A significant institutionalization of the study of the media in Britain was the Open University's Mass Communication and Society course, which began in 1977. Here a great deal of the work being done in the various British research traditions was published, collected or disseminated. Of even greater importance for cultural studies was the establishment of the Open University's degree programme in popular culture (U203, Popular Culture), which ran from 1982 to 1987. This course drew on history, sociology and literary studies as well as cultural studies, and clearly benefited from the fact that Stuart Hall had moved to the Open University as Professor of Sociology in 1979. The U203 course 'readers' have, like the CCCS publications, assisted in the definition of the field by providing students with access to materials otherwise widely dispersed and difficult to find. Indeed, Jim McGuigan (1992) has suggested that the Open University reader *Culture, Ideology and Social Process* (Bennett *et al.* 1981b), which contained a digest of Gramsci's *Prison Notebooks*, was where the concept of hegemony was first 'popularized'. The work of Tony Bennett, Stuart Hall, Colin Mercer, Janet Woollacott, James Curran, Michael Gurevitch and many others went into the Open University courses and into the collections that defined and exported the enterprise. For many outside Britain the Open University course readers have provided the most accessible and coherent account of the work going on in British cultural studies. Within Britain some (Harris 1992; McGuigan 1992) have argued that U203 was of comparable significance to the CCCS in the formation of British cultural studies.

As we have already seen in the case of the *History Workshop* and *Working Papers in Cultural Studies*, journals have played a significant role in this history. *New Left Review* provided a forum for local and international debates as well as translations of European work. *Theory, Culture and Society*, which commenced in 1982, published cultural studies articles and acted as an interrogator of the field: not only of its tendency towards literary/aesthetic modes of analysis but

also of how far 'the sociology of culture should be coterminous with Marxist approaches', as its first editorial put it. *Marxism Today* has led the way in the analysis of 'New Times' (dealt with briefly in Chapter 7), publishing cultural studies' critiques of the threat represented by, and the inadequacy of the Left's response to, Thatcherism. The film journal *Screen* (formerly *Screen Education*) made substantial theoretical contributions to the textual analysis of film and television. It maintained close links with European semiotic and structuralist theory, but its avant-garde privileging of the 'progressive' text recalled elite interpretations of popular culture and exposed it to extended controversies with members of the CCCS – particularly David Morley (1980b).

In recent years concentrations of prominent cultural researchers have formed at Goldsmith's College, University of London, which has several centres doing cultural studies and related research, as well as at the Institute for Cultural Research at the University of Lancaster, with smaller groups at such places as the University of Sunderland and Nottingham Trent University. These concentrations tend to be multidisciplinary and diverse in their topics and approaches, without the single-minded mission one finds in accounts of the early years of the CCCS (Hall 1992; Steele 1997). They represent, though, more than a simple consolidation of the institutionalization of cultural studies. Popular culture researchers at Manchester Metropolitan University, through the Manchester Institute of Popular Culture, have started to redefine cultural studies as 'popular cultural studies' while they subject the CCCS subcultures tradition to a thorough renovation (Redhead 1997).

No intellectual movement is monolithic, no attempt to describe its essential features uncontested. There are certainly more contributing streams shaping the field of cultural studies than I have listed above. In later chapters I will be adopting further, complicating, perhaps contradictory, and more contemporary perspectives on this history. For the moment, however, and rather than continue this list until all interests are satisfied, I want to close by acknowledging some of the more marginalized, but significant, contributions over the 1970s and 1980s. Feminist work on media audiences developed, almost single-handedly, a critique of conventional accounts of the function of TV soap operas for female viewers. Dorothy Hobson, Charlotte Brunsdon and (from Holland) Ien Ang's work has been incorporated into the mainstream of media studies, convincingly challenging the orthodoxies on the pleasures offered by popular television. Angela McRobbie mounted a most effective critique of subcultural studies, including her own early work, as discounting the feminine. Some feminist writers, such as Judith Williamson and Ros Coward, appealed directly to a general audience through columns in magazines and newspapers in order to articulate their critique of masculinist representations.[11]

Another margin, for some time, seems to have had a physical location, in Cardiff, where Terence Hawkes, John Fiske, Christopher Norris and John Hartley all worked. Neither Fiske nor Hartley make much of an appearance in British cultural studies' bibliographies until 1978, when their *Reading Television* appears as a member of Methuen's New Accents series, edited by Terence Hawkes. Fiske was taken up by Methuen as editor of its Studies in Communication series, which has published Hartley and other Cardiff alumni Tim O'Sullivan and Danny Saunders. Both *Reading Television* and the series have remained influential teaching texts in colleges and universities, but Fiske enjoyed a much higher profile (and exercised greater influence) in the United States and Australia than he did in the United Kingdom (he retired from active research in the field in 2000). It seems possible that the field of study has been subjected to a degree of metropolitan control and that there are geographical margins as well as theoretical or ideological ones. It may be significant that Fiske and Hartley both extended their marginality by moving to Australia (in Hartley's case twice); there is a comforting symmetry in the fact that the journal they helped develop in Australia, the *Australian Journal of Cultural Studies*, itself returned to 'the centre' as the international journal *Cultural Studies* – although traces of that history have disappeared from the journal itself. (In a further twist to this tale, Hartley now edits the *International Journal of Cultural Studies* from Australia.) The importance of Methuen rescuing this group from the margins and placing them in their preferred export bag is not to be underestimated. Publishing firms are institutions, too, and Methuen's (now Routledge) move into cultural studies and literary theory in the mid-1970s provided an outlet for the work of many who are now key figures in cultural studies theory and practice, while the establishment of the two series (Studies in Communication and New Accents) helped to stake out a market. For those who developed their understanding of cultural studies through publishers' leaflets and bookshop bulletins, the accumulation of titles on the Methuen, and later the Routledge, list constituted a map of the field. While publishing decisions are now more closely related to pedagogic outcomes than many would like, today Routledge faces considerable competition (from at least Sage, Arnold and Continuum in the UK and a number of university presses in the US) and publishing opportunities in cultural studies have increased. Being marginal is not quite as easy as it used to be.

Part II
CENTRAL CATEGORIES

Texts and contexts

The most recognizable and possibly the most important theoretical strategy cultural studies has developed is that of 'reading' cultural products, social practices, even institutions, as 'texts'. Initially borrowed from literary studies, and its subsequent wide deployment owing significant debts to the semiotics of Barthes and Eco, textual analysis has become an extremely sophisticated set of methods – particularly for reading the products of the mass media. This chapter, consequently, will concentrate on textual approaches to the mass media.

Chapter 2 has already described how British literary studies attempted to extend its territory by dealing with media products and popular cultural forms; Hoggart, Williams, and Hall and Whannel all accomplished this extension. In general, however, the success of such attempts was limited by a reluctance to modify literary studies' methods and the ideological/aesthetic assumptions upon which these methods were based. For most, this reluctance took some time to overcome; it was not until the late 1960s and early 1970s that the necessary modifications began to occur, and this was largely due to the importation of semiotics. European explorations of semiotics began to appear in English in the late 1960s; Barthes' *Elements of Semiology* was published in England in 1968, *Mythologies* in 1972, and Eco's 'Towards a Structural Enquiry into the Television Message' also in 1972. Within literary theory, local variants appeared quite quickly; Stephen Heath and Colin McCabe published their collection on semiotics, *Signs of the Times: Introductory Readings in Textual Semiotics*, in 1971. Hall, in particular, appears to have assimilated these ideas very early on; his 'The Determination of News Photographs' (1980b), first published in 1972, applies Barthesian semiotics to a series of news photographs in the British press.

If the first wave of media analysis derived from literary studies, this next wave found its initial stimulus elsewhere – in sociology, in particular in sociology's interest in the mass media's role in the construction of social and political consensus. The part the media played in determining definitions of the normal, the acceptable and the deviant had become an explicit public concern during the political demonstrations of 1968. Sociologies of deviance focused on how such categories were constructed and defined through their representation in the media, especially in the news. Possibly the earliest 'standard' critical work on the media's construction of reality, Stanley Cohen and Jock Young's *The Manufacture of News* (1980; first published 1973), was explicitly situated within the sociology of deviance. As their preface to the 1980 revised edition says, Cohen and Young's 'search for the overall models of society implied in the media's selection and presentation of stories about crime, deviance and social problems' may have been novel in 1973 but by 1980 it had become much less so (p. 10). With the wider acceptance of the subject matter came the adoption of new methods of analysis from outside sociology. Cohen and Young's revision of the contents for the 1980 edition is significant. While the sociological framework remained, a number of strategic changes were made: several American mass communication studies were deleted, and new pieces from the Birmingham Centre for Contemporary Cultural Studies were included. The new pieces deployed semiotic/structuralist methods of textual analysis and Althusserian theories of ideology – contemporary markers of British cultural studies.

It does seem as if the late 1960s/early 1970s is the point at which aesthetic/moral analyses of the media give way before the more sociological accounts. The result is an increased focus on social meanings and on the political implications of media messages. When semiotic analytical methods are incorporated into such interests both the power of 'texts' and the importance of the social and political contexts of their production and reception are acknowledged. This combination – a legacy of the mixed parentage of literary studies and sociology – gave the cultural studies tradition of textual analysis its distinctive character, in theory and in practice.

ENCODING/DECODING

While it is difficult to specify any precise moment as *the* seminal one when the practices of 'left-Leavisism' became semiotic/structuralist, it is customary to see Stuart Hall's important article 'Encoding and Decoding in Television Discourse' as a turning point.[1] In it, Hall makes a conclusive break with the hitherto dominant American communication models, with aesthetics and with the notion of the audience as passive consumers of mass culture. In their place,

Hall installs a new vocabulary of analysis and a new theory of cultural production and reception.

The article opens with a ritual attack on American empiricist and behavioural explanations of the processes of communication. Hall (1980c) argues with those explanations that see communication as a 'loop', or as a direct line from sender to receiver. He points out that just because a message has been sent, this is no guarantee that it will arrive; every moment in the process of communication, from the original composition of the message (encoding) to the point at which it is read and understood (decoding), has its own determinants and 'conditions of existence' (p. 129). What Hall emphasizes is that the production and the consumption of the message are overdetermined by a range of influences, including the discourses of the medium used (the use of the image in TV, for instance), the discursive context in which the composition takes place (such as the visual conventions of TV news) and the technologies used to carry the message (the different signifying function of 'live' or taped coverage, say, of a TV news story).

Hall insists that there is nothing *natural* about any kind of communication; messages have to be constructed before they can be sent. And just as the construction of the message is an active, interpretive and social event, so is the moment of its reception. Society is not homogeneous, but is made up of many different groups and interests. The television audience cannot be seen as a single undifferentiated mass; it is composed of a mixture of social groups, all related in different ways to dominant ideological forms and meanings. So there is bound to be a lack of fit between aspects of the production and reception processes – between the producer's and the audience's interpretation of the message – that will produce misunderstandings or 'distortions'.

This potential for misunderstanding is limited, Hall points out, by the fact that our communication systems – both the linguistic and the non-linguistic – work to 'encode' our languages for us in advance. We do not have to interpret the television discourse from square one because we have already learned the codes from which it is constructed. When we receive a message about the world that minimizes the use of verbs, pronouns and articles (as in 'French Air Crash Disaster Inquiry Shock') we immediately recognize the codes of news. Some codes are so thoroughly learned that they appear not to be codes at all, but to be 'natural':

> Certain codes may, of course, be so widely distributed in a specific language community or culture, and be learned at so early an age, that they appear not to be constructed – the effect of an articulation between sign and referent – but to be 'naturally' given. Simple visual signs appear to have achieved a 'near-universality' in this sense: though evidence remains that even apparently 'natural' visual codes are culture-specific. However, this does not mean

that no codes have intervened; rather, that the codes have been profoundly *naturalised*.

(Hall 1980c: 132)

As Hall goes on to explain, the more 'natural' a code appears to be, the more comprehensively the practice of coding has been disguised.

Visual communication (the photo and the television image, in particular) appears not to be composed of discourses at all, since its signs appear to be natural images of the real world (after all, a picture of something is just that – a picture of something). It is necessary to emphasize the fact that the visual sign in the television message has to be encoded too. Indeed, visual 'languages' work like any other language. To the extent that visual languages may fool us by appearing to be natural, it is crucial to crack the codes, interpret them and release their social meanings.

All of this provides us with a slightly contradictory model: of a television message that is open to various readings by various readers, but that is composed through a set of highly conventionalized codes that we apprehend as natural and that we are therefore unlikely to decode in ways that differ markedly from the intentions of the encoder. Hall deals with this contradiction by arguing that the television message may be polysemic but it is not totally pluralistic; that is, while there is a degree of openness about its meanings, there are also limits. If meanings are not entirely *predetermined* by cultural codes, they are composed within a system that is *dominated* by accepted codes:

> Connotative codes are *not* equal among themselves. Any society's culture tends, with varying degrees of closure, to impose its classification of the social and cultural and political world. These constitute a *dominant cultural order*, though it is neither univocal nor uncontested. ... The different areas of social life appear to be mapped out into discursive domains, hierarchically organized into *dominant* or *preferred* meanings.
>
> (Hall 1980c: 134)

This notion is important because it emphasizes the fact that dominant meanings are not irresistibly imposed, they are only 'preferred'. Readers from social groups who find themselves at odds with these dominant meanings – subcultural groups, workers on strike, single mothers, blacks – may well resist them in their own interpretations of the television message.

The process of constructing, as well as the process of reading, the message is similarly complex. To look at it from the 'encoder's' side of the process, although there are rules and conventions that facilitate the reproduction of the dominant

way of seeing and representing the world, actual signifying practices involve a kind of performance, a calling up and deployment of what one considers to be the appropriate codes and discourses. From the point of view of the television programme producer the problem is not so much one of breaking out of a restrictive straitjacket of codes, but of convincing the viewer to construct the same reading of the programme as the producer. So TV drama producers will use ominous music to warn us of a threat and to fix its meaning *as* a threat. Or the use of specific representational codes tells us immediately how to view a character; in mainstream cinema, for instance, we immediately know who the villain is by the way in which they are represented to us – colour, camera angles, the use of cutaways and so on. Representational codes are made to 'work' towards the preferred meaning. As Hall puts it:

> In speaking of *dominant meanings*, then, we are not talking about a one-sided process which governs how all events will be signified. It consists of the 'work' required to enforce, win plausibility for and command as legitimate a *decoding* of the event within the limit of dominant definitions in which it has been connotatively signified.
>
> (Hall 1980c: 135)

'Encoding' television discourse is the process of setting 'some of the limits and parameters within which decodings will operate. If there were no limits, audiences could simply read whatever they liked into the message' (p. 135).

Negotiating a reading

Hall next considers how the audience's relation to these limits might be better understood. And it is here he makes his most influential formulations. Drawing on the work of the sociologist Frank Parkin, Hall argues that we can identify three 'hypothetical' positions from which the decoding of a television message may be constructed: he calls these the dominant-hegemonic position, or (as it is more widely described now) the 'preferred' reading, the 'negotiated' position and the 'oppositional' position. To read the message from the dominant or preferred position, the viewer 'takes the connoted meaning from, say, a television newscast or current affairs program full and straight, and decodes the message in terms of the reference code in which it has been encoded' (p. 136). It has become clear that, while such a position might exist theoretically, it rarely occurs in practice. The majority of us read television by producing what Hall calls 'negotiated' readings, which 'accord the privileged position to the dominant definitions of events while reserving the right to make a more negotiated application to local conditions'. As

he goes on to say, this negotiated reading will be 'shot through with contradictions' (p. 137). A worker on strike may agree with a current affairs report arguing that it is in the national interest for wage increases to lag behind inflation, while still maintaining his claim for better pay or working conditions in his particular place of employment. The negotiated reading will acknowledge the dominant definitions of the world but may still claim exceptions to the rule in specific cases.

The final position is the oppositional. Here the viewer understands the preferred reading being constructed, but 'retotalizes the message within some alternative framework of reference': 'This is the case of the viewer who listens to a debate on the need to limit wages but "reads" every mention of the "national interest" as "class interest"' (p. 138). We occupy this position every time we witness a political broadcast or advertisement for the political party we usually vote *against*. Instead of reading sympathetically or compliantly, we adopt an opposing position to that from which the message is produced. The result is a reading that is the opposite of what seems intended, possibly confirming our decision to vote for the opponent.

Hall sees these three positions as anything but discrete. He talks of the 'most significant political moments' being the point 'when events which are normally signified and decoded in a negotiated way begin to be given an oppositional reading' (p. 138). Texts can change their meaning and can be worked on by their audiences. Sexist advertising, for instance, is a dominant practice that nevertheless offends many and provokes opposition. To read such ads as offensive or degrading is to hijack their meaning, turning the dominant into the oppositional. Over such representations, Hall says, the 'struggle in discourse' is joined (p. 138). The 'structured polysemy' of messages makes their specific reading at any one time a political struggle between dominant and subordinated meanings.

To talk of the battle for the control of the message is not merely hyperbolic. As I wrote the original version of this chapter the Chinese government was engaged in just such a struggle, reconstituting film of the massacre in Tiananmen Square so that its dominant meaning was reversed; the students' demonstration was reframed as an attack on the soldiers, its participants criminalized in order to legitimate their punishment and the resultant programme of repression. Here the struggle over the meaning of one set of television messages literally became a struggle of life and death.

The importance of the 'Encoding/Decoding' article lies in its demonstration that although the moments of constructing and reading a television message may be determinate moments there is still a range of possible outcomes in both cases. Now that textual analysis is well established this may not seem such a radical advance. But when one considers the pre-eminence of American communication theory at the time, it was a significant break with conventional

assumptions. Not only does Hall insist on the possibility of a lack of fit between the codes used by the encoder and those used by the decoder (this does occur in American traditions too), but he also insists on explaining this disjunction in ideological, political terms. Hall suggests that such moments are not accidents, but are the signs of structural differences produced and determined by other social/economic/cultural forces and made available for analysis in the reading of the television message. This message then becomes a new kind of research resource for inquiries into culture and society. Where the earlier notion of the 'effects' of the media localized the meaning (and the effect) of the message in the individual reader, the encoding/decoding model defined media texts as moments when the larger social and political structures within the culture are exposed for analysis.

THE ESTABLISHMENT OF TEXTUAL ANALYSIS

Textual analyses of television

Reading Hall's article now, one can see how strongly it asserts the polysemic nature of the message and how presciently it alludes to new conceptualizations of the television audience – conceptualizations that were further developed in the mid- to late 1980s. Yet the primary use made of this article during the 1970s was to describe the ideological forces that shape television messages. Most British cultural studies analyses of television during these years examined the ideological and discursive 'work' Hall mentions from a particular perspective, concentrating on the ways in which the contradictions and divisions within society are smoothed over or naturalized within specific television programmes and genres. Cultural studies analysis of the media generally emphasized the construction of consensus, the reproduction of the status quo, the irresistibility of dominant meanings. So although the idea of the passivity of the audience was dismantled in favour of the 'preferred', 'negotiated' and 'oppositional' reading models, the application of these models tended to construct an audience that was, nevertheless, still helpless before the ideological unity of the television message. Although the theoretical possibility of aberrant readings was always admitted, the primary effort was put into establishing just how difficult, *how* aberrant, such readings in practice would be. The power of the text over the reader dominated this stage of media analysis.

Nevertheless, the period produced extremely useful, pioneering studies. Charlotte Brunsdon and David Morley's (1978) analysis of the BBC magazine programme *Nationwide* is a case in point. (*Nationwide* was an early evening magazine programme, closer in format to American or Australian breakfast television than to the conventional current affairs programme. It was outstandingly

successful, a TV institution in Britain for many years.) In the first of a number of studies of this programme, Brunsdon and Morley present a textual analysis of the codes and conventions that define *Nationwide* for its viewers, supported by some quantitative analysis of its patterns of selection – what kind of stories appear most frequently, for instance. They stress how actively *Nationwide* works to present itself as a simple reflection of the way its viewers see the world:

> It [*Nationwide*] presents itself as catching in its varied and comprehensive gaze 'everything' which could possibly be of interest to us, and simply 'mirrors' or reflects it back to us. What is more, it 'sees' these events in exactly the same perspective, and speaks of them in exactly the same 'voice', as that of its audience. Everything in *Nationwide* works so as to support this mirror-structure of reflections and recognitions. The ideology of television as a transparent medium – simply showing us 'what is happening' – is raised here to a high pitch of self-reflexivity. The whole of the complex work of the production of *Nationwide*'s version of 'reality', sustained by the practices of recording, selecting, editing, framing and linking, and the identificatory strategies of producing 'the scene, *Nationwide*', is repressed in the program's presentation of itself as an unproblematic reflection of 'us' and 'our world' in 'our' program. *Nationwide* thus naturalises its own practice.
>
> (Brunsdon and Morley 1978: 9)

Analysing the ways in which this is done, Brunsdon and Morley highlight a variety of discursive (or 'encoding') conventions and expose their effects. For example, we may recognize their description of the inclusiveness of television anchorpersons' cosy address to their audience:

> The audience is constantly implicated through the linkperson's discourse, by the use of personal pronouns: 'tonight we meet …', 'we all of us know that … 'can happen to any of us', 'so we asked …'. The audience is also implicated by reference to past or coming items, which we have all seen/will see, and (by implication) all interpret in the same way. There is a reiterated assertion of a co-temporality ('nowadays', 'in these times of …') which through its continuous present/immediacy transcends the differences between us. 'of course …' *Nationwide* assumes we all live in the same social world.
>
> (Brunsdon and Morley 1978: 18–19)

Brunsdon and Morley explore this mode of address in their examination of the links created between segments within the programme:

This [the elision of the distinction between presenters and audience] can be most clearly seen in the use of … 'Let's …'. Tom Coyne: 'Let's take a look at our weather picture'; 'Let's go to Norwich'; Michael Barratt: 'Let's hear from another part of East Anglia'. Here, the audience's real separation from the team is represented in the form of a unity or community of interests between team and audience; the construction of this imaginary community appears as a proposition we can't refuse – we are made equal partners in the *Nationwide* venture, while simultaneously our autonomy is denied. This, with its attendant, possessive, '*our* weather picture', is the least ambiguous form of the 'co-optive we', which is a major feature of the discourse and linking strategies in *Nationwide*.

(Brunsdon and Morley 1978: 19)

Even though the picture of British life transmitted through *Nationwide* is extremely selective, Brunsdon and Morley demonstrate how actively and successfully its constitutive codes and discourses construct a consensual, 'preferred' view – not only of the meaning of the programme but of its definition of the society.

Hall *et al.* (1981), in 'The Unity of Current Affairs Television', draw similar conclusions from their analysis of the serious BBC current affairs programme *Panorama*.[2] Their argument is constructed a little differently, however. Starting from an investigation of the notion of bias – television journalists' lack of objectivity – the authors discovered how even-handed, in fact, treatment of a specific

Figure 3.1 **Hugh Scully and Frank Bough – two of the presenters of BBC I's** *Nationwide* **(used with kind permission from the BBC)**

79

political issue had been: both in the time allowed contending parties and in the way in which they had been treated. This did not end the inquiry, however. Rather, by interrogating how the notions of 'objectivity', 'neutrality', 'impartiality' and 'balance' were understood by the journalists and their audience the authors formed the view that these very principles supported the status quo and militated against the consideration of alternative points of view.

The Glasgow Media Group's (1976, 1980, 1982) work has shown how the media will always seek out opinion from those persons or groups already, almost automatically, authorized to speak: parliamentary political parties, employers' groups, trades unions and so on. On any one topic the range of interests canvassed and explanations sought will in practice be limited to those already recognized and legitimated by previous media representations. Occasionally even this narrow range can be further restricted. The Glasgow group's research revealed that in at least one case no union or worker's explanation of the purpose of a crippling strike in Scotland was ever broadcast on the television news to counter government and employers' groups' accusations. Professional newsgathering practice must take some of the blame for this, as well as the news producer's need to construct a sense of unity with the programme's audience. But Hall *et al.* (1981) take the Glasgow research a little further; not only are certain groups recognized as having a voice and others not, but the system of recognition is dramatically skewed in favour of parliamentary definitions of politics:

> Television *reproduces selectively* not the 'unity' of any one Party, but the unity of the Parliamentary political system as *a whole. Panorama*, above other Current Affairs programs, routinely takes the part of guardian of unity in this *second* sense. ... As a consequence, the agenda of problems and 'prescriptions' which such a program handles is limited to those which have registered with, or are offered up by, the established Parliamentary parties.
>
> (Hall *et al.* 1981: 115)

This may not seem much of a worry until one realizes how often parliamentary agendas exclude issues non-parliamentary groups consider to be of national importance. 'Green' or environmental politics, for instance, has only recently achieved legitimacy (that is, elected representatives) in some countries, and has still to achieve it in others. Yet conservationists have been trying to secure recognition of their agenda for years. One can see how this agenda might challenge the interests of business, economic growth and 'progress' – all firmly established within the ideologies of the major political parties. It is not hard to imagine in whose interests the marginalization of green politics may have been. Despite its persistence and resourcefulness, it is only where green politics has been accepted

80

within mainstream – electoral or parliamentary – politics that the media represent its definition of issues as legitimate. As a result of green candidates winning elections in Germany and Australia (to use two examples I am aware of personally), media representations of conservationist policies changed, gradually, to the point where conservationists are authorized as 'experts' or consulted as 'concerned citizens' rather than as members of the lunatic fringe. Hall *et al.* help explain how such exclusions occur, and how they can be reversed:

> The media remains a 'leaky system', where ideological reproduction is sustained by 'media work' and where contradictory ideologies do in fact appear; it reproduces the existing field of the political class struggle in its contradictory state. This does not obscure the fact, however, that the closure towards which this 'sometimes teeth-gritting harmony' tends, overall, is one which, without favouring particular positions in the field of the political class struggle, *favours the way the field of political struggle is itself structured.*
>
> (Hall *et al.* 1981: 116)

Given such an account, one might understand why the authors focus so strongly on the reproduction of dominant ideologies through the media; for them, the possibilities of change are extremely limited.

Hall *et al.*'s discussion had explicit political objectives; similarly, in the case of the Glasgow Media Group the political objectives injected a lively note of polemic. Nevertheless, the political objectives of cultural studies analyses of the media during the 1970s were significantly, and in general, overshadowed by the novelty and productiveness of the analytical methods employed. The most notable effect of such interventions as those outlined above was not a widespread mobilization around critiques of the politics of the media. Rather, there was an explosion of interest in the 'reading' of cultural texts – for their own sake as much as for their cultural significance as 'maps of meaning'. The most widespread development of teaching and publication in cultural studies has occurred in this form. The Methuen New Accents series published Hawkes' *Structuralism and Semiotics* (1977) and Fiske and Hartley's *Reading Television* (1978). Shortly after this, Methuen's Studies in Communication series published a set of books aimed at applying these analytical methods to each of the mass media in turn: John Hartley's *Understanding News* (1982), Gillian Dyer's *Advertising as Communication* (1982) and Andrew Crisell's *Understanding Radio* (1986), with later additions from Roy Armes, *On Video* (1989), and myself, *Film as Social Practice* (Turner 1988; revised in 1993, 1999). Supporting these specific applications came an introductory text, Fiske's *Introduction to Communication Studies* (1982), and a

useful glossary of terms, O'Sullivan *et al.*'s *Key Concepts in Communication* (1983). Other publishers entered the field, too; one particularly successful venture was Boyars' publication of Judith Williamson's *Decoding Advertisements* (1978). While it was distinctive for its explicit feminist and post-Freudian influences, *Decoding Advertisements*, like the others, introduced readers to the principles of, largely, semiotic analysis and then applied them to the particular media forms with which it was concerned.

During the late 1970s and early 1980s the semiotic/structuralist tradition of textual analysis became institutionalized in media studies and communications courses in secondary and university education in Britain. The existence of a similar practice – the close analysis of literary texts – in traditional English courses in higher education probably contributed to the readiness with which this new field of study was taken up. It may also explain why Fiske and Hartley's *Reading Television* (1978) spends so much of its time, on the one hand, drawing analogies between the need to analyse the literary text and the need to analyse television while, on the other hand, explicitly excluding literary modes of analysis and literary assumptions of value. Most of the work produced at this time by, for instance, the CCCS had long forsaken literary models, and so these admonitions were clearly addressed to a new, non-cultural studies audience. *Reading Television* was significant because it took these new methods to new audiences and to new classes of students.

As was Raymond Williams around this time, Fiske and Hartley were keen to differentiate themselves from the dominant American traditions of communication study. Their account of content analysis and of traditional explanations of the function of television (largely, its socializing effects) is used to justify the proposition of alternative approaches: semiotic analysis and Fiske and Hartley's idea of television as the equivalent of 'the bard' in modern society.

Fiske and Hartley approach television as an oral, rather than a literate, medium, and resist its incorporation into literary studies:

> Every medium has its own unique set of characteristics, but the codes which structure 'the language' of television are much more like those of speech than of writing. Any attempt to decode a television 'text' as if it were a literary text is thus not only doomed to failure but it is also likely to result in a negative evaluation of the medium based on its inability to do a job for which it is in fact fundamentally unsuited.
>
> (Fiske and Hartley 1978: 15)

Their description of the function of television draws on Hall's encoding/decoding model:

The internal psychological state of the individual is not the prime determinant in the communication of television messages. These are decoded according to individually learnt but culturally generated codes and conventions, which of course impose similar constraints of perception on the encoders of the messages. It seems, then, that television functions as a social ritual, overriding individual distinctions, in which our culture engages in order to communicate with its collective self.

(Fiske and Hartley 1978: 85)

Television, they suggest, performs a 'bardic function' for the culture. Just as the bard translated the central concerns of his day into verse, television renders 'our own everyday perceptions' into its specialized language system. It serves the needs of the culture in particular ways: it addresses collective audiences rather than the individual; it is oral rather than literate; it operates as a centring discourse, appearing as the voice of the culture with which individuals can identify; and it takes its place in the cycle of production and reproduction of the culture's dominant myths and ideologies. Fiske and Hartley divide television's bardic function into categories that include the articulation of a consensus about reality; the implication of individuals into membership of the culture; the celebration, explanation, interpretation and justification of the doings of individuals within the society; the demonstration of the practical adequacy of the culture's ideologies and mythologies, and, conversely, the exposure of any practical inadequacy resulting from changed social conditions; and the guarantee of audience members' status and identity. There is some overlap in these categories, but the general notion of the bardic function continues to be useful. Of particular importance is its explicit refutation of enduring popular demonologies of television: accounts of the medium's function that assume it serves purposes never previously conceived of or needed, and is therefore to be deplored.

The second half of *Reading Television* consists of textual readings of individual television programmes: dancing competitions, game shows, news, sport and drama. In most cases the mode is explanatory, outlining the construction of the dominant or preferred meaning. Since the readings function as demonstrations of the semiotic methods outlined earlier in the book, there are few occasions to interrogate current theoretical models. However, in the most interesting reading, that of the popular BBC game show *The Generation Game*, Fiske and Hartley develop a critique of the notion of the 'preferred reading'.

The analysis is enclosed within a chapter dealing with rituals of competition in game shows and in sport on television. Fiske and Hartley note *The Generation Game*'s difference from other kinds of quiz shows – *Let's Make a Deal*, for instance. *The Generation Game* was an evening game show hosted by ex-vaudeville comic

Bruce Forsyth, in which competing family groups were given a range of comical tasks to perform in order to earn points towards a prize at the end. *The Generation Game*, however, despite its use of prizes, was markedly non-competitive, exploiting the spectacles of embarrassment provided by its competitors' attempts to do things they were no good at: 'throwing' a pot, decorating a cake, performing amateur theatricals and so on. Participation held its own rewards:

> This loss of substance of the competitiveness may well signify the irrelevance of the values of a free-enterprise, competitive society to the norms of family or community life. *The Generation Game*, in its final effect, asserts the validity of non-competitive communal values within the structure of a competitive society, and is thus working within an area of cultural tension for which our society has not found a comfortable point of equilibrium.
>
> (Fiske and Hartley 1978: 157)

Fiske and Hartley move from this perception to a suggestion of dissatisfaction with the notions of domination that have underpinned their analyses throughout the book:

> So while the simple binary model of dominant/dominated may indicate the basis of our class structure, we must be chary of applying it too directly to the texts. A cultural text is always to a certain extent ambivalent. It never merely celebrates or reinforces a univalent set of culturally located attitudes, but rather reflects the tensions caused by the many contradictory factors that any culture is continually having to reconcile in a working equilibrium.
>
> (Fiske and Hartley 1978: 157)

To move further into the analysis of these tensions within particular historical moments, or of the specific sociocultural reasons for the difference of *The Generation Game*, is something the book is prevented from doing by its concentration on textual analysis and by its introductory nature. Also, within the field of study itself, while the relation between texts and culture was well outlined, the theoretical orthodoxies that might account for the relation between texts and history still remained to be developed.

The meaning of the star

If Fiske and Hartley are ultimately limited by their textual focus, Richard Dyer's work shows at least one way out of that difficulty. First of all, while Dyer subjects texts to analysis, he avoids any suggestion that he is examining the 'text in itself' –

the text as an independent, discrete object of analysis. Dyer is interested in the discourses used to construct texts and the social histories of these constitutive discourses. Second, he broadens the idea of the text by acknowledging the importance of extratextual material in the construction of any particular text's meanings. Consequently, his analyses draw on representations not normally considered (fan magazines, for instance). Dyer's analytical procedure is strenuously intertextual and also, as he puts it, 'dialectical, involving a constant movement between the sociological and the semiotic' (R. Dyer 1982: 2). The result is the mobilization of textual analysis in the service of the social analysis of discourse.

His subject, in the books I refer to here, is the meaning of film stars: the social meaning of the images of a Jane Fonda, a Marilyn Monroe or a Marlene Dietrich. Dyer's first book dealing with this topic, *Stars* (1982), asks specific questions about just what kind of 'social reality' film stars might construct, what they might signify and how they might function within film texts. Dyer examines the social construction of the image of the star through the full range of its representations – fan magazines, interviews, pinups, news stories, publicity and promotional material, and so on – and how this is inscribed into specific film narratives. He reveals how stars accrue meanings that are relatively independent of the characters they play but that contribute to their characterizations on the screen; this is why it is unsurprising for us to find that James Stewart plays the naive liberal lawyer and John Wayne the retired gunslinger (rather than the other way around) in *The Man Who Shot Liberty Valance*. In his analysis of Jane Fonda's career Dyer outlines how 'her' meanings changed *between* texts, as it were, over time. And finally, he examines the ideological function of stars for society: how they manage to represent both the type and the ideal of the individual in society. Dyer explores the central contradiction in the signification of stars: they are simultaneously representative of society and uniquely individual, both typical and extraordinary. In *Stars* and in his second study, *Heavenly Bodies* (1986), Dyer insists on the social content of cinema texts, on the historically produced competencies and expectations brought to the cinema by the audience, and on the already coded meanings that enter the sound stage with the performers. *Heavenly Bodies*, too, provides accounts of the ways in which subgroups within the mass audience can appropriate a star's image and insert it into new contexts, giving it new meanings: his discussion of Judy Garland's particular meaning for gay subcultures is an example of this.

Screen *theory*

Dyer's work does not belong to the same tradition as that of the Birmingham CCCS. While not typical of it, his interests in cinema are part of that branch of

screen studies most closely identified with the British Film Institute (BFI) in London and the major film journal in Britain, *Screen*. *Screen* has been influential and controversial, identified with a particular theoretical/critical 'line', a particular aesthetics and a particular political stance. Influenced by the semiotic/psychoanalytic cinema theory of Christian Metz and by Althusserian theories of ideology, and focused on the problem of the construction of subjectivities particularly as defined in post-Freudian and feminist appropriations of psychoanalysis, *Screen* marked out a position that opposed much of the cultural studies work done in Britain in the 1970s. While articles published in *Screen* made important contributions to the development of textual analysis, the journal's prevailing theoretical position involved an extreme textual determinism. At one point, the CCCS set up a special research group to consider what became known as '*Screen* theory'; Stuart Hall's (1980e) and David Morley's (1980b) critiques are among the products of that research group.

It would be wrong to see *Screen* as speaking with one voice over this period (see Tudor 1999: 102), but certain concerns and preferred theoretical protocols did pervade its pages. *Screen*'s concern with semiotic explanations of the relation between language and the subject, and its interest in Lacan's view of subjectivity as an empty space to be filled through language led it to foreground vigorously the role of representation, and thus of the text, in constructing the subject. *Screen* theory saw the processes of *interpellation*, the way the individual subject is 'written into' the ideologies of his or her society through acquisition of its language systems, as central and comprehensive processes, particularly in film and television. Texts are discussed in terms of their capacity to place or 'position' the viewer, inserting or 'suturing' him or her into a particular relationship to the narrative and into an uncomplicated relationship to dominant ideologies. There is little the viewer can do about this ideological positioning other than to accept it; in *Screen* theory texts always and irresistibly tell us how to understand them.

Understandably, this textual determinism provoked some argument. Among the most controversial aspects of the position was its apparently categoric character; could we really say that *all* texts worked like this for *all* readers? On British TV at the time (the mid-1970s) a subgenre of critical dramatized documentaries was in vogue, producing texts whose narratives appeared to undermine dominant ideologies. The British docudrama *Days of Hope*, which dealt with aspects of British working-class history from the Great War to the beginnings of the Depression, was widely seen as a genuinely political critique of both Labour and Conservative party politics over that period that established unmistakable parallels between the Britain of the 1920s and a contemporary Britain torn by inflation, unemployment and battles between unions and government. It was a particularly realistic piece of television, and it provoked outcry from the

Conservatives, who pilloried the BBC and its writer, Jim Allen, for their (supposed, in the BBC's case) Marxist leanings.

The debate over this text reached epic proportions.[3] *Screen* theory replied through Colin McCabe, arguing that the generic form of the programme, its realism, far from enhancing its progressive effect, actually rendered it unable to criticize society.[4] Realism, McCabe (1981) argues, is a set of representational codes that offers the viewer a comfortable position from which to see even bitter political struggles as natural or inevitable. Setting such struggles in the past inevitably implies their resolution in the present, while the narrative's construction of a superior, knowledgeable position for viewers protects them from responding critically or 'progressively' to the events depicted. Realism, the argument goes, precodes the reality it represents within common-sense understandings of the world; so even when it depicts terrible happenings we leave the text sighing acceptingly, 'Oh well, that's the way it is (or was), there is little we can do about it'. Realistic fictions in all media inscribe the reader into a controlling discourse – a set of values, a narrator's voice or the control of the perspectives of the camera – that takes on the role of an authoritative narrator. McCabe argues that this authoritative narrator tells the reader what to think, closes off questions and rewards them by delivering them to the end of the fiction. The realist text cannot question reality or its constituent conditions without destroying the authority of this narrator. And since the realist text depends on the reader seeing *it* as reality, it cannot question itself without losing its authenticity. The progressive alternative would be a text that challenges viewers by questioning their common-sense views of the world, and, *Screen* theory argues, this can be done only by breaking the conventional patterns of representation – by breaking with the dominant conventions of realism.

The 'realism debate' has been influential and lasting. The celebrated BBC TV drama *The Boys from the Blackstuff*, screened in the early 1980s, provoked a rematch between the *Screen* theorists and those who felt that TV realism *did* have the potential to produce an 'oppositional' reading despite its dominant generic form. Stephen Heath (1985) and others have argued that it is impossible to 'read off' a set of ideological positions automatically from the generic form of a text, and I have argued elsewhere that the realist form used in some Australian cinema has offered clearly progressive readings as dominant positions (Turner 1986). Ultimately such protests prevailed. The idea that the realist text is 'not so much "read" as simply "consumed/appropriated" straight, via the only possible positions available to the reader – those reinscribed by the text' (Morley 1980b: 166–7) is usually presented in a much less categoric fashion now – in *Screen* and elsewhere.

The position taken on this issue, however, is typical of *Screen* theory. It presented a consistent critique of conventional popular film and television texts,

proposing a renovatory, avant-garde aesthetic that questioned dominant repre-
sentational conventions. The search for the 'progressive text', which was both
textually unconventional (non-realist) and politically anti-bourgeois, dominated
much of the work published in *Screen* in the late 1970s and early 1980s. Indeed,
for some time it became a reflex to deal with new television and film texts in
terms of their perceived progressiveness or their lack of it, and this led *Screen*
into an elitist political cul-de-sac from which it was difficult to say anything
useful about any popular text. One reason for *Screen* theory's insistence on chal-
lenging conventional textual forms was the conviction that the text itself, rather
than forces outside and prior to the text, constructed the subject position from
which the viewer made sense of it. The avant-garde offered a way out of this: a
more interrogative set of representational conventions might produce a more
critical and questioning audience/subject. While there has been widespread
acceptance of this last proposition, *Screen* theory in general has been
contentious. As we have seen, representatives of the CCCS vigorously resisted
Screen's textual determinism as denying history, the polysemic nature of signs
and discourses, and the 'interrogative/expansive nature of all readings' (Morley
1980b: 167). Subsequent revisions of the position seem to acknowledge the fact
that *Screen* theory tended to isolate 'the encounter of text and reader from all
social and historical structures *and* from other texts ... which *also* position the
subject' (Morley 1980b: 163).

One stream within this body of theory that clearly does *not* ignore the forma-
tion of the subject within other texts or social structures, however, is the feminist
critique of popular film narrative. Laura Mulvey's 1975 *Screen* article 'Visual
Pleasure and Narrative Cinema' is almost invariably cited as the key text, but the
critique is more widespread and diverse than this would suggest. In general,
feminist criticisms of mainstream film and television argue that the way in which
these media represent the world replicates other representational structures'
subordination of women. Crudely, the argument is that if popular texts establish
a position from which we find it comfortable to view and identify with them it
should not surprise us to discover that the viewing position constructed within
the conventional discourses of (say) Hollywood cinema is that of the male, not
the female, viewer. While the female body is, conventionally, traversed by the
camera – lit, framed and explored as an object of male desire – the male body is
not subjected to the same regime of inspection for the pleasure of the female
viewer. This despite the fact that half the audience, on balance, will be female.
Mulvey and others argue that even the pleasures offered by film are colonized,
offered to women as experiences that involve the denial of their own female
subjectivity if they are to be enjoyed. The pleasures of looking, of voyeurism
and narcissism proffered by Hollywood cinema, Mulvey argues, are masculinist

and, in some genres (for example, horror films, certain kinds of thrillers), actively misogynist. Mulvey's original formulations have been revised, by her (1981) and others, leading to far more positive readings of, for instance, Hollywood action cinema (Tasker 1993) and female spectatorship (Stacey 1994). Notwithstanding these substantial revisions, Mulvey usefully alerted us to the fact that texts can provide a very limited number of viewing positions for an audience to occupy, and that these correspond to a narrow range of ideological effects. Despite the formation of each member of the audience as a separate subjectivity, and despite the polysemy of the text, we are not granted a temporary exemption from the ideological frames of our social existence when we enter a movie theatre. Feminist critiques demonstrate that the vastly dominant discourses in the media naturalize masculine pleasures; we need to be shown how to notice this effect.

DETHRONING THE TEXT

David Morley was among the foremost critics of *Screen* theory and its privileging of the power of the text, and his work has provided one of the most important countervailing strands of thought. It will be addressed in more detail in the following chapter, but for the moment it is important to note how Morley's attempt to develop Hall's encoding/decoding model came to demonstrate, instead, that individual readings of television are even more complex and unpredictable than Hall's model would imply. As a continuation of the Brunsdon and Morley (1978) textual analysis of *Nationwide*, Morley (1980a) played an episode of the programme to twenty-six groups of varied class, social and occupational backgrounds and then studied their decodings of the text. The results conclusively undermine the linkage of particular readings with particular class positions (as if the working classes all read one way and the middle classes all read another); they also reveal that making sense of television is an intensely social and interactive activity. Given the diversity of response Morley collected in the *Nationwide* study, it was difficult to see how the text *could* produce a subject position that overrode those produced by other social forces such as gender, ethnicity, occupation and so on. It was also clear, however, that the subject positions produced by these other social forces were also unpredictable, disunited and even internally contradictory. Thus, Morley – and others who developed this area of audience studies – re-established the importance of the context in which texts are consumed and of the social content brought to them by specific audiences.

Other work proceeding within Birmingham and elsewhere at the time proved complementary. The so-called subcultures group at the CCCS established

89

approaches that emphasized the minority rather than the majority, the subordinate rather than the dominant, the subculture rather than the culture. Studies of urban youth in Britain that drew on history, sociology and anthropology had emphasized the strategies subordinate groups used to make their *own* meanings in resistance to those of the dominant culture. Not only did they negotiate with or oppose the dominant, but in many cases they actively appropriated and transformed (and thus subverted) dominant meanings. (Examples of this tradition of research can be found in Hall and Jefferson 1976; further discussion of this tradition will be presented in Chapter 5.)

The introduction to *Resistance Through Rituals* (Hall and Jefferson 1976) argues that culture is made up of contributing smaller groups or class fragments, social groups that develop their own 'distinct patterns of life', giving 'expressive form to their social and material life-experience'. Culture is not monolithic, as in a sense is implied by the encoding/decoding models, but is made up of many competing, overlapping and conflicting groups. Each of these groups defines itself through its distinctive way of life, embodied in its institutions (a motorbike club, for instance), its social relations (their specific place within the domain of work or the family), its beliefs and customs, and its 'uses of objects and material life'. All these 'maps of meaning' constitute the subculture and make it intelligible to its members (p. 10). Within a subculture, then, the most mundane object can take on specific meanings; within punk culture, the humble safety pin was appropriated as an offensive decoration and worn openly on ripped clothing or in some cases inserted into the skin.

Many subcultural studies examined the way in which these maps of meaning were composed, and what meanings were attributed to the practices, institutions and objects within the subcultural group. As Hall and Jefferson (1976) point out, the study of subculture is more than an essentially sociological study of the structure and shape of social relations; it becomes interested in 'the way [these structures and shapes] are experienced, understood and interpreted' (p. 11). The effect – at least in that part of the tradition I am going to consider here – is to turn the subculture into a text, its examination into a variant of textual analysis, and the interpretation of its meanings into a highly contingent activity.

As a result, the definition of what constitutes a text broadened dramatically; the new definition included cultural practices, rituals, dress and behaviour as well as the more fixed and 'produced' texts such as television programmes or advertisements. The emphasis shifted towards the generation of meanings through social practices and, even more significant, towards the location of these meanings in those who participated in the practice rather than the practice itself. This reinforced the importance of the audience/participants in the production of meaning and highlighted how often texts are in fact read 'against the grain',

through oppositional socially produced positions that 'make over' their dominant meanings. The 'meaning' of a text was allowed to be more provisional, perhaps contradictory, and subculturally specific. As a consequence it became debatable whether or not the primary source of meaning was the set of social relations into which the text was inserted or the specific forms of the texts themselves. The text was 'dethroned'; it lost its determining authority, its ability to determine how it would be understood by its readers.

Subculture

Possibly the most influential deployment of subculture studies within the mainstream of cultural studies was Dick Hebdige's *Subculture: The Meaning of Style*, published in Methuen's New Accents series in 1979. In this book Hall's textual struggle for meaning takes on a material form in subcultural style: the dress codes of punks, the musical codes of reggae, the retrospective dandyism of the teddy boys. Hebdige's is one of the livelier and more accessible of the books to come out of this tradition, and his account of the representational codes of specific urban subcultures in 1970s Britain still makes stimulating reading.

In *Subculture*, Hebdige uses semiotics to interpret the meanings – ambiguous and contradictory – produced by subcultural dress, music and behavioural styles. One influence on Hebdige's approach is literary criticism (specifically the work of the *Tel Quel* group in France); another influence comes from cultural studies' appropriations of ethnographic techniques, particularly the work of Phil Cohen.

Hebdige singles out Cohen's work for its linkage of class experience and leisure styles, and for his explanation of the relation between youth subcultures and their parent cultures. Cohen exerted a profound influence on the CCCS's research on subcultures; this is evident in *Resistance Through Rituals*, as Hebdige notes (1979: 80), in the various authors' interpretations of 'the succession of youth cultural styles as symbolic forms of resistance'. Most important, Cohen's explanation of the basic or 'latent' function of subcultures provides the rationale for Hebdige's own reading of specific subcultures as texts. For Cohen, the function of subculture was to 'express and resolve, albeit magically, the contradictions which remain hidden or unresolved in the parent culture' (p. 77). The skinheads' fundamentalist caricature of working-class dress is thus read as a challenge, confronting the gradual *embourgeoisement* of working-class culture. Cohen relates the specifics of style to the more general 'ideological, economic and cultural factors which bear upon subculture' (p. 78) through a close reading of leisure styles that Hebdige regards as exemplary:

Figure 3.2 **Cover of Dick Hebdige's** *Subculture:The Meaning of Style* **(used with kind permission of Methuen & Co.). Appropriately enough, this is the only one of the New Accents series to feature a genuinely stylish cover**

Rather than presenting class as an abstract set of external determinations, [Cohen] showed it working out in practice as a material force, dressed up, as it were, in experience and exhibited in style. The raw material of history could be seen refracted, held and 'handled' in the line of a mod's jacket, in the soles on a teddy boy's shoes.

(Hebdige 1979: 78)

Subculture: The Meaning of Style offers readings and case studies that reflect changes in the way texts were being defined and exerts an influence on the studies of popular culture that follow it; one can see the continuities between Hebdige's work and that of Iain Chambers, for instance. But Hebdige's assessment of the political function of subcultural style was probably his most significant contribution. The meaning of subculture, he says, is like any other ideological territory – open to contestation: 'and style is the area in which the

opposing definitions clash with most dramatic force' (p. 3). Further, subcultures are enclosed within the larger processes of hegemony, against which their signifying practices need to be set:

> Individual subcultures can be more or less 'conservative' or 'progressive', integrated *into* the community, continuous with the values of that community, or extrapolated *from* it, defining themselves *against* the parent culture. Finally, these differences are reflected not only in the objects of subcultural style, but in the signifying practices which represent those objects and render them meaningful.
>
> (Hebdige 1979: 127)

Hebdige is most interested, however, in those subcultural styles that seem to challenge hegemony, that offer an 'oblique gesture of Refusal'; there, 'the objections are lodged, the contradictions displayed ... at the profoundly superficial level of appearance: that is, at the level of signs' (p. 17).

The book largely engages with subcultures at the level of signs, too: an example is this account of the mode of dancing associated with British punks, the 'pogo':

> Dancing, usually an involving and expressive medium in British rock and mainstream pop cultures, was turned into a dumbshow of blank robotics ... the pogo was a caricature – a *reductio ad absurdum* of all the solo dance styles associated with rock music. It resembled the 'anti-dancing' of the 'Leapniks' which Melly describes in connection with the trad boom. ... The same abbreviated gestures – leaping into the air, hands clenched to the sides, to head an imaginary ball – were repeated without variation in time to the strict mechanical rhythms of the music ... the pogo made improvisation redundant: the only variations were imposed by changes in the tempo of the music – fast numbers being 'interpreted' with manic abandon in the form of frantic on-the-spots, while the slower ones were pogoed with a detachment bordering on the catatonic.
>
> (Hebdige 1979: 108–9)

Hebdige lays out his texts for us to examine, but always insists on their subversive, resistant potential:

> Style in subculture is, then, pregnant with significance. Its transformations go 'against nature', interrupting the process of 'normalisation'. As such, they are gestures, movements towards a speech which offends the 'silent majority',

which challenges the principle of unity and cohesion, which contradicts the myth of consensus. Our task becomes, like Barthes', to discern the hidden messages inscribed in code on the glossy surfaces of style, to trace them out as 'maps of meaning' which obscurely re-present the very contradictions they are designed to resolve or conceal.

(Hebdige 1979: 18)

Interestingly, in *Hiding in the Light* (1988) Hebdige bids 'farewell' to the study of youth subcultures by denying the connection between youth subcultures and the signification of negation or resistance. Admitting that his argument was reinforced by punk's explicit political agenda and that subsequent youth movements no longer seem to articulate such a strong political resistance, Hebdige draws the useful theoretical lesson that 'theoretical models are as tied to their own times as the human bodies that produce them'. While Hebdige may overstate the case to maintain that 'the idea of subculture-as-negation grew up alongside punk, remained inextricably linked to it, and died when it died' (p. 8), it is true that this formulation did run the risk of merely inverting the politics of consensus, simply equating the subordinate with the resistant.

Subsequent development, however, has expanded the range of research approaches employed to examine the relations between music, style and popular youth subcultures – so as to avoid the kinds of alignments of which Hebdige accuses his own work. Sarah Thornton's (1995) study of dance clubs focuses on the discourses used to create hierarchies and 'distinction' in the 'taste cultures' found there. While in many ways she reads these 'clubculture' styles as texts, she also makes use of interviews and other sources of information that are more empirical in their foundations. She explicitly disclaims any interest in the relation between subcultures and resistance, and accuses the methodologies used within the Birmingham CCCS ethnographies as being 'empirically unworkable' (p. 8). Most importantly, her focus is on the subculture in her sights, not on its relation to a parent culture or the mainstream. As she puts it, borrowing from the French sociologist Bourdieu, her interest is in the making and operation of 'subcultural distinction' (p. 14).

Further instances come from Steve Redhead's work (1990, 1997) and from the group of allied researchers connected with research projects at Manchester Metropolitan University. While in some sense continuing the work identified with subcultures at the CCCS, Redhead's work also moves us on: it shifts away from the idea that the subculture is the object of study in favour of focusing more directly on the cultural networks which make up the contemporary experience of popular cultures. As a result, this more recent and still emerging tradition resists treating the subculture primarily as text, and prefers more historical modes of analysis.

POLYSEMY, AMBIGUITY AND READING TEXTS

Aspects of the work described in the preceding section – the focus on the audience and on strategies of resistance within subcultural fragments of the 'mass' audience – have been mobilized in other ways. Over the last decade and a half, as something of a reaction against the dethroning of the text, many have argued that, especially in the case of television or popular texts, this potential for resistant readings is in fact a property of texts themselves, and not merely of the audience members' socially produced methods of reading them. Where once the endeavour was to alert us to the construction of a consensual reading, many studies during the 1980s were interested in describing very different aspects of the text; the networks of ambiguity and contradiction that invite and accommodate the reader's adoption of different, even ideologically contradictory, subject positions. Texts were seen to be loaded with an excess of meaning, leaking through the boundaries of any 'preferred' readings into the social formations of the readers, and thus producing a range of meanings and pleasures. In this section I will note some aspects of the development of this conceptualization of the relationship between text and reader.

In 'Dance and Social Fantasy', Angela McRobbie (1984) resists the emphasis on social rather than textual influences on readers and audiences, and attacks the kind of subcultural and ethnographic research on youth discussed in the preceding section:

> One of the marked characteristics of most academic writing on youth has been its tendency to conceive of youth almost entirely in terms of action and of direct experience. Attention has been paid to young people in school, on the dole, and on the street, all sites where they are immediately visible to the social observer. This has had the effect of reducing the entire spectrum of young people's experience implicitly to these moments, neglecting almost totally those many times where they become viewers, readers, part of an audience, or simply silent, caught up in their own daydreams. To ignore these is to miss an absolutely central strand in their social and personal experience. It means that in all these subcultural accounts we are left with little knowledge of any one of their reading or viewing experiences, and therefore with how they find themselves represented in these texts, and with how in turn they appropriate from some of these and discard others. This absence has also produced a real blindness to the debt much of those youth cultural expressions owe to literary texts, to the cinema, to art and to older musical forms.
>
> (McRobbie 1984: 141)

Texts are social formations, too, not simply raw material to be processed through other social determinants like gender and class. Furthermore, McRobbie suggests that the varying social uses to which texts may be put are available to us through close analysis. She cites as an example the way in which discussion of a film may become a social activity or event; her point is that this is possible only because even popular texts like Hollywood films inscribe into their forms an awareness of their varied usage: 'The polysemy (or multiple meanings) of the text rises to the surface provoking and pandering to *different* pleasures, *different* expectations and *different* interpretations' (p. 150).

McRobbie concludes her argument by criticizing an earlier piece of her own, on the magazine *Jackie* (1982), which attacked the fantastic, non-realist properties of *Jackie*'s view of the world. In the more recent piece, McRobbie admits that her earlier account misunderstood and undervalued the pleasures the magazine offered, and attempted instead to impose an idealized notion of her own in their place. Her misunderstanding of the pleasures of the text, she argues, led to a devaluing of the readers' experience of it.

The notion of pleasure has increasingly been placed in opposition to that of ideology. There are varieties of pleasure that are located within the body, their production having physical sources. Whereas the meanings we give to the world we live in are socially produced, there is an argument that suggests our physical pleasures are our own. Such a theory implies a limited degree of individual freedom from the forces of ideology. As is so often the case, Barthes provides a starting point here with his discussion of the pleasures produced by certain kinds of literary texts in *The Pleasure of the Text* (1975). While the complexities of this position are not relevant here (I will talk a little more about them in Chapter 6), the effect of theories of pleasure is to raise the possibility that communication may have more consequences than the generation of meaning. Further, and more centrally for our purposes here, where texts are seen to produce both pleasures *and* meanings, the two may well contradict or counteract each other. Male audiences may find it hard to resist the voyeuristic pleasures offered in the classic Robert Palmer music video 'Simply Irresistible', no matter how ideologically alert they may be to its chic sexism. As Colin Mercer (1986: 54) says, analysts of popular culture may need to 'look over [their] shoulders and try to explain a certain "guilt" of enjoyment of such and such *in spite of* its known ideologies and political provenance'. Alternatively, some marginalized individual pleasures may contradict and resist dominant ideological positions.

Pleasure and resistance

For some time, John Fiske's work represented perhaps the most unequivocal development of this last possibility; Fiske identifies the category of 'the popular' with those pleasures he believes resist and stand outside the forces of ideology. Fiske characterizes popular culture in general, and popular television in particular, by its ability to generate 'illicit' pleasures and therefore subversive meanings.

One can chart the development of this position. In his contribution to Robert Allen's collection *Channels of Discourse*, Fiske (1987a) describes the complexity of the relations among texts, readers and culture in an impeccably even-handed manner, acknowledging the dialectics of resistance and determination, textual openness and ideological closure in the production of textual meaning:

> A close reading of the signifiers of the text – that is, its physical presence – ... recognizes that the signifieds exist not in the text itself, but extratextually, in the myths, counter-myths, and ideology of their culture. It recognizes that the distribution of power in society is paralleled by semiotic struggles for meanings. Every text and every reading has a social and therefore political dimension, which is to be found partly in the structure of the text itself and partly in the relation of the reading subject to that text.
>
> (Fiske 1987a: 273)

The picture here is one of balance, but nevertheless one that depicts ideological systems maintaining their purchase against significant competition. The even-handedness works to produce a consensual model of cultural production that recalls Hall's encoding/decoding explanations.

Fiske ultimately distances himself from such a position in order to explain why there is, in practice, no direct or necessary equation between popularity and ideological unity. To do this, Fiske draws on, among others, John Hartley's 'Encouraging Signs: Television and the Power of Dirt, Speech and Scandalous Categories' (1983), in which Hartley discusses television as a 'dirty' (socially unsanctioned) category that thrives on ambiguity and contradictions. Television's special quality, Hartley says, is its ability to 'produce more meaning than can be policed' (1983: 76), a quality television producers deal with by attempting to limit their programme's potential for meaning. This, Hartley argues, inevitably fails, as ambiguity 'leaks' into and out of the text. An 'encouraging sign' of the weakness of the tenure of any hegemonic meaning, this leakage is the result of 'semiotic excess', a proliferation of possible readings, an excess of

meaning. Fiske (1986) suggests that this semiotic excess – not ideological unity – is intrinsic to popular cultural forms, explaining both their popularity and the apparent unpredictability of reactions to them:

> I suggest that it is more productive to study television not in order to identify the means by which it constructs subjects within the dominant ideology (though it undoubtedly and unsurprisingly works to achieve precisely this end), but rather how its semiotic excess allows readers to construct subject positions that are theirs (at least in part), how it allows them to make mean-ings that embody strategies of resistance to the dominant, or negotiate locally relevant inflections of it.
>
> (Fiske 1986: 213)

Fiske's enterprise can here be understood as an attempt to explain how popular culture seems, on the one hand, to be at the mercy of the culture industries and, on the other hand, to exercise a stout resistance and even subversiveness at times in its response to specific texts and their proposed meanings. The attribution of ambiguity to the text explains how texts might determine their preferred readings while still containing the potential for subversive or resistant 'misreadings'.

In *Television Culture*, Fiske (1987b) mobilizes developments in audience studies, the dethroning of the text, and his sense of the subversiveness of pleasure to present a view of popular culture audiences that is many miles from the manip-ulated masses of 'effects' studies. Drawing on de Certeau's theorizing of the creativity of popular culture, Fiske sees 'the popular' in rather a Brechtian way – as a relatively autonomous, if subordinated, voice competing with the dominant for representation. The making over of the dominant meanings in popular culture is seen as a successful political strategy that 'empowers' otherwise subor-dinated groups and individuals.[5] The textual analysis this motivates is most interested in the production of politically progressive readings. The majority of *Television Culture* deals with what Fiske calls 'activated texts', those produced largely through appropriation by their audience rather than, say, successful posi-tioning by their producers. These activated texts do not constitute an aberration, at the fringe of television's cultural function, but are among its defining charac-teristics:

> Television's open-ness, its textual contradictions and instability, enable it to be readily incorporated into the oral culture of many and diverse groups in many and diverse ways so that, while it may not in its broadcast mode be a form of folklore, it is at least able to serve folkloric functions for some of its audiences. Its popularity among its diversity of audiences depends upon its

ability to be easily and differently incorporated into a variety of subcultures: popularity, audience activity, and polysemy are mutually entailed and inter-dependent concepts.

(Fiske 1987b: 107)

Fiske is aware of the implications of announcing that capitalism's determining structures do not work, however; and so he is careful to acknowledge that the 'plurality of meanings' within television texts is not 'of course, a structureless pluralism', but is 'tightly organized around textual and social power'. The emphasis is nevertheless on the alternatives to the preferred meanings and the politics of their construction:

The preferred meanings in television are generally those that serve the inter-ests of the dominant classes: other meanings are structured in relations of dominance–subordination to those preferred ones as the social groups that activate them are structured in a power relationship within the social system. The textual attempt to contain meaning is the semiotic equivalent of the exercise of social power over the diversity of subordinate social groups, and the semiotic power of the subordinate to make their own meanings is the equivalent of their ability to evade, oppose, negotiate with this social power. Not only is the text polysemic in itself, but its multitude of intertextual rela-tions increases its polysemic potential.

(Fiske 1987b: 127)

The obvious limitation to the progressive effect of this multitude of textual possibilities is that the textual system may well be more porous than the social system; making over the meaning of a television programme may be much easier than climbing out of a ghetto, changing the colour of one's skin, changing one's gender, or reducing one's dependence on the varied mechanisms of state welfare. In some of Fiske's (1988) subsequent work, the category of the text vanished under the pressure of these competing definitions and forces:

What excites me are the signs that we may be developing a semiotic ethnog-raphy that will help us toward understanding concrete, contextualised moments of semiosis as specific instances of more general cultural processes. In these moments, there are no texts, no audiences. There is only an instance of the process of making and circulating meanings and pleas-ures.

(Fiske 1988: 250)

At this point, it is as if British cultural studies has turned back on itself, expunging the category of the text as if it is an impediment to the analysis of discourse.[6] Yet, as we have seen, textuality must be merely a methodological proposition, a strategy to enable analysis, not an attempt to claim privileged status for a range of cultural productions. In cultural studies, no text can be independent of the methodology that constructs it as one. So far, the methodologies have not been conservative or rigid structures, inhibiting further development. The trends I have been charting, in fact, reveal how directly changes in method have been produced by shifts in the definition of what constitutes a text.

The category of the text, however, and explanations of the production of textual readings have become increasingly problematic. The difficulty is that, from one point of view, texts are held to contain meanings immanent in them, at least in the form of a set of limits so that one cannot read simply what one wants off them; they are also held to reproduce dominant ideological structures and thus must exercise some degree of dominance or preference towards a reading or group of readings. From the contrary point of view, however, texts contain the possibility of being read against the grain and producing resistant, or subordinated readings, mobilized by specific groups within the culture; they are also held to be historically contingent, subject to shifts in the contexts of their reception that can entirely change their specific meanings and their wider cultural significance. This last factor is one not yet explored here, and to deal with it I cite a book that takes the problems of defining and reading the text very seriously indeed – but without jettisoning the category altogether.

Bennett and Woollacott's (1988) book on the popular fictional hero James Bond goes beyond Morley's (1980a) account of different readers producing dominant, negotiated and oppositional readings of the *Nationwide* text; these authors outline how different social and historical conditions can produce vastly different *dominant* readings of the multitextual figure of James Bond. *Bond and Beyond: The Political Career of a Popular Hero* is in many ways exemplary in its attempt to survey the historical, industrial and ideological field that produces its texts – the films, novels and publicity connected to the figure of James Bond. The book contains analyses of the internal structures of individual texts, of the ways in which the meanings of the texts might be historicized, of how Bond's meaning has changed over time, of the relationship between the films and the novels, and of the professional ideologies of the filmmakers and how these might have affected the specific translations of the novels into film. The problem of fully explicating a body of popular texts, however, is apparent in the fact that even this well-designed set of approaches has left gaps for the critic and the fan alike to question.

Bennett and Woollacott frame their project, quite explicitly, within arguments about textual analysis. Their instincts would seem to lie with those audience

studies that recognize the social and discursive factors mediating the relations between texts and audiences; they are very critical of an excessive emphasis on the properties of the text:

> The case of Bond throws into high relief the radical insufficiency of those forms of cultural analysis which, in purporting to study texts 'in themselves', do radical violence to the real nature of the social existence and functioning of texts in pretending that 'the text itself' can be granted an existence, as a hypostatised entity, separated out from the always variable systems of inter-textual relations which supply the real conditions of its signifying functioning.
>
> (Bennett and Woollacott 1988: 6–7)

This view aligns Bennett and Woollacott with those who would follow discourse(s) as the object(s) of study, who would see texts as 'sites around which a constantly varying and always many faceted range of cultural and ideological transactions are conducted' (p. 8). However, as they reveal later in the book, while their sympathies might lie with the audience studies, they reject at least one of Morley's unspoken assumptions: that the varying readings of the one programme are of the 'same' text rather than the production of many, multiple texts.

Inter-textuality and textual shifters

Having distanced themselves from the two major traditions, Bennett and Woollacott develop a number of terms to help them redefine the connection between texts and society. First, they extend the idea of intertextuality, the system of internal references between texts: they introduce the hyphenated term *inter-textuality*, which refers to 'the social organisation of the relations between texts within specific conditions of reading' (p. 45). Bennett and Woollacott insist that texts cannot relate even to each other independently of specific social conditions and the meanings they put into circulation. The term *inter-textuality* forces analysis to move continually between the text and the social conditions that frame its consumption, and limits textual interpretations to specific historical locations. The career of James Bond spans more than four decades, and his meanings have been produced by quite different social and textual determinants at any one point. James Bond, within one set of inter-textual relations, is an aristocratic, traditional British hero who celebrates the imperial virtues of breeding, taste and authority; and within another set of inter-textual relations, the *same* books are read as producing a figure who is modern, iconoclastic, a living critique of an outmoded class system and whose politics are those of Western capitalism, not

merely of Britain. The inter-textual relations examined and exposed at any specific historical point are seen to exert some force on the reader and on the text, producing what Bennett and Woollacott call 'reading formations':

> By 'reading formations' here, we have in mind ... those specific determinations which bear upon, mould and configure the relations between texts and readers in determinate conditions of reading. It refers, specifically, to the inter-textual relations which prevail in a particular context, thereby activating a given body of texts by ordering the relations between them in a specific way such that their reading is always already cued in specific directions that are not given by those 'texts themselves' as entities separable from such relations.
>
> (Bennett and Woollacott 1988: 64)

This is not to suggest that texts are absolutely relative and bear no determining characteristics at all, but to emphasize the fact that texts do not simply contain set meanings they will generate willy-nilly, no matter what the conditions of their reception. Even relatively stable textual properties, such as genre, can be seen as 'cultural and variable' rather than 'textual and fixed' (p. 81). The authors demonstrate this by insisting on the temporal variation of dominant readings of the Bond texts, by examining the shifts in the ideological significance James Bond carries at specific points in the figure's history. 'Textual shifters' allow us to chart the ways in which certain aspects of the figure are foregrounded in one ideological context and other aspects in another context, as 'pieces of play within different regions of ideological contestation, capable of being moved around differently within them' (p. 234).

One such 'shift', for instance, is the representation of Bond's girlfriends, the varying sexual and power relations constructed between Bond and the girls over time and across texts. Similar is the shift in the depiction of the villains from, at one time, Cold War fanatics to, at another time, rapacious criminal masterminds. This is difficult stuff, so it might be best to quote a brief section of the account of the 'textual shifters' and their effect on the ideological significance of Bond. Below, Bennett and Woollacott summarize the ideological effect of the different readings of James Bond outlined in the preceding paragraph's explanation of inter-textuality. They are examining the distinction between the Bond of the late 1950s and that of the mid-1960s; between an earlier Bond who signified traditional, autocratic Britain, nostalgic for its imperial past, and the later Bond who was the epitome of the modern, classless, swinging, 'pop' Britain – the version ultimately to be confirmed with Sean Connery's casting in the first generation of Bond films:

Whilst, initially, Bond had supplied a point of fictional reference in relation to which an imperialist sense of nation and nationhood could be symbolically refurbished, he was now made to point in the opposite direction – towards the future rather than the past. Functioning as a figure of modernisation, he became the very model of the tough, abrasive professional that was allegedly destined to lead Britain into the modern, no illusions, no-holds-barred post-imperialist age, a hero of rupture rather than of tradition.

(Bennett and Woollacott 1988: 239)

Such judgements go beyond the demonstration of a simple difference of interpretation in different contexts; the work of the 'textual shifters' does not merely produce different readings of the 'same text' but, rather, acts 'upon the text, shifting its very signifying potential so that it is no longer what it once was, because, in terms of its cultural location, it is no longer where it once was' (p. 248). It is a different text.

Often even those accounts of audiences that acknowledge the audience's freedom to read texts in their own way still read the text first and then ask the audience for their, possibly variant, readings. The codes of the text are examined first to establish '*what it is* that is variantly decoded' (p. 261). In such cases (and we shall meet some examples in the following chapter) the authority of the text over its readings is implicitly accepted. Bennett and Woollacott argue that this is illogical; a text cannot have an entirely abstract meaning that is independent of what the (a) reader makes of it. Texts and readers generate their meanings in relation to each other and within specific contexts:

The relations between texts and readers, we have suggested, are always profoundly mediated by the discursive and inter-textual determinations which, operating on both, structure the domain of their encounter so as to produce, always in specific and variable forms, texts and readers as the mutual supports of one another.

(Bennett and Woollacott 1988: 249)

Bennett and Woollacott argue for a more genuine balance: for the recognition that texts, readers and readings are culturally produced and that one should examine their formation as a complex set of negotiations and interrelations. The competition between text and context is reformulated, not reducing the text to its context or redefining the idea of context itself, but rather proposing that 'neither text nor context are conceivable as entities separable from one another' (p. 262). Currently, and in principle, there seems little to argue with here; as aspects of

Bennett and Woollacott's own book demonstrate, the problem remains one of practice, of actually carrying out such a programme.

This is a problem because, while we might all theoretically accept the contingency of the text, in practice we all tend to see *certain* readings as inextricably bound into specific texts. We might argue for a multitude of possibilities, but this does not mean that, as Bennett and Woollacott say, 'all readings have the same cultural weight, or that any old reading can come along, parachute itself into the arena of readings and secure a space for itself'. Their view is that there are usually historical (that is, extratextual) reasons why the 'readings of a text cluster around a set of limited options' (p. 267). However, the nomination of those historical reasons for the Bond texts has occupied a book, and to explore fully the 'limits' to the range of options available would take many others. Thus it is hard to imagine a means of testing this proposition. Further, and for only one example of competing arguments, studies of narrative reveal remarkable structural similarities in texts from a range of periods and cultures. There is at least a suggestion that these structures exert a determinate force on their readers. So, we are still left with the thorny problem of the nature of critical practice. Texts are potentially both open and closed, their readings and their textual forms are produced and determined by wider cultural and ideological factors; yet we can talk, as do Bennett and Woollacott, of the dominant construction of Bond (say) in the 1960s, as if these limits are available and can be specified. We know that as soon as we specify them we can be accused of trying to fix a singular meaning, or we can be challenged on just whose meaning we propose.

Decentring the text

One strategic response to this problem is to decentre the text altogether, using it only as a resource through which one might examine other aspects of social life. Richard Johnson (1983) talks of a CCCS study of the media's representation of the first 'post-Falklands' Christmas in Britain in 1982. This study was 'premised on the belief that context is crucial in the production of meaning', and used texts as a means of examining the construction of a holiday period during a specific historical moment. In this example, texts were not studied for themselves, but 'for the subjective or cultural forms' they 'realised' and made available (p. 35). In Johnson's case, the subjectivities constructed through such forms are of primary interest. The texts still needed to be 'read', however, and dominant meanings proposed. Stuart Laing also offers the representational history of a period through the survey of texts in *Representations of Working-Class Life 1959–64* (1986). Here, the analysis of literary, television, stage and film texts is combined with intellectual and social histories to produce an account of the popular

construction of the working class during these years. In many ways a model for a new kind of cultural analysis at the time it was published, Laing's book still has the problem of opting for one dominant reading of the texts he consults.

Notwithstanding these difficulties, such studies adopt an approach to the text that usefully exploits the theoretical shifts we have been describing; they reject the Leavisite notion of the unique, unified text; they acknowledge the historical determinations of texts' meanings for their audiences; and they are sceptical about the authority of the readings produced by the critic/analyst. They prefigure what has become a more common tactic in recent years as the influence of post-modernism has grown: readings of the multiplicity and heterogeneity of meanings released by textual forms. Postmodernism has been less influential in the British cultural studies tradition than in, say, the American, and I will return to it in Chapter 6. Here, suffice to say that it has encouraged the return to a new formalism in textual analysis which, on the one hand, implicitly privileges the protocols of textual analysis as if their performances were an end in themselves and, on the other hand, provisionalizes the readings produced by these perform-ances. Hall (1990: 22), among others, has regretted the proliferation of discoveries of playfulness and pluralism in popular texts; one can see how such work would run against the grain of the original interest in texts and contexts I have outlined in Hall's own work. Postmodernism, however, particularly through its use of the idea of discourse, has also challenged cultural studies to think about texts in new ways. The broad appropriations of Foucault's connection between discourse and power have explored the potential for new kinds of textual analysis.

By some writers, this connection is used simply to move from analysing 'texts' to analysing 'practices' (Jordan and Weedon 1995: 11), itself a reorientation away from studying the 'production of meaning' towards understanding the 'social distribution of power'. Others suggest that Foucault's insights enable us to turn large, otherwise intractable, sets of cultural-industrial discourses and practices into texts: the discursive regimes of fashion, for instance. Elizabeth Wilson (1994) has framed her discussion of fashion 'within the proliferation of discursive and social practices that centre on the human body'. Drawing on Foucault's argu-ment that 'modernity inaugurates a multitude of practices which act on the body – to discipline it, to make it more apt, ... to alter and adapt it to the modern world' (pp. 408–9), Wilson goes on to suggest that this 'discursive universe' does not repress but, rather, 'actively produces' the modern body: 'drilling, eurythmics, aerobics – and of course fashion and beauty culture – may all be seen as part of this disciplinary mode, and, like dieting, exercise and dance, they have become integral to twentieth-century life' (p. 409). Given such a position, the practices of aerobics, their legitimating fashion-discourses, and their material effect upon the body and behaviour become texts, available for cultural analysis and critique.

TEXTUAL EVENTS

Cultural studies' interest in texts has been among the attributes its critics – particularly those from within history and sociology – have most attacked. As noted above, the 'textualising' of social relations has extended the purchase of the category of the 'text'. Consequently, this trend has provoked extremely sceptical responses from other disciplines with different definitions of what might constitute acceptable evidence of social processes. Textual analysis inevitably focuses on the point of consumption rather than of production. This, too, has left cultural studies open to criticisms that it has a blind spot in relation to political economy, to an informed analysis of the conditions of production of the texts it goes on to inspect (Murdock 1989; Harris 1992; McGuigan 1992). In one notorious example, a collection of essays aimed at highlighting these perceived weaknesses in cultural studies, *Cultural Studies in Question* (Ferguson and Golding 1997), was attacked in print by two of its own contributors (McRobbie 1999; Morley 1998) as constituting an unfair and outdated misrepresentation of the state of the field. Morley's primary point was that the criticisms mounted in Ferguson and Golding's introduction ignored the continual process of critique and elaboration which has shaped cultural studies' thinking on texts and contexts over the last twenty years. Certainly, the movements I have been describing in this chapter do seem – despite the occasional formalist revisionism – gradually to have become more sceptical about the authority of textual analysis in that they consistently question the status of the readings it produces. While certainly not amounting to a realignment with political economy, these are movements which have interested themselves in (for instance) the audience more than the text for much of the last decade. It is to this aspect – cultural studies' engagement with the audience – that I will turn in the following chapter. Before I do, however, I wish to deal briefly with a discussion of textual analysis from Nick Couldry's *Inside Culture* (2000). Couldry's discussion is one of relatively few recent attempts to return to textual analysis in order to re-evaluate its usefulness as a methodology.

Couldry responds to some of the claims for the expansion of the notion of the text outlined above, and its part in the construction of the 'popular reality' described in John Hartley's work (1996), by insisting that we ask 'what is a text, considered as a social object?' (Couldry 2000: 80). What Couldry learns from such work as Hartley's is that, in order to do this, textual analysis must be 'transformed to take account of the actual complexity of textual production' (p. 86). Rather than focusing on the discrete 'text–reader' relationship, Couldry proposes that we analyse what he calls the 'textual environment'; composed of meanings, texts and readers, the textual environment is constituted by a pattern of 'flows' rather than objects and consumers. Because we make things into texts by the way we read or consume them, Couldry wants to investigate the process of textualiza-

tion – 'how particular complexes of meanings come to be treated as texts to be read, within the textual environment' (pp. 81–2). Such a process, he argues, involves complex 'extra-textual conditions', which include something like the Bennett and Woollacott idea of the reading formation. We need to know more, though, about how people actually negotiate this textual environment:

> People's negotiations involve active processes. We may screen some material out entirely, and make a more explicit and considered choice about other material. Some texts we may read closely, working hard to connect them with other texts. Or we may read a text with limited attention, incompletely, without any great interpretative work. This is where questions of 'textuality' and 'tactics' come in. ... There are also passive processes, which affect what texts are available to particular people. These range from material exclusions (economic, educational), to other more subtle forms of exclusion (like people's sense of what is 'appropriate' for them, for their 'taste') which by endless repetition come to have an almost material force (compare Bourdieu, 1984).
>
> (Couldry 2000: 84)

As a result of such variations, those texts that do attract close attention 'are not simply there' as discrete objects: rather, they emerge as part of a 'textual event' which itself needs to be studied (p. 86). To read texts in this way, Couldry says, 'is to have decentred textual analysis in the traditional sense' (p. 87). Indeed, what Couldry suggests is along the lines implied, but not as fully developed, in Hartley's work (1996, 1999): a multitextual, multimedia reading practice which would include the features of the text, the historical 'reading formation', the marketing and production strategies, and the discourses circulating about the text and its themes. Clearly, this looks much more like a thoroughly 'cultural' (rather than 'aesthetic' or 'semiotic') account of the text, and one that offers significant methodological possibilities for future work.

Couldry concludes his discussion of textual analysis a little provocatively by pointing out that there is another factor in determining the textual event which is not largely acknowledged:

> there must somewhere come a point where our questioning of the text stops and we recognise that particular texts *do* exercise power over us, and for reasons that sociological 'context' can only partly explain. We take pleasure in programmes, in films, in novels, music and dance, and these pleasures, while embedded in 'history' ... contain something left over which sociology on its own has difficulty explaining: the realm of *aesthetics*.
>
> (Couldry 2000: 86–7)

Of course, sociology is not the only one to have difficulty explaining aesthetics. Cultural studies' displacement of the aesthetic and of issues of cultural value has become notorious and remains unresolved. This is particularly the case in discussions of television. For many years cultural studies-inflected accounts of television have quarantined the notion of 'quality' – setting it aside from consideration in order to maintain the principled break with elite traditions of popular culture analysis. Some now argue that to set aside such a significant factor in understanding the meanings and pleasures of television – the operation of notions of quality, no matter how contingent or informal they might be – can only be a temporary strategy. Sooner or later, it is argued from within both television and cultural studies (see Brunsdon 1990, 1997; Frow 1995), this nettle has to be grasped. How that might be integrated into a mode of cultural studies textual analysis is yet to emerge, although there are recent ventures in that direction which suggest how it might be done and, on the other hand, how contentious the issue remains (see, for instance, Jacobs 2001).

Given the complexity of the history of textual analysis within cultural studies, the distance it has travelled from its roots in literary studies (indeed, the distance it has helped literary studies to travel!) and the genuine theoretical problems, we can imagine how liberating it must have been to turn to the audience and inquire into how *they* read their texts. At a stroke the presumption of the critic could be displaced, or at least deferred. The sense of security that empiricist reporting, rather than interpretive argument, engenders must have come as a relief, too. Yet, audience studies are more than a scientific cul-de-sac away from the mainstream of cultural studies. Over the second half of the 1980s they became the major influence on the theory and practice of cultural studies. In the following chapter I will look at the growth in studies of the audience within cultural studies, focusing in particular on the work of Morley and Hobson.

Audiences

MORLEY AND THE *NATIONWIDE* AUDIENCE

One consequence of cultural studies' concentration on textual analysis from the early 1970s onwards was the deflection of attention away from the sites at which textual meaning was generated – people's everyday lives. Paradoxically, the stuff of these lives lay at the heart of the enterprise of cultural studies, and yet the progressive concentration on the text distanced cultural studies from this initial interest. An additional worrying by-product of textual analysis was the elitism implicit in its de facto privileging of the academic reader of texts. It could be argued that the development of its own tradition of audience studies challenged such elitism and reconnected cultural studies research with the lives it most wished to understand.

'Audience studies' within cultural studies have been predominantly studies of *television* audiences, and that will be the focus of this chapter too. David Morley's *The 'Nationwide' Audience* (1980a) is our starting point. Widely discussed and criticized – even by Morley himself in a subsequent book, *Family Television* (1986) – *The 'Nationwide' Audience* has exerted a significant influence over the approach taken to audiences since its publication. This is a testament not so much to the success of its initial objective (testing out the Hall/Parkin encoding/decoding model) as to its categoric demonstration of the complex polysemy of the television text and the importance of *extratextual* determinants of textual meaning.

Morley's book builds on his (and Charlotte Brunsdon's) earlier analysis of *Nationwide*, referred to in the previous chapter. Brunsdon and Morley (1978)

focused on the way the programme structured its relationship with the viewer and reproduced a particular version of 'common sense' in its account of the world. The authors took for granted the audience's predisposition to accept the dominant or preferred meaning, and concentrated on locating the textual strategies they saw as reinforcing this predisposition (I noted some of these in Chapter 3). While *The 'Nationwide' Audience* is informed by similar assumptions, its primary objective is quite different: it tracks down the *variations* in specific audiences' decodings of the same *Nationwide* programme.

Morley is clearly aware of the criticisms of Hall's original encoding/decoding model (1980c). Its inference that different readings might be the product of audience members' different class positions had proved to be particularly contentious. Nevertheless, *The 'Nationwide' Audience* is aimed at examining what Morley characterizes as the 'close' relation between the audience members' specific interpretation of the television message and their social (that is, not merely class) position: the ways in which 'individual readings will be framed by shared cultural formations and practices preexistent to the individual' (p. 15). Such a view may resist the idea of a 'mass', undifferentiated audience, but it also resists the temptation to individuate each audience member completely. Audiences are not passive consumers of the television message, but their reading positions are at least partially socially determined. This point of balance between autonomy and determination is still the orthodox one, and this may largely be due to Morley's effective demonstration of its validity in this study. Less widely shared is his more particular goal, that of tracing the 'shared orientations' of individual readers to specific factors 'derived from the objective position of the individual reader in the class structure' (p. 15). It is not surprising that Morley fails to achieve this goal in *The 'Nationwide' Audience*; many would hold that the 'specific factors' (class, occupation, locality, ethnicity, family structure, educational background, access to varied forms of mass communication and so on) are so many and so interrelated that even the attempt to make definitive empirical connections is a waste of time.

A more fruitful proposition, advanced in Morley's introductory chapters and more extensively developed in his conclusion, foregrounds the role of discourse in constituting and differentiating individual readings. Morley argues that readers decode texts through the available and relevant discourses:

> The meaning of the text will be constructed differently according to the discourses (knowledge, prejudices, resistances etc.) brought to bear upon the text by the reader and the crucial factor in the encounter of audience/subject and text will be the range of discourses at the disposal of the audience.
>
> (Morley 1980a: 18)

This raises a question that may in fact be appropriate for empirical research, the unequal distribution of 'cultural competencies'; that is, the way cultural apparatuses such as the education system regulate people's access to knowledge, to ways of thinking – discourses. An individual's particular mode of access will allow him or her more or less choice, and specific *kinds* of choices. Individuals will be 'culturally competent' in a more or less restricted/elaborated range of discourses. The work of Pierre Bourdieu in France has produced important evidence of the workings of such mechanisms there, but it has not yet been replicated in other countries (see, for example, Bourdieu and Passeron 1977; Bourdieu 1984).

This is not a question *The 'Nationwide' Audience* follows through, however. For this book Morley examined the production of textual meaning by showing an episode of *Nationwide* (already 'processed' by the researcher) to twenty-six different groups of viewers. Each group was then asked about its response to the programme, initially through relatively 'open' questions, which became more 'focused' and direct as the interviews developed. Groups were used rather than individuals in order 'to discover how interpretations were collectively constructed through talk and the interchange between respondents in the group situation' (p. 33). While there were quite significant variations *among* groups, there was little disagreement *within* groups as to their view of the programme. The composition of the groups did not constitute a representative cross-section of the community; all participants were part- or full-time students. Nevertheless, the range of occupation among these students was wide: they included trade union organizers, university arts students, schoolboys, apprentices to trades, bank managers, teacher training students and print managers. The racial mix ranged from totally white groups through mixed-race groups to totally black groups. Morley notes each group's dominant party-political orientation, class background, gender and ethnicity, and then summarizes their responses – occasionally quoting verbatim, occasionally reporting 'objectively' and occasionally actively constructing an interpretation of what was being said.

The results are interesting. Some groups, particularly the predominantly black ones, found the programme utterly irrelevant, would never have watched it voluntarily and expressed impatience at the whole exercise. Others participated very actively in the experience but produced readings that were internally contradictory and actually rejected what one might have thought were the interests of their own class. One such group of white male union officials with working-class backgrounds and Labour (left of centre) political orientations found itself largely in sympathy with the dominant reading position, which was, according to Morley's account, socially conservative and slightly antipathetic to left-wing politics. The group's acceptance of this position was not thoroughgoing, however; at one point in the programme's discussion of government economic policy the group

members vigorously rejected what they saw as the dominant position. Morley seizes on this 'rejection of a *particular* position within an overall acceptance of the *Nationwide* framework' as 'a classic' example of the Hall/Parkin negotiated code (p. 103).

By the end of the exercise apprentice groups, schoolboys and bank managers were aligned with each other as those groups that most readily reproduced what Morley had categorized as the dominant decodings. Clearly there could be no simple correlation between their readings and their occupational groups, or between their readings and their classes. Morley concludes that social position 'in no way directly correlates' (p. 137) with the readings he has collected, although he does argue for a formula that links social position *plus* the possession of certain 'discourse positions' (p. 134). Morley's study demonstrates that it is not possible to tie differential readings to gross social and class determinants, such as the audience's occupation group. The polysemy of the message is a product of forces more complex and subtle than these, and Morley admits this. In his closing sections Morley presents an exemplary account of the problems of textuality dealt with in Chapter 3 of this volume, which argues that, while texts can be appropriated by readers in different ways and cannot be said to 'determine the reader', interpretations are not 'arbitrary': they 'are subject to constraints contained within the text itself' (pp. 148–9).

Critics have attacked the methods Morley used in this study.[1] First of all, Morley's own admission of the minimal variations *within* each group's reading should make us question these readings. It is likely that a consensualizing process was engendered by the grouping itself, so the experiment may well have been measuring *that* process, not the normal process of the individual decoding television texts in the family living room. The interviewer may also have reinforced any consensualizing process or otherwise exercised an influence over the responses. It is highly probable that the mechanisms of the research project would themselves have consequences. Certainly, the screening of a programme such as *Nationwide* outside its normal context of consumption – the home, in the early evening – changes its nature. The adoption of this strategy removed one crucial element from the relationship between a television programme and its audience: the choice made to watch it in the first place. Morley was showing *Nationwide* to arbitrarily selected groups of people, some of whom would never have watched it otherwise and cared little about watching it then. Once produced, the audience responses to the programme were treated inconsistently; some were interpreted and reworked by the researcher, while others were taken at face value. Unfortunately, the audience comments needed themselves to be treated as texts, and subjected to more sophisticated analysis than they received. And, finally, as Morley himself concedes in *Family Television* (1986: 40–4), he was the victim of

crude assumptions about the kinds of relationships he might expect to reveal between the meanings generated and their roots in 'deep' social structures such as class. However, and despite all this, *The 'Nationwide' Audience* is an important book because it provides us with empirical evidence that the polysemy of the television text is not just a theoretical abstraction, but an active, verifiable and determinate characteristic. Morley's continuing body of work has greatly advanced our understanding of the social dimension of television discourses, and we will return to it later in this chapter.

WATCHING WITH THE AUDIENCE: DOROTHY HOBSON AND *CROSSROADS*

The 'Nationwide' Audience is a map of the contributing streams to cultural studies at the time it was written; it is determined to 'slay the father' of American communication models and 'effects' studies; it is heavily influenced by the CCCS/Hall arguments on the nature of texts, readers and subjects; it marks the point where the encoding/decoding model starts to break down; and it employs elements of the so-called ethnographic approach to audiences and to subcultures that was being developed in the CCCS during the 1970s. Its appropriation of ethnographic methods is anything but thorough, however.

Ethnography is a term used to describe a tradition of work in sociology and anthropology that provides techniques for researchers to enter another culture, participate in it and observe it, and then describe the ways in which it makes sense for those within it. A tall order, it contains all kinds of problems for the researcher, who must be sympathetic enough to understand the culture's meaning systems and yet objective enough not to be submerged by them. Stuart Laing (1986: ch. 2) has described how partcipant–observer accounts of working-class urban cultures became a popular genre in British publishing during the 1950s and 1960s; the work of Phil Cohen and Paul Willis provided the basis for the CCCS ethnographies of urban subcultures in the 1970s.[2] Compared to such research, however, there is actually little that is ethnographic about Morley's method, other than his use of focus interviews with audiences and his attempt to relate their readings of texts to their cultural backgrounds. His strategies of description are still the product of a shotgun wedding between the empirical scientist and the semiotician. Morley's book is, however, among the earlier attempts to appropriate ethnographic methods for a cultural studies approach to audiences. The theoretical and methodological problems this raised will come up again later in this chapter, but I will turn now to the next important moment in the development of this tradition in cultural studies, the publication of Dorothy Hobson's *Crossroads: The Drama of a Soap Opera* in 1982.

Hobson's early work provides some indication of the benefits these methods can produce. In her discussion of housewives and the mass media (primarily radio, in the extract published in *Culture, Media, Language*), she quotes extensively from interviews with women, and uses these quotations as texts to be interrogated, evidence to be understood (Hobson 1980). The *Crossroads* book, however, is more substantial than this. *Crossroads* was an early evening soap opera set in a motel in the Midlands, and shown in Britain on a commercial channel, not the BBC; it had a regional flavour, with its production company and the bulk of its audience in the Midlands and the North of England. It was widely acknowledged as the nadir of technical quality in British television drama, and was the object of warnings from Britain's regulatory authorities about its low standards on a number of occasions. (At the time, the regulatory climate in Britain was extremely interventionist; technical and aesthetic standards could be vigorously policed by statutory industry bodies.) Hobson's book on *Crossroads* is often discussed as if it is a study of the programme's audience, but it is important to realize this is only one part of the project. *Crossroads: The Drama of a Soap Opera* was researched at the time when a central character, played by Noele Gordon, was being written out of the programme for what seemed to many of its viewers spurious reasons. Since the soap was seen as irretrievably down-market, many 'discriminating' viewers could not have cared less about the damage this decision would inflict on *Crossroads*. But to the regular (and, presumably, 'undiscriminating') viewer it was an appalling development. Audience reaction was intense, and public pressure on the television production company was severe. Hobson's book exploits this as a moment when the relations among producers, programmers, performers, programmes and audiences were unusually clearly exposed, when the structures that connected them were showing signs of strain, and thus when an observer might learn rather more than usual.

The book begins with a discussion of TV soaps and their history, and then moves into a closely observed study of the production of *Crossroads* itself. Hobson attended production meetings, rehearsals and taping sessions, and talked to those involved about what she observed. She outlines the nature and effects of production schedules (once one learns of the speed at which episodes are taped one can understand why the set looks as if it is lit by two fluorescent tubes); and she reveals how those working in the programme sustain pride in their professionalism despite the punishing schedule of production. Her approach is sympathetic, but she does not hesitate to draw conclusions about the consequences of the practices and ideologies she observes. It is an eminently readable book: theoretically informed but relatively simply expressed. As a result, *Crossroads: The Drama of a Soap Opera* provides an exemplary account of how the culture industries work, through its examination of the articulation among

the broadcasting institutions, the production company, the programme-makers and the audience.

Hobson's discussion of the last of these elements, the audience, is my focus here. The key strategic difference between her approach and that of David Morley in *The 'Nationwide' Audience* is that instead of bringing audiences into *her* academic researcher's world, she goes into *theirs*. She watches television with her audience subjects, in their own homes, at the normal time. Her research data come from interviews and observations made while watching episodes and from the 'long, unstructured conversations' she had with her subjects after the programmes finished. She stresses that these interviews were 'unstructured' for a reason:

> I wanted viewers to determine what was interesting or what they noticed, or liked, or disliked, about the program and specifically about the episodes which we had watched. I hoped that they would indicate the reasons for the popularity of the program and also areas where they may have been critical.
>
> (Hobson 1982: 105)

Like Morley, she was convinced that audiences 'work on' television texts to change their specific meanings. But she was not as interested in the process of decoding as she was in assessing the effectiveness of the professional practices of encoding. Hobson's study of production practices, and of the strategic/narrative decisions made in the script and the performance of the episodes, provided her with an idea of what the producers of the programme expected of their audience. Her evenings spent watching (the programmes she had seen taped) with their eventual audience were intended to enable her to check how closely the assumptions behind the encoding were accepted by the audiences. It turned out not to be as simple as that. She found that while she may have wanted to talk about individual episodes, her subjects' conversation quickly moved to 'the programme in general':

> It became clear through the process of the study that the audience do not watch programs as separate or individual items, nor even as types of programs, but rather that they build up an understanding of themes over a much wider range of programs and length of time of viewing.
>
> (Hobson 1982: 107)

The critic's isolation of the individual television text, then, may misunderstand this mode of television consumption. Hobson also discovered the importance of the specific context within which the family would view the programme:

One of the interesting aspects of watching television *with* the audience is to be part of the atmosphere of watching a program with families and to see that the viewing situation is very different for different people. To watch a program at meal time with the mother of young children is an entirely different experience from watching with a seventy-two-year-old widow whose day is largely structured around television programs. Family situations change both the ability to view with any form of concentration and also the perspective which the audience have on a program.

<div align="right">(Hobson 1982: 111)</div>

In this, as in her previous study, Hobson quotes extensively from her subjects, enriching the work with ethnographic details that make the book rewarding and lively. Clearly, the method of watching with the audience and talking at length with them about the programme revealed far more than the more formal and artificial methods used in Morley's book. The method has been used quite widely since and to great effect by, among others, John Tulloch.[3]

As Hobson gained an understanding of her audiences' relation to the programmes she became progressively critical of the attitudes of the authorities who regulated television in Britain at the time (and who insisted that *Crossroads* improve its technical standards if it was to continue on the air), and of the production company itself (the members of which seemed to feel, paradoxically, a greater degree of respect for their programme than for its audience). Consequently, Hobson becomes increasingly polemical as the book proceeds, arguing that viewers' concern about proposed changes in the series should have been taken more seriously by its producers. She knew, better than the producers, how important the programme was to some of its viewers, and had talked to enough of these viewers to know that common-sense explanations of soap operas as 'escapism' or 'fantasy' were too simplistic. The way in which soaps are interwoven into everyday life is so admirably demonstrated in a 'digressive' anecdote from the book that I wish to quote it at length:

I once sat on a train returning from London to Birmingham when British Rail were running their £1.00 tickets during the winter of 1980. Four pensioners sat at a table next to me, complete with their sandwiches and flasks of coffee, and they talked together about many topics of mutual interest. The conversation moved to exchanges about their respective children and grandchildren and names were mentioned. Suddenly, without comment one of the women said, 'What about Emily's trouble with Arthur, what do you think about it all?' (This is not remembered verbatim.) The conversation continued about the mess that Emily was in now that it had

been found out that he was already married, and how it had seemed too good to be true for her to have found someone like him. How would she be, and how would it all end? As swiftly as the topic had arisen, it had switched back to talking about other topics. The uninitiated or 'culturally deprived' would be forgiven for not realizing that the troubles of poor Emily and the misery which Arthur had brought to her were not the problems of the children or relatives of two of the speakers. However, anyone who was aware of the current storyline of the soap opera *Coronation Street* would have known instantly that it was the fate of the fictional characters which were [sic] being discussed. Yet from the conversation it was obvious that the speakers were playing a game with the serial. They did not actually believe that the characters existed; they were simply sharing a fantastic interest in the characters outside the serial. How many of us can honestly admit not to having done that ourselves? How many were not saddened at the fate of the 'beautiful young Sebastian' as he visibly declined before our eyes in *Brideshead Revisited* during this winter? It is a false critical elitism to allow the 'belief' and enjoyment in a fictional character in one program and deny others the right to that belief or enjoyment in another.

(Hobson 1982: 125)

Who owns the programme?

Hobson argues strongly for a recognition of the way texts are appropriated by their audiences. Even silly or fantastic stories may connect with a viewer's own life and enrich it: 'Stories which seem almost too fantastic for an everyday serial are transformed through a sympathetic audience reading whereby they strip the storyline to the idea behind it and construct an understanding on the skeleton that is left' (p. 136). The assumption that the audience for such programmes is culturally impoverished, mere passive consumers, she sees as simply elitist:

> To look at a program like *Crossroads* and criticize it on the basis of conventional literary/media analysis is obstinately to refuse to understand the relationship it has with its audience. A television program is a three part development – the production process, the program, and the understanding of that program by the audience or consumer – and it is false and elitist criticism to ignore what any member of the audience thinks or feels about a program.

(Hobson 1982: 136)

Indeed, she is driven to ask, 'whose program is it anyway?', the title of her penultimate chapter. The ensuing argument about who 'owns' the plot of *Crossroads*

and who should decide if a character is to be eliminated suggests that television producers should be held to have social as well as commercial responsibilities. 'Television companies play a contradictory game with their viewers', Hobson says, 'by creating an illusion of possession'. Can they blame the viewers, she goes on to ask, 'for believing that the television company and the programs have something to do with them?' (p. 153). Hobson argues that audiences have 'ownership' rights because of the place the programme fills in their lives. In particular, she focuses on the uses made of the programme by pensioners and the elderly generally, to show how their pleasures are dismissed and denigrated even by those who provide them. The importance of television to the elderly is directly related to the failure of society to provide other kinds of personal contact; as Hobson says, 'There *is* something wrong in the lives of many people and the reassurances which they derive from fictional programs should not be underestimated' (pp. 148–9).

Her conclusion is, again, polemical in its attack on elitist modes of television criticism. Possibly, the force of the book's advocacy has enabled some to take it less seriously as a research project than it deserves (see McGuigan 1992: 144). Also, one suspects, her untheoretical vocabulary made the book a little unfashionable at the time – as were the objects of her crusade, elderly and female soap audiences. Certainly, while it is often cited, *Crossroads: The Drama of a Soap Opera* is not as widely discussed as Morley's *Nationwide* book. But Hobson can claim to have richly clarified the relations between television and its audience:

> Communication is by no means a one-way process and the contribution which the audience makes to *Crossroads* is as important as the messages which the program-makers put into the program. In this sense, what the *Crossroads* audience has revealed is that there can be as many interpretations of the program as the individual viewers bring to it. There is no overall intrinsic message or meaning in the work, but it comes alive and communicates when the viewers add their own interpretations of a program. In criticising the program, those who attack it have missed out on the vital aspect of the appeal of the program to the viewers. It is criticised for its technical or script inadequacies, without seeing that its greatest strength is in its stories and connections with its audience's own experiences.
>
> (Hobson 1982: 170)

One would not want to accept such an unqualified claim for the power of the audience over the text (and ideology, for that matter) without argument. However, in such a claim we can see the trunk supporting a number of branches of contemporary cultural studies: the accent on the specific pleasures of the audience that leads to the populism in John Fiske's work, and the concentration on

precisely what viewers *do* with a programme that motivates Ien Ang's (1985) study of *Dallas*, Janice Radway's (1987) study of feminine romance fiction, David Buckingham's (1987) study of *EastEnders*, John Tulloch and Albert Moran's study of *A Country Practice* (1986), Bob Hodge and David Tripp's (1986) study of children and television, and Marie Gillespie's (1989 and 1995) study of the uses of video among South Asian families in West London. Hobson's influence may not have been direct in all of the above instances, but it has been profound, not only in her revelation of the gaps in our understanding of the ways in which popular texts and audiences are related, but in her demonstration of the power of a method of research.

WIDENING THE FRAME: TV IN THE HOME

David Morley's *Family Television: Cultural Power and Domestic Leisure*, published in 1986, clearly benefits from Hobson's work in its choice of research methods and in its focus on the gender relations within the family as they affect the watching of television. Morley explicitly acknowledges his debt to Hobson and those who followed her, such as Radway (1987) and Modleski (1984). This is a very different project from that of *The 'Nationwide' Audience*. The earlier book was still interested in the ways in which audiences understood texts; the text was the central, if implicit, object of study. *Family Television* is interested in the social processes within which television viewing is enclosed; Morley's central thesis is 'that the changing patterns of television viewing could only be understood in the overall context of family leisure activity' (p. 13). After Hobson, television viewing was seen as more of a social, even a collective, activity, fully absorbed into everyday routines. Accordingly, Morley shifts his interest from the text to 'the domestic viewing context itself – as the framework within which "readings" of programs are (ordinarily) made' (p. 14). As a result the 'unit of consumption' is no longer the individual viewer; it is the family or household. Further, rather than assuming that television viewing somehow supplants family functions, Morley's study reveals how television is adapted to 'families' economic and cultural (or psychological) needs' (p. 21). Finally, as Stuart Hall says in his introduction to the book, Morley brings together 'two lines of critical enquiry which have tended to be kept in strict isolation – questions of interpretation and questions of use' (p. 9).

Clearly, any investigation into the uses of television within the family must involve some interrogation of the power structure within the family. Inevitably, this will foreground questions of gender and the asymmetrical distribution of power within the (average) family. Morley alerts us to this possibility before outlining procedure, and gender differences are a major element in the ethnographic accounts that follow.

The study is aimed at detailing the 'changing uses of television', in different types of families, from different social positions. The focus is on the following issues:

a) the increasingly varied uses of the household television set(s) – for receiving broadcast television, video games, teletext, etc.;
b) patterns of differential 'commitment' and response to particular types of programming;
c) the dynamics of television use within the family: how viewing choices are expressed and negotiated within the family; the differential power of particular family members in relation to viewing choices at different times of the day; the ways in which television material is discussed within the family;
d) the relations between television watching and other dimensions of family life: television as a source of information on leisure choices; leisure interests and work obligations (both inside and outside the home) as determinants of viewing choices.

(Morley 1986: 50)

Eighteen families were interviewed in their own homes – first the parents, then the whole family together. Interviews were 'unstructured' (but limited to one and a half hours), and Morley accepts, largely, participants' own accounts of what they do. The families surveyed were white, working class to lower-middle class, and composed of two parents with two or more children. All owned video recorders. Morley admits this is by no means a representative sample, but he claims, legitimately enough, that it is certainly sufficient to provide a foundation upon which to base a more comprehensive study.

Morley is more 'ethnographic' in his reporting of this research than in *The 'Nationwide' Audience*; he provides fuller descriptions of the family members and their comments, although we still learn very little about each family's social situation or specific characteristics. The book does provide, however, rich evidence of the complexity of patterns of television use and of how deeply embedded this usage is in other social practices. It also provides some ripe examples of real eccentricity:

This man plans his viewing (and videotaping) with extreme care. At points he sounds almost like a classical utilitarian discussing the maximisation of his pleasure quotient, as he discusses the fine detail of his calculations as to what to watch, and what to tape, in what sequence:

'And like evening times, I look through the paper and I've got all my programs sorted out. I've got it on tonight on BBC because it's *Dallas* tonight and I do like *Dallas*, so ... I don't like *Wogan*, but We started to watch *EastEnders*, didn't we? And then they put *Emmerdale Farm* on, so we've gone for *Emmerdale Farm* 'cause I like that and we record *EastEnders* – so we don't have to miss out. I normally see it on a Sunday anyway. I got it all worked out to tape. I don't mark it [in the paper], but I register what's in there; like tonight, it's *Dallas*, then at 9pm it's *Widows* and then we've got *Brubaker* on until the news. So the tape's ready to go straight through. What's on at half seven? Oh, *This Is Your Life* and *Coronation Street*. *This Is Your Life* we have to record to watch *Dallas*. I think BBC is better to record, because it doesn't have the adverts. *This Is Your Life* we record because it's only half an hour, whereas *Dallas* is on for an hour, so you only use half an hour of tape.

'Yeah, Tuesday. If you're watching the other program it means you're going to have to cut it off halfway through, and I don't bother, so I watch the news at nine o'clock. ... Yes, 'cause there's a film at 9pm on Tuesday, so what I do, I record the film so I can watch *Miami Vice* and then watch the film later.'

The bottomless pit of this man's desire for programs to watch cannot be entirely fulfilled by broadcast television, and before he became unemployed they were renting a video film practically every night as well as watching broadcast television.

(Morley 1986: 70–1)

This man never goes out, and Morley perceptively observes that this seems to be related to his loss of employment; in going out, he experiences the loss of total power he has established in his home.

Power in the family

The issue of power within the family comes to dominate the book. Male dominance is clear in most of the families and takes the most bullying of forms: some men not only chose the programmes for the whole family and denigrated the choices of others, but also took possession of the remote control device when they left the room in order to stop anyone switching around the channels in their absence. Women rarely knew how to work the video recorder. Men liked to watch in total silence, while women and children found this oppressive; to resist this regime women tended to watch the black-and-white set in the kitchen, while the children retreated upstairs. Women had fewer moments of 'licensed' leisure, when

they were free to give the television their undivided attention; as Hobson found, many women are cooking meals or bathing children at the times when their favourite soaps are on and can watch their favourite shows only in brief bursts. Many women talked of the pleasure of being able to watch afternoon soaps free of this regime, although they also spoke guiltily of this, as if it were an indulgence of which they should be ashamed.

Morley found that gender was a 'structural principle working across all the families interviewed' (p. 146). It affected differences within the family over the control of viewing choices, amounts of viewing, the use of videos, 'solo' viewing and the guilt aroused by this pleasure, programme-type preferences, channel preferences, comedy preferences and a number of other variables. Morley is quick to point out, however, that what may appear to be a set of essential gender differences are in fact 'the effects of the particular social roles that these men and women occupy within the home' (p. 146). So, a woman who was the main breadwinner while her husband stayed home caring for the house and children exercised a degree of domestic power and demonstrated viewing preferences more like those of the males in the survey than those of other women.

However, Morley does argue that there are basic differences between the 'positioning of men and women within the domestic sphere' that are revealed by this study:

> The essential point here is that the dominant model of gender relations within this society (and certainly within that subsection of it represented in my sample) is one in which the home is primarily defined for men as a site of leisure – in distinction to the 'industrial time' of their employment outside the home – while the home is primarily defined for women as a sphere of work (whether or not they also work outside the home). This simply means that in investigating television viewing in the home one is by definition investigating something which men are better placed to do wholeheartedly, and women seem only to be able to do distractedly and guiltily, because of their continuing sense of their domestic responsibilities. Moreover, this differential position is given a greater significance as the home becomes increasingly defined as the 'proper' sphere of leisure, with the decline of public forms of entertainment and the growth of home-based leisure technologies such as video, etc.
>
> (Morley 1986: 147)

His last point is a worrying one: that despite the interrogation of stereotyped gender roles over the last two decades, an entirely new set of social practices now conspire against women's attempts to achieve more power within their domestic situations.

Morley's last chapter does not present a comprehensive summary of his results. Rather, it concentrates on the relationship between television and gender, the way in which the use and control of television in the home is overdetermined by the social construction of gender roles within the family. This concentration nevertheless allows him to discuss the full range of topics he set up at the beginning: programme choice, control of programme choice, use of the video recorder and so on. He stresses repeatedly that the patterns he observes are not essential to men and women but to the domestic roles they play, and to the wider construction of masculinity and femininity within the culture. He also admits that gender has assumed a more singular focus for the study than originally intended, and that this does leave out aspects (class and age, for instance) that may well have demanded closer attention (p. 174). Another factor more or less ignored in Morley's reporting of the interviews is education – both its content and the differential access to it: how that affects choices among television genres, forming opinions about what is 'good' and worthwhile television – and thus guilt about watching 'trivial' melodramas.

The end of the audience

As Fiske (1988) has noted, *Family Television* sees Morley move away from the encoding/decoding model of an audience 'preference' to the concept of 'relevance':

> The preferred reading theory still grants precedence to the text, although it allows the viewer considerable scope to negotiate with or oppose it according to his or her position in the social formation. *Preference* is a textual concept. *Relevance*, however, is a social one: the viewer makes meanings and pleasures from television that are relevant to his or her social allegiances at the moment of viewing; the criteria for relevance *precede* the viewing moment.
>
> (Morley 1986: 247)

Fiske goes on to argue that such a position destroys the category of the audience. One can see what he means. Morley's study directs us to those social forces that produce the audiences, effectively leading us away from the examination of texts and audiences and towards a more wide-ranging study of the practices and discourses of everyday life. In *Television, Audiences and Cultural Studies* (1992) Morley develops this position further, articulating it as an effect of two general shifts in the field: 'one concerning the decentring of television as the focus of interest ... and the other involving a broader consideration of the functions of such media in the construction of national and cultural identities within the

context of a postmodern geography of the media' (p. 1). While the influence of the postmodern will be taken up in Chapter 6, the general shift Morley describes is also visible in Fiske's recent work – particularly in his application of de Certeau's theories of popular resistance to analyses of American popular culture.[4] Ethnographic approaches almost inevitably resist restriction to a single arena of discursive contest – such as the audience's response to television. They generate a considerable compulsion to go beyond such a restriction: the conception of a television audience as *only* a television audience. Everyday life is more complex than that. Even John Tulloch's (1989) brief inquiry into his own family's varying responses to television texts generates a series of diverging and ever-widening social histories, refusing simple explanations for their responses, and pursuing the goal of the 'thick interpretation of cultures' (p. 200).[5] This 'thick' interpretation cannot be achieved through the methods employed by Morley or Hobson, but it is interestingly addressed by a much more recent study, Gauntlett and Hill's *TV Living* (1999), which we will deal with later on in this chapter.

TEXT AND AUDIENCE: BUCKINGHAM'S *EASTENDERS*

Tulloch's article is a 'note on method' rather than an extended study, and it is provoked by the reading of another British study of a text and its audiences, David Buckingham's *Public Secrets:* EastEnders *and Its Audience* (1987). *EastEnders* is an extraordinarily successful British soap opera that began airing in Britain on the BBC in 1985. At the time of Buckingham's research *EastEnders'* audience figures comprised nearly a third of the nation, and its characters and performers enjoyed almost continuous exposure in a notoriously down-market popular press. Set in a traditional working-class area of London, the East End, it was regarded as more realistic, more lively, and its storylines and subjects as more 'contemporary' than any of its competitors on British TV.

Buckingham approaches the relation between the programme and its audiences in four separate but related ways: through interviews with the producers he outlines their understanding of the programme and its likely audience; through an extensive textual analysis of specific episodes he suggests how the audience may produce various versions of the text; through a survey of the marketing and promotion of the programme he discusses the intertextual frame within which its audiences might place *EastEnders*; and, finally, through interviews with groups of young people he addresses the specific ways in which they make sense of it themselves.

Buckingham's book is sufficiently aware of current debates about the problem of textual meaning and the current revival of the category of the audience to attempt to mark his own work off – often a little spuriously – from that of Hobson or Morley. *Public Secrets'* focus is not essentially theoretical, however,

since its main interest is in the popularity of the programme itself; this leads to extensive discussion of its texts. Nevertheless, the book does participate in the debates initiated by Hobson and Morley and develops discussions of the ways in which the genre of TV soaps generates meanings and pleasures, and of the ways in which children understand television soap operas.

Creating the audience

The book's first chapter, 'Creating the Audience', analyses the ways in which the producers and the BBC's management initially conceived of the programme. In this chapter Buckingham falls within, and largely reproduces the conclusions of, a strong tradition of production studies.[6] While he establishes that television production 'involves the creation, not merely of programs, but also of audiences' (p. 8), his interviews with those responsible for the programme reveal the limits of their knowledge about the audience they intend to 'create'. Relying on instinct and intuition rather than empirically based or analytic knowledge, the producers used the little audience research that actually occurred 'largely as a means of confirming beliefs which were already held, and as valuable ammunition in arguing the case with senior management' (p. 14). Paradoxically, the programme's producers insist on their instinctive ability to predict their audience's interests while nevertheless making it clear that they do not in any way share those interests. Buckingham's research, like Hobson's, reveals the significant fact that those who make soap opera would never be caught watching one. Hobson (1982) deals at length with television producers' implied contempt for the pleasures they are employed to produce. Buckingham also uncovers this attitude but, unlike Hobson, does not linger to consider what this might say about the relation between the institution of television and its audiences. Instead, he outlines the corporate planning that mobilized these relatively unexamined assumptions about the TV audience and that influenced the nature of the production:

> Prior to the launch of the BBC's new early evening package, its audience at this time of the day tended to be predominantly middle-aged and middle-class. In order to broaden that audience, *EastEnders* would have to appeal both to younger and older viewers, and also to the working-class audience which traditionally watched ITV [the competing commercial network]. The choice of a working-class setting, and the broad age range of the characters thus also made a good deal of sense in terms of ratings.
>
> In addition, *EastEnders* sought to extend the traditional audience for British soaps, which is weighted towards women and towards the elderly.

> Having a number of strong younger characters, it was argued, meant that the program would have a greater appeal for younger viewers than other British soaps. ... Strong male characters would also serve to bring in male viewers who were traditionally suspicious of the genre.
>
> (Buckingham 1987: 16)

As Buckingham's group interviews later discovered, younger viewers categorically refused to identify with the young characters and instead located their interest in the slightly illicit behaviours of the adults. Such details reveal how shaky the production team's assumptions could be, and their unreliability as predictors of audience reaction. As Buckingham says, the producers' conception of the text's relation with its audience was 'confused and contradictory' (p. 27), a dead end for anyone hoping to explain *EastEnders'* success in building its audience.

Consequently Buckingham moves to a more 'reader-orientated' approach to explain the audience's active production of meaning. Such a phrase invokes the influence of reader-response and reception theory within literary studies, and Buckingham depends substantially on this tradition in his second chapter. He also acknowledges the debates within the field of media and cultural studies – those surveyed in Chapter 3 and in this present discussion – and situates himself in the (by now) familiar role of one who is in search of a balance between the power of the text and the autonomy of the reader:

> Perhaps the most critical problem ... is of balancing the 'text' and 'reader' sides of the equation. On the one hand, there is a danger of favouring the text at the expense of the reader: certain kinds of psychoanalytic theory, for example, regard the text as having almost total power to position and even to 'construct' the reader, and leave readers very little room to negotiate. Yet, on the other hand, there is a danger of favouring the reader at the expense of the text: certain reception theorists, for example, effectively deny that texts exist at all – instead, all we have to work with is an infinite multiplicity of individual readings.
>
> (Buckingham 1987: 35)

Following Eco, Buckingham suggests that the problem is exacerbated when we talk about soap opera because it is intrinsically a more 'open' form, offering 'multiple levels of interpretation'. Even with soap operas, however, the possibilities are not unlimited; one can still 'talk about readings', says Buckingham, 'not as infinitely various, but as differentiated in more or less systematic ways' (p. 37):

While I would agree that it is ultimately impossible to reduce a soap opera to a single 'meaning' ... it remains possible to specify the ways in which it invites its viewers to produce meaning. If one cannot say what *EastEnders* 'means' to its audience, one can at least say a good deal about how it *works*. For example, the ways in which the viewer is allowed or denied access to privileged information – whether we are 'let into' secrets or kept guessing – plays a significant part in determining our interpretation. Likewise, the extent to which we are invited to 'identify' with particular characters – and the different types of identification which are encouraged – also serves to orientate us towards the text, and enables us to make sense of it, in specific ways.

(Buckingham 1987: 37)

Buckingham appropriates an aspect of literary reception theory here, in his application of Wolfgang Iser's notion of textual 'invitations'. From this perspective, texts do not produce or determine meaning, they 'invite' their readers to accept particular positions, to explore particular speculations or hypotheses, to share particular information (the 'public secrets' of Buckingham's title) denied to some of the characters themselves, to call up memories of earlier events in the serial, their specific knowledge of the programme. Such invitations occur within the narrative itself, within constructions of character, and within the programme's constitutive discourses – its particular formations of 'common sense'. This process does not necessarily work to construct a unitary, non-contradictory reading of the text; rather, the 'ways in which [the viewers] are likely to respond to these invitations ... are potentially extremely variable and, in many cases, contradictory' (p. 83).

Children as audiences

Although Buckingham never actually employs the term *ethnographic*, that tradition of audience research underlies much of *Public Secrets*. To discover how a section of the audience responded to the 'invitations of the text', Buckingham conducted a series of small group discussions with a total of sixty young people between 7 and 18 years old, all from London. The groups were organized by age, but the racial mix varied. The discussions lasted one hour and twenty-five minutes on average, and were conducted in schools or, in a minority of cases, youth clubs. Buckingham describes them as 'open-ended', although he directed them with 'fairly basic questions' about viewing habits and about favourite or least favourite *EastEnders* characters:

Sometimes, generally towards the end of the discussion, I would draw the group's attention to characters or stories which they had failed to mention, at least partly to discover if there were reasons for this. Finally, usually for about the last twenty minutes of the session, I would screen a videotape of the last few scenes from the latest episode of *EastEnders*, occasionally pausing the tape to invite comments from the group.

(Buckingham 1987: 158)

Buckingham says this constituted a 'relatively self-effacing role' for the interviewer, which allowed the group to set its own agenda for discussion. He realizes, of course, that the situation and his role in it were highly artificial, but denies that this had any serious effect on the success of the discussions or on the insights they generated. One would have to accuse Buckingham of naïveté about what might constitute a genuinely 'open-ended' discussion and about the role of the interviewer in ethnographic work, but the research often illuminates the children's relationship to the programme.

Unlike Morley, Buckingham actively interprets the children's responses; descriptions of tone and delivery often accompany the quotations from their conversations. As is the case with other work on children and television within this tradition (notably that of Hodge and Tripp (1986) or that of Patricia Palmer (1986)), the conversations are richly revealing. In contrast to, say, Hodge and Tripp's *Children and Television*, *Public Secrets* illuminates the audience's relation to a specific programme rather than their general use of the medium, but there are a number of general points that deserve noting. Among them is Buckingham's claim that, while the content of the *EastEnders*' episodes may be a source of fascination to the children he interviewed, it is 'the process of *revelation*, both within the narrative and in its subsequent reconstruction in discussion, which constitutes much of the pleasure' (p. 166). He found that the children were well aware that information was carefully doled out to them by the narrative, and that revelations of the programme's 'secrets' were strategically rationed. Far from being victims of the narrative process, they understood its economy, its need for rationing, and enjoyed the pleasures of speculation, anticipation and revelation/discovery it delivered.

Buckingham argues, as do Hodge and Tripp (1986) in their more extensive study, that his young viewers did not passively absorb television, nor did they confuse its representation of the world with reality. The children Buckingham talked to were 'prepared to grant a degree of credibility to this representation', but they were also 'highly critical of what they regarded as its partiality and implausibility' (p. 200). Buckingham sees the degree of critical distance displayed as a crucial factor, and also notes that this was in no way incompatible with the children's 'general enjoyment of the program':

I would argue that this critical distance did not undermine their pleasure, but in fact made certain forms of pleasure possible. ... The children's comments ... reveal a complex and shifting combination of different responses. They were by turns moved, deeply involved, amused, bored, mocking and irreverent. The essentially playful way in which they were able to move between these different positions suggests that they had a considerable degree of autonomy in defining their relationship with television.

(Buckingham 1987: 200)

This chapter's concluding focus is upon children and television, but it also contributes to the body of research that provides empirical evidence of the contingency and variability of audiences' readings of television.

Public Secrets concludes by reiterating its case for the need to approach a popular text from multiple perspectives. These multiple perspectives, however, are not as 'multiple' as they might seem. Hall's encoding/decoding model is still visible in Buckingham's method; the major component of his approach has been to examine the dialectic between the determination of meaning by the encoder and the production of meaning by the decoder. So the project does not take us onto unfamiliar ground. Buckingham's view of the relations between text and audience is orthodox in its rejection of a privileged role for either category in the production of meaning. The only unfamiliar feature in his book is perhaps the explicitness of its use of reception theory, in his insistence on the importance of understanding how a text *works* rather than 'means': 'that is, *how it enables viewers to produce meaning*' (p. 203). However, as one might have expected in a book engaged in analysing the audience of a popular TV soap opera, it is most rewarding when it documents specific interactions among audience, text and everyday lives.

The object of interest implied in the preceding comment is popular culture, everyday life itself, rather than a more restricted interest in television or the mass media. It is also an interest basic to the enterprise of cultural studies. Within this enterprise, ethnographic work has established a firm position, and it is not surprising to see its influence extend (or, more accurately, contract) from the analysis of social groups to the analysis of media audiences. Yet the transposition from one theoretical objective to another has not been without its costs and its illogicalities.

I want to look at the more thorough applications of ethnography to the analysis of urban subcultures in the next chapter, but before continuing with the topic of media audiences I want to address, albeit briefly, the ways in which cultural studies of media audiences have appropriated ethnographic techniques, and ask just what is ethnographic about them.[7]

MEDIA AUDIENCES AND ETHNOGRAPHY

The use of the term *ethnography* in this context is itself contentious. Ethnography comes from anthropology; within this discipline it is a written account of a 'lengthy social interaction between a scholar and a distant culture':

> Although its focus is often narrowed in the process of writing so as to high-light kinship practices, social institutions, or cultural rituals, that written account is rooted in an effort to observe and to comprehend the entire tapestry of social life. An extensive literature has been elaborated by anthropologists attempting to theorize, among other things, the nature of the relationship between culture and social behaviour, the epistemological status of 'data' gathered in the field, the nature of 'experience' itself, and the status of explanatory social theories imported from the ethnographer's own cultural universe. ...
>
> Despite these not inconsequential difficulties, however, anthropologists have at least aimed through ethnography to describe the ways in which day-to-day practices of socially situated individuals are always complexly overdetermined by both history and culture.
>
> (Radway 1988: 367)

Clearly this is a very different activity from that practised by Hobson or Morley. The procedure of interviewing audiences in their homes employs an ethnographic technique but disconnects it from the purpose for which it was developed. As Radway (1988) argues, ethnographic studies of media audiences have been extremely 'narrowly circumscribed', the field of their interest 'surveyed and cordoned off by [their] preoccupation with a single medium or genre':

> Even when we have attempted to understand not simply how women read romances or families watch television but also how those activities intersect with, contradict, or ratify other cultural practices carrying out the definition of gender, for example, we have always remained locked within the particular topical field defined by our prior segmentation of the audience of [sic] its use of one medium or genre. Consequently, we have often reified or ignored totally other cultural determinants beside the one specifically highlighted.
>
> (Radway 1988: 367)

As a result, the researcher engages not another culture, but an arbitrarily disconnected fragment; this is not merely a problem of detail, but a major disadvantage. The practice of watching TV is separated from all those other social

practices that collaborate to make it a meaningful activity. And yet, Radway concludes, this seems not to have occurred to the media researchers themselves:

> Ethnographers of media use have ... tended to rule out as beyond our purview questions of how a single leisure practice intersects with or contradicts others, how it is articulated to our subjects' working lives, or how it is used to contest the dominance of other cultural forms.
>
> (Radway 1988: 367)

Virginia Nightingale (1989) has suggested it makes no sense to use the term *ethnographic* in connection with cultural studies of media audiences. For a start, ethnographic research is simply descriptive rather than critical, and thus not ideally suited to cultural studies' political purposes. Indeed, as she puts it, the practice is logically compromised: it draws on 'interpretive procedures to understand texts around which the audience clusters', but it restricts itself merely to 'descriptive measures ... to account for the audience' (p. 53). Further, as she rightly says, the meeting between cultural studies scholars and the 'other' culture they are investigating can be as brief as a single one-and-a-half-hour interview in the home. This is hardly a sufficient period to provide a complex understanding ('thick description') of the structure of the subjects' everyday lives – within which their television viewing is, of course, enclosed. The practice of seeking audience readings of texts that have already been 'read' by the researchers is fraught with all the contradictions discussed in Chapter 3; additionally, in these studies the practice is also deployed as a spurious method of authenticating the researcher's reading. As Nightingale puts it, the interviewees' descriptions of their experiences of the text are 'co-opted' (p. 55) by the researcher as if these ethnographic data could be relied on, as other data cannot, as utterly authentic. There is a naïve trust in the empirical here that could come only from a convert. The most basic problem, however, is the aim of or strategy behind the methods used; comparing some of the work we have looked at in this chapter with Paul Willis's more traditional ethnographies (to be discussed in the following chapter), Nightingale says:

> While the encoding/decoding audience research uses the same research techniques as Willis, their research strategies are quite different. Willis's aim was to demonstrate the working of social process, to explain cultural reproduction through the interlocking of education and the labour process. This type of broad social aim, with its singularity of focus, is missing from the encoding/decoding studies, which concentrate on several, and more limited, aims such as explaining the popularity of the text [Hobson and Tulloch],

teaching about British cultural studies [Ang] or demonstrating the opera-
tions by which pleasure is encoded in the text [Ang and Buckingham].

(Nightingale 1989: 58)

Given the validity of this point, one wonders why the term *ethnography* has
become conventionalized in this connection. Nightingale suggests the label's
function is to reconnect cultural studies with the studies of community life from
which in many ways it originally grew, as well as to confer unity onto the intellec-
tual field of cultural studies through the enclosure of one theoretical tradition
within another – hitherto rather separate – tradition.

Whatever the reason, a consequence of the ethnographic studies of media
audiences was the revival of interest in less text-based analyses of popular
culture, and in the practices of everyday life. Fiske (1988) moved from an interest
in the audience to the suggestion that we abolish the category altogether in order
to focus on the generation of 'meaningful moments' in popular culture;
Nightingale (1989) asked for a 'mixed genre' method that approaches popular
culture from a number of theoretical perspectives, 'triangulating' our angles of
inspection as community studies research has done in the past; and Radway
(1988) returned to the idea of the analysis of 'everyday life' as a reorientation for
American cultural studies. For Morley, by 1992, the issue was no longer a matter
of thinking about texts and audiences at all; rather:

> the challenge lies precisely in the attempt to construct a model of television
> consumption which is sensitive to both the 'vertical' dimension of power and
> ideology and the 'horizontal' dimension of television's insertion in, and artic-
> ulation with, the context and practices of everyday life.

(Morley 1992: 276)

One hears the wheel turning as we head back to the original targets of cultural
studies.

Media ethnographies did not disappear, however. Indeed, as the claims for the
explanatory power of such ethnographies have become more modest the number
of useful and highly focused studies seems to have increased. Much current prac-
tice eschews the attempt to understand large-scale processes in favour of focusing
on specific patterns of media consumption among particular communities.
Marie Gillespie's (1989, 1995) work with Indian families in Southall, West
London, for instance, examining the part played by television in the formation
and transformation of identities, provides an exemplary model of how we might
increase our understanding of the tactics employed by specific groups of media
consumers. (Gillespie is notable for employing essentially traditional ethno-

graphic approaches in her research, living among the communities she discusses in her work.) Ann Gray (1992) examines how women use the VCR: her object of study is a technology, not a set of texts, and involves a combination of contextual and other factors. Highly aware of the theoretical complexities of the research approaches chosen, Gray's work builds in many ways on Morley's *Family Television*, extending its insights and bringing new dimensions to our understanding of the gendered use of technology within the domestic setting. Her focus reflects the need for audience studies to start thinking about the use of new media forms or systems of delivery. Shaun Moores, the author of one of the standard accounts of media ethnographies (1993), has examined gender and generational conflicts in the domestic setting around the use of satellite television (1996), and there is now a growing literature on cybercultures. Such studies shift the territory of media ethnography towards what is now more commonly referred to as cultural consumption, and I will deal with that later on in this chapter.

Examples remain, however, of what has been called the first generation of media audience research: that which employs a variation on the encoding/decoding model and which is primarily interested in the social influence of the media, particularly news.

Greg Philo's *Seeing and Believing* (1990) is in some ways a return to the territory of the original *Nationwide* studies. His interest is slightly different, however, and draws on his background as a member of the Glasgow Media Group, which produced the 'Bad News' series in the 1980s. In *Seeing and Believing* Philo sets out to track the relation between the knowledges and opinions gleaned from the media and those supplied through other sources, from other systems of belief. His focus is on the role television news plays in what he calls 'the production of belief'. Philo's research methodology reverses, in a sense, that of the *Nationwide* studies:

> In pursuing [how what is understood from the media relates to existing systems of belief] it did not seem very useful to show audiences a particular programme and then attempt to gauge possible 'effects'. Instead it seemed more fruitful to ask groups to write their own programmes. This would show what they thought the content of the news to be on a given issue. It might then be possible to compare this with what they actually believed to be true and to examine why they either accepted or rejected the media account.
>
> (Philo 1990: 7–8)

Pictures were supplied to accompany the news stories, and a series of structured questions were aimed at finding out what respondents believed to be 'true' in regard to this news topic (a miner's strike), what relation television news

reports were perceived to have to this 'truth', and what were respondents' primary sources of information about what they perceived to be 'true'. The results provide an instructive map of the complex interactions between individuals' knowledge, personal experience and their varying receptiveness to the explanations of the news media.

THE AUDIENCE AS FICTION

Before we move on, we should acknowledge that there are ways of dealing with audiences or conceiving of them which do not involve focus groups, interviews or face-to-face encounters with 'real' members of audiences. In a number of pieces published during the 1980s, John Hartley (1987, 1988) took a position that opposed the current ethnographic examinations of the audience. Hartley makes the legitimate protest that any study of 'the *Nationwide* audience' or 'the *EastEnders* audience' actually has to invent such an audience in order to study it at all. There is no such social group as 'the *EastEnders* audience'. We do not live our lives as members of audiences, at least not exclusively so. We might be audiences at one point in our daily lives, but we are many other things besides: workers, commuters, readers, parents and so on. Nor are we socially defined by our membership in particular audiences; while we might be among the audience of *Days of Our Lives* at one point in our television viewing, we will be among the audience of *MTV* or *Sixty Minutes* at others. The category of the audience, Hartley argues, is a fiction of those who speak for it, those who research it, those who try to attract it, and those who try to regulate and protect it – the critics, the academics, the television industry and the broadcasting regulatory bodies.

Hartley begins his article 'Invisible Fictions: Television Audiences, Paedocracy, Pleasure' (1987) by considering the idea of the national television audience. If the nation is, in Benedict Anderson's phrase, an 'imagined community', an invention in which we all participate, then the national TV audience is too: 'one unwarranted, invisible fiction – the imagined community of the nation – is used to invent and explain another: the [national] television audience' (p. 124). This latter fiction is produced by the three major institutions that 'invent' television, or, as Hartley puts it, that 'construct television discursively': the critical institutions (academics, journalists and pressure groups), the television industry (networks, stations, producers) and the regulatory bodies within the political/legal system.

Hartley demonstrates what he means by this, taking each of the 'imagining institutions' in turn. The critical or scholarly institution is dealt with by way of academic research on audiences, largely the work we have been surveying in this chapter. Hartley points out that Morley's audience was explicitly constructed on

a class basis. Morley's research thus arbitrarily selected groups of people he then called 'an audience' for the purpose of his study; he collected them in a group that would otherwise not have been formed, in a place they would otherwise not have occupied, and asked them to become the audience of a programme they may otherwise not have chosen to watch: 'Clearly, Morley's audience ... is an invisible fiction, produced by his project, which was itself a product of academic/critical institutional discourses. ... It's Morley's *method* that is empirical, not the audience he constructs for his research' (p. 126). Like Morley's, according to Hartley most academic audience research tends to see audiences as an independently existing social category, possessing intrinsic and observable properties that are more or less the same nationwide. This invention is then taken up by and used within the industry and the regulatory bodies.

The television industry and the regulatory bodies, while often pursuing competing objectives, reveal a surprising degree of similarity in their conception of the audience. For the industry,[8] where the interest is simply in maximizing the number of viewers, and where it is also acknowledged that the audience is 'literally unknowable' (p. 129), the solution is to treat audiences as children – to enclose them within what Hartley calls a 'paedocratic regime':

> This isn't to say that television is merely infantile, childish, or dedicated to the lowest common denominator – those would be certain mechanisms for losing the audience. On the contrary, broadcasters paedocratise audiences in the name of pleasure. They appeal to the playful, imaginative, fantasy, irresponsible aspects of adult behaviour. They seek the common personal ground that unites diverse and often directly antagonistic groupings among a given population. What is better, then, than a fictional version of everyone's supposed childlike tendencies which might be understood as predating such social groupings? In short, a fictional image of the positive attributes of childlike pleasures is invented. The desired audience is encouraged to look up, expectant, open, willing to be guided and gratified, whenever television as an institution exclaims: 'Hi, kids!'
>
> (Hartley 1987: 130)

The regulatory bodies, too, see the audience this way: as a group to be protected, their rights defended by broadcasting standards, censorship and (in the United Kingdom and Australia) interventionary official instruments of broadcasting policy. They see themselves as acting, as it were, *in loco parentis* for the nation as a whole.

Hartley's own version sees the audience as primarily the product of the television industry; television sells audiences, after all, to advertisers. It is a product,

however, that television producers know very little about, hence their reliance on ratings and on 'those imaginary, paedocratised representations of the audience that networks promote throughout the industry':

> Networks minimise their risks by stabilising not demand but supply, but neither networks nor producers know what will 'sell'; they don't know who they're talking to and they don't 'give the public what it wants' because they don't know. This structural uncertainty at the heart of the television industry means that networks and producers alike are afraid of the audience: afraid of offending it, of inciting it, of inflaming it – above all, afraid of losing it.
>
> (Hartley 1987: 135)

In order not to lose the audience, and because they have very little idea of how else to relate to their audience, television programmes instruct their audiences in how to understand and enjoy television:

> Since audiences don't exist prior to or outside of television, they need constant hailing and guidance in how-to-be-an-audience – hailing and guid-ance that are unstintingly given within, and especially between, shows, and in the meta-discourses that surround television, the most prominent among which, of course, are those publications aptly called television guides.
>
> (Hartley 1987: 136)

The most obvious example of instruction in 'how-to-be-an-audience' is, of course, the laugh track on television sitcoms and variety shows.

The clear tendency in Hartley's argument at this point is textual; seeing audi-ences as the product of discourses, or the *regimes* constructed through a range of discourses, is to direct attention away from a hypothesized 'actual' audience and back to the discourses that call them into being: the criticism, the programmes, and government broadcasting policies and regulations. The audience, in Hartley's view, cannot be investigated as a 'real' group, ethnographically or other-wise, and so we are ultimately left with the text or, more accurately, the discursive regime within which the texts are produced and received. The notion of audi-ences as 'invisible fictions' throws out a significant challenge to ethnographic research and explanations, and differentiates Hartley's work decisively from that of his former collaborator, John Fiske.

Hartley's more recent work (1996, 1999) presents a rather different account, however, of television audiences. His focus here is on what he refers to (following Yuri Lotman) as 'the mediasphere', or the full range of media forms, texts, prod-ucts and contexts from which we construct our own 'popular reality'. Hartley's

interest in this later work is not so much in the production of meanings from media texts; rather, it is in the production of cultural identities through the popular media. Far from seeing the relation between the individual subject and the media as an infantilized relation, the later Hartley offers an extremely optimistic account of how the subject or, more accurately, the citizen constructs his or her identity from the resources accessed through the popular media. Tabloid media, the interest in celebrity, and unrespectable forms of talk (Ricki Lake, Jerry Springer and so on) can be read as serving positive functions for their audiences through their performance of hitherto subordinated identities.

This is not the paedocratic audience, subject to the industrial, institutional and cultural regimes that call them into being. Rather, this is a new mode of constructing, as a first step, 'cultural citizenship' (crudely, the confirming of identity or membership) before moving on to the next step, 'DIY' – do-it-yourself – citizenship (crudely, the recognition of difference):

> In my view 'cultural citizenship' is at a late stage of rights-formation, moving into formal legislative existence in a number of contexts, while DIY citizenship is much more recent, fleeting and of uncertain outcome. But it can be seen as 'citizenship' nonetheless, because semiotic self-determination is 'claimed' as a 'right' and 'taught' as a mode of civility or neighbourliness by this within its purview. It is – or could be– the citizenship of the future; decentralized, post-adversarial, international, based on self-determination not state coercion right down to the details of identity and selfhood.
>
> (Hartley 1999: 161)

This may look like a return to the resistant and self-determining reader identified with John Fiske's work and criticized by Jim McGuigan (1992) as a form of 'cultural populism' (this will be dealt with in Chapter 6). However, it is important to note that the position Hartley takes in this late 1990s work is grounded in a highly contemporary reading of the cultural significance of certain shifts in media content and formats over that decade. Fundamental to the concept of DIY citizenship is Hartley's neologism 'democratainment' (1999), which is used to describe what Hartley sees as the democratizing relation between the media and its audiences today. Simply, he argues that we are making different use of television in particular and the media in general than has previously been the case. The basis for this, from Hartley's point of view, is the growth of tabloid media, the proliferation of access provided by a more diverse, more available, multi-channel television environment, and the political locations of the voices seen to benefit from such access and becoming audible through life-style, reality and talk-show programming.

FROM RECEPTION TO CONSUMPTION

In his introduction to *Rethinking the Media Audience* (1999) Pertti Alasuutari discerns three generations of media audience research in British cultural studies. The first generation is essentially the encoding/decoding studies exemplified by Morley's *Nationwide* research; here the focus was on the reading of a text or body of texts to understand the process of reception. The second generation was the 'ethnographic' turn where, rather than focusing upon the text, the primary interest was in understanding how media audiences' behaviours and understandings were enclosed within the forms of everyday life. The third generation emerges from the critiques of ethnography discussed earlier in this chapter, as well as some discomfort with the legitimacy of the category of the audience itself. The research focus for this kind of work may seem relatively limited – as in Ann Gray's study of the gendered use of the VCR, for instance. But increasingly it has been acknowledged that such work helps us understand something much larger: 'the cultural place of the media in the contemporary world' (Alasuutari 1999: 7). As David Morley puts it in his contribution to *Rethinking the Audience*, 'the emphasis on viewing practices [as the starting place of media audience research] should now be reframed within the new focus on the broader discourses within which media audiences are themselves constructed and inscribed' (1999: 197). What he calls for is a model of 'media consumption capable of dealing simultaneously with the transmission of programmes/contents/ideologies (the vertical dimension of power) and with their inscription in the everyday practices through which media content is incorporated into daily life (the horizontal dimension of ritual and participation)' (p. 197). At this point the study of audiences begins to merge with other traditions and we move from the territory of audience reception to the broader analysis of cultural consumption.

The BFI Audience Tracking Study

An example of what such a shift can produce is found in David Gauntlett and Annette Hill's *TV Living: Television Culture and Everyday Life* (1999). *TV Living* describes the British Film Institute (BFI) Audience Tracking Study, an offshoot of an earlier mass observation study, *One Day in the Life of Television*, which involved 22,000 people from around the UK writing a diary of their television viewing on 1 November 1988. The Audience Tracking Study selected a representative group of 509 participants from this larger sample to complete questionnaire diaries on fifteen occasions over a five-year period (1991–6). Their study emerges from a rich heritage, including the British Mass Observation movement during the 1930s and 1940s, but more particularly David Morley's work – from the *Nationwide* studies through to *Family Television*. In addition,

they draw on the example of the television documentary *Seven Up* and its successors in focusing on 'longitudinal' issues: on the changes in their subjects' relation to television over significant periods of time and through major transitions and events in their lives.

The primary data available to the research teams were the completed diaries, themselves organized around a mixture of standardized and one-off open-ended questions, which enabled tracking of particular issues of interest to the researchers, as well as allowing sufficient flexibility to pick up the respondents' personal concerns. The relationship between the respondents and the researchers does seem to have had a personal dimension, too, with researchers sending birthday cards and writing personally in response to major events in the participants' lives (Gauntlett and Hill 1999: 13). The material is written up in what is largely a reporting format, which discusses the range of responses provided before presenting a summary of findings under each chapter heading. Topics for the chapter headings include 'television and everyday life', 'news consumption and everyday life', 'video and technology in the home' and 'retired and elderly audiences'.

TV Living is a valuable resource of information about how people's use of media is imbricated into their daily lives. While often the summaries of findings do not provide us with especially surprising results, they are powerful simply because they are the product of long-term, detailed, empirical and qualitative research. So, for example, we find in the summary of the chapter headed 'Television's personal meanings' confirmation of several propositions that have been part of television studies' agenda since the early 1990s:

- Talk about, and stemming from issues raised in, television programmes is a part of many people's social lives. For some, an important part of the pleasure of TV viewing was talking about it afterwards. Conversations were able to make use of the shared reference points, in relation to social issues and popular culture, established by television.
- Identities were negotiated in relation to TV and other media material, but in subtle ways which even a qualitative study like this has difficulty picking up.

(Gauntlett and Hill 1999: 139)

Not earth-shattering in themselves, these are nevertheless useful conclusions, partly because they amplify the propositions made in much more speculative work, such as John Hartley's (1999). Further, in many cases *TV Living* provides new information about particular areas that have not been extensively researched in the past: the use made of television by the elderly, for example.

The primary evidence for these conclusions comes from the diaries, and there is limited space, even in a book of this relatively generous size, for including large samples of these. The authors have followed Morley's example from *Family Television* in providing the reader with access to a great number of short quotations from the respondents' diaries, though, and this adds a great deal of colour and interest to the book. As with *Family Television*, however, it is a little difficult to assess the precise status given to these comments as they are treated in various ways within the text: sometimes they are interrogated or interpreted, and at other times they seem to be taken at face value. The precise way in which the evidence has been evaluated, then, in order to reach the conclusions presented is not entirely clear throughout. Such issues aside, *TV Living* is clearly a significant new contribution to our understanding of media consumption.

Cultural consumption

We may well be able to describe a great deal of the traditions of British cultural studies as having, in one way or another, studied cultural consumption, but the explicit nomination of this focus has not got a very long history. It does mark the shift away from the text and away from a predominantly media focus, which seems to be the most significant feature of the field's progress in the 1990s. The move towards cultural policy, the interest in space and cultural geographies, and the increasing influence of Foucault's account of cultural practices and discourses are also related developments. John Storey, in *Cultural Consumption and Everyday Life* (1999), is representative when he finds that the notion of cultural consumption enables him to bring together a range of different disciplinary perspectives: 'work on reception theory in literary studies and philosophy; work on consumer culture in anthropology, history and sociology; [and] work on media audiences (both ethnographic and theoretical) in media studies and sociology' (p. xii). Approached from such perspectives, the conventional view, which regarded consumption as an entirely commercial transaction, evidence of the successful manipulation of the consumer by the market, starts to fade into the background. In its place is the argument that the consumption of culture is itself 'productive'; that is, it is through the consumption of commodities and the production of meanings and pleasures around them that we produce our own culture. Even as we consume the most 'commercial' of commodities, the Barbie doll for instance, we are transforming them into culture. Think of what happens to that doll as its owner plays with it over time. No longer simply a commodity, it becomes a component of the individual's cultural identity and personal history.

This is not simply an argument for the 'power of the consumer' operating as a hedge against his or her domination by market capitalism – again a version of the

resistant reader. In the best examples of this work, as Storey points out, there is a clear awareness of the competing forces and asymmetries of power involved – and the dangers of romantic optimism about the power of the consumer. However, as Daniel Miller (1995) has argued, assumptions about consumption have been allowed to flourish relatively untouched by close examination in an academic environment where, alternatively, the economies of production are much more closely inspected. As a result, we may be making some quite crucial errors of judgement:

> Sociology and cultural studies, in particular, have poured forth accounts of consumer imperatives. They describe a new, self-reflexive, materialistic, hedonistic desire. This is backed by a mixture of esoteric theories of post-modernity and psychoanalysis. These are projected on to housewives and other consumers in what has become a largely self-perpetuating discourse. To choose between these and the economist's projections of individual maximisers is an unpleasant task.
>
> (Miller 1995: 37)

Miller provocatively suggests that perhaps the prime motivation for consumer behaviours might in fact be 'thrift': 'the search for good value through low prices for commodities and services regarded as household necessities' (p. 37). That we can't categorically deal with that suggestion reinforces Miller's point: we have a limited capacity to examine critically the assumptions behind our notion of consumption. From his point of view, the failure seriously to acknowledge the cultural and political function of consumption is itself a highly political gesture:

> I have argued ... that there is a specific resistance by politics to the actual process of consumption, since the trivialisation of consumer action is impor-tant to the maintenance of respect for conventional political power. Consequently the major strategy of those with an interest in cultural consumption has been to 'politicise' consumption.
>
> (Miller 1995: 40)

The examples he provides of such an activity, the politicization of consump-tion, include 'green' politics and the history of consumer resistance movements in the US.

In a highly polemical but challenging piece, Miller goes on to argue that 'the increasing domination of consumption' in the global economy 'may prove ulti-mately progressive even at the moment when it seems most oppressive' (p. 41). He points out that the focus on consumption is mainly concerned with 'the

consequences of the economy rather than reifying its mechanisms'. So, rather than happily relying on the market as the means for distributing goods and opportunities, this allows us to focus on the human consequences of the act of consumption. Second, Miller values the inherently pluralist and semi-autonomous nature of the process of 'cultural self-construction' to which cultural consumption contributes. In a position that reminds me a little of Hartley's DIY citizenship, there is a kind of freedom in the choices provided, Miller argues, and so 'the imperatives of consumption may be as varied as the cultural contexts from which consumers act' (p. 42).

This work takes us quite a distance from the analysis of media audiences, while providing a useful framework within which to place their behaviours in response to media texts. In Miller's collection *Acknowledging Consumption* we have contributions from sociology, history and geography, among other fields. Cultural studies moves well beyond concern with the media text in order to understand other systems for the production of meaning, and as it does so the disciplinary influences come from other sources: sociology, anthropology and history. It is to some of these disciplinary influences and their histories that I turn in the following chapter.

Ethnographies, histories and sociologies

It is possible to see the arguments around texts and audiences as proceeding from an interrelated, even quite compact, body of ideas. There are other areas in British cultural studies, however, that are not quite so compactly organized, the boundaries of their fields of interest less clearly marked out. In many cases this is due to the complex relation between cultural studies and established disciplines such as history and sociology. In this chapter I want to indicate some of the benefits cultural studies has drawn from ethnographies of social groups, from the new histories of discourses and institutions, and from the political economies and sociologies of the media industries. Although what follows is only a sampling of these various fields – there is an especially rich tradition of histories of 'the popular' that is not considered here – it may usefully extend our view of cultural studies and its breadth of interests.

ETHNOGRAPHY

The Uses of Literacy (Hoggart 1958) is usually regarded as an ethnography of the everyday lives of the northern English working class between the wars. Within the CCCS there has always been a strong interest in ethnography, with the Centre producing a far greater range of work than that suggested by the previous chapter's examples from media audience studies. Much of the best work 'starts not with a text or a theory (although it is certainly theoretically informed and alert) but with a social group – bikers, schoolboys, housewives – and observes their use of commodities and messages to produce culture, meanings and interpretations' (Batsleer *et al.* 1985: 145). Over several decades the tradition has taken

on numerous forms: the collection and analysis of oral history, Hobson's studies of media audiences, a range of histories of popular movements and class formations, and, perhaps centrally, the analyses of urban subcultures associated with Phil Cohen, Paul Willis, Dick Hebdige and, in its strongest feminist formation, Angela McRobbie. Having just dealt with the 'ethnographic' strategies employed by audience research in the previous chapter, it may be helpful to demonstrate how vastly different are the strategies employed in what have become the foundational moments in cultural studies ethnography from the 1970s and 1980s.

Paul Willis's study of working-class youths leaving school, *Learning to Labour: How Working Class Kids Get Working Class Jobs* (1977), took three years to research. Willis focused on a group of twelve 'non-academic' working-class boys who had close links with each other and with an 'oppositional', rebellious culture in their school. His subjects were studied as a group and as individuals through participant observation, group discussions, informal interviews and diaries. Willis contacted the group halfway through their penultimate year of school and followed them through their last year and then into their first six months of work. As part of his research method, Willis attended classes with them and worked alongside them at their places of employment; while they were at school he interviewed their parents, junior teachers, senior masters and careers officers; while they were at work he interviewed their foremen, managers and shop stewards. He also made comparative studies of five other groups of youths selected from within the same school, from other schools, and from a mixture of class and academic affiliations. The studies are informed by a detailed understanding of the town and the locality. In addition to what it tells us about its subjects, *Learning to Labour* analyses their school's structures of discipline and control, and the ideological systems from which they were constituted. This is a very different exercise from that of sitting with a family for an hour and a half, or even for a number of such periods, while they watch television.

Cohen, class and subculture

Just as the media audience studies are inappropriate representatives of the ethnographic tradition within the CCCS, it would also be wrong to see Dick Hebdige's work on subcultures as typical. While Hebdige acknowledges Phil Cohen's influence, there are crucial differences between their work; Cohen's is the more centrally placed in this tradition. Cohen's 1972 article 'Subcultural Conflict and Working-Class Community' offers a much more rigorously historicized account of subcultural style than has so far appeared in Hebdige's work.[1]

Cohen's subject, initially, is the housing estates in working-class areas of East London that were developed in the 1950s and which, he says, have actively partic-

ipated in the destruction of a working-class community in those areas. His research in the field led Cohen (1980) to argue that the physical structure of the housing projects actually reframed the ideologies of those who used them:

> The plans are unconsciously modelled on the structure of the middle-class environment, which is based on the concept of *property* and *private owner-ship*, on individual differences of status, wealth and so on, whereas the structure of the working-class environment is based on the concept of community or collective identity, common lack of ownership, wealth, etc.
>
> (P. Cohen 1980: 81)

The physical form of these new housing estates was, as it were, middle class; the occupants were not. This disjunction resulted in a deep ideological fissure within the communities they housed: between a nostalgic class loyalty and a bourgeois upward mobility, between an ideology of work and production and one of leisure and consumption, and between the traditional working-class community and its effacement. The contradictions within the larger, 'parent', culture had a most forceful impact on their youth subcultures and manifested themselves in aspects of subcultural style: in the gangs of mods, skinheads and 'crombies' who successively occupied the urban space within and around these housing estates.

Cohen's analysis of these styles, unlike Hebdige's later analysis, assiduously relates them to the 'parent culture' that produced them and from which derive the lived contradictions the subcultural style is designed to resolve 'magically':

> The succession of subcultures which this parent culture generated can thus all be considered so many variations on a central theme – the contradiction, at an ideological level, between traditional working-class puritanism and the new hedonism of consumption; at an economic level, between a future as part of the socially mobile elite or as part of the new lumpen proletariat. Mods, parkas, skinheads, crombies all represent, in their different ways, an attempt to retrieve some of the socially cohesive elements destroyed in their parent culture, and to combine these with elements selected from other class fractions, symbolising one or another of the options confronting it.
>
> (P. Cohen 1980: 82–3)

Cohen goes on to provide examples of how the symbolic structures of subcultural style might be decoded:

> The original mod life-style could be interpreted as an attempt to realise, *but in an imaginary relation*, the conditions of existence of the socially mobile white-

145

collar worker. While the argot and ritual forms of the mods stressed many of the traditional values of their parent culture, their dress and music reflected the hedonistic image of the affluent consumer. ... The skinheads' ... life-style ... represents a systematic inversion of the mods – whereas the mods explored the upwardly mobile option, the skinheads explored the lumpen. ... [Their] uniform signified a reaction against the contamination of the parent culture by middle-class values and a reassertion of the integral values of working-class culture through its most recessive traits – its puritanism and chauvinism.

(P. Cohen 1980: 83–4)

Unlike Hebdige, however, Cohen does not imply that such a reading of subcultural style is in itself sufficient. There are, he says, three necessary levels of subcultural analysis: historical analysis, which 'isolates the specific problematic of a particular class fraction'; structural or semiotic analysis of the subsystems of style – largely the analysis of dress, argot (slang), music and ritual Hebdige employed; and 'phenomenological' (or what we might understand as more specifically ethnographic) analysis of 'the way the subculture is actually "lived out" by those who are the bearers and supports of the subculture' (p. 83).

Cohen acknowledges ethnography's obligation to develop a methodology that can protect it against accusations of subjectivity. To understand a subculture without 'disappearing' into it is extremely difficult; yet if one does 'disappear' into it, one's statements about it are compromised. Hebdige's (1988) recanting of his *Subculture* thesis implicitly acknowledges a methodological failure: his approach was unable to prevent him from writing his own political wishes into his analyses. It is clear that Cohen's (and later Willis's) attempts to provide an 'objective' rationale for the researcher's practice are justified. However, and as their work suggests, if ethnography is vulnerable to the accusation of being 'under-theorized' it is also true that the development of a theory of analytical practice within the field is no easy matter. Operating as ethnographies do, at the point where determinate social conditions become specific lived conditions, it is difficult *not* to privilege 'the real', the empirical evidence of one's own eyes and ears, and to allow this category of evidence to overwhelm all others. This runs against the theoretical grain of cultural studies. Nevertheless, under the pressure of 'real' evidence it is tempting – almost irresistibly so – to reject theory as inadequate to deal with the 'actual' complexity of the practices of everyday life.

Willis and Learning to Labour

Paul Willis's work provides us with contrasting evidence of the power of such a temptation and of an exemplary resistance to it. *Profane Culture* (1978), his study

of two oppositional subcultures (motorbike club members and hippies), was researched under the auspices of the CCCS between 1969 and 1972. Although it was published in book form in 1978, a year after *Learning to Labour*, it represents an earlier example of ethnographic work from the Centre and bears numerous marks of this. 'The real' is explicitly privileged in *Profane Culture*, not through a deliberate theoretical argument, but through its insinuation into the validating rhetoric of the book. Within a persuasive and legitimate argument reclaiming the importance of subjective experience for cultural analysis, Willis nevertheless allows 'the real' and the theoretical to be opposed as if they were mutually exclusive categories. The hippies' 'living out' of their ideas is applauded as 'more heroic, ... fuller, more resonant and honest than [their] dry cerebral statement' (p. 89); the motorbike club members' frank admission of their lack of emotional sympathy with other human beings is preferred over a phony 'cerebralised compassion' (p. 30). The intoxicating attraction of the 'authentic' looms large in *Profane Culture*, and produces a more romantic identification with its subjects than we find in the more sharply theorized analyses in Hebdige's *Subculture* (1979). The connections Cohen routinely makes between his subcultures and their 'parent culture' are not made in *Profane Culture* either, and Willis's project suffers from this; the sexism of the motorbike culture, for instance, is masked by the absence of such systemic connections.

Willis is not unaware of these theoretical problems, however, and it is clear that the theoretical inconsistencies in *Profane Culture* are not meant to signify a categoric rejection of theory. *Learning to Labour* (1977) is as useful an example of a densely theorized practice as *Profane Culture* is of a theoretically compromised one.

Although it was published a year earlier than *Profane Culture*, the research for *Learning to Labour* was conducted between 1972 and 1975, and it is a more sophisticated example of Willis's work. The project studies a group of working-class boys, rebels and 'anti-academic' in their school, in order to see how their school experiences equip them for later life. Willis finds that 'the lads', as he calls them, determinedly resist the ideologies of the school and that this resistance well prepares them for the unskilled working-class jobs in which they end up. Masculine working-class subcultural codes of work, of earning and of success enable the boys to choose 'happily' not to engage in white-collar, educated or skilled labour, and to deny that they have any other genuine options. Once within work, they find the shop-floor culture within the factory entirely familiar, structured as it is by the same discourses and power relations as their 'counter-school' culture.

A major study, *Learning to Labour* employs ethnography as the primary element within its analysis of cultural forms and social reproduction. Other

elements include a sophisticated macropolitical analysis of the workings of ideology and social power within working-class culture, and analysis of the discourses that structure the ethnographic evidence. Willis, like Hebdige and Cohen, sees the importance of style; for instance, he accounts for the significance 'the lads' attribute to smoking through its valorization 'as an act of insurrection' that invokes associations 'with adult values and practices', the antithesis of the school (p. 19). His emphasis on the way school life is 'lived' by these boys enables him to detect how completely their social practices invert its values:

> They construct virtually their own day from what is offered by the school. Truancy is only one relatively unimportant and crude variant of this prin-ciple of self-direction which ranges across vast chunks of the syllabus and covers many diverse activities: being free out of class, being in class and doing no work, being in the wrong class, roaming the corridors looking for excitement, being asleep in private. The core skill which articulates these possibilities is being able to get out of any class: the preservation of personal mobility.
>
> (Willis 1977: 27)

The aim of these boys is not to do any school work; some boast of having written nothing all term. By reading the boys' cultural practice from their own point of view, Willis is able to reveal how their apparently aimlessly disruptive behaviour has a tactical significance. While the book contains skilled and illumi-nating analyses of the functions of discourse (the 'masculinity' of physical labour as inscribed in working-class discourse, for instance), it is most important for its diagnosis of the structural nature of these boys' choices and their ultimate class position. As Willis says, 'The difficult thing to explain about how working class kids get working class jobs is why they let themselves' (p. 1), and the answer is finally that they consider their choice to have served their own best interests within the existing class structures. Accurately enough, they see the carrot of credentialism offered to them as a giant con; rather than chase the chimera of middle-class upward mobility, they opt to withdraw from the race and seek unskilled employment. The choice is rewarded by their sense of commonality with their workmates and by their access to the adult male working-class culture that the ability to earn a wage provides. The boys' rejection of qualifications, their contempt for education, their masculinist privileging of physical over mental work and their ridicule of those who accept the ideologies of the school all rein-force the conviction that their interests will be served by virtually any working-class job and defeated by virtually any middle-class job. A better example of the process of hegemony would be hard to find.

The product of Willis's ethnography is consequently a profound critique of the hegemonic function of the education system. His study reveals precisely how the system works, and the last third of *Learning to Labour* attempts to expose its inequities in theory as well as in practice. Willis's 'lads', setting up their 'counter-school culture', have in fact come to an accurate recognition of their political location; the role for Willis's cultural analysis is to develop his readers' recognition of this in order to advance arguments for sociopolitical change. This is a complex and important section of the book, but one lengthy quotation may indicate how it depends on and transcends the ethnographic information it has produced:

> Bourdieu and Passeron have argued that the importance of institutionalised knowledge and qualifications lies in social exclusion rather than in technical or humanistic advance. They legitimate and reproduce a class society. A seemingly more democratic currency has replaced real capital as the social arbiter in modern society. Bourdieu and Passeron argue that it is the exclusive 'cultural capital' – knowledge and skill in the symbolic manipulation of language and figures – of the dominant groups in society which ensures the success of their offspring and thus the reproduction of class position and privilege. This is because educational advancement is controlled through the 'fair' meritocratic testing of precisely those skills which 'cultural capital' provides.
>
> Insofar as this is an accurate assessment of the role and importance of qualifications, it supports the view that it is unwise for working class kids to place their trust in diplomas and certificates. These things act not to push people up – as in the official account – but to maintain there those who are already at the top. Insofar as knowledge is always biased and shot through with class meaning, the working class student must overcome his inbuilt disadvantage of possessing the wrong class culture and the wrong educational decoders to start with. A few can make it. The class can never follow. It is through a good number trying, however, that the class structure is legitimated. The middle class enjoys its privilege not by virtue of inheritance or birth, but by virtue of an apparently proven greater competence and merit. The refusal to compete, implicit in the counter-school culture, is therefore in this sense a radical act: it refuses to collude in its own educational suppression.
>
> (Willis 1977: 128)

We are here a long way from *Profane Culture*'s dismissal of the 'cerebral'; there is nothing 'dry' about this analysis of the lived conditions Willis's subjects have to negotiate.

Interesting for its thoroughgoing use of Gramscian theories of hegemony at a time when CCCS media studies were more influenced by Althusser, and foreshadowing the complex analyses of ideological formations within popular culture that developed in the mid-1980s, Willis's book is a graphic example of just how useful the employment of ethnographic method can be. It has not merely described a social process, but provided the basis for its social and political analysis.

Critiques of subcultural research

Such an achievement as that of *Learning to Labour* has not protected ethnography from criticism, however (Batsleer *et al.* 1985: 146). Richard Johnson (1983: 45–8) has warned against ethnography's unifying tendencies (the suppression of conflicts and contradictions), its sentimental construction of an essential 'working-class-ness', and its close identification with empiricist models of culture. Further, when we read ethnographic studies there is always a point at which we need to ask who is speaking, and for whom. It is a problem that refuses to go away; it surfaces in Hebdige as an insouciant confidence in the objective validity of his judgements on style and taste, in Willis as an implicit identification with the group he is studying, and in Buckingham as the denial that his intervention in the subculture might affect the outcome of his research. As a consequence of the importance of description in ethnographic work, it would seem that implicit assumptions tend to be more difficult to isolate and excise; they are embedded in the experience to be described. As Richard Johnson (1983) says, 'Intellectuals may be great at describing *other* people's implicit assumptions, but [are] as "implicit" as anyone when it comes to their own' (p. 45). Angela McRobbie's (1981) critique of the Birmingham subcultural research makes this abundantly clear.

Focusing on Willis and Hebdige in particular, McRobbie uncovers at least one of the implicit assumptions behind their studies: their privileging of masculine culture. McRobbie (1981) names the significant absence in this body of work – the subject of women's place within the subcultures considered and the lack of any consideration of women's own subcultures.[2] She notes how the male ethnographers have been 'blinded' by their choice of subcultures, with which they have already established an identification:

> Writing about subcultures isn't the same thing as being in one. Nonetheless, it's easy to see how it would be possible in sharing some of the same symbols – the liberating release of rock music, the thrill of speed, or alcohol or even of football – to be blinded to some of their more oppressive features.
>
> (McRobbie 1981: 114)

As a result, she argues, such studies unconsciously reproduce their subculture's repressive attitude towards women. Willis, for instance, never attempts to go outside the male lineage of his subjects in *Learning to Labour*. Their relationships within the family, with their mothers, female siblings and girlfriends, are all but ignored; yet, as McRobbie says, working-class culture includes the bedroom and the breakfast table as well as the school and the workplace (p. 115).

McRobbie's criticism of Hebdige is more substantive, bearing on the ideological function of the subcultural styles he examines. Subcultural style is predominantly masculine; indeed, McRobbie says, 'subculture's best kept secret' is 'its claiming of style as a male but never unambiguously masculine prerogative':

> This is not to say that women are denied style, rather that the style of a subculture is primarily that of its men. Linked to this are the collective celebrations of itself through its rituals of stylish public self-display and of its (at least temporary) sexual self-sufficiency.
>
> (McRobbie 1981: 117)

McRobbie indicates how the writing of women into the argument of *Subculture* might radically revise it; if subcultures reproduce the dominant structures of gender relations in their primarily masculine styles, then Hebdige's argument about the oppositional and resistant force of these styles is compromised. McRobbie's article reminds us of the problems remaining in ethnographic method, as well as the durability of conservative constructions of gender.

More recently, McRobbie's own work has itself been criticized for its failure to observe methodological protocols which might help distance her from her subject matter and from her own implicit assumptions. McRobbie remains a cogent commentator on rationales for cultural studies research into subculture formations (1994, 1999). However, Jim McGuigan's irritation with McRobbie's 'ever more open-minded populist appreciation of mainstream youth culture' (1992: 111) seems more understandable when one reads her work on young unemployed women in Birmingham and on 'rave' culture. Certainly, the Birmingham study is heavily anecdotal, its formal research methods limited: 'the girls would frequently come to see me and stay for a chat when I had the time' (McRobbie 1991: 222). Willis, too, seems to have lost interest in formal ethnographic methodology for *Common Culture* (1990). This book is Willis's report on a number of projects carried out by a team of researchers for the Gulbenkian Foundation. More populist in its orientation than the late 1980s work of John Fiske, *Common Culture* is also influenced by de Certeau as it celebrates the 'symbolic creativity' of

the popular. The evidence is anecdotal: 'our ethnographic research and presentation have not aspired to a full methodological rigour', Willis admits, preferring to 'range widely' in the search for examples of 'symbolic creativity' without 'really providing accounts of whole ways of life' (1990: 7).

Contentious though it may be, and fashionable though it is in contemporary media studies, ethnographic work is nevertheless an important element in the enterprise of cultural studies. Within the history of the CCCS, it occupied a strategic role, making links with descriptive social anthropology and with 'history from below' (Hall 1980a). That tradition has continued to develop and mutate (Redhead 1997) and to expand into new disciplinary locations. Tracey Skelton and Gill Valentine's collection *Cool Places: Geographies of Youth Cultures* (1998) includes ethnographic accounts of subcultures as well as, for instance, a discussion of the construction of young people's cultural space by cultural geographer Doreen Massey.

HISTORIANS AND CULTURAL STUDIES

Tony Bennett (1986b: 11) has claimed that Left historians' elitist neglect of popular culture as a field of inquiry during the 1950s effectively delivered the area to the various participants in the mass culture debates outlined in Chapter 2. From there it was rescued by Hoggart and others, and incorporated into the territory of cultural studies. Popular culture, even the concept of 'culture' itself, has remained a site of disputation between historians and cultural studies analysts ever since. Despite the importance of the *category* of history to the developing protocols of cultural studies, the field's relation with the academic profession – the discipline and institution – of history has never been without tension or ambiguity. In recent years, in particular, while cultural studies has taken an increasing interest in history, some historians have expressed a sense of being overtaken or displaced by cultural studies (Geraghty 1996; Steedman 1992).

E. P. Thompson and his *The Making of the English Working Class* (1978a) play a key role in this relationship. *The Making* not only constructs the English working class, 'calling it up' through the writing of its story, it also ushers in a new kind of history. Instead of focusing on the elite and the powerful, Thompson's history places its distinctive emphasis on those who lived ordinary lives but who nevertheless participated in, and were the agents and victims of, historical processes. This is not a history of political parties and legislation but of cultural formations and social relations – particularly those within popular culture.

History and theory

Notwithstanding its wider ramifications in questioning the construction of history, the bulk of the work to proceed from this reorientation of British social history is, in a sense, internal to the discipline; it deals with substantive issues within British social history and historiography and, despite its admitted importance in these areas, need not concern us here. However, at its outer reaches one would have expected such an intellectual movement within the discipline of history to have been nicely consonant with intellectual movements within cultural studies from the late 1960s to the 1980s. And yet that was not the case. It is true that Richard Johnson's period as director of the CCCS coincided with a more broadly historical conception of the Centre's work. It is also true that the new history shared many of its key orientations with work going on in cultural studies, such as 'the centrality of the notion of experience and the consequent assertion of the agency of the individual within history' (R. Johnson 1979a: 65). Thompson's stated aim of examining 'the peculiarities of the English' – just what was distinctive about British social development in comparison with that of other countries – is also quoted as a CCCS objective under both Richard Johnson (1980) and Hall (1980a). But there were crucial differences between the two movements: most notably, the new history was suspicious of cultural studies' theoretical interests (readers will recall the *History Workshop* controversy from Chapter 2, pp. 57–8), and the new history ultimately served humanist rather than materialist ideologies. Further, although the new history's emphasis on experience enabled it to cooperate with ethnographic research, its implicit empiricism set it in opposition to structuralist/semiotic notions of textual analysis. Even while some post-Thompsonian social histories became almost Foucauldian in their emphasis on discourse and ideology (see, for example, Cunningham 1980), Thompson himself maintained his opposition to European theory in virtually all its forms – but especially in its Althusserian guise.

English historians' resistance to theory, and their suspicion of those who come from outside their discipline (or even beyond their shores), has not entirely disappeared. A residual wariness may still be apparent in their concentration on nineteenth-century (rather than twentieth-century) social histories of popular culture, and in the continuing resistance to textual analysis. This is by no means the whole story, however. Patrick Wright's *On Living in an Old Country* (1985), for instance, demonstrated how arguments around issues of heritage and enterprise culture in Thatcher's Britain could bring history and cultural critique together, and the case studies collected in Corner and Harvey's *Enterprise and Heritage* (1991) provide more recent examples. Further, as a result of Left historians' reconsideration of popular cultural formations we have theoretically and politically informed histories of popular movements and of popular pastimes such as

cricket and football. The best of such studies give the lie to any claim that history is 'untheorized'. Hugh Cunningham's (1982) history of leisure in mid-Victorian England is theoretically sophisticated and richly argued; Gareth Stedman-Jones's (1982) work has consistently focused on institutions, their discourses and their ideologies. Although Tony Bennett (1986b: 18) accuses Chas Critcher of a left-wing populism that forever chases an 'authentic' but now 'lost' popular culture, Critcher's (1982) history of football is clearly aware of more than empiricist approaches. By the 1990s, certainly, the 1970s' arguments between history and cultural studies had largely been resolved by the acknowledgement, on both sides, of the need to explain the popular movement as a cultural formation – acknowledging the usefulness of the kind of cultural theory Thompson eschewed.

Media history

Predictably, perhaps, an area where the new history and cultural studies have met relatively productively is media history. There is a strong tradition of media history in Britain; it includes a number of orthodox histories of media institutions and industries, such as George Perry's *The Great British Picture Show* (1975), as well as more Gramscian accounts such as Scannell and Cardiff's (1982) study of the BBC. The most substantial of the press and broadcasting histories to have emerged from the combination of media sociology, the new history and cultural studies is James Curran and Jean Seaton's (1985) magisterial *Power Without Responsibility: The Press and Broadcasting in Britain*. Published in 1981, with several revised editions since, *Power Without Responsibility* is influenced, curiously, by both E. P. Thompson and Antonio Gramsci. It provides a model for the kind of work that is now much more firmly established within cultural studies: the cultural history that succeeds in relating institutional, industrial, political and ideological analysis to produce a complex and often deliberately disjunctive account of cultural production.

Curran and Seaton's history of the press ties the content of the papers to ideological and regulatory conditions as well as to the economic conditions of ownership and control. It offers a critique of previous press histories that questions the democratic consequences assumed to flow from the free market and the role of advertising, and that demonstrates how the press in Britain has not merely reflected dominant social attitudes but produced a conservative version of them. At its best, this history accurately describes not only the politico-economic structures within which the press operates, but also the textual forms that assist in reinforcing these structures:

In a[n] indirect way, the press reinforced attachment to the status quo by the way in which it tended to depict reality. Its focus on political and state office as the seat of power decentred capital and masked the central influence of business and financial elites. By reporting the news in terms of discrete and disconnected events, it encouraged acceptance of the social structure as natural – the way things are. Its expanding entertainment content also tended to portray life as relatively unchanging, a panorama of individual drama determined by the laws of human nature and the randomness of fate. By thus blocking out alternative, structural explanations of how society operates, the human interest stories of the popular press have contributed as much as its political commentary to sustaining the extraordinarily resilient consensus of postwar Britain.

(Curran and Seaton 1985: 120)

Within this passage there are many lines of agreement between Curran and Seaton's view of social process within the media and those taken by, say, the majority of CCCS studies of the media at the time. Indeed, Curran and Seaton acknowledge the work of the CCCS, praising *Policing the Crisis* (Hall *et al.* 1978) and endorsing cultural studies' Althusserian view of the media's 'relative autonomy': 'The media do not merely express the interests of the ruling class, rather they have an independent function in ordering the world. The media do not merely "reflect" social reality; they increasingly help to make it' (Curran and Seaton 1985: 281).

Nevertheless, Curran and Seaton's historical and sociological pedigrees tell in the end; they ultimately resist a full appropriation of cultural studies approaches as internally contradictory and unscientific (pp. 278–80). The book concludes, however, by similarly questioning the bases of the authors' own tradition of mass communication research:

The empirical evidence of the pluralists [here, defenders of market forces, and also cultural studies theorists] gives powerful backing to the determinists' [here, the mainstream of British political economies of the media] conviction that the media exert an important and uncontrolled influence. Yet the deterministic explanation in terms of class manipulation and exploitation is too mechanistic, obscuring a series of complex relationships which have yet to be explained.

(Curran and Seaton 1985: 282)

The work of explaining these relationships has largely proceeded through the application of Gramscian theories of hegemony within cultural studies, and this

will be addressed in Chapter 6. The argument over class and the media's determination of reality will be taken up again in the next section, which deals with political economies and sociologies of the media, and their relation to cultural studies.

The final area I wish to touch on here is one that receives significant influences from outside Britain: from European appropriations of post-Freudian theory that examine the cultural construction of consciousness and from the work of Michel Foucault, who sees history as the product of ways of thinking about things, of discourse. Foucault's histories of sexuality or of such institutions as the prison or the hospital are histories of ways of thinking about the body and gender or about the relationship between the individual and the state. The links between such an enterprise and Williams' originating enterprise in *Culture and Society* (1966) should be clear: in both cases, we are looking at a history of the social production and the social function, not only of certain ideas, but also of certain kinds of consciousness. In the cultural studies of the early 1980s the construction of such a history was the objective of a number of analyses of English educational institutions and the disciplinary discourses flourishing within them.

The 'Moment' of Scrutiny

As we have seen, cultural studies soon separated itself from literary studies – despite the close links between its theoretical influences and those of literary studies, and despite the fact that many of those who worked in cultural studies had literary training. When it came time to applying the new history and to exploiting the new theoretical influences from Europe that made it possible to examine institutional discourse as a serial historical text, it was probably inevitable that the discipline of English should be a target for such analysis. Widdowson's collection *Re-reading English* (1982) draws heavily on the main institutional locations of cultural studies – the CCCS and the Open University – for its contributors, who then interrogate the main institutional locations of literary studies. The volume offers histories of the rise of English as an academic discipline, accounts of theoretical issues within it, alternative models of critical analysis and suggestions for future directions. It is the explanation, however, of English as the product of volatile 'ensembles of cultural and ideological pressures' (p. 8) that is the strategic move; it makes 'English studies' the subject of discursive analysis and thus turns the tables rather neatly on a discipline that has made everything else the object of *its* modes of analysis.

Brian Doyle's (1982) chapter, 'The Hidden History of English Studies', examines the foundation of the discipline, its enclosure within ideas of the nation and

its implication into the structure of gender relations within what he calls 'the national family'. What most interests Doyle is how English has carefully erased the traces of its own history and naturalized itself as a discipline and as a tradition of texts. The main objective of Doyle's piece is to reverse the process – to historicize the institution of English studies, and to provoke such critiques of its practices and assumptions as are presented in the subsequent chapters of *Re-reading English*. This work is continued by a subsequent volume in the same series, *Rewriting English* (Batsleer *et al.* 1985), which develops some of the suggestions in Widdowson's collection by tracing the 'politics of literacy and literature outside the institutions of literary criticism and of English in higher education'. Beginning with the 1930s, this book examines historical shifts in the constitutive discourses of English in British schools, before looking at a range of working-class and women's writing – the relations, as they put it, between genre and gender – across a broader historical range.

Francis Mulhern's *The 'Moment' of Scrutiny* (1979) also deals with an aspect of the discursive and institutional history of the 1930s. Although it emanates from English literary studies, this has become a widely used and respected book within cultural studies. Its subject is *Scrutiny*, the influential English literary journal produced by a group dominated by F. R. Leavis from 1932 to the early 1950s, and reprinted in both collected and selected form in the 1960s. Leavis and *Scrutiny* play ambiguous roles within British cultural histories from the Left. *Scrutiny* took on the social and political battles the Left neglected during the 1930s and thus deserves admiration; on the other hand, its championing of a particularly petit-bourgeois, evaluative and moralistic version of textual criticism has made it anathema to Marxist literary and cultural scholars. Yet there was common ground between the two traditions; Williams himself suggested that the exploration of such territory was an objective of his involvement in the journal *Politics and Letters* (see the section on Williams in Chapter 2). As Mulhern points out, *Scrutiny* actually opened up space for the analysis of such cultural institutions as itself, although this space was ultimately to be occupied by the work of Raymond Williams and, among others, the CCCS.

Mulhern's book is an exemplary history of the journal: its contributors; its cultural, institutional and political contexts; and its ideological function. Enclosed within an analysis of the rise of English that provides interesting comparisons to Doyle's, Mulhern's account of *Scrutiny* resembles Scannell and Cardiff's institutional histories: its territory is criss-crossed by contradictions, anomalies and the complex relations between individuals and their social and ideological contexts. Mulhern's objective, as he puts it, is to 'analyse the conditions in which the journal came into being': 'the elaboration and modifications of its discourse over its life-time, the objective functions that it performed in the

culture of mid-century England – and so, to define and assess what is called here the "moment" of *Scrutiny*' (1979: ix).

The driving impulse behind *The 'Moment' of Scrutiny* seems to be the need to understand the journal's curiously ambiguous relationship with the Left and with practical politics – both of which *Scrutiny* kept at arm's length. As the account becomes less traditionally historical and more discursive in its focus and analysis, the ideological underpinnings of the *Scrutiny* line – and the reasons for its ultimate opposition to the Left – are more clearly revealed. Mulhern concludes his history by arguing that the version of literary criticism institutionalized and disseminated through *Scrutiny* is a discourse 'whose foremost general cultural function is the repression of politics':

> This discourse has done much to shape, and still sustains, England's cultivated, politically philistine ... intelligentsia; it is reproduced ... by the entire national educational system: it is a key element in the cultural 'formula' of bourgeois Britain, part of an ensemble of cultural *domination*.
>
> (Mulhern 1979: 331)

Dennis Dworkin's recent history of British Cultural Marxism (1997) adds further texture to Mulhern's account – and to standard accounts of British cultural studies such as the one you are now reading – by teasing out a large number of contributing threads to the history of cultural studies which roots it in Left politics during the 1930s. Tom Steele (1997), too, has taken up the challenge posed by those arguments which place the foundation of cultural studies in the adult education classroom by writing a fascinating history of adult education and cultural studies that takes us back to the late nineteenth century. He also reveals, among other things, patterns of intellectual trade with European theory hitherto unconnected to the history of British cultural studies.

It is significant that many of these histories of the role of English, of literary studies and of a tradition of textual practice again uncover cultural studies' roots in literary studies. It is as if the new methodologies have to prove their penetrative force by discovering their own origins. These histories also foreground the problem of aesthetics – still a key item in literary categories, but only recently returning to the agenda of cultural studies (as we saw in Chapter 3). In this regard, the historicizing of the discipline of English has a strategic value in that it also 'denaturalizes' the aesthetic categories it has privileged. Deployed in this way, history is anything but disinterested; within contemporary cultural studies it can operate as a highly polemical strategy of discovery. The analysis of cultural institutions, and of the discourses that constitute them and enable them to function, is a major development within cultural studies and of profound significance.

Within this development, the category of history has become crucial and its definition and uses contested, but it has radically extended the purpose and power of cultural studies research.

SOCIOLOGY, CULTURAL STUDIES AND MEDIA INSTITUTIONS

Another kind of institutional analysis, this time directed at the media industries, has also exerted a significant influence on the nature of cultural studies' accounts of cultural production. This has not come from within cultural studies, however, but from the British media sociologies of the 1970s.

Sociology is another of the disciplines from which (or against which) cultural studies developed. Many of the key figures in cultural studies either come from or currently work under the institutional umbrella of this discipline: Tony Bennett, Stuart Hall, Simon Frith, David Morley and Angela McRobbie among them. Morley (1992) has written about the importance of sociology to cultural studies work, specifying its usefulness as a hedge against more literary/aesthetic influences. Sociology has helped to resist, says Morley, the 'textualization' of cultural studies 'which often allows the cultural phenomena under analysis to drift entirely free from their social and material foundations' (p. 5). David Harris's *From Class Struggle to the Politics of Pleasure* (1992), taking it one step further, attempts to write the history of British cultural studies almost entirely from within the discipline of sociology. While Harris's argument is often contentious, it is certainly true that there are many areas where sociology has proved fundamental to the development of British cultural studies.

During the early 1970s there was an exceptionally strong revival of British media work outside, and at times competing with, the work of the cultural studies centres. Where cultural studies research was preoccupied with the analysis of the text and the processes of its encoding or decoding, other traditions focused their interests elsewhere. The two most influential and long-lasting traditions, and the ones I want to deal with in this section, are characterized by the politically and sociologically informed analysis of the economic conditions determining media institutions' activities and the application of ethnographic methods to study the media as a workplace, as an industrial culture.

In British media analysis the boundary between the practices of political economy and sociology has become quite porous; Marxist sociologists have presented what amounts to a political economy of the media in order to demonstrate the importance of the ownership of media outlets. As we shall see when we look at an example of Murdock and Golding's work, some media sociologists invoke classical Marxist theory in order to claim ownership as the most crucial aspect of the relationship between the media and society. The power of media

owners is not untrammelled, however; it is mediated by those who work in the institutions and industries they control. The extent, then, of the owners' control of their media cannot be determined without knowledge of how it affects those who work for them. Consequently ethnographies of the working lives of media professionals also assumed a strategic importance within arguments about the power of the media and the economic or structural basis of that power.

Over this period cultural studies reserved some of its most bitter criticism for sociology's political economies of the media. Cultural studies accused the tradition of economism of a blind adherence to the traditional Marxist base/superstructure model of society, of a 'top-down' version of ideology that sees cultural effects flowing inevitably from economic conditions of ownership and control. Most of these accusations were vigorously denied, of course, and countered with criticism of cultural studies' textual determinism or its cavalier dismissal of the industrial conditions and the economic decisions that govern the media institutions. While it was widely referred to and often exploited as a source of convenient empirical detail, media sociology was rarely taken on as a model for cultural studies practice.

Eventually the tables were turned. Jim McGuigan's *Cultural Populism* (1992) mounted a sustained critique of Stuart Hall, dealing with what McGuigan calls Hall's 'special demon' of political economy. According to McGuigan, Hall 'scrupulously avoided economic reductionism by normally steering clear of economic determinations' altogether (p. 34), thus contributing to the development of a debilitating schism between the 'micro-processes of meaning and the macro-processes of political economy' (pp. 171–4). At the time McGuigan's critique represented something of an orthodoxy, a developing view of the need to reconsider political economy that ultimately did have an effect on the shape of the field and the kind of work occurring there.

Because of the history of antagonism between the two approaches, I am wary of appearing to minimize or perhaps elide the differences between British cultural studies and British political economies of the media by dealing with the latter in a book on the former. However, these political economies do represent a strong and coherent tradition within British media studies that exerted an important, if contested, influence on cultural studies in the 1970s and 1980s, and exert an even more profound and certainly less bitterly contested influence within cultural studies now. In this section I want to recognize this influence by indicating, if only very briefly, the kind of information it produced: my 'exemplary' text is Graham Murdock and Peter Golding's 'Capitalism, Communication and Class Relations' (1977).

The authors begin this article by glossing the kinds of questions their approach throws into relief – at least at the time of writing:

questions about the relations between communications entrepreneurs and the capitalist class, about the relations between ownership and control within the communications industries, about the processes through which the dominant ideology is translated into cultural commodities; and about the dynamics of reception and the extent to which members of subordinate groups adopt the dominant ideas as their own.

(Murdock and Golding 1977: 15)

Murdock and Golding take the classical Marxist line in seeing the economic structure of the society as the sphere most requiring close analysis if we are to understand history. They regret that the economic determinants of culture have been relegated to the background in cultural studies textual analysis. Murdock and Golding, like Marx, insist that 'property ownership, economic control, and class power' are 'inextricably tied together' – even in such areas of cultural production as the media (p. 28).

Their political economy of the media argues that those who own the media control the way it produces culture; and those who control cultural production are themselves enclosed within a dominant capitalist class in whose interests the media represent reality. Therefore to focus simply on the media's representations of the real, the product of these relationships, is to ignore the structure that determines their very existence. Responding to the accusation that their explanation of the connection between the media and class power is a little mechanical, Murdock and Golding point out that their conception of this connection is (like Raymond Williams') that of a subtle process of 'setting limits, exerting pressures, and closing off options' (p. 16). Against the accusation that they are reviving the crude dichotomy between base and superstructure, with its insistence on the decisive role played by the economic base, Murdock and Golding stress the dynamism and interrelatedness of the system they describe while nevertheless insisting on the importance of understanding the processes of material production *before* 'intellectual production', or the economic bases before the cultural bases (p. 17). While Murdock and Golding do make concessions to the cultural field, they also make it clear that they are critical of 'top-heavy analyses in which an elaborate economy of cultural forces [i.e. texts] balances insecurely on a schematic account of economic forces shaping their production' (p. 19). In their brief critique of a Stuart Hall article, Murdock and Golding suggest that Hall fails to understand that questions 'of resources and of loss and profit play a central role in structuring both the processes and products of television production, including the output of news and current affairs'. 'Economics,' they conclude, 'is clearly not the only factor in play, but equally it cannot be ignored' (p. 19).[3]

Murdock and Golding's specific project in the article I am examining is to explain how ideological influence 'from above' (p. 20) takes place, and to demonstrate that the 'control over material resources and their changing distribution is *ultimately* the most powerful of the many levers operating in cultural production' (p. 20). The ensuing analysis of the movement in media ownership from 'concentration to conglomeration' – the increasing concentration of media ownership in the hands of an ever smaller number of individuals, and the increasing interconnection between media industries and other sectors of business – is powerful and important. They trace the agglomeration of media companies and the effective reduction in the number of owners; when this process is seen in conjunction with the commercial diversification of media companies – which therefore expands their sphere of influence throughout the business and financial sector – we have persuasive evidence of how media owners might be stitched into the interests of an elite capitalist class fraction. In a later article Murdock (1982) provides more detailed evidence of this alignment, again delivered persuasively.

While this style of argument has now been assimilated into all varieties of media studies, it was resisted by representatives of both the culturalist and the structuralist paradigms in the cultural studies of the 1970s. The culturalists rejected its implicit denial of individual agency or power within media institutions, while the structuralists insisted that the primary determining force came from culture or ideology, which framed the definition of interests produced by owners, industry workers and audiences alike. Culturalist scepticism could be somewhat ameliorated, however, by the results of another branch of media sociology that complemented and responded to the political economies: these were the occupational sociologies that examined how the internal workings of media institutions complicated the economic determinations described by Murdock and others. Their focus was on the way in which the owners' control of the media was expressed, mediated or countervailed by the social structures within the specific institution.

This is a rich tradition, drawing on American occupational sociologies as well as ethnography. Initially, British work concentrated on the production of news, publishing such accounts of media professions as Jeremy Tunstall's *Journalists at Work* (1971), Philip Elliott's *The Making of a Television Series: A Case Study in the Sociology of Culture* (1972) and Philip Schlesinger's *Putting 'Reality' Together: BBC News* (1978) (see also Elliott 1977 for an overview of this kind of work in sociology). *Putting 'Reality' Together* presents an intelligent history of the institution of news and offers a sociological account of this institution – an account consonant with that offered within British political economies and in some cases explicitly opposed to that likely to be produced within cultural studies. The book's theoretical allegiances are declared in a privileging of the

economic determinants of the institution, and of the demands of the industry against more textually based procedures. Most significantly for our purposes here, Schlesinger's book establishes the importance of industrial/institutional work practices and professional ideologies as factors in the media's production of culture.

Putting 'Reality' Together provides a number of work-practice studies, showing how the cultures of the newsrooms produce certain effects on the news they publish: for instance, how the practices of newsgathering themselves naturalize action, pace and immediacy as intrinsic to the profession and thus discriminate against more considered, researched and reflective journalism. The work-practice studies may not reveal evidence of direct intervention by media owners, but they do reveal how conservative the forces are that shape media production at the shop-floor level. This may not in all instances substantiate the political economists' structural accounts, but the ideological effects are certainly no different from those proposed by Murdock and Golding.

Cultural studies, although explicitly differentiated from the tradition that produced Schlesinger's book, has nevertheless benefited from it. There have been a number of production studies of particular programmes or groups of texts; in addition to those examined in some detail in Chapter 4, there are Tulloch's two studies (with Manuel Alvarado on *Dr Who* (1983) and with Albert Moran on *A Country Practice* (1986)) and Manuel Alvarado and Edward Buscombe's (1978) study of the stylish British private-eye show *Hazell*. In general, the ethnographic studies have found a relatively uncontested place within cultural studies media research, but one cannot say this generally of the influence from what are, in the end, the social sciences and communications research traditions. To some extent, it has to be said, the ambivalence felt from one side of this divide is reciprocated on the other.

Cultural studies and sociology

But we must not overemphasize this schism; there have always been moments of cooperation, co-option, even a merging of the two traditions. Murdock's (1976) research into urban adolescents, for instance, was included in the CCCS *Resistance Through Rituals* collection; the first issue of *Media, Culture and Society* carried a manifesto that advocated the amelioration of theoretical differences, and had an editorial board that included representatives from both traditions;[4] and Nicholas Garnham (1987) provided one of the lead articles for the first issue of *Cultural Studies*. In fact one can see how the theoretical directions taken by the two traditions have converged over the years. Under the influence of theories of the postmodern and arguments about post-Fordism,

163

cultural studies is now more interested in the political/economic conditions surrounding the institutions that produce culture; courses on media institutions and media policy now accompany courses on media text analysis within colleges and universities, and issues of ownership and control are taken seriously even by those who do not accept them as the *ultimate* factors in the relationship between the media and society. Critiques of cultural studies have had their effect on changes in practice, and in the seriousness with which the processes and mechanisms of cultural production are now taken. Cultural studies is gradually finding ways to make use of sociological approaches, albeit by modifying their definitions of ideology and adopting Gramscian notions of hegemony rather than the more instrumental notions identified with the early political economies. In turn, political economists have been able to add cultural studies' textual and discursive analysis to their repertoire of methods; as we have seen, institutions can be investigated as discursive entities, and this is particularly useful, for instance, in the analysis of news values. Murdock (1989) has himself attempted to develop the common ground between the two positions by arguing that neither approach – alone – can be considered entirely sufficient. David Morley's work has increasingly bridged the divide as well, most clearly in his collaboration with the cultural geographer Kevin Robins (Morley and Robins 1995) and in his magisterial *Home Territories* (Morley 2000), where disciplinary boundaries seem to dissolve entirely. In fact, it is possible to argue that his work reflects a significant shift towards sociology as cognate disciplinary territory (Long 1997).

Since the early 1990s cultural studies has become more interested in the analysis of institutions, both as powerful locations for the establishment of dominant discourses and as political and economic formations that also shape and determine cultural production. And the usefulness of sociological methods of research, as well as sociological theory – and more than just the odd mention of Bourdieu – seems to be quite widely acknowledged. Nevertheless, that does not constitute grounds for a merger between cultural studies and sociology. There are more differences to divide the two fields than the hoary old spectre of economism. Chris Rojek and Bryan Turner (2000) recently criticized cultural studies' influence on sociology, what is referred to as the 'cultural turn' in the discipline, but which they regard as (still) too dominated by the textual. Rejecting the 'aestheticisation of life' produced by cultural studies, which displaces the preferred 'politicisation of culture' (p. 629), Rojek and Turner are scathing about what they describe as 'decorative sociology'. Even what I have suggested is a cultural studies' shift towards sociology is regarded as worrying. The 'co-option of sociology' by cultural studies is accused of weakening the historical and comparative dimension in social research as well as neglecting the 'tensions between the material basis of power and the social organisation of culture' (p. 645).

At times it seems that the natures of these interests, certainly with regard to the media, must remain fundamentally different. As James Carey (1989) has argued in relation to the work of the CCCS, cultural studies has noτ developed the study of the mass media as a subject or as a discipline: the ultimate goal of sociologies of the media. Rather, in cultural studies the media are 'centred' as a 'site on which to engage the more general question of social theory: "How is it … that societies manage to produce and reproduce themselves?" ' (p. 110). The answers cultural studies theorists provide to this general question clearly differentiate them from the sociologists and the historians surveyed in this chapter. This is largely due to the models of culture and ideology employed.

It is to this question, then, that we must now turn: to the ways in which the category of ideology is understood and used within cultural studies – ways that differentiate it both from the humanistic insistence on the individual agency of the historians and from the 'top-down' economic determinism of the more traditional political economists. This will take us across a minefield of slippery concepts.

Chapter 6

Ideology

The use of the term 'ideology' has gone a little out of fashion in British cultural studies texts published since the mid-1990s. While it certainly still figures as a dominant concept in the teaching of cultural studies, it is not nearly as prominent in cultural studies research and writing as it once was. I can think of a number of reasons for this. As British cultural studies has interested itself more in issues of identity (see Chapter 7) the nature of the work accomplished in the field has changed slightly but significantly. With the focus on identity, cultural studies becomes a little more descriptive, focusing on the content of the identities under examination and their specific relation to the cultural and political environment. The larger interests being served within this framework tend not to come into sharp focus and, to be fair, are routinely seen as already established and understood. Second, the category of ideology still implies – even if only vestigially – a relation of domination and subordination that no longer sits comfortably with discussion of the social distribution of power as dispersed and contingent. Here, the influence of Foucault is again significant. As we have seen, Foucault's account of the distribution and operation of power is presented through discursive histories of systems of regulation, discipline and behaviour internalized by the human subject. So, for example, histories of the school, the prison or the hospital might focus on the organization of time and space – the daily timetable or the schoolroom – as key elements in shaping the comportment of the subject. In such a theoretical framework ideology looks like a slightly clumsy instrument for the analysis of cultural institutions and structures. Hence the rather old-fashioned tinge that currently adheres to the concept.

Nevertheless, and notwithstanding any of the above, it is probably still true to say that ideology remains the single most important conceptual category in cultural studies – even if it remains one of the most contested. Indeed, according to James Carey, 'British cultural studies could be described just as easily and perhaps more accurately as ideological studies for they assimilate, in a variety of complex ways, culture to ideology' (1989: 97). This assimilation has been so complete that even the distinction between culture and ideology can seem a strategic rather than a substantive one at times. Consequently one can understand the antagonism between cultural studies and the political economists/sociologists we have just been discussing. For the latter group ideology's function is largely instrumental – to misrepresent 'the real' and to mask any political struggle; for cultural studies ideology is the very site of struggle. While there is certainly some truth in the claim that cultural studies succeeds only too well in its attempt to separate the cultural from the economic, one can see why the study of everyday life might resist the suggestion that the analysis of economic forces provides a sufficient explanation of the workings of culture and ideology. Nevertheless, Richard Johnson (1979b) usefully reminds us that the economistic recovery of a base/superstructure model of society is not necessarily opposed to cultural studies' versions of ideology; he makes the significant distinction, however, that within cultural relations 'the outcomes of ideology or consciousness are not determined in the same kind of way as in economic or political relations' (p. 234). This argument emphasizes the importance of understanding just how ideology, culture and consciousness are related to each other and thus how any 'outcomes' of their relationship might be analysed.

This is not a simple matter, however. The category of ideology is still a major theoretical problem, within both cultural studies and Marxist theory in general. It is now customary for cultural studies' adoption of Althusserian models of ideology in the 1970s to be represented as utterly deterministic, utterly mechanical. Within many contemporary accounts, the similarities between Althusser and Gramsci are glossed over and the differences exaggerated to legitimate the adaptation of Gramsci's theory of hegemony as a necessary correction to Althusserianism. However, just as Althusser's theoretical dominance during the 1970s produced numerous critiques and ultimate revision,[1] the later dominance of Gramsci has provoked debate as well (Bennett 1992; Harris 1992; Philo 1990). Accordingly, even the relatively widely accepted positions canvassed in this chapter must be understood as provisional and contestable.

Nonetheless, we can construct something of an orthodox history of cultural studies' development of the category of ideology, beginning with the appropriation of Althusserian theory during the 1970s and the gradual incorporation of Gramscian theories of hegemony to resolve the culturalism/structuralism split.

Significantly, Gramsci sees ideology as a site of particularly vigorous contestation, and the popular culture as a source of considerable resistance to hegemonic formation. Since the late 1980s this view of popular culture, coupled with the development of the notion of pleasure as a force that may oppose the workings of ideology and with postmodernist theories that privilege sensation over meaning, has encouraged something of a retreat from ideology as the all-powerful determining force it seemed to be in the 1970s. I wish to sketch out this theoretical narrative in this chapter, a chapter that will necessarily both recall and amplify the discussions of ideology presented in earlier chapters.

THE RETURN OF THE REPRESSED

I will begin with what is still the most comprehensive attempt to formulate a cultural studies orthodoxy on ideology so far, Stuart Hall's 'The Rediscovery of "Ideology": The Return of the "Repressed" in Media Studies' (1982). This article knits together the major European theoretical influences on cultural studies – Saussure, Lévi-Strauss, Barthes, Lacan, Althusser, Gramsci – within a history of ideology's 'repression' and recovery in media research. Some of Hall's early explanatory manoeuvres have been repeated in this book, so the following does not need to be a full account. Nor, it should be said, is the article itself able to present a full account of the workings of ideology across the whole spectrum of cultural studies' interests. Hall provides, predominantly, an account of ideology within the text, treating the function of ideology within the construction of everyday life as a secondary concern. He does, however, distance himself from a simple structuralist appropriation of Althusser, and his adoption of a theory of hegemony represents a significant shift away from the predominantly textualist theoretical formation of both his own work at the time (1981) and the field of study itself.

'The Return of the "Repressed"' deals specifically with the study of the media, and nominates three distinct phases in media research from the 1920s to the present. Hall concentrates on the break between the second and third phases; the second phase (roughly from the 1940s to the 1960s) is dominated by the sociological approaches of 'mainstream' American behavioural science, while the third phase (from the late 1960s to the present) sees the development of 'an alternative, "critical" paradigm' (1982: 56). Hall charts this paradigm shift as one marked not only by differences in methods or research procedures, but also by differences in political and theoretical orientations. The category of ideology is the key to these differences: 'The simplest way to characterize the shift from "mainstream" to "critical" perspectives is in terms of the movement from, essentially, a behavioural to an ideological perspective' (p. 56). Within the behavioural perspective

ideology was 'repressed'; within the 'critical' (that is, for our purposes, cultural studies) tradition it was recovered as the central category that connected the media to society. Hall's article concludes by outlining the ways in which the function of ideology is understood within this critical tradition.

The first phase of media research (from the 1920s to the 1940s) can be exemplified by the work of the Frankfurt School, and indeed by the British variant in the 'culture and civilization' tradition we met in Chapter 2. Researchers in this phase saw the media as a powerful and largely unmediated force that had entirely negative effects on mass culture. This diagnosis was ultimately rejected, Hall suggests, by the second phase: mainstream American mass communication research in the 1960s. This body of work questioned the earlier assumptions of media power – most importantly, television's potential to produce either positive or negative effects independently. Because it employed a very simple idea of media messages, and of social structure, American mass communication research was able to see the media as unproblematically reflective of society. If society was composed of a plurality of different groups, then this plurality would naturally be expressed within the media – as in other aspects of democratic society. If all social groups had access to the media, as they presumably did in all democratic countries, then their interests were in no danger of being ignored or suppressed. Capitalist democracies were congratulated for becoming 'pluralist' societies in which all points of view contributed to the forming of cultural values – a broadly consensual formation founded on the tolerance and incorporation of difference.

The Frankfurt School's warnings about the manipulative potential of mass culture were made redundant by pluralism; mass communication theorists even announced an 'end to ideology', the abolition of unresolvable social or political conflicts (p. 60). Although there was little attempt to interrogate the processes that produced the normative consensus upon which pluralism rested, there was no doubt that it *was* formed and that the media played an unproblematic role within it:

> At the broader level, the media were held to be largely reflective or expressive of an achieved consensus. The finding that, after all, the media were not very influential was predicated on the belief that, in its wider cultural sense, the media largely reinforced those values and norms which had already achieved a wide consensual foundation. Since the consensus was a 'good thing', those reinforcing effects of the media were given a benign and positive reading.
>
> (Hall 1982: 61)

Hall goes on to explain that this comfortable faith in consensus was soon dealt a powerful blow by deviance theory, which focused on those who were *not*

included within the consensual definitions of the normal and the acceptable. Deviance theory revealed pluralism to be a sham, its norms serving the interests of a discriminatory definition of society and actively participating in the subordination of groups that did not fit this definition. While the definitions of specific groups as deviant were characteristically justified through reference to *natural* conditions – as with the ill, the insane or the deformed – this did not explain the deviant status attributed to blacks, the poor, political demonstrators and so on. Deviance theory revealed that the 'differentiations between "deviant" and "consensus" formations were not natural but socially defined'; furthermore, they were 'historically variable' (p. 62). (As noted earlier in this book, the treatment of environmentalists over the last few years has demonstrated this 'historical variability'.) A benign and democratic process now stood exposed as a cultural power game in which the 'consensus ascribers' defined the rules and thus determined the result.

Consensus was, then, constructed: it was a form of social order that entailed the 'enforcement of social, political and legal discipline', and that necessarily served 'the given dispositions of class, power, and authority' (p. 63). This understood, the next question to be asked was 'whether the consensus did indeed spontaneously simply arise or whether it was the result of a complex process of social construction and legitimation' (p. 63). This, in turn, raised questions about the role of the media in such a process:

> For if the media were not simply reflective or 'expressive' of an already achieved consensus, but instead tended to reproduce those very definitions of the situation which favoured and legitimated the existing structure of things, then what had seemed at first merely a reinforcing role had now to be reconceptualised in terms of the media's role in the process of consensus formation.
>
> (Hall 1982: 63–4)

The formation of the 'definitions of the situation' was itself a process that deserved analysis; if definitions could vary, and if they tended to be produced in ways that favoured the existing social order, then the supposedly reflective role of the media, and indeed of language, needed to be reassessed. This reassessment inevitably led to the conclusion that 'reality could no longer be viewed as simply a given set of facts: it was the result of a particular way of constructing reality' (p. 64).

The construction of 'the real' through the media consequently returned to the foreground, replacing the idea of reflection as the major issue in critical media research. A casualty of such a focus was the pluralist model of social order, which saw 'the real', as it were, as naturally emerging rather than produced by represen-

tation, and cultural power as widely dispersed throughout the society rather than concentrated within dominant interests. The critical paradigm not only challenged the 'naturalness' of the real, but also argued that the media were a key mechanism for the maintenance and exercise of centralized cultural power – responsible for 'influencing, shaping, and determining [an individual's] very wants' (p. 65). This influence was not exercised through the direct transmission of instructions from A to B, but rather through the ideological shaping and structuring of media representations of the world, of 'the real', of the 'natural':

> [This was] a way of representing the order of things which endowed its limiting perspectives with that natural or divine inevitability which makes them appear universal, natural and coterminous with 'reality' itself. This movement – towards the winning of a universal validity and legitimacy for accounts of the world which are partial and particular, and towards the grounding of these particular constructions in the taken-for-grantedness of 'the real' – is indeed the characteristic and defining mechanism of 'the ideological'.
>
> (Hall 1982: 65)

The cultural function of ideology

This return of ideology to the agenda of media research opens the way for discussion of the cultural function of ideological processes. Hall suggests these inquiries took place on two fronts: the first was the territory of cultural reception, and focuses on the elaboration of ideology in language(s); the second was the articulation of ideology into social formations, the territory of cultural production.

Hall begins with language, drawing on post-Saussurean structuralist appropriations of semiotic models that use the language system as an analogy for all signifying structures – social practices, narratives, myths. As we saw in Chapter 1, Saussure argues that, since meaning is not inherent in things, it has to be attributed culturally. Further, 'different kinds of meanings can be attributed to the same events'. Hall asks how this process of attribution is structured: How does one meaning win credibility and acceptance while alternative meanings are downgraded and marginalized?

> Two questions followed from this. First, how did a dominant discourse warrant itself as *the* account, and sustain a limit, ban or proscription over alternative or competing definitions? Second, how did the institutions which were responsible for describing and explaining the events of the world – in

modern societies the mass media, *par excellence* – succeed in maintaining a preferred or delimited range of meanings in the dominant systems of communication? How was this active work of privileging or giving preference practically accomplished?

(Hall 1982: 67–8)

Both questions are about the 'politics of signification', the ways in which the social practice of making meanings is controlled and determined. Neither question has yet been categorically answered; however, the attempts to provide answers have focused on the relation between ideology and discourse, and between ideology and institutional structures.

The account Hall goes on to develop focuses on the media's use of their power to 'signify events in a particular way' (p. 69), and stresses the fact that this ideological power is always contested: ideology becomes a site of struggle and a prize to be won, not a permanent possession of dominant groups. But he also reminds the reader that ideology has deeper roots than the social practices of media production; it structures the most basic systems of cultural organization. (In Chapter 1, I used the definition of gender as an example of this.) Every culture has its own 'forms of episodic thinking' that provide its members with 'the taken-for-granted elements' of their 'practical knowledge' (p. 73). This 'common sense' is rarely made explicit, and is often in fact unconscious, but it too is built upon a comprehensive foundation of ideological premises.[2]

A feature of the 'way things are signified' to us is the invisibility of the process of signification itself. Propositions about the world implied within a news report (the superiority of capitalism over other social systems, for instance) become merely descriptive statements – 'facts of the case' (p. 74). The effect of ideology in media messages is to efface itself, allowing the messages to appear as natural and spontaneous presentations of 'reality'. Hall talks of this phenomenon as 'the reality effect'. Not only do we generally understand reality as 'a result or effect of how things had been signified', but we also 'recognize' specific representations of reality as obvious. The circle closes, as this recognition effectively validates the representation:

But this recognition effect was not a recognition of the reality behind the words, but a sort of confirmation of the obviousness, the taken-for-grantedness of the way the discourse was organized and of the underlying premises on which the statement in fact depended. If one regards the laws of a capitalist economy as fixed and immutable, then its notions acquire a natural inevitability. Any statement which is so embedded will thus appear to be merely a statement about 'how things really are'. Discourse, in short, had the effect of sustaining certain

'closures', of establishing certain systems of equivalence between what could be assumed about the world and what could be said to be true. 'True' means credible, or at least capable of winning credibility as a statement of fact. New, problematic or troubling events which breached the taken-for-granted expectancies about how the world should be, could then be 'explained' by extending to them the forms of explanation which had served 'for all practical purposes', in other cases. In this sense, Althusser was subsequently to argue that ideology, as opposed to science, moved constantly within a closed circle, producing, not knowledge, but a recognition of the things we already knew. It did so because it took as an already established fact exactly the premises which ought to have been put in question.

(Hall 1982: 75)

Hall highlights a number of concepts that follow from this 'reality effect'. First is the idea of naturalization – the representation of an event or a discourse such that it is legitimated by nature rather than problematized by history. Second is the polysemy of language, which held that the same set of signifiers could produce different meanings and thus made the effect of naturalization something to be worked at, produced. And third is the fact that meaning, once it is seen in this contingent way, 'must be the result ... of a social struggle' (p. 77). Before taking up this last point, Hall warns against collapsing the notion of ideology into that of language. They are not the same thing, and ideology must be articulated through language. Second, he notes that the struggle over meaning is not to be reduced to a class struggle:

Though discourses could become an arena of social struggle, and all discourses entailed certain definite premises about the world, this was not the same thing as ascribing ideologies to classes in a fixed, necessary or determinate way. Ideological terms and elements do not necessarily belong in this definite way to classes; and they do not necessarily and inevitably flow from class positions.

(Hall 1982: 80)

Just as cultural studies theorists have resisted a reduction of the cultural to its economic determinants, this view of discourse and ideology is reluctant to equate them with class affiliations.

The reason, in both cases, is the insistence on the 'relative autonomy' – in the first place, of culture and, in the second place, of ideology – of cultural forms from economic conditions:

The fact that one could not read off the ideological position of a social group or individual from class position, but that one would have to take into account how the struggle over meaning was conducted, meant that ideology ceased to be a mere reflection of struggles taking place or determined elsewhere. ... It gave to ideology a relative independence or 'relative autonomy'. Ideologies ceased to be simply the dependent variable in social struggle; instead, ideological struggle acquired a specificity and a pertinence of its own – needing to be analysed in its own terms, and with real effects on the outcomes of particular struggles.

(Hall 1982: 82)

Hall provides us with an example of this social struggle over meaning. In his brief account of the British general election of 1979 he reveals the power exercised through the 'definitions of the situation', highlighting the ideological effects of discourse while proposing that Thatcher's electoral victory was the profoundly material effect of a successful ideological bid to redefine the situation. He sets the scene by noting how closely the British working class had been aligned with the Labour party and the union movement until the prevailing definitions of this relationship were seriously challenged. The challenge hit at the heart of a hitherto 'natural' alignment and replaced it with another equally 'natural' construction of the union movement:

The theory that the working class was permanently and inevitably attached to democratic socialism, the Labour Party and the trade unions movement, for example, could not survive a period in which the intensity of the Thatcher campaigns preceding the General Election of 1979 made strategic and decisive inroads, precisely into major sectors of the working class. ... And one of the key turning-points in the ideological struggle was the way the revolt of the lower-paid public service workers against inflation, in the 'Winter of Discontent' of 1978–9, was successfully signified, not as a defence of eroded living standards and differentials, but as a callous and inhuman exercise of overweening 'trade-union power', directed against the defenceless sick, aged, dying and indeed the dead but unburied 'members of the ordinary public'.

(Hall 1982: 83)

In the final pages of his essay, Hall turns from language to the role of ideology within the social formation – social practices, class and other social groups, institutions. Here, too, he resists a reduction of the notion of ideological dominance to class domination. The idea that dominance was imposed by one class on all the others was always vulnerable to the contention that ideological dominance had to

be understood as something accomplished at the unconscious as well as the conscious level:

> [We need] to see it as a property of the system of relations involved, rather than as the overt and intentional biases of individuals; and to recognise its play in the very activity of regulation and exclusion which functioned through language and discourse before an adequate conception of dominance could be theoretically secured.
>
> (Hall 1982: 85)

The classical Marxist notion that the 'ruling ideas' are those of the 'ruling classes' is consequently jettisoned for the 'enlarged concept of hegemony':

> Hegemony implied that the dominance of certain formations was secured, not by ideological compulsion, but by cultural leadership. It circumscribed all those processes by means of which a dominant class alliance or ruling bloc, which has effectively secured mastery over the primary economic processes in society, extends and expands its mastery over society in such a way that it can transform and re-fashion its ways of life, its *mores* and conceptualisation, its very form and level of culture and civilisation in a direction which, while not directly paying immediate profits to the narrow interests of any particular class, favours the development and expansion of the dominant social and productive system of life as a whole. The critical point about this conception of 'leadership' – which was Gramsci's most distinguished contribution – is that hegemony is understood as accomplished, not without the due measure of legal and legitimate compulsion, but principally by means of winning the active consent of those classes and groups who were subordinated within it.
>
> (Hall 1982: 85)

Producing consensus

As Hall goes on to say, this last point is crucial. A weakness in the Marxist accounts of ideology had always been their failure to account for the 'free consent of the governed to the leadership of the governing classes'. While they had understood that political power was exercised by the dominant groups within a society, they had not understood that this was achieved through a *combination* of the maintenance of the cultural power of the minority and the active or inactive consent of the powerless majority. Hegemony managed to explain both processes.

This returns us to the problem foregrounded at the beginning of Hall's article, how to account for the production of consensus. As Hall says, the pluralists were right to focus on the media's consensual role, but wrong to assume that it simply reflected a consensus already existing out there in society. Rather, he says, the media institutions actually manufacture consent. It is still very difficult, nevertheless, to explain exactly how this process occurs, because media institutions are generally free of direct compulsion and constraint and 'yet freely articulate themselves systematically around definitions of the situation which favour the hegemony of the powerful' (p. 86). There is a structural relation that means the media can prize their independence from, but comply with, dominant definitions. Hall explains it this way:

> Now consider the media – the means of representation. To be impartial and independent in their daily operations, they cannot be seen to take directives from the powerful, or consciously to be bending their accounts of the world to square with dominant definitions. But they must be sensitive to, and can only survive legitimately by operating within, the general boundaries or framework of 'what everyone agrees' to: the consensus. ... But, in orienting themselves in 'the consensus' and, at the same time, attempting to shape up the consensus, operating on it in a formative fashion, the media become part and parcel of that dialectical process of the 'production of consent' – shaping the consensus while reflecting it – which orientates them within the field of force of the dominant social interests represented within the state.
>
> (Hall 1982: 87)

An important point to note here is that this process affects both state-owned and commercial media institutions; Hall's reference to the state is not meant to be taken too literally.[3] Further, the role of the media in constructing consent is not to be understood in terms of any 'bias' or deliberate 'distortion' in its representations of events:

> When in phrasing a question, in the era of monetarism, a broadcasting interviewer simply takes it for granted that rising wage demands are the sole cause of inflation, he is both 'freely formulating a question' on behalf of the public and establishing a logic which is compatible with the dominant interests in society. ... This is a simple instance, but its point is to reinforce the argument that, in the critical paradigm, ideology is a function of the discourse and of the logic of social processes, rather than an intention of the agent.
>
> (Hall 1982: 88)

This notion is often the most difficult to accept – that the broadcaster mentioned above will, unwittingly if not inevitably, 'speak' the dominant discourse. As we have seen throughout this book, the dialectic between autonomy and determination structures the articulation of ideology within language and within institutions. This makes it necessary to insist that the broadcaster might indeed frame his or her own specific view of the 'truth', but will do so from within an ideological framework that itself prefers some 'truths' and excludes others.

Hall concludes by reminding his reader that there is much work to be done in this area, and that the critical paradigm's position is by no means fully developed or secure.

THE TURN TO GRAMSCI

Hall's seminal essay centres on media research and only briefly examines the theoretical problems of outlining the function of ideology within popular culture in general. It says little about the relations between the individual subject and ideological structures. This aspect of cultural studies' notions of ideology has been frequently criticized:

> The Althusserian drift of much early cultural studies work ... would reduce [the individual subject] to the status of a mere personification of a given structure, 'spoken' by the discourses which cross the space of his subjectivity. However, it is not simply Althusser who is at issue here; much of the psychoanalytic work on the theory of ideology generates an equally passive notion of subjectivity, in which the subject is precisely 'spoken' by the discourses which constitute that person. I want to try to formulate a position from which we can see the person actively producing meanings from the restricted range of cultural resources which his or her structural position has allowed them access to.
>
> (Morley 1986: 43)

This is from Morley's *Family Television*. The fact that the issue is raised there underlines a key point: that the theoretical problems of the category of ideology underlie the key debates within *all* the areas we have canvassed so far – within the study of texts, of audiences, of subjectivities, of institutions and of the construction of everyday life. While the culturalism/structuralism split may now have dissolved, the three-way split of economic versus cultural determination versus individual agency still dominates, in one form or another, arguments about the formation of culture and the role of ideology. The power of the idea of hegemony is that it appears to accommodate all sides of this theoretical triangle: Gramsci's

work, while prefiguring Althusser's emphasis on the determining role of ideology and the state, offers a more complex definition of popular culture and of ideological struggle. In Gramsci's view, popular culture is the battleground upon which dominant views secure hegemony; further, it is a permanent battleground, the parameters of which are partly defined by economic conditions, but that specializes in political struggle expressed at an ideological, representational level.

Tony Bennett offers an account of the turn to Gramsci in the introduction to *Popular Culture and Social Relations* (Bennett *et al.* 1986). He outlines the strategic benefits of a theory of hegemony for the study of popular culture. He begins by noting that the culturalist and structuralist traditions in cultural studies, however else they may have differed, both saw culture as governed by dominant ideologies. Disputes prospered over explanations of the maintenance of this dominance and the precise diagnosis of its structure and effects, but culture was 'divided into two opposing cultural and ideological camps – bourgeois and working class'. Bennett suggests that Gramsci's radicalism within traditional Marxism lies in his resistance to this orthodox class-based formulation, and indeed to this orthodox view of ideology:

> Where Gramsci departed from the earlier Marxist tradition was in arguing that the cultural and ideological relations between ruling and subordinate classes in capitalist societies consist less in the *domination* of the latter by the former than in the struggle for *hegemony* – that is, for moral, cultural, intellectual and, thereby, political leadership over the whole of the society – between the ruling class and, as the principal subordinate class, the working class.
> (Bennett *et al.* 1986: xiv)

This is not a cosmetic or merely a terminological shift. The idea of hegemony does not suggest that domination is achieved by manipulating the worldview of the masses. Rather, it argues that in order for cultural leadership to be achieved the dominant group has to engage in negotiations with opposing groups, classes and values – and that these negotiations must result in some *genuine* accommodation. That is, hegemony is not maintained through the obliteration of the opposition but through the *articulation* of opposing interests into the political affiliations of the hegemonic group. There has to be some change in the political orientation of the dominant group in order to convince those it will lead to accept this leadership. Any simple opposition, such as that between the bourgeoisie and the working class, is dissolved by such a process:

> As a consequence of its accommodating elements of opposing class cultures, 'bourgeois culture' ceases to be purely or entirely bourgeois. It becomes,

instead, a mobile combination of cultural and ideological elements derived from different class locations which are, but only provisionally and for the duration of a specific historical conjuncture, affiliated to bourgeois values, interests and objectives. By the same token, of course, the members of subordinate classes never encounter or are oppressed by a dominant ideology in some pure or class essentialist form; bourgeois ideology is encountered only in the compromised forms it must take in order to provide some accommodation for opposing class values.

(Bennett *et al.* 1986: xv)

Hegemony offers a more subtle and flexible explanation than previous formulations because it aims to account for domination as something that is won, not automatically delivered by way of the class structure. Where Althusser's assessment of ideology could be accused of a rigidity that discounted any possibility of change, Gramsci's version is able to concentrate precisely on explaining the process of change. It is consequently a much more optimistic theory, implying a gradual historical alignment of bourgeois hegemony with working-class interests. Most important, while Gramsci's account clearly recognizes the function of the state and of public culture, it also foregrounds the ideological role of the representation of 'common sense', the power of the 'taken-for-granted', and thus the importance of the entire field of popular culture.

Bennett stresses the fact that Gramsci actually defines popular culture by acknowledging the very contradictions that have been ignored in many previous definitions; in Gramsci's view, popular culture is both dominated and oppositional, determined and spontaneous:

To the degree that it is implicated in the struggle for hegemony ... the field of popular culture is structured by the attempt of the ruling class to win hegemony and by the forms of opposition to this endeavour. As such, it consists not simply of an imposed mass culture that is coincident with dominant ideology, nor simply of spontaneously oppositional cultures, but is rather an area of negotiation between the two within which – in different particular types of popular culture – dominant, subordinate and oppositional cultural and ideological values and elements are 'mixed' in different permutations.

(Bennett *et al.* 1986: xv–xvi)

This holds the competing forces within the popular in balance, avoiding the reductionism and economism of other descriptions while still insisting on the importance of popular culture as the field upon which political power is negotiated and legitimated.

Bennett notes a number of advantages the theory of hegemony has delivered to cultural analysis. First, and as we have seen already, it has disposed of a class essentialism that linked all cultural expression to a class basis. Second, it has made it possible to examine popular culture without necessarily taking a position for or against its particular manifestations (that is, without being critically elitist or uncritically populist). Third, it has underlined how *movable* the 'political and ideological articulations of cultural practices' can be: a specific cultural practice does not carry a particular ideological significance eternally, and so it is theoretically possible to produce, for instance, a feminist version of Hollywood romance. This 'opens up the field of popular culture as one of enormous political possibilities' (p. xvi). And finally, Bennett argues, the attack on class reductionism allows for due account to be taken 'of the relative separation of different regions of cultural struggle (class, race, gender)' (p. xvi). There is certainly still much to be done in this area, but Gramsci does provide an integrating framework that, notwithstanding its totalizing tendencies, admits difference and contradiction as essential constituents of culture and ideology.

It is possible, as Chantal Mouffe (1981) has noted, to see Gramsci as having anticipated Althusser in a number of areas: interest in the 'material nature of ideology, its existence as the necessary level of all social formations and its function as the producer of subjects' (1981: 227) occurs within Gramsci's writings but is only fully formulated much later by Althusser. The crucial difference between them lies in the central role negotiation and change play within Gramsci's model of society. Mouffe describes how Gramsci envisaged the process of intellectual and thus political reform through the transformation of ideologies. It is a process in which various elements within an ideological system are rearranged and then integrated, or 'articulated', into a new system:

> According to [Gramsci], an ideological system consists in a particular type of articulation of ideological elements to which a certain 'relative weight' is attributed. The objective of ideological struggle is not to reject the system and all its elements but to rearticulate it, to break it down to its basic elements and then to sift through past conceptions to see which ones, with some changes of content, can serve to express the new situation. Once this is done the chosen elements are finally rearticulated into another system.
>
> (Mouffe 1981: 231)

As Mouffe points out, such a process cannot be understood as reducible solely to class interests. Rather, the transformed ideological system will draw its elements from varying sources, all contributing to a common 'worldview' that passes for the organic and natural expression of the whole bloc of dominant and

consenting groups. The turn to Gramsci reaffirms the importance of under-standing ideology, but categorically withdraws from the installation of a monolithic or mechanical explanation of its workings. This more historically contingent and negotiated view reinforces claims for concrete practical analysis of ideological formations within cultures, as against a mechanical 'reading off' of ideological meanings from cultural forms. Hegemony describes the attempt to produce uniformity and coherence, but it also implies that such attempts must always, eventually and necessarily, fail. Therefore the analysis of cultural forms and practices should involve a search for 'contradictions, taboos, displacements in a culture' that might fracture the fiction of homogeneity. As Richard Johnson (1979b) has noted, Gramsci's view of the relation between the base and the super-structure is unique because it assumes, as its very ground, the existence of 'massive disjunctions and unevenness'. As a consequence of the incompleteness of any hegemonic tenure, there is always some residue of previous formations, surviving 'concrete features of a society that cannot be grasped as the dominant mode of production and its conditions of existence' (1979b: 233), but that still need to be explained.[4] Since the turn to Gramsci, cultural studies is better equipped to provide such explanations.

THE RETREAT FROM IDEOLOGY: RESISTANCE, PLEASURE AND THE NEW REVISIONISM

Readers might remember how vigorously cultural studies resisted the political economists' 'top-down' version of ideology; such a view marginalized the cultural into a mere effect of other forces and reduced the subject to a mere junction box within a complex but remote communications system. Cultural studies has been, constitutionally, much happier with 'bottom-up' versions of ideology; such versions attribute power to the subject and to the subcultural group to intervene in the signifying and political systems, and to produce change. Culturalism clearly adhered to such a view, and many structuralist interrogations of the Althusserian dominant ideology thesis indicated their sympathy with it too. Gramsci's theory of hegemony does seem uniquely well designed for its ultimate deployment as the consensual principle within cultural studies' conceptions of ideology. It does allow for power to flow 'bottom up', and severely qualifies assumptions about the effectiveness of power imposed from the 'top down'. It is not alone, however, in its role as a support for theories of resistance to ideological domination. The latter half of the 1980s was marked by a proliferation of interest in the ways in which ideologies *fail* to determine, *fail* to interpellate the subject, *fail* to prefer readings. We have already seen how such a function has been served by the appropriation of ethnography within audience studies; there are other locations as well.

De Certeau and resistance

Michel de Certeau is an influence in this area. In *The Practice of Everyday Life* (1984), de Certeau emphasizes the tactics employed by subordinated groups to win small victories from larger, more powerful and ultimately determining systems. De Certeau argues that, while members of popular culture cannot gain control of the production of culture, they do control its consumption – the ways in which it is used. Like ethnographic audience researchers, de Certeau emphasizes how creative popular culture is, how its members continually seek out ways of operating that serve their own interests while appearing to acknowledge the interests of the dominant group. If popular culture has to 'make do' with what is offered to it, it still has the potential to 'make over' these offerings to its own ends. De Certeau suggests that much of this 'making do' with and 'making over' of cultural forms and products is subversive; it represents the victory of the weak over the strong. Examples of the kinds of practices in which such subversions operate include reading, shopping, cooking, even renting an apartment:

> [Renting] transforms another person's property into a space borrowed for a moment by a transient. Renters make comparable changes in an apartment they furnish with their acts and memories; as do speakers, in the language into which they insert both the messages of their native tongue and, through their accent, through their own 'turns of phrase' etc, their own history.
>
> (de Certeau 1984: xxi)

When de Certeau talks of renting a house as an insinuation of oneself into another's place, he is choosing to emphasize not the economic power the landlord has over the tenant, but the tenant's power to change the nature of the space itself: in addition to simply living in the apartment, the tenant can repaint, move the furniture, redecorate, change the garden, fill the premises with friends or offend the neighbours by playing loud music or having parties. Through such tactics, the tenant will actively serve his or her own ends and implicitly challenge the power of ownership enjoyed by the landlord; this, while still paying rent and thus serving the landlord's economic interests. Shopping, similarly, offers little opportunity for the denial of the economic relationship between buyer and seller, but buyers can invent their own uses for the products they purchase; youth subcultures provide particularly rich examples of the appropriation of everyday objects for scandalous use. Even window-shopping can be seen as a 'making over' of the pleasure of buying into the pleasures of the spectacle, of the imagination.[5]

De Certeau discusses a particularly clear example of 'bottom-up' power: the use of employer's time by the employee – '*la perruque*', which means 'the wig'. '*La perruque*' may be the personal phone call on the work phone, using the machine

shop to make home furniture in the lunch hour, or the appropriation of office stationery. It has the practical effect of saving the employee money, and the additional pleasure (for the employee) of costing the employer money. It also has the ideological effect of resistance: it undermines a system that is meant to discipline the worker. The cooperative code of silence observed by other workers aware of the operation of '*la perruque*' actively subverts the cellular, competitive regime essential to the maintenance of discipline within the workplace.

One can see the similarity between de Certeau's approach and that taken by, say, Hebdige in *Subculture: The Meaning of Style* (1979). In both cases, a process of *bricolage* makes over cultural forms and practices in order to produce moments of resistance, opposition, subversion. The raw materials of subcultural dress styles are mass-produced, commercially marketed garments; their combination in a range of subcultural styles from skinheads to Goths offends and subverts conventional notions of fashion. Such a phenomenon would not surprise de Certeau; indeed, he implies that within popular culture generally the imposition of a system of control almost inevitably invites its subversion. Examples of this are not hard to locate. For many school pupils in Britain and Australia, for instance, uniforms are compulsory. Their actual function, however, is not only to serve as a sign of the institution and of the pupil's submersion in it; they also operate as the chosen battleground on which students test and challenge school authority by their creative modification of the uniform's details – the length of the skirt, the colour of the shirt, the cut of the trousers, the width of the tie, the outlawed decoration or hairstyle and so on. Thus, while cultural structures are strategically organized to control the kinds of meanings and pleasures we produce, they are always vulnerable to the possibility that we may actually use these structures to produce subversive, resistant effects.

De Certeau's work has been appropriated by cultural studies and, as we saw earlier, is particularly evident in John Fiske's recent writings. Fiske (1988) defends its usefulness by claiming that 'we have for too long simplistically equated power with social determination and have neglected to explore how resistant, evasive, scandalising bottom-up power actually operates' (p. 249). He argues that now we need to extend our understanding of 'the forces of domination and their effectivity' to those measures 'we' use to deal with them every day. Fiske is by no means the only one to have turned his attention to the other side of the ideological coin. Indeed, the combined effect of a range of new critiques and approaches has threatened to sideline the notion of ideology altogether. The influence of Foucauldian theories of discourse and their focus on the operation of power upon the body – thus disciplining behaviour without even needing to organize ideas (the disciplinary regime of the prison, for instance); feminist critiques of the construction of subjectivity with the consequent recovery of 'the

private' as an arena for cultural analysis; and new varieties of theories of resistance such as Willis's 'symbolic creativity' (1990) have made the practice of the 'ideological critique' less fashionable. In addition, the determining power of ideology is significantly challenged by two theoretical developments which have emerged since the mid-1980s: the examination of the role of pleasure and postmodernism.

Pleasure

The introduction of pleasure as a category separate from ideology has changed the landscape of cultural studies. Within earlier formations, the pleasures of popular culture were seen to be the sugared pill of ideology and were interrogated for the politics they administered. Giving oneself over to the sensory pleasures of popular film, television or music was surrendering to the 'enslaving violence of the agreeable' (Bourdieu, quoted in Mercer 1986: 60). There has been a competing perspective, however, that has gathered force more recently and that draws on a number of different influences. First, Bakhtin's theory of 'the carnivalesque' has been widely and often carelessly adapted to conceive popular culture as intrinsically a source of resistance – its illicit, denigrated pleasures not only offending but also subverting the control of its masters.[6] One can see how this might dovetail with Brechtian notions of the popular as somehow organic and authentic, the natural source of opposition to bourgeois domination.[7] The appropriation of 'the carnivalesque' has been attacked as a misunderstanding of Bakhtin's (1968) original idea, an idea specific to a particular discussion of Rabelais, and as a romantic populism that grossly exaggerates the political power of popular pleasures (see Bennett 1986b: 14–15). It certainly commits the essentialist error of attributing particular ideologies to particular cultural forms and particular class formations. Nevertheless, the proposition that popular culture systematically produces events, attitudes and modes of entertainment that break conventions and challenge their founding assumptions has considerable force. Television, as Hartley (1982) has pointed out, is a medium that can be both mundane and scandalous. As I have argued elsewhere, among the pleasures television offers is the spectacle of its formulas, its formal regimes, being fractured. Examples of such spectacles occur particularly in live TV; in technical hitches and foul-ups (visible in domesticated form in such programmes as *Foul-Ups, Bleeps and Blunders*), but also in transgressive and parodic TV drama such as *Ally McBeal* or the early episodes of *Moonlighting*, anarchic TV comedy such as *The Young Ones* and *The Fast Show*, or the various incarnations of the *Saturday Night Live* satire and variety concept (Turner 1989). If the spectacle of the boundaries being transgressed *is* among the distinctive pleasures of popular TV

one can understand the continuing interest in notions of transgression and the carnivalesque.

The second, and perhaps more important, influence is from Roland Barthes, who has separated one aspect of pleasure entirely from ideology. *Jouissance* is the physical pleasure Barthes says may be produced by the literary text. Barthes (1975) likens *jouissance* to orgasm; it is an overwhelming expression of the body and is thus beyond ideology, a product of nature rather than of culture.[8] Barthes' initial suggestion has been widely taken up; by some the body has been separated off and made the location for the last stand, as it were, against cultural determination. The idea releases other potentials as well – of addressing areas of experience that have been left out of the accounts so far: sexual pleasure, for one, but also laughter, or the visceral pleasures some find on roller coasters and others find watching car chases on movie screens. There is now a large international literature that theorizes the body in this way through the perspectives of gender, sexuality and identity (cf. Grosz and Probyn 1995). The interest in the body offers new arguments about the function of certain cultural practices – such as those around food, for example (Probyn 2000). It is important to remember, though, that this runs as a complicating stream within a much more substantial history of feminist theory that sees the female body as overwhelmingly the product of determining ideological systems. Sue Thornham (2000) deals with this tradition at some length (see Chapter 7 for more on this). That said, within the body of work I am addressing here, it does seem logical to assume that there may be pleasures the body will produce irrespective of ideology; if so, then ideology would come into the picture in determining our understanding of these pleasures.

All of this represents, potentially at least, a radical *volte-face* for Marxist cultural analysis. Barthes' notion calls up something very similar to the romantic ideal of the essential individual who experiences such pleasure, and who does so beyond the appeal of ideology. If the body, as the location of pleasure, is seen to be separable from 'a subject' that is constructed through language and ideology, then we have reached the limits of theories of ideology:

> Any analysis of the pleasure, the modes of persuasion, the consent operative within a given cultural form would have to displace the search for an ideological, political, economic or, indeed, subjective *meaning* and establish the coordinates of this 'formidable underside'. And I think that we have to take the concept of *jouissance* (orgasm, enjoyment, loss of stasis) with a pinch of salt as a sort of a 'nudge' in a certain direction because what we are really concerned with here is a restructuring of the theoretical horizon within which a cultural form is perceived.
>
> (Mercer 1986: 55)

We have already seen how this 'nudge in a certain direction' has been taken. In previous chapters it has been implicated in the focus on the ambiguity of the text, on semiotic excess within textual studies; in the recovery of the polysemy of the message in audience studies; and in the insistence on the subjective experience of everyday life within ethnographies. All these strategies attempt to account, in one way or another, for a dimension of the subjective experience of cultural forms and practices that is in some way resistant to dominant ideologies.

Fiske's *Television Culture* (1987b), while by no means deserving the bogeyman status it seems to have acquired, still represents the most uncompromising use of this understanding of pleasure (see the review by Bee 1989); it celebrates popular television as playfully resistant to ideological control. Television is a 'semiotic democracy' that recognizes the rights of consumers to make what sense they will of the pleasures on offer and rewards them through a process of 'empowerment'. And yet pleasure is also hegemonic, inscribing the subject into a message that is marked by its structured polysemy – as well as by its negotiated character. His critics suggest that the impulse to recognize the importance of such pleasures as those produced by ritual or spectacle, or to acknowledge the textual openness of 'live' television or of the (then) new forms such as the music video, paints Fiske into a corner. His view of the popular becomes so optimistic, so celebratory, that there seems little need to worry about the function of representation in reproducing the status quo. Similarly, Willis's *Common Culture* (1990) is so intent on understanding the productive uses of popular culture that it overstates the political effects that might flow from such uses. John Hartley's *Uses of Television* (1999) also offers an optimistic reading of the democratic potential of a pluralizing media, even though this is grounded in a particular moment rather than offered as a permanent attribute of the relation between television and the audience.

Critics of such arguments remind us that the central conflict between determination and agency must be maintained in cultural studies. Though we must retain a sense of the transgressive or tactical possibilities of popular culture, it is also essential to retain a sense of the frame within which they are produced, within which even the carnivalesque must be licensed. One does not ask for a return to the analyses of the 1980s, which took an elitist critical view of popular pleasures in order to see them as the uncomplicated bearers of dominant ideologies. However, one might argue that it is important to acknowledge that the pleasure of popular culture cannot lie outside hegemonic ideological formations; pleasure must be implicated in the ways in which hegemony is secured and maintained. As Mercer (1986) says, it is 'absolutely crucial' that we attempt to understand this, that we 'engage with' the 'currency' of popular culture, 'with the terms of its persistence, its acceptability and its popularity' and with 'the specific ways in

which we *consent* to the forms of popular culture' (1986: 50). Pleasure, whether ideologically or physically produced, is among the means of production of this consent.

Determinism, agency and cultural populism

The relations among pleasure, cultural power, desire and popular culture have not so far been adequately theorized; they constitute a key current issue for cultural studies. As Terry Lovell (1980) said some time ago, too much of the work on pleasure has concentrated on individual desires and pleasures, omitting those that derive from and create shared, collective experiences: 'collective utopias, social wish fulfilment and social aspirations' (1980: 61). We simply do not know how pleasure aligns us with or supports us against dominant views of the world. We do not even know how texts produce all their varieties of pleasure, although this has not prevented many of us from naming what we think are the particular pleasures of specific texts. There is some progress being made, however. We can say that pleasure must not be understood as either 'solidly ideological/repressive or solidly liberatory'; furthermore, we can say that there is 'no *general* form of pleasure with ascertainable political and cultural effects' (Mercer 1986: 67). John Hartley's recent work on television (1999) interrogates the collective experience of the medium; Morley (2000) deals directly with the role of the media in constructing the definition of 'home' and 'nation'. And the development of the territory of cultural consumption discussed in Chapter 4 seems to hold enormous potential for precisely the issues Terry Lovell raises – as issues of pleasure mutate into questions of consumption, identity and everyday life.

During the second half of the 1980s it seemed that British cultural studies, as a product of its Gramscian revision of Althusserian models of the dominant ideology thesis, had become more interested in the resistance to, rather than the reproduction of, dominant ideologies. To some observers, the publication of Fiske's *Television Culture* and the new emphasis on agency within audience studies by Radway, Ang, Buckingham and others constituted such an endorsement of the popular audience's capacity to resist the workings of hegemony that capitalism had ceased to be a problem. Meaghan Morris's (1988) attack on the celebration of 'banality in cultural studies' suggested that the interest in cultural democracy had gone too far: 'it sees mass culture not as a vast banality machine but as raw material made available for a variety of popular practices'. This trend, she argued, seemed to be dominating the intellectual field:

I get the feeling that somewhere in some English publisher's vault there is a master disk from which thousands of versions of the same article about

pleasure, resistance and the politics of consumption are being run off under different names with minor variations.

(Morris 1988: 21)

As a result, Morris suggested, the critical project of cultural studies evaporated. What Morris called 'the banality' of cultural studies, James Curran (1990) called the 'new revisionism'. Critiques of the new revisionism were energetic and frequent in the early 1990s. David Harris's attack on what he called 'the politics of pleasure' saw 'highly refined and cultivated populism' as the problem, 'designed to raise the morale of the radical petit bourgeois' (1992: 170) – that is, those who practise cultural studies. And populism was the target of the most developed critique, Jim McGuigan's *Cultural Populism* (1992).

McGuigan acknowledges the fundamental importance of the populist tradition within British cultural studies. It is this tradition which motivates the attacks on elite definitions of culture and focuses attention on the productivity of, as well as the determinations on, everyday life. What starts out, however, as a retrieval of particular class experiences of everyday life – especially working-class experiences – ends up, according to McGuigan, as 'an uncritical celebration of mass-popular cultural consumption' (1992: 49). McGuigan traces the beginning of the problem to British cultural studies' attempt to reconcile the Althusserian dominant ideology thesis with conceptions of the active audience, but sees the 'turn to Gramsci' as exacerbating the trend towards what he calls a 'consumptionist' view of culture. Such a view, says McGuigan, ignores the social, political and economic frame within which popular culture is produced and thus overestimates the degree of freedom enjoyed by the individual subject when making his or her own meanings within popular culture. Cultural populism's disinterest in the insights provided by political economy is of particular concern to McGuigan, as it is to other critics of the new revisionism such as Curran and Schlesinger.

In summary, McGuigan argues that there is an uncritical populist drift in contemporary cultural studies; that cultural populism's solidarity with ordinary people has become increasingly sentimental and thus increasingly apolitical; that the taken-for-granted schism between micro-processes of meaning and macro-processes of political economy is one of the main reasons for cultural populism's limitations, its tendency to overestimate the political effect of the processes it celebrates; and that the grounds for criticism of this situation have been 'deconstructed in response to the postmodern condition' – by which he means that theories of postmodernity have exacerbated the 'consumptionist' trend in cultural studies (pp. 171–4).

Cultural Populism is better at diagnosing the problem than it is at providing examples of alternative modes of analysis, but it received a deal of assent when it

was first published. The phenomenon it attacks, however, had virtually run its course by 1992. Encounters with this kind of cultural populism in contemporary British cultural studies are relatively uncommon now, as the pendulum's movement away from containment and towards resistance seems to have reached the end of its trajectory. Nevertheless, McGuigan's book describes a moment when cultural studies seemed on the brink of retreating from the category and effectivity of ideology altogether.

Cultural Populism sounded a further resonant note in associating the rise of cultural populism with theories of postmodernism. For McGuigan, as we can deduce from the points made earlier on, postmodernism plays an ambiguous role in British cultural studies. On the one hand, its influence has disabled the kind of criticism of consumptionist positions he recommends in his book; on the other hand, he welcomes some aspects of postmodern theory because they reconnect 'cultural analysis with political economy' (p. 217). McGuigan's ambivalence remains representative of British cultural studies in general.

POSTMODERNISM

The proposition of the arrival of the postmodern era has, of course, been massively influential within the social sciences and the humanities, as well as within popular discourses in the media and in design professions such as architecture. Originally drawn from arguments made within architecture, theories of postmodernity suggest we are experiencing a break with some of the fundamental assumptions of modernity. As we shall see below, evidence of this break is discovered in a dizzying range of cultural and economic forms and trends, but they all share the capacity to fracture and fragment continuities, histories, traditions and forms. Identified by Jameson (1991) with shifts in the structure and process of late capitalism, and by Baudrillard (1981) with the changing cultural function of representation, postmodernism is enormously expansive in its implications and notoriously difficult to define. Postmodernism's own conscientious scepticism about stable definitions, 'grand' explanatory narratives and the status of the history it sets out to periodize, contribute to this difficulty.

This book cannot provide a primer on postmodernism. There is not the space required and in any case it has exerted only limited influence on cultural studies practice in Britain so far – and it seems the moment when it might exert a stronger influence has now passed. Postmodernism has, nevertheless, been a persistent presence within broader debates, particularly those converging around the notions of dominance and hegemony. As we have seen already, its contributions have also reinforced the trend towards provisionality in textual analyses within

189

cultural studies. Relevant aspects of postmodernist theory in this context include its postulation of the disconnection between the signified and the signifier; the free play of the signifier privileging the power of the reader to decode the message in his or her own interests; and, in some of its formulations, the celebration of the popular which emerges from a critique of modernist (that is, elitist or progressive) accounts of mass culture. One can see how such positions would align with the 'bottom-up' analyses dealt with above as well as the account of consumption in Chapter 4, ascribing more cultural power to the consumer and delimiting the determining influence of the economic, the political, the ideological.

Indeed, Georgina Born (1987) has described what Jim McGuigan later called cultural populism as the 'postmodern perspective' in cultural studies:

> Postmodern cultural studies ... started out with a special interest in popular culture, a primary orientation toward *consumption* and an overwhelming *optimism* of tone. In reaction to the pessimism of the mass culture critique, and the Adornian–Horkheimer stress on the cultural commodity as exchange value, postmodernists stress use value, the reality of purpose and meaning in commercial popular culture. Writers have turned positively to leisure, to pop texts, wanting to understand (buzz words) 'pleasure', 'desire', and the 'romance' of their consumption. ... The point is to blast open the view of commercial cultural goods as closed, univocal and aesthetically impoverished – hence the references to post-structuralist notions of 'the end of the author', indeterminate reading, and the fragmented but active reading subject; to reception aesthetics; and, from semiotics, to the idea of cultural texts as polysemic, open, grasped through a 'struggle for the sign'.
>
> (Born 1987: 60)

The writers Born has in mind here include Dick Hebdige, Iain Chambers and Angela McRobbie, but it has to be said that of these it is probably only Chambers (1986) who could be regarded as having wholeheartedly embraced the benefits of postmodernist theory. This raises the first difficulty in talking about the influence of postmodernism within British cultural studies: describing postmodernism itself.

A complication is that, as Kellner suggests, there are at least three 'families of terms' used to frame discussions of the postmodern. These distinguish between 'modernity and postmodernity, as two different historical eras; between modernism and postmodernism, as two different aesthetic and cultural styles; and between modern and postmodern theory, as two different theoretical discourses' (Kellner 1995: 46). There is no systematic relation between these families of terms, and it is common for any one of them to be invoked as if it alone

covered the field. In practice, the definition of the postmodern in specific texts and cultural formations is almost infinitely flexible. Dick Hebdige, in a famous passage, gives us some sense of the problem:

> When it becomes possible for people to describe as 'postmodern' the decor of a room, the design of a building, the diagesis of a film, the construction of a record, or a 'scratch' video, a television commercial, or an arts documentary, or the 'intertextual' relations between them, the layout of a page in a fashion magazine or critical journal, an anti-teleological tendency within episte-mology, the attack on the 'metaphysics of presence', a general attenuation of feeling, the collective chagrin and morbid projections of a post-War generation of baby boomers confronting disillusioned middleage, the 'predicament' of reflexivity, a group of rhetorical tropes, a proliferation of surfaces, a new phase in commodity fetishism, a fascination for images, codes and styles, a process of cultural, political, or existential fragmentation and/or crisis, the 'de-centering' of the subject, an 'incredulity towards metanarratives', the replacement of unitary power axes by a plurality of power/discourse formations, the 'implo-sion of meaning', the collapse of cultural hierarchies, the dread engendered by the threat of nuclear self-destruction, the decline of the university, the func-tioning and effects of the new miniaturised technologies, broad societal and economic shifts into a 'media', 'consumer' or 'multinational' phase, a sense (depending on who you read) of 'placelessness' or the abandonment of place-lessness ('critical regionalism') or (even) a generalised substitution of spatial for temporal coordinates – when it becomes possible to describe all these things as 'postmodern' (or more simply, using a current abbreviation, as 'post' or 'very post') then it's clear we are in the presence of a buzzword.
>
> (Hebdige 1988: 181–2)

Postmodernism is, however, as Hebdige goes on to argue, more than a buzzword. Appropriating Raymond Williams from *Keywords*, Hebdige makes the point that 'the more complexly and contradictorily nuanced a word is, the more likely it is to have formed the focus for historically significant debates' (p. 182). Kellner puts it slightly differently:

> [T]he term 'postmodern' is often a placeholder, or semiotic marker, that indi-cates that there are new phenomena that require mapping and theorizing. Use of the term may also be a sign that something is bothering us, that new confusing phenomena are appearing that we cannot adequately categorize or get a grip on.
>
> (Kellner 1995: 46)

Postmodernism and British cultural studies

From such a point of view, the imprecision, the shifting and contested nature of the proposition of postmodernity does not render it useless at all. However, to survey the influence of discourses of postmodernity within British cultural studies is to encounter widespread resistance. If, as Jim McGuigan says (quoting Huyssen), postmodernism possesses a 'specifically American character' (1992: 214), that may help account for it being more widely taken up as an explanatory tactic in American versions of cultural studies than in their British, Australian or Canadian counterparts. But there have to be more fundamental considerations involved than mere parochialism.

Hebdige, again, is useful here. He locates three principles common to all varieties of postmodern theory which run against the grain of a neo-Gramscian British cultural studies, although he stops short of constructing a 'polar opposition' between the two intellectual movements (1988: 205). These principles involve a negation of large, totalizing theories or 'grand narratives', of 'teleology' (in this context, something like an ideal concept of the 'real') and of utopias. On the face of it, British cultural studies' Marxian roots would place it in opposition to all three principles. Furthermore, British cultural studies has been continually concerned with interrogating certain political and discursive categories – 'the nation', 'the national past', 'heritage' and so on – which postmodernism spurns as tainted by their implication in 'grand narratives' or made redundant by one of postmodernism's own 'grand narratives', the process of transnationalism and globalization. Finally, British cultural studies' implicit populism, a populism which can extend – as we have seen – to a sentimental investment in 'the living textures of popular culture' (p. 203), may be very comfortable within some formations of postmodernity but radically conflicts with the more elitist 'higher aesthetic' of the postmodernism identified with Lyotard or Baudrillard (p. 204).[9]

Critiques of postmodernism within British cultural studies support much of Hebdige's account, but also suggest that the critical practice within most applications of postmodernism is regarded as too relativistic and too formalist to be useful as cultural and political critique. Jordan and Weedon protest that, within postmodernism, 'everything is seen in terms of plurality and play':

> Divisions such as class, gender and race, which have long histories in which oppression is paramount, become just another difference. Structuring power relations disappear and oppositional cultural struggle is contained within a convenient narrative of postmodernism which is both politically dangerous and of limited analytical value.
>
> (Jordan and Weedon 1995: 548)

Hall attacks the inherent abstraction within the postmodern:

> The question is not whether one is a deconstructionist, but whether these new theoretical techniques and the new positions opened up by feminism and by black struggles, as well as the new theoretical positions opened up by the postmodernist and the poststructuralist debates, can be won over and drawn into an understanding of the larger historical/political project that now confronts the humanities. It is perfectly possible to write elegant treatises on 'the other' without ever having encountered what 'otherness' is really like for some people to actually live. It is perfectly possible to invoke the post-modernist paradigm and not understand how easily postmodernism can become a kind of lament for one's own departure from the centre of the world.
>
> (Hall 1990: 22)

Corner and Harvey (1991) also criticize an easy relativism in postmodern analyses, again challenging the usefulness of substituting theories of 'difference' for 'a predominantly class based analysis'. Furthermore, what they clearly regard as the ahistorical nature of postmodern analysis is sternly rejected:

> Much postmodern theory has endeavoured to understand and to map the contours of a restricting capitalism, its ever-expanding realm of commodi-fied culture and its often fragmenting effects on individual human consciousness and cultural practice. But the theory seems to us to be at its weakest in those variants which reject or ignore the possibility of historical analysis and the unity (even if complex and contradictory) of culture, society and economy.
>
> (Corner and Harvey 1991: 18)

These are significant obstacles to the British take-up of postmodern theory, then, which help explain why it is still to exercise a substantial influence on this tradition. It has played a part, though, figuring in feminist work on consumption (McRobbie 1994; Pleasance 1991), as well as attempts to talk about the media in new ways, such as Andrew Wernik's *Promotional Culture* (1991).

David Morley's recent work, particularly that completed in collaboration with Kevin Robins, is possibly the best example of theories of the postmodern being taken up and used in the ways McGuigan suggests they should be – to reconnect cultural studies with political economy. In *Television, Audiences and Cultural Studies* (1992), Morley suggests that cultural studies needs to think of the media and communications systems in new ways, as processes in the construction of a

'postmodern geography'. By this he means how communications technologies of all kinds are involved in the 'ongoing construction and reconstruction of social spaces and social relations' (1992: 272). Equipped with a clear understanding of the political economy of the media industries as well as of the processes occurring in front of the domestic television set, Morley develops these concerns in his collaboration with Kevin Robins, *Spaces of Identity: Global Media, Electronic Landscapes and Cultural Boundaries* (Morley and Robins 1995).

In *Spaces of Identity* Morley and Robins continue to deal with some of the terms central to British cultural studies – nation, culture, identity – but respond more than most in this tradition to the transformations which have occurred within the globalizing media industries. Haunted by a relatively new preoccupation for British cultural studies – the construction and maintenance of a 'European' identity – Morley and Robins look at the way in which space, time and identity are being restructured by the 'new communications geography':

> Patterns of movement and flows of people, culture, goods and information mean that it is now not so much physical boundaries – the geographical distances, the seas or mountain ranges – that define a community or nation's 'natural limits'. Increasingly we must think in terms of communication and transport networks and of the symbolic boundaries of language and culture – the 'spaces of transmission' defined by satellite footprints or radio signals – as providing the crucial, and permeable, boundaries of our age.
>
> (Morley and Robins 1995: 1)

As a result, Morley and Robins perceive a 'global identity crisis', within which the construction of identity – in Britain, in Europe – requires rethinking. How the 'imagined community' must now be imagined has undergone major industrial shifts. These shifts, however, are not homogeneous or comprehensive; for instance, the processes of both globalization and localization seem to be thriving simultaneously despite their apparent contradictoriness. (These issues are also further examined in Morley 2000.)

Morley and Robins' analyses make positive, explicitly political, use of postmodernist theories of cultural identity. Nevertheless, they too sound the familiar warnings about the limitations of certain kinds of postmodernist analysis:

> There is also a further set of questions which we must address, which concern the tendency of theories of postmodernity to fall into a kind of formalist, poststructuralist rhetoric, which overgeneralises its account of 'the' experience of postmodernity, so as to decontextualise and flatten out all the significant differences between the experiences of people in different situa-

tions, who are members of different social and cultural groups, with access to different forms and quantities of economic and cultural capital. The point is simply that 'we' are *not* all nomadic or fragmented subjectivities, living in the same 'postmodern' universe.

(Morley and Robins 1995: 218)

Accordingly, at the end of their book Morley and Robins revisit 'the cultural imperialism thesis' (pp. 220–7) to remind us that, while the processes through which the media's cultural power are many and complex, the media 'are (still mainly) American'. It is a sign of the fundamental need to tie cultural analysis to cultural politics, of grounding the analysis in an assessment of the contemporary alignments of political power.

It is to this aspect of British cultural studies, its politics, that I wish to turn in the last chapter of this part. While 'politics' is not a central theoretical category in the way in which 'texts' or 'ideology' are, it is a major objective of British cultural studies practice and demands attention here. We have already noted how closely tied was the development of British cultural studies to issues of class, and how much of the early ethnographic and textual work was undertaken in order to understand the systematic subordination of working-class interests within contemporary Britain. Other interests attracted attention too. Race and gender both figure importantly within the history of British cultural studies but have not yet played a part within the outline I have presented. In Chapter 7 I survey some of the contributions made by work which has set out to achieve particular political objectives within cultural studies.

Politics

POLITICS, CLASS AND CULTURAL STUDIES

Providing an overview of a field as contested and as heterogeneous as cultural studies inevitably involves smoothing out some rough edges. This book has been organized around my view of the central theoretical issues within cultural studies. As some readers of the first edition noted, the effect of this strategy of organization was to concentrate on the work of theoretical development rather than on the idea of cultural studies as a political project. This is a legitimate criticism. Cultural studies has had continually to deal with the tension between the relatively abstract work of theoretical clarification and an active political engagement which 'tries to make a difference in the institutional world in which it is located' (Hall 1992: 284). As a consequence of the first edition's focus on cultural studies primarily as an academic and theoretical enterprise, this tension all but disappears. So, too, does much of the evidence of cultural studies' attempts to 'make a difference'.

In this chapter, first written for the second edition, I want to retrieve the sense of cultural studies as a political project, as a practice which has maintained a sustained engagement with the world in which it operates. This engagement is manifest in the range of social and political debates to which cultural studies has made its contribution: instances include the media's representation of the unions and industry; the public construction of the meaning of AIDS and its effects; critiques of government policies in schooling, policing, heritage management, media regulation and urban planning; and so on. In addition, cultural studies has participated in the broad alliances formed among the politics of feminism, anti-

racism and gay and lesbian activism. We have already encountered examples of such work in the preceding chapters.

The politics of cultural studies

The term 'politics' in cultural studies carries with it the broadest possible application: it refers to the distribution and operation of power. It is not confined to electoral or party politics, nor to the consideration only of the operation of power by the state. The ways in which power operates, the range of sites upon which power is constituted, the mechanisms through which power is distributed throughout the society are many and various. From the beginning cultural studies has engaged in theorizing the operation of political power in this broad sense, but it has also accepted the challenge of looking at specific instances, particular conjunctures where analysis and critique have the potential to effect political change or to expose political effects to greater scrutiny.

Cultural studies also has its *own* politics, its own allocations and distributions of power, and it has continually debated what actually counts as politics within the field. The debate about cultural populism reviewed in the previous chapter is an example of this. We saw how the implicit optimism of 'the politics of pleasure' ultimately ran up against the dominant mode of cultural studies analysis, which is still overwhelmingly critical. At times, debates within cultural studies have been conducted through discourses that were abstract, theoreticist, alienating or obscure. At such moments, and the quasi-linguistic discussions of textuality which dominated much of the late 1970s would be an example, cultural studies has looked like an entirely self-contained theoretical project. Notwithstanding such an impression, the tension between theory and politics has remained a constitutive feature. How theoretical debates were eventually resolved determined which political categories mattered for analysis, and thus determined what counted (at that time, and for specific reasons) as the practice of cultural studies. So, the politics of cultural studies involves not only its engagement in issues external to the field, but also, and first of all, the constitutive theoretical and political contests for inclusion *within* the field. As we shall see, the campaigns mounted from within cultural studies to include gender and race among the 'categories that mattered' had to challenge categories that were already theoretically established before they could be put to work in more practical ways. From the beginning, the category which dominated cultural studies theory and practice and which therefore served to frustrate both of these campaigns was that of class.

From the account given so far, it should not be difficult to trace British cultural studies' close coupling of the notions of 'class' and 'culture', and its related commitment to the analysis of working-class culture. Hoggart's personal

history of everyday life in prewar Britain, Williams' strategic reorientation of the definition of culture towards the anthropological 'whole way of life', Thompson's recovery of 'history from below', all (albeit in Williams' case implicitly) place class at the centre of cultural studies by directing fresh attention to the culture of the working class. Key projects from the 1970s, such as the CCCS collections *Resistance Through Rituals* and *Working Class Culture* or Paul Willis's *Learning to Labour* (1977), do the same. In practice, the culture of the working class was a persistent preoccupation for much of the first two decades of British cultural studies. This preoccupation, as we have seen, revolutionized the study of popular culture from the mid-1960s to the mid-1980s by dismantling the orthodox critiques of mass cultural forms and practices and revealing the class interests these critiques served. When we reviewed the ethnographic work of Cohen, Willis and, later, McRobbie (in Chapter 5) the explanatory benefits of their focus on class was clear. Similarly, in the foundational work on texts and audiences the investigation of possible homologies between class position and reading position in successive studies of television enabled a deeper understanding of the processes through which social meanings are made, as well as of the forms of television programming.

More recently, however, the dominance of the category of class within cultural analysis has been questioned. McGuigan (1992) and McCabe (1992), among others, have both argued that the centrality of class within the analyses produced by the CCCS was a weakness, leading to the essentializing of working-class characteristics as fundamental to an implicitly nostalgic construction of English culture. As we shall see below, critiques from the perspectives of feminism and black politics have persistently argued that the preoccupation with class marginalized other political perspectives. Such critiques, together with the decline in the influence of Althusserian theories of ideology and the subsequent turn to Gramsci, gradually modified British cultural studies' dependence on the category of class. Furthermore, it became increasingly clear that the course of British social and cultural history since the arrival of 'Thatcherism' (the group of conservative political alignments associated with the prime ministership of Margaret Thatcher) defied any attempt to identify specific class interests with set ideological positions. Cultural studies' response to this history has been strategic and productive, a good example of cultural studies' continuing determination to test its theoretical principles against the specific historical conjuncture.

Stuart Hall's collection of essays *The Hard Road to Renewal: Thatcherism and the Crisis of the Left* (1988) is one of many locations where we can see this response elaborated. In these essays Hall analyses precisely what kind of threat Thatcherism represents to the Left. Crucial for his analysis is Thatcherism's spec-

tacularly successful reconstruction of hitherto traditional political alignments between working-class interests and Left populism. After Thatcher, a new alignment emerged, connecting New Right populism, conservative ideologies and the working class. This new formation was radically disabling to many on the Left, partly because of the Left's tendency – like that of early British cultural studies – to reduce the broad field of politics to that of class struggle. In a sense, given certain understandings of the relation between class and politics, what had occurred under Thatcher was theoretically impossible. The treatment Hall recommends for this disabled condition is to follow Gramsci's advice and direct attention 'to what is specific and current about this moment' (1988: 162). What was specific and current about the moment in question, precisely the divorce between working-class populism and leftist discourse, challenged some of the assumptions upon which class analysis had been based. In their place what emerges is a recognition of what Hall calls 'the diversification of social struggles' as the 'structures of the modern state and society complexify and the points of social antagonism proliferate' (p. 168):

> We are living through the proliferation of the sites of power and antagonism in modern society. The transition to this new phase is decisive for Gramsci. It puts directly on the political agenda the question of moral and intellectual leadership, the educative and formative role of the state, the 'trenches and fortifications' of civil society, the crucial issue of the consent of the masses and the creation of a new type or level of 'civilisation', a new culture.
>
> (Hall 1988: 168)

This new culture acquired a name, New Times, a term taken up by the magazine *Marxism Today*, which signalled 'something of the diversity of social and political upheavals in Britain ..., including the success of "Thatcherism", the decline of traditional working-class politics, the emergence of a politics of identity and consumption, and most importantly the challenge these represent to the left' (McRobbie 1994: 25).

As McRobbie's description suggests, New Times was a complex phenomenon. The emergence of a new 'politics of identity and consumption' actually offered some genuine opportunities for certain political positions – feminism, for instance – but the aggressive economic individualism of the new 'enterprise culture' seriously undermined the philosophical legitimacy of the welfare state and thus the rights of those it protected. New Times required exactly the kind of close political analysis cultural studies was able to provide. Widely debated and elaborated as a political formation, New Times was also a genre of critical writing about contemporary political debates, its continuity with central traditions in

British cultural studies neatly caught in the title of John Clarke's *New Times and Old Enemies* (1991). As Clarke points out, the New Times critique represented a committed attempt to revive the intellectual basis for Left politics:

> The intellectual limitations of an unmodernized and fundamentalist left meant little attention was given to the rapid social transformations that have reworked the face of British society or to the accomplishments of the New Right in transforming the field of politics. The loosely integrated threads of New Times are an attempt to diagnose and cure this crisis by delineating the new social terrain on which the left must fight if it is not to be politically marginalized.
>
> (Clarke 1991: 155)

If political marginalization was to be resisted it was clear this 'new social terrain' could no longer be mapped solely through the discourses of class.[1]

It is not only under the heading of New Times that issues of class began to be nudged aside in response to new historical conditions. As Patrick Wright (1985) had suggested it would, the New Right's capture of the discursive territory of national identity, its vigorous blending of the values of a hypercapitalist 'enterprise culture' with signifiers of heritage, regenerated debates about definitions of the nation. In contemporary Britain the new 'enterprise culture' perfected the art of using specific constructions of the national past as alibis for policy initiatives in the present:

> [T]he new Conservatism has made its own particular and ambitious contribution to the process of restructuring Great Britain. Through a number of different and sometimes conflicting strategies, it has at once challenged, popularized and commodified the values of a more ancient, patrician and rural Conservatism. At the same time, it has selected and projected a new vision of Britain, a new heritage, rooted in the memory of the great industrial entrepreneurs of the nineteenth century. A complex and purposefully selective process of historical recollection is apparent in this project, which involves reviving the ideals of eighteenth century free-market capitalism, for popular participation and consumption in the age of multinational corporations, but through a celebration of the values of the Victorian age.
>
> (Corner and Harvey 1991: 14)

The essays in Corner and Harvey's *Enterprise and Heritage* (1991) examine the potentially contradictory partnership between enterprise and heritage, interrogating the interests served by such developments as that of the Docklands in East

London. Underpinning the collection is the benefit of cultural studies' long engagement with cultural policy and planning, evident in the essay by Franco Bianchini and Hermann Schwengel on 'the inner city' and by Ken Worpole on new forms of 'leisure provision' in urban centres.

The 'retreat' from politics

Given the regular appearance of such unequivocally political projects as *Enterprise and Heritage* and *The Hard Road to Renewal*, it is curious how frequently cultural studies' gradual and slight withdrawal from a predominantly class-based analysis has been described as a retreat from politics. For some commentators, cultural studies has compromised itself by becoming institutionally respectable; it is now a legitimate professional destination for academics and graduate students. For others, the self-doubt implicit in the discourses of New Times and the conservatism lurking in British cultural studies' resistance to postmodernism must be read as signs of political exhaustion. Valda Blundell *et al.*'s (1993) Canadian collection *Relocating Cultural Studies* offers such a reading:

> Cultural studies scholarship in the 1980s and 1990s has thus not surprisingly reoriented itself away from the celebration of resistance in much English work of the 1970s. Diversified politically over and above responses to the new geocultural circumstances of the USA, Australia and Canada, it has either become less political, treating textual processes (processes to do with the way in which literate, visual and oral–aural cultural forms signify or 'have meaning') as more aesthetic than political in a postmodernist vein, or alternatively has kept alive a sense of politics in respect, primarily, of institutional and policy debates.
>
> (Blundell *et al.* 1993: 9)

The second alternative foregrounds the role of cultural studies in policy debates, an issue which is perhaps livelier and more current in Australia and Canada than in Britain (see Tony Bennett's (1992) essay and the ensuing discussion in Grossberg *et al.* 1992). It is true, though, that a policy dimension has been fundamental from the beginnings of British cultural studies (it is really only the American variant of cultural studies which remains relatively uninterested in such applications). However, to reduce contemporary cultural studies either to an overly formalist textualism or to cultural policy studies is to exaggerate drastically recent trends.

Patrick Brantlinger (1990) is more persuasive when he describes the movement away from 'the ideological critique' (that is, a class-based critique), as dominated

by 'issues of representation' (what is now more commonly referred to as identity politics) but nevertheless retaining a 'radical–critical edge' (p. 101):

> The cultural politics practiced by oppositional critics today – whether feminists, postmodern ethnographers, Marxists, Foucauldians, or some other variety – can be understood as the struggle for full representation and participation by those who have been under- and mis-represented in the schools, the curriculum, the artistic and literary canons, as well as in government, the economy, institutions of all sorts. … And the target they are likely to aim at first is not the ideology or false consciousness of 'those others', but the misrepresentation of others through the ideological practices of those with power.
>
> (Brantlinger 1990: 107)

Ann Gray and Jim McGuigan agree with this, noting how the claims of 'feminism, black politics, the discourses of "the other"' have 'decentred' British cultural studies from its 'narrowly national and social class preoccupations' (1993: x). It is certainly from within feminism and black politics that the most developed critiques of the internal politics of cultural studies have emerged, and within which there is clear evidence of a sustained external engagement with material political issues. It is towards these two areas that I wish to direct the rest of this chapter.

WOMEN TAKE ISSUE

The feminist contribution to cultural studies has been immensely productive and often profoundly discomforting. The theoretical foundations and political objectives of a 'pre-feminist' cultural studies were by no means identical with those of feminism. By the mid-1970s cultural studies' established interest in the public domain, in class history, in ideology and hegemony – together with its caution about issues of identity, subjectivity and its silence on the personal operation and gendered nature of power – meant that feminist cultural studies had to develop in opposition to much that had hitherto been regarded as fundamental. Feminists also looked to some relatively unfashionable theoretical sources for their explanations: Freud, for instance, figures more importantly than Marx, as many of the issues foregrounded by psychoanalysis – sexuality, family and identity, for instance – were also central to feminism (Brantlinger 1990: 138). Consequently, it is not surprising that feminist interventions into cultural studies should cluster around the production of subjectivity rather than the production of history. The insistence on the 'personal as political', the explicit recognition of the subordina-

tion of women in cultural analyses and the emphasis on cultural consumption have emerged as specific objectives of feminist work which the 'centre' of cultural studies has come, albeit somewhat reluctantly, to accommodate.

Morag Shiach's account of the relation between feminism and the study of popular culture has outlined how, paradoxically, cultural studies' early emphasis on recovering marginalized forms of social history and cultural production 'effectively marginalised many of the cultural forms and practices of nineteenth century women' (1991: 40) – the cultural practices of working-class girls, for instance. Approaches to contemporary culture were similarly guilty of unthinkingly privileging cultural forms which excluded or marginalized women (such as organized sports like football, or the biker subculture dealt with in Willis's *Profane Culture* (1978)). In response, we have already seen how feminist critiques, such as Angela McRobbie's (1981), exposed the gendered character of much subcultural analysis and thus provoked the development of counter-analyses of (for instance) teenage girls' subcultures (McRobbie 1991, 1994). Within the development of the analysis of television, feminist accounts of soap texts and audiences (Hobson 1980; Ang 1985; Geraghty 1991; Seiter *et al.* 1989; Gray 1992; Brunsdon 1997) and appropriations of issues of spectatorship from film theory (Pribram 1988) radically revised conventional understandings of the relationship between television texts and their audiences. Towards an understanding of the cultural construction of sexuality, feminist work has almost single-handedly led the way (Rose 1986). None of these developments came easily, however, despite the fact that one might have imagined that cultural studies provided a theoretical and political environment within which feminist work could prosper. The struggle for acknowledgement of the theoretical and political marginalization of the feminine within cultural studies itself is recorded in two major collections published by the CCCS.

Women Take Issue: Aspects of Women's Subordination (1978) by the Women's Studies Group is the first collection of feminist essays published by the CCCS. As the volume's introduction explains, even the CCCS failed to provide a welcoming environment for a feminist cultural studies:

> We [the Women's Studies Group] found it extremely difficult to participate in CCCS groups and felt, without being able to articulate it, that it was a case of the masculine domination of both intellectual work and the environment in which it was being carried out.
>
> (Women's Studies Group 1978: 15)

Aimed at redressing 'the continual absence from CCCS of a visible concern with feminist issues', the editors describe the production of *Women Take Issue* as a classic exercise of incorporation: the process 'involved other members of the

CCCS in the areas of study and interest we have been working on and has contributed towards making feminism more "acceptable" within the department' (p. 15).

There is little doubt that there were genuine difficulties in making feminism 'acceptable'. Stuart Hall's choice of metaphor to describe the process at Birmingham is illustrative:

> As the thief in the night, [feminism] broke in; interrupted, made an unseemly noise, seized the time, crapped on the table of cultural studies. The title of the volume in which this dawn-raid was first accomplished – *Women Take Issue* – is instructive: for they 'took issue' in both senses – took over that year's book and initiated a quarrel.
>
> (Hall 1992: 282)

Hall admits that the CCCS, in spite of its best intentions, offered stiff resistance to the disruption that feminism threatened to cause the current formations of the cultural studies project:

> We were opening the door to feminist studies, being good, transformed men. And yet, when it broke in through the window, every single unsuspected resistance rose to the surface – fully installed patriarchal power, which believed it had disavowed itself.
>
> (Hall 1992: 282)

Ironic and self-reflexive though this is, Hall's auto-critique of male resistance at the CCCS has attracted some attention. Charlotte Brunsdon (1996) has responded to Hall's account, and Sue Thornham's (2000) recent history of feminist theory and cultural studies uses it as an exemplary narrative (both its form and its content) about the role of feminist work which itself reveals the difficulties feminist theory has faced in becoming 'mainstream'.

Notwithstanding the debates around the politics of the language used in Hall's essay, the editors of *Women Take Issue* present an account of the difficulties they faced that is substantially the same. From their point of view, women had 'always already been "left out"' of the field of study because of the 'taken-for-grantedness, and hence, invisibility of women's subordination' (Women's Studies Group 1978: 10), and attempts 'to write them in' were not welcomed – even by those who endorsed feminism's objectives and who supported a collectivist model for intellectual work. *Women Take Issue* does 'write them in', however, presenting the work of such writers as Charlotte Brunsdon, Dorothy Hobson, Chris Weedon, Janice Winship and Angela McRobbie in an attempt to make cultural studies serve the

needs of women. Aligning itself explicitly with the Women's Liberation Movement, this collection shifted cultural studies away from issues of resistance and class identity, and towards a closer analysis of cultural consumption, the 'personal' dimensions of culture and 'the problematic of "femininity"' (Shiach 1991: 42). From this beginning, many new debates within cultural studies subsequently emerged: around the function of pleasure and consumption, the investigation of agency and the television audience, and the broad range of issues around identity, sexuality and the body.

Off-Centre

It would be difficult now to conceive of a cultural studies that was not in some way 'post-feminist'; a feminist politics now inhabits the field – if not every one of its productions. But it would be wrong to see the two traditions as having resolved their differences, as blending unproblematically. This is the theme underlying the second CCCS collection, the 'successor project, in which the continuing contributions of feminists to cultural studies at Birmingham could be documented' (Franklin *et al.* 1991: ix–x), *Off-Centre: Feminism and Cultural Studies*. In a section detailing the 'lack of overlap' between feminism and cultural studies, the editors point out that 'the models of culture employed within cultural studies have remained largely uninformed by feminist theories of patriarchy' (p. 8). Consequently there 'remain substantial difficulties in defining what might be meant by specifically feminist understandings of culture' (p. 11), and political objections to, for instance, 'analysing culture "as a language" when feminists have persistently highlighted "the objectifying practices" (or, the construction of woman as object) within language itself' (p. 10). Class, too, remains a contentious issue in much the same way as was outlined earlier in this chapter.

Off-Centre contains three groups of essays which follow the pair of introductions situating feminism in relation to cultural studies, Marxism and Thatcherism. The first group of essays examines issues of representation and identity in popular culture and is relatively continuous with the kinds of analysis first developed in *Women Take Issue*. The second group provides a critical history of abortion legislation in Britain, an issue given added urgency by the introduction of the Alton Bill in 1987; this Bill aimed to reduce the upper time limit for legal abortion to 18 weeks. Introducing the section, Maureen McNeil and Sarah Franklin emphasize the fact that it is upon such territory that feminist interventions into cultural studies have been of profound significance:

Whereas the analysis of science within cultural studies has remained something of a neglected area, it has emerged as one of the most powerful

trajectories within contemporary feminist scholarship. In part, this is the result of feminist challenges to science as a form of patriarchal epistemology, thus addressing the very nature of knowledge and what it is to know. ... However, the feminist critique of scientific epistemology was not primarily motivated – as was much of the post-modern movement – by largely philo-sophical or theoretical concerns. To the contrary, the feminist critique of scientific epistemology has deep roots in the social and political concerns of the women's movement, which, from its inception in the early 1970s, identi-fied scientific and medical power-knowledges as key sources of patriarchal control over women.

(McNeil and Franklin 1991: 134)

It is, of course, the politics of gender which feminism brings to this issue; what feminism, in turn, takes *from* cultural studies are the strategies of analysis (and their limitations).

The final group of essays in *Off-Centre* provide a 'gendered account of Thatcherism' almost as a counter-analysis to that of Stuart Hall. (These are not, of course, the only feminist responses to Thatcherism.[2]) The focus here is again on the 'enterprise culture' identified with Thatcherism, and on what McNeil calls the 'flatfooted' response of the Left (Franklin *et al.* 1991: 222). But the discussions go into quite different territory to that explored by Hall. They include tracing the complex and often contradictory consequences of Thatcher's 'mode of inhabiting femininity' (p. 224); analysing specific 'gendered rhetorics' constructing new meanings for the family and working women; and developing critiques of new regulatory methods for defining (or restricting the proliferation of versions of) sexuality. Together they depict a wide range of often oppressive instances where 'women were constructed as a political category which they experienced as gender difference': for example, 'middle-class women running up against the barriers of mythical fears of the female professional' or 'black, single mothers dealing with cuts in welfare, racist constructions of their domestic lives and of welfare scroungers' (p. 236). Unlike the New Times critique of Thatcherism, however, these accounts of feminist politics in action record some victories, expressing confidence in feminism's ability to understand and respond to the challenge that Thatcherism and the enterprise culture present. As McNeil cautiously concludes, 'feminism has both made more and less of a difference to the gender politics of the period of Thatcher than is generally believed' (p. 237).

This is just a snapshot of feminist cultural studies, of course, but what these collections demonstrate are two central attributes: the oscillating pattern of

opposition and convergence which has marked the theoretical relationship between feminism and cultural studies; and feminism's success in turning cultural studies' disciplinary tactics upon itself, raiding cultural studies for approaches which might be employed to advance a feminist politics (cf. Thornham 2000).

THERE AIN'T NO BLACK ...

The 'Englishness' of British cultural studies is deeply embedded in its theoretical and political history. While it has been explicitly anti-statist for much of this history, it has also been implicitly nationalist – focused on the 'peculiarities of the English'. What counted as 'English', however, remained for some time relatively unexamined, the issue of race or ethnicity theoretically invisible at just the time when successive waves of immigration from the old Empire raised public concern about race and national identity to unprecedented levels. The first CCCS publication to deal with racial issues was *Policing the Crisis*, published in 1978 and dealing with the racial motivations behind the moral panic generated around a 'mugging' crisis in London in 1972. Stuart Hall, one of the authors, has remarked how 'late' this book was, referring to the long and 'profound theoretical struggle' within cultural studies to include the politics of race on its theoretical and political agenda (1992: 282). Like feminism, the question of race had to overcome resistance from within cultural studies during its battle for inclusion.

As was the case with *Women Take Issue*, the collectivist publication of a group of essays from the CCCS, *The Empire Strikes Back* (Centre for Contemporary Cultural Studies 1982), marks the point where the issue of race breaks into the discourses of cultural studies. As with the feminist collection, *The Empire Strikes Back* locates its project within cultural studies. The battle for inclusion in this case is not against the dominance of class, but rather against the dominance of the Gramscian model of the 'national-popular':

> There are many reasons why issues raised by the study of 'races' and racism should be central to the concerns of cultural studies. Yet racist ideologies and racist conflicts have been ignored, both in historical writing and in accounts of the present. If nothing else, this book should be taken as a sign that this marginalization cannot continue. It has also been conceived as a corrective to the narrowness of the English left whose versions of the national-popular continues [sic] to deny the roles of blacks and black struggles in the making and remaking of the working class.
>
> (Centre for Contemporary Cultural Studies 1982: 7)

207

Written by Paul Gilroy, this introduction sets out his two angles of attack: on the marginalization of racial issues within the field of cultural studies and on the enabling ethnic exclusivity of British cultural studies' residual nationalism.

These two angles of attack are maintained consistently throughout Gilroy's subsequent work, which constitutes a powerful political critique of much that cultural studies has taken for granted. Time and again we hear Gilroy's solitary voice reminding cultural studies of the effects of its implicit nationalism on the formation of the field:

> I have grown gradually more and more weary of having to deal with the effects of striving to analyse culture within neat, homogeneous national units reflecting the 'lived relations' involved; with the invisibility of 'race' within the field and, most importantly, with the forms of nationalism endorsed by a discipline which, in spite of itself tends towards a morbid celebration of England and Englishness from which blacks are systematically excluded.
>
> (Gilroy 1987: 12)

It is nationalism rather than class, Gilroy argues in *There Ain't No Black in the Union Jack* (1987), which is the major cause of the invisibility of race within cultural criticism. He emphasizes the point in a startling comparison between the racial politics of the ultra-conservative British politician Enoch Powell and Raymond Williams. Arguing that both understand race through issues of immigration, Gilroy notes that Williams, like Powell, 'draws precisely the same picture of the relationship between "race", national identity and citizenship as Powell'. That is, both stress that 'social identity is the product of "long experience"', which presumably results in a degree of assimilation or integration that eventually subordinates the signs of racial difference to the signs of 'genuine' Britishness (p. 49).

Not only is nationalism able to infect the discourses of the Left with a tendency towards racial homogeneity but also, according to Gilroy, it resists being 'filled with alternative concepts' (1987: 55): it always tends towards a singular, exclusivist definition of national identity.[3] The idea of nationhood and the language used to represent it are therefore 'inappropriate' for both the black movement and the socialist movement in Britain. There are some qualifications, however:

> I have not intended to suggest that the attempt to put these insights into political practice necessitates the abandonment of any idea of Englishness or Britishness. We are all, no doubt, fond of things which appear unique to our national culture. What must be sacrificed is the language of British nationalism which is stained with the memory of imperial greatness. What must be

challenged is the way that these apparently unique customs and practices are understood as expressions of a pure and homogeneous nationality.

(Gilroy 1987: 68)

By the time Gilroy publishes his next book, however, this line has hardened considerably.

The Black Atlantic: Modernity and Double Consciousness opens by wondering how 'much of the recent international enthusiasm for cultural studies is generated by its profound associations with England and the idea of Englishness' (1993: 5). From here, Gilroy raises the question of the 'ethnographic specificity of the discourse of cultural studies itself' (p. 5). In *The Black Atlantic* Gilroy continues his campaign to dislodge the cultural nationalism of British cultural studies on the one hand, and on the other hand to oppose constructions of race that are entirely dominated by ethnicity. It attacks both the idea of the nation-state and the ethnocentric definitions of cultural purity used to legitimate it – expressions of what he calls 'ethnic absolutism'. Gilroy repeats his familiar account of the founding traditions of British cultural studies:

> The intellectual seam in which English cultural studies has positioned itself … can be indicted. The statist modalities of Marxist analysis that views modes of material production and political domination as exclusively *national* entities are only one source of this problem. Another factor … is a quiet cultural nationalism which pervades the work of some radical thinkers. This crypto-nationalism means that they are often disinclined to consider the cross catalytic or transverse dynamics of racial politics as a significant element in the formation and reproduction of English national identities.

> (Gilroy 1993: 3–4)

One consequence of this has been the marginalization of the work of black intellectuals within histories of British cultural studies, the failure to acknowledge how 'the politically radical and openly interventionist aspirations found in the best of its scholarship are already articulated to black cultural history and theory' (p. 6). Figures mentioned in this connection include C. L. R. James and Stuart Hall, although in a couple of undeveloped but interesting asides Gilroy suggests that what he has in mind is a more dispersed and fundamental influence than that of individual writers or theorists:

> [T]he entry of blacks into national life was itself a powerful factor contributing to the circumstances in which the formations of both cultural studies and New Left politics became possible. It indexes the profound transformation of

209

British social and cultural life in the 1950s, and stands, again usually unac-
knowledged, at the heart of laments for a more humane scale of social living
that seemed no longer practicable after the 1939–45 war.

(Gilroy 1993: 10)

The reinsertion of race into the class-based history of the social and political
foundations of British cultural studies is not the primary concern of *The Black
Atlantic*, however. The objective of this book is to suggest an alternative to
nationalist or ethnic absolutism. In place of the nation-state or ethnicity, Gilroy
offers a very different model of the cultural community:

In opposition to ... nationalist or ethnically absolute approaches, I want to
develop the suggestion that cultural historians could take the Atlantic as one
single, complex unit of analysis in their discussions of the modern world and
use it to produce an explicitly transnational and intercultural perspective.

(Gilroy 1993: 15)

The idea of the black Atlantic 'transcends both the structures of the nation-
state and the constraints of ethnicity and national particularity' (p. 19). Through
cultural and political exchange and transformation, ethnicities and political
cultures have been 'made anew', Gilroy argues. In Britain, the settler communities
have 'forged a compound culture from disparate sources. Elements of political
sensibility and cultural expression transmitted from black America over a long
period of time have been reaccentuated in Britain' (p. 15). As a result, identities
are hybridized, nationalities subordinated to other kinds of communities and
networks of relationships, the importance of the nation-state diminished or
bypassed. Gilroy draws a neat example of what he means from the music industry:

North London's Funki Dreds, whose name itself projects a newly hybridised
identity, have projected the distinct culture and rhythm of life of black
Britain outwards into the world. Their song, 'Keep on Moving', was notable
for having been produced in England by the children of Caribbean settlers
and then re-mixed in a (Jamaican) dub format in the United States by Teddy
Riley, an African-American. It included segments or samples of music taken
from American and Jamaican records by the JBs and Mikey Dread respec-
tively. This formal unity of diverse cultural elements was more than just a
powerful symbol. It encapsulated the playful diasporic intimacy that has
been a marked feature of transnational black Atlantic creativity.

(Gilroy 1993: 16)

The case is expanded persuasively later on in the study with reference to hiphop and a broader discussion of black popular music.

Gilroy's has been a sustained project, opening up space for consideration of the politics of race and finding that, in order for this to happen, the association between cultural studies and discourses of English/British nationality required interrogation too. Certainly his writings constitute major applications of cultural studies insights to questions of race, and provide the beginnings of a tradition within the field. Race and ethnicity have found their way into subcultural theory and ethnography (Hebdige 1979; Gillespie 1995; Skelton and Valentine 1998), into studies of such textual forms as popular music (Hebdige 1987), and interrogations of nation and identity (Ali 1991; Hall 1993, 1996a; Hall and Du Gay 1996). In the Gray and McGuigan anthology (1993), it is interesting to note that the section on difference and identity commences with Phil Cohen and Erica Carter on subcultures but is dominated by a series of articles on ethnicities and racial issues by Hall, Gilroy, Kobena Mercer and others. Despite this, it would be fair to say that the politics of race has not been as successful as the politics of feminism at carving out a place within the field – even though the long silence on these issues that lasted almost to the end of the 1970s has now been broken and even though it has pursued useful links to related discussions of postmodernity, globalization and the diaspora. This is perhaps one area where the exporting of cultural studies to America has been politically enabling, connecting British debates to a well-established network of arguments and the work of such writers as Cornel West, Michelle Wallace and bell hooks. Such a development is nicely consonant, in fact, with Gilroy's postulation of a black Atlantic. Nevertheless, while issues of blackness and British identity may have benefited from this connection, it may well have assisted in confining discussions of race within, largely, the consideration of black and white identities. Other mixed-race identities – Chinese, Pakistani and Indian, for instance – are still the subject of much less specific discussion and research.

In Britain the resonance of Gilroy's attack on British cultural studies' residual nationalism was considerable. It is notable that this attack occurred at the time it did: when issues of national identity and the process of national definition were once again becoming highly visible in British cultural politics, both contradicted and provoked by the chimera of the united Europe of 1992. Gilroy's diagnosis of the Euro- and ethno-centricity of post-Gramscian cultural studies is telling; whether the case for the black Atlantic is ultimately a persuasive one or not, it is easy to see why this book has been regarded as an important intervention.

IDENTITY

Standing in the wings throughout much of this chapter has been the issue of identity. For many years, identity was an issue that was folded either into debates about the construction of subjectivity or about the process of identification addressed by psychoanalytic theory. The turn towards issues of gender and race has helped to reorient the discussion of identity: overwhelmingly in recent years, its focus has been on the politics of particular cultural identities within specific historical conjunctures.

Considering the degree to which the Britishness of British cultural studies was disavowed in its early days, the current prominence of debates specifically about British cultural identities is remarkable. Some have argued that there is a direct line through 'black British cultural studies' to the kind of interests I am suggesting now dominate the current field. In their history of black British cultural studies, Houston A. Baker Jr, Manthia Diawara and Ruth H. Lindeborg refer to the two phases through which, Stuart Hall argues, black cultural studies has developed in Britain. The first phase deals with issues of access to representation and the interrogation of the accuracy of media stereotypes and so on. The second phase moved black British cultural studies towards the question of the cultural construction of identities (Baker *et al.* 1996: 7). The consequent challenge to assumptions about the normative whiteness of British identity, their account suggests, had a more general effect: it drew attention to the processes through which cultural identities were constructed, and onto their social and political consequences. Identities were suddenly problems to be examined conjuncturally or contingently, rather than fixed permanent entities to be policed or protected. The consequence, according to Baker *et al.,* was 'liberatory for definitions of British identity', breaking free of exclusivist or essentialist approaches to ethnicity, nationality, identities of all kinds (p. 7).

Those who witnessed the media's promotion of 'Cool Britannia' in the late 1990s can testify to how vigorously the project of identity formation has been undertaken within popular and political culture in the UK since the early 1990s. From the Spice Girls to British Airways' updated livery, to the Blair-ite project of 'rebranding' Britain in ways which more accurately reflected its new identities – particularly that of Britain as a multicultural society – British industries and institutions alike seemed interested (for varied reasons, of course) in actively participating in the production of new national identities. In its own way, this too was a response not only to a fracture in the connection between an unspoken normative whiteness and British nationality, but also to a fracture in the assumed relationship between ethnicity and cultural identity. The gates were suddenly open to a broad and lively project of identity formation.

Cultural identity was not merely a fashionable topic pursued by the advertising industry and government spin doctors. Questions of identity attained remarkable centrality within research and debate in the humanities and social sciences generally over this period (Du Gay *et al.* 2000: 1). Again, this interest was not motivated by an attempt to shore up or 'fix' the identities under examination. Rather, identities of all kinds were universally described as 'contingent, fragile and incomplete'. The fact that identities could be seen as less fixed, more contested and more malleable than before provided a welcome opportunity. It suggested that identities were now 'more amenable to reconstitution than was previously thought possible' (Du Gay *et al.* 2000: 2). As a result, identity was retrieved as a thoroughly political category, in which direct engagement was worthwhile and in which much was at stake.

It is possible to exaggerate this trend, of course. Lawrence Grossberg, for instance, has expressed irritation at the 'tendency to equate cultural studies with the theory and politics of identity and difference' (Grossberg 1996: 87). Nevertheless the 1990s were remarkable for the extent to which the politics of cultural studies was played out through debates around identity instead of class or gender. (Beverley Skeggs (1997) has described the disappearance of 'working class' as a category of self-identification over this period.) Indeed, over this period a new subcategory of cultural studies publishing began to appear in British publishing catalogues, with the proliferation of cultural studies accounts of explicitly British cultural identities – something that would once have been hard to classify as a cultural studies project.

The complication here, of course, is that it is not only identities that are contingent, 'unfixed', impermanent and fluid, but also the theories used to deal with them. As with so much cultural theory that attempts to explain the cultural production of the individual subject, attempts to explain the cultural production of identity have not yet produced an agreed position. While there is now agreement that identities are indeed culturally produced and that they operate in relation to the social and historical field, there is not much agreement about how this process might work. We have already met some of the contenders for the explanatory role: Althusserian accounts of the interpellation of the subject, the Lacanian analogy describing the recognition of the independent subject through the 'mirror phase', and Foucauldian accounts of the construction of the subject through discourse. Hall's review of these contenders is representative, however, in arguing that while each of these theories have their uses none of them are sufficient by themselves (1996b: 7).

A familiar sticking point is the debate between agency and determination: to what extent is identity the product of a series of choices, as it were, rather than determined by social, historical and discursive contexts. While there is some

agreement about the social and political framework held to overdetermine the process of identity formation, there is still no convincing argument which explains how, given the available possibilities, 'certain individuals occupy some subject positions rather than others' (Hall 1996b: 10).

However, the direction I want to highlight in this section does not represent the project of theoretical clarification as it affects the category of identity. Rather, it actually constitutes a step away from the highly theoretical discussions of subjectivity in language and identification in psychoanalysis. In *Identity: A Reader*, Du Gay, Evans and Redman describe the work I have in mind as an 'historically and contextually informed understanding of the limited and specific forms of personhood that individuals acquire in their passage through social institutions' (2000: 4). Du Gay *et al.* do not seem to think much of this strand of research (they refer to it as 'thin'). Nonetheless, this work is entirely characteristic of so much of British cultural studies in its insistence on specific, contextualized and historicized accounts of 'particular forms of personhood' within the 'specific cultural milieux' in which they are located (p. 4).

I quoted Patrick Brantlinger earlier in this chapter, referring to an analogous research tradition through the term 'identity politics'. In the US, in particular, 'identity politics' has been used to describe the activities of particular defined groups in addressing issues of access or representation in order to protect or advance the group's interests. Since what I want to go on to discuss is not, strictly speaking, identity politics it is worth digressing briefly here to differentiate between identity politics in the US and the 1990s focus on identities in the UK.

The history of identity politics in the humanities in the US initially involves literary theory more than cultural studies. There, an already strong tradition of feminist literary theory and a growing interest in postcolonial theory and literary multiculturalism was informed by the relatively late arrival of cultural studies' focus on popular culture and representation. A product of this confluence of theoretical and political interests was 'identity politics': the interrogation of cultural and political practice for the way in which specific identities are located, defined and spoken about. In recent years the deployment of 'identity politics' has increased in the US – as a political and as an institutional tactic. It is possible to see some downside to this: an increasingly fragmented cultural landscape as self-defining groups compete for power, and the increasingly pragmatic mobilization of identity used simply to achieve specific temporal objectives.

The situation in the UK strikes me as significantly different. For one thing, as we saw in the preceding discussion of black British cultural studies, so much of the argument about identity within British cultural studies has converged around the twin poles of ethnicity and nation. There, rather than breaking down the community into competing exclusive fractions (which is roughly how I see the

situation in the US), discussions of identity within the UK have more often been about redefining larger community definitions (such as the nation) so as to be more inclusive. Or, alternatively, they have been about breaking down the sharpness and exclusivity of the definition of cultural identities. The emphasis on the contingency and malleability of identities, rather than on their exclusivity and incontestability, has reduced the exclusionary implications of the concept.

That said, it is important to realize that the examination of identity as we are describing it here may be a quite different project from the original interests of British cultural studies. Although Gilroy argues that 'a tacit intellectual convergence around problems of identity and identification was ... an important catalyst for cultural studies' from the outset (1996: 41–2), the focus on identity moves us away from examining culture as a whole process, to some extent. Instead, we have a focus upon how specific fractions of the culture are placed within the power structure and how this placement derives its logic from the performance of cultural processes such as representation.

Some argue that such a focus, grounded as it is in assumptions of commonality among members of large and diverse groups, has an essentializing logic of its own (Gilroy 1996). Notions of group identity, be they ethnicities or genders, can operate as normatizing agents – treating women or blacks or 'Asians' as if they have identical needs or interests no matter what their histories might be. On the other hand, many arguments about identity and power are productive attempts to claim a degree of sovereignty, some political control over aspects of cultural representation and experience. Such arguments lead inevitably to the analysis of the power relations currently in place and the interests they serve.

NEW ETHNICITIES

Paul Gilroy's critique of British cultural studies' engagement with identity, 'British Cultural Studies and the Pitfalls of Identity' (1996), outlines three important themes he suggests underpin the theoretical development of this field. First is the idea of the subject and subjectivity. Second is the idea of 'sameness'. Recognizing one's similarity to and difference from others moves us away from considering the formation of the individual subject's identity and towards thinking about collective or communal identity. The third theme is 'solidarity'; here 'connectedness and difference become bases on which social action can be produced' (1996: 40):

> This third element moves decisively away from the subject-centred approach that goes with the first approach and the intersubjective dynamic that takes shape when the focus is on the second. Instead, where the relationship between

identity and solidarity moves to centre-stage, another issue, that of the social constraints upon the agency of individuals and groups, must be addressed.

(Gilroy 1996: 40–1)

This third way of thinking about identity is politically enabling, then, in its focus on the social structures which both limit and produce specific identities within specific historical conjunctures. Gilroy, though, is aware of the consensualizing force of 'solidarity', and wary in particular of using the idea of the nation as the central legitimizing principle for either 'sameness' or 'solidarity'. Indeed, while advocating a cultural studies which engages directly with multiculturalism, he is critical of what he regards as the 'retreat' of institutionalized multiculturalism in the US and the UK from 're-examining the concept of culture in any thoroughgoing manner'. In particular, he is concerned at the drift towards managing multiculturalism through a pluralistic view of 'separate, but equal, cultures', producing 'parcels of incompatible activity'. Gilroy's suggestion is more radical and more fundamental:

A political understanding of identity and identification – emphatically not a reified identity politics – points to other more radical possibilities in which we can begin to imagine ways for reconciling the particular and the general. We can build upon the contributions of cultural studies to dispose of the idea that identity is an absolute and to find the courage necessary to argue that identity formation – even body-coded ethnic and gender identity – is a chaotic process that can have no end.

(Gilroy 1996: 48)

Working solely from Gilroy's article it is probably hard to understand what this might actually mean in practice and what these 'radical possibilities' are. To begin to fill these details out it is helpful to turn to Stuart Hall's call for the development of 'new ethnicities'.

In a widely cited essay, called 'Minimal Selves', first published in 1987 but increasingly taken up in the 1990s, Hall outlines the polemical position that places ethnicity at the centre of debates about identity, representation and belonging. Like Gilroy, wary of the dangers of nationalism (although, alternatively, recognizing that nationalism has varied political potential), Hall applauds those who have reached 'for a new conception of ethnicity as a kind of counter to the old discourses of nationalism or national identity' (1996a: 118). This, again, is in relation to that fundamental achievement of breaking the nexus between an exclusive, taken-for-granted, ethnicity and national identity. Although Hall recognises that ethnicity, like other principles of 'sameness' such as nationality,

can carry regressive potentials too, he argues that it can be made to 'carry other meanings' in order to 'define a new space for identity'. While these 'other meanings' are not designated, their motivating principle is 'to insist on difference – on the fact that every identity is placed, positioned, in a culture, a language, a history' (pp. 118–19). What is different about these new ethnicities is that they are more fluid and negotiated identities than previously. This kind of identity is 'not necessarily armour-plated against other identities. It is not tied to fixed, permanent, unalterable oppositions. It is not wholly defined by exclusion' (p. 119). Crucially, they are multiple and hybrid identities – strategic, even, rather than essential. As Jim McGuigan notes, this was a radical proposition when applied to British cultural identities that had for so long been 'dogmatically' tied to 'connotations of nationalism, imperialism, racism and the state' (1996: 141). In subsequent pieces published through the 1990s, Hall seemed to be proposing that what we now think of 'diasporic' identities – identities which recognize more than one location, 'home' or language – are increasingly the norm for postmodern societies. Rather than focus on continuities of location as the source of identity, Hall directed attention to the effect of widespread migration on identity. McGuigan explains the concept this way:

> Nobody moves from one place to another or inherits or appropriates a mix of cultures without being changed by the experience. In effect, identities became multiple rather than singular for the person or the group. A 'new ethnicity', in consequence, is one which is constructed out of cultural differences, the experience of difference, not the repetition of similarity.
>
> (McGuigan 1996: 141)

It is probably worth pointing out that, while the developments outlined above certainly represent a significant shift in British cultural studies and within debates about identity in contemporary Western cultures, they also represent a significant reconstitution of British nationalism. The theory, then, has a specific as well as a general relevance. This is reflected in the number of research projects that have dealt with particular examples of these 'new ethnicities' in the UK since the early 1990s. I want to mention several here as a way of demonstrating what kind of cultural identities this formulation helps us to understand.

Among the most substantial examples would be Marie Gillespie's (1995) study, referred to in Chapter 4, which examines how television and video are used to recreate and modify cultural traditions within Punjabi communities in London. Gillespie acknowledges the influence of black British cultural studies on her project, while recognizing the difference between her choice of subjects and cultural practice from the more widespread emphasis on black settlers'

217

'expressive cultures' – popular music, dance, fashion and style (1995: 4). Gillespie's focus is on 'consumption rather than expressive culture' – the use of television within an 'Asian' urban community in Britain. Acknowledging the importance of the media in the construction of identity, Gillespie's project deals with the diasporic community's use of television in the maintenance and production of their original culture, and as a means of negotiating relations with more hegemonic constructions of their adopted culture. Her research highlights the contradiction faced, in particular, by the younger members of this community: that of negotiating their rights within and sense of belonging to British society while maintaining respect for and identification with the values and traditions of their parents (p. 5). That process of negotiation is sufficiently contingent and complicated to make a detailed, long-term ethnographic study the most appropriate and productive approach.

Ethnographic methods have in fact been quite widely used in research projects on the construction of 'new ethnicities' and other forms of identity. The two examples below come from Skelton and Valentine's collection of cultural geography, *Cool Places* (1998). Claire Dwyer, working with young Muslim women in a suburban town north of London, provides clear evidence of her subjects' fluid adoption of varying identities according to the context. Her focus was on fashion, and many of her respondents moved between Asian and English fashions with some facility, perfectly demonstrating the concept of hybridity. 'Hybridity', in this context, characteristically refers to a combination of different elements which neither blends nor assimilates, but which maintains the sense of the difference of the component parts. These young Muslims created combinatory styles that were different from anything worn in either of their source cultures. While not an uncontested set of choices, and while not universally the option taken by Dwyer's respondents, they provide practical instances of how these young women negotiated their cultural location through the construction of visible cultural identities.

David Parker's work is also aimed at an ethnicity that has itself been marginalized by the focus on black British subjects: the British Chinese (1998). By examining both media representations of 'Chineseness' and interviewing young British-born Chinese who have moved to Hong Kong, Parker presents an interesting analysis of these young people's identifications with ethnicity and nationality. His account presents a more pessimistic reading of the process of identity formation than Dwyer's. For Parker's young British Chinese subjects Britain no longer represents an exciting opportunity; particularly since the 1997 handover, it is Hong Kong which provides that. When they 'return' to Hong Kong, however, they find that this simply doubles the number of nations to which they do not properly belong and their cultural identity is reconstituted accord-

ingly. According to Parker's research, the return to Hong Kong fosters 'a new awareness of the commonalities' between these British-born Chinese and other British-born Chinese in the former colony. In addition, they experience a growing identification with the broader transnational category of 'overseas Chinese' – a diaspora composed of young Chinese people who have grown up elsewhere (and, for many, with the ability to speak Cantonese but unable to read and write Chinese) (1998: 75). As Parker reminds his readers, 'any understanding of British Chinese identity must recognise the opening up of a new dimension, the return to Hong Kong':

> [This] complicates simple notions of either assimilation or British-based cultural hybridity. In fact it is only when British born Chinese people return to Hong Kong that a self-definition in terms of a national category like British Chinese becomes prominent.
>
> (Parker 1998: 73)

While there is now a rich field of debate and research around such locations, it is worth concluding this section by emphasizing the contingency of the political functions even of these 'new ethnicities'. David Morley's discussion of the construction of identity and belonging, *Home Territories* (2000), includes a reminder:

> There is no more reason to assume that nationalist forms are always and inevitably reactionary than there is to assume that 'crossover' practices [that is, those we have been discussing under the heading of new ethnicities] and hybrid forms are always liberatory. The politics of these issues is always conjunctural and 'what matters politically is who deploys nationality or transnationality, authenticity or hybridity against whom, with what relative power'.
>
> (Morley 2000: 240)

FROM CONSUMER TO CITIZEN

As we have seen across a range of theoretical fields, discussions of contemporary culture have increasingly directed attention away from the nation as the location of community identities. Culture must be constituted at least in part through the shared experience of movement across national borders, certainly in the Western world. David Morley quotes James Carey's argument that modern technologies of communication have given rise to communities which do not exist in 'place' but in 'space'; they are 'mobile, connected across vast distances by appropriate symbols

and interests' (2000: 149). The national community is itself constructed over-whelmingly through these same communications technologies, and may indeed only have a substantive existence through the media (an argument John Hartley has made repeatedly (1996, 1999)). Nevertheless, communications technologies also have a 'disembedding' function, transgressing national or geographic bound-aries and thus 'enabling individuals (and sometimes families and whole communities) to escape, at least imaginatively, from their geographical locations' (Morley 2000: 149–50). Nick Couldry (2000) argues that there is a case for suggesting that 'the very idea of the *place* of culture' needs to be questioned. Cultural space is increasingly likely to be defined by cultural flows rather than geographic or political borders (p. 96), as modernity 'tears space away from place' (Giddens 1990: 18).

Within such a context the construction of identity is increasingly under-stood through attention to the processes of cultural consumption. There is, of course, the broad tendency within contemporary industrialized cultures to conceive of their citizens through the rhetoric of the market – as consumers. The Blair project of 'rebranding Britain' shamelessly appropriated the jargon of market research, redefining the national identity as a category of consumption. What Morley and Robins refer to as the 'toe-curlingly embarrassing phrase' of 'Cool Britannia' (2001: 3) functioned as a catchy slogan for a marketing campaign on behalf of the nation. Significantly, as they point out, far from constituting a confident flaunting of British cultural achievements (the popular media's spin on Cool Britannia), the rebranding exercise represented a recogni-tion that 'Britishness' was only one of a number of competing brands in the global marketplace – and that Britain had become a marginal player in this competition.

Consumption – shopping, if you like – has assumed increased importance as what we choose to buy and display have become central components of 'how we see ourselves' (Morley and Robins 2001: 10). This is not without its contradic-tions. On the one hand, we shop for our identities within an increasingly global marketplace characterized by international standardization and the ubiquitous-ness of major brands like Nike, Benetton, Levi's and so on. On the other hand, 'greater forms of flexibility, new forms of "personalised identity"' are available to at least some of us as consumer choice seems continually to expand (p. 10). Consumption provides us with modes of visible self-fashioning on an unprece-dented scale, not only through products to decorate the body but also through an expanding range of services that remake the body itself. The physical self becomes a commodity to be developed and capitalized – one of the 'key forms of cultural capital in which we are nowadays encouraged to invest our identities' (p. 10).

Women and consumption

It is significant, of course, that, as Sue Thornham points out and as we noted in an earlier section of this chapter, if identity is constructed through consumption or style, then 'for women such construction has both a longer history and a rather different meaning than for men' (2000: 128). Early subcultural theory, as we have seen, enacted a preference for masculine subcultures, which in part derived a sense of authenticity and thus their political legitimacy from their rejection of commercialized style. Commercial consumption – 'shopping for identity' – was explicitly not part of the landscape of this early work with its focus on the 'lived' authentic community roots of subcultural practices and identities. As a result, Thornham argues, the CCCS subcultural tradition was founded on a number of fundamental, if unspoken, binaries: 'between conformity and resistance, passivity and activity, consumption and appropriation, which identified the former with femininity and the latter with masculinity' (p. 13).

The understandings of consumption and subcultural style developed in these early studies were not easily translated into an understanding of the relationship between women and consumption. Any sense that consumption might constitute a mode of resistance is largely inconsistent with the implications of this literature. Furthermore, a commonplace of second-wave feminism is the attack on the commodification of femininity and the construction of women as victims of the market: through the promises of fashion, the models of femininity and beauty and so on. Drawing on Rachel Bowlby's work (1985), Thornham points out the opposing manner in which male and female consumption is conventionally characterized. Male consumers are assumed to be making rational decisions, actively motivated by already established identities; female consumers are seen as passive and irrational purchasers, their frivolous acts of consumption seeking to establish their identities. While the gendered nature of this construction is obvious, it is by no means clear what is the appropriate response, from within feminism, to women's implication in consumption.

Consequently, there are competing explanations of the political function of consumption for women. While one point of view suggests that contemporary consumerism offers women an opportunity to escape or intervene in the cultural construction of gender, another argues that no matter what pleasures are on offer the result is necessarily a regressive commodification of the feminine. Such incompatible arguments encourage the view that this is a highly contingent relationship in which the politics are not always determined in advance, and that there are competing possibilities which should not be overlooked. It is possible, for instance, that the openly excessive nature of women's fashion presents the feminine as a knowing performance which serves actually to foreground and display the constructedness of gendered identities (Thornham 2000: 142–6).

Thornham's view of this debate tends to opt for the more positive reading. She acknowledges that the pleasures of fashion, like those of consumption generally, are ambiguous, but also acknowledges Elizabeth Wilson's suggestion that fashion might act as a vehicle for women's fantasy – a site of knowing and creative play and self-representation. Even though this may well be a fantasy which is played out for or originates in the male viewer, it can also be a site 'for our own liberatory fantasies, a place where identity can be renegotiated' (p. 147). There is evidence to support that possibility. Work within other areas of consumption, such as Jackie Stacey's (1994) research with women fans of American movie stars in postwar Britain, for instance, describes the appropriation of the products of the market in the service of the women's specific personal interests. 'Star-gazing', for Jackie Stacey's respondents, seems to have served a highly positive cultural function, far more positive (and far more rational) than is usually assumed within generalized accounts of the capacity of the movies to provide interludes of 'escapism'.

Citizenship

Nonetheless, it is entirely understandable that the category of consumption causes some nervousness in cultural studies. The framing of the individual subject as a consumer configures identity in a highly specific way – foregrounding their differentiation from others and privileging one aspect only of the material and structural conditions within which they must exist. With the postmodern habit for announcing the death of the nation-state, the role of the state in forming identities has tended to be downplayed as government takes a back seat to the media even in forming the democratic subject. Governments themselves have aided and abetted this trend as the responsibilities attributed to government have been progressively reduced. Often the withdrawal of government services is justified in terms of providing access to the logics of the market; Tony Blair's reduction of the single mother's benefit, for instance, was defended as means of providing the recipients with 'the choice' to enter the workforce. This trend is countervailed by a focus upon the politics of what pulls us together as members of a community, or of a nation. At this point, the politics of thinking of identity through the notion of the subject as consumer is played off against thinking of the subject as citizen.

It is now commonplace for media and cultural studies to rail against the contemporary trend which encourages the privatization of public enterprises, which opts for 'user-pays' versions of public policy, and which increasingly thinks of the subject of democracy as operating within a menu of choices that is structured like those of the market (Chaney 1994: 104–5). The decline of public-service broadcasting is just one location where government's tendency to

privilege the logics of consumption over the principles of citizenship has been attacked (see Bromley 2001). Typically, the preferences expressed in audience ratings are used to argue against the provision of services the market does not find profitable – information and education services, for instance. In response to such policies, critics protest that the market is not a sufficient or even appropriate mechanism for distributing wealth, opportunity and access among the society. There is more to this, though, than a critique of market capitalism; citizenship has a philosophical pedigree which assures its place in the discussion of democratic society. Citizenship is the concept which actually connects the individual subject to the rest of their society, and certainly to the larger political framework where our rights and responsibilities as members of the society are inscribed. So, while we may think of our existence as individual subjects in a particular way, to think of ourselves as citizens is to frame our identity quite differently – and we need to do both.

For Jim McGuigan the relationship between citizenship and identity is 'at the heart of the matter', whether our focus is on 'the cultural constructions of the self or the rights to cultural resources that contribute to the politics of changing material conditions'. The citizen's cultural rights figure large in his reckoning, as they contribute to 'our sense of human dignity and meaning, the pleasures and knowledges that make life tolerable' (1996: 147). As this comment implies, McGuigan is keen to emphasize the difference between the personal and the political: between an individualist tradition interested in the formation of the self and a more collectivist tradition which fosters claims for cultural recognition as among the rights of the citizen. Significantly, McGuigan's book deals with cultural policy and the public sphere and it is largely within cultural policy studies that debates about citizenship, its rights and responsibilities have occurred. The call for debates about multiculturalism, which we saw in Gilroy's work and which is implicit in Hall's, is most likely to be played out in practice through policy debates about cultural citizenship. The development of a stronger body of theoretical debate around the role of government in the production and maintenance of cultural citizenship is an area in which sociology has interested itself as well, and currently it constitutes one of the areas of genuine intellectual trade between cultural studies and sociology.

There are other political categories which have found a place within cultural studies (sexuality, for instance, in a broad alignment across feminism to gay and lesbian rights), and have extended the purchase of cultural studies as a theoretical field and as a political practice. While class no longer stands alone on centre stage, its influence remains a powerful one. But the process represented in the preceding accounts of race, gender and identity does seem to be constitutive in

cultural studies, whereby the work of theoretical clarification and the practice of politics are not articulated to each other without debate or negotiation. That such a tension remains so fundamental to British cultural studies may be regarded as an encouraging sign of the importance of politics to the field. As Stuart Hall has said, living with such tensions may be an 'extremely difficult road', but it does have 'something to do with the conditions and problems of developing intellectual and theoretical work as a political practice' (1992: 281).

Conclusion

'DOING' CULTURAL STUDIES

The point of cultural studies is particularly pragmatic. It is a means of generating knowledge about the structures we live in, and the knowledge it generates is meant to be used. As we have seen over the account I have presented, British cultural studies started out developing methodologies for the textual analysis of representations – what may look like a clearly academic interest. This, however, was just one step along a road which has lead to many destinations and applications; for example, it has lead to important interventions into the formation of cultural policy on urban design, media regulation, the arts industries or multiculturalism. As part of this journey British cultural studies has developed a distinctive mode of research, a mode which allows it to meet its objectives of analysing the articulation between cultural processes and structures in specific historical conjunctures. In this conclusion I want to deal briefly, then, with how we 'do' cultural studies: how do we go about research within this tradition.

In addition to the many textbooks introducing cultural studies to its readers and researchers, there are now many guides to cultural studies methodologies. As well as handbooks on research methods within specific fields – film, visual culture, television studies – there are also guides to particular aspects of cultural studies research (Alasuutari 1995; McGuigan 1997). There is a good reason for the proliferation of these guides. Cultural studies research methods have been the target of a lot of criticism over the years (see the Introduction to Ferguson and Golding 1997). The high profile given to the work of theoretical clarification is criticized, for instance, for two primary reasons. First, it is routine for cultural

studies to be represented as an overly abstract and theoreticist field, and the language in which it is written described as alienating. The focus on theory is seen as unnecessarily obsessive, a diversion from more applied projects, and also implicitly elitist. Second, it is also argued that this theoreticism does not translate into an appropriate level of theoretical rigour when applied to research projects. Cultural studies is accused of an insouciant promiscuity in relation to the research methods of other fields and disciplines. That is, cultural studies is criticized for raiding other disciplines for bits and pieces of their methodologies without sufficient respect for (or knowledge of) the theoretical integrity of those methodologies. As we saw in our discussion of ethnography, the fact that cultural studies' versions of ethnography can be extremely limited when compared to those within the social sciences has been used to substantiate claims that cultural studies research methods lack thoroughness.

Of course, these debates have occurred within cultural studies as well (indeed primarily, as David Morley (1998) has protested). As a result, cultural studies research has set out to address these accusations by being a little less cavalier in its appropriations of research methodologies from other fields. Perhaps more importantly, it has fully recognized the value of adopting multiple methodologies, of approaching a topic from a number of disciplinary or methodological perspectives. It is now not at all unusual to encounter the 'triangulation' that Virginia Nightingale recommended back in 1989 as the most profitable approach to research because it acknowledged the complexity and multidimensional nature of cultural studies topics. I hasten to acknowledge that there are many much earlier examples of such a multidimensional approach within this tradition: Willis's *Learning to Labour* (1977) and Hall *et al.*'s *Policing the Crisis* (1978) are two outstanding examples. My argument is, however, that over the last decade or two such an approach has become much more routine, and in fact might be regarded as having established, implicitly, a model for the procedure of cultural studies research.

A useful demonstration of this model can be found in a book called, appropriately, *Doing Cultural Studies: The Story of the Sony Walkman* (1997), a reader for the Open University's 'Culture, Media and Identities' course, and co-written by Paul Du Gay, Stuart Hall, Linda Janes, Hugh Mackay and Keith Negus. This book examines a cultural product – the Sony Walkman – from a number of perspectives. The authors discuss how the product has been represented in advertising and thus how it is implicated in the construction of particular identities. This involves, for instance, analysing the range of meanings mobilized in particular campaigns – recognizing the cultural specificities in campaigns in particular countries. A second section examines Sony, the firm that produced the Walkman, in order to explain the industrial culture responsible for its design and produc-

tion. This is a complex examination involving the consultation of published accounts, interviews with key contributors to the design process, and the development of a history of the process of design and development. Part of this story is the cultural identity of Sony itself, its relation to 'Japanese-ness' and the cultural sources of the product's design. In the third section, *Doing Cultural Studies* asks more specific questions about the marketing and design of the Walkman, following through the various models, the proliferation of specialized or niche-marketed versions, in order to develop a design history of the product. In Section 4 they outline the economic logic of the product from the point of view of the manufacturer. Sony's place in the global market, as one of the big six multinational music companies, is a crucial element in this account. The fifth section discusses the consumption of the product through reference to published statistics on age, class, gender and so on. Finally, the adoption of the Walkman by subcultural groups as a signifier of resistance or identity leads into the final section, which discusses how the use of the Walkman has been regulated by civic authorities – by notices on the walls of the London Underground, for instance, asking commuters to adjust the volume of their personal stereos.

In order to generate the information they need the authors have drawn on a wide range of material and employed most of the methodologies we have been discussing throughout this book. They have consulted published histories and press accounts of the company, the design process and the marketing plan. They have closely examined specific representations as texts, locating the meanings generated around the product in advertising, news reports and other locations. Statistical evidence of consumption, as well as other empirical data around marketing and design development, has also been used, as well as the published academic and press information available on the political economy of the music and media industries over the last two decades. Finally, there is a significant component of oral history, or personal interviews with Sony staff, who provide direct accounts of the design and marketing processes, as well as the specific production decisions required to get the Walkman onto the market. This is extremely comprehensive. Even so, there are still areas of information which are missing. There is no attempt to deal directly with consumers, for instance; the consumption section primarily cites statistics or other data that deal with the consumption process as an aggregation of individual choices rather than focusing, as ethnography tends to do, on specific choices made by specific individuals in response to specific conditions.

Nonetheless, what emerges is a fascinating story, successfully catching the multidimensional roles the Sony Walkman has played in contemporary popular culture, as well as the complicated logics behind its commercial production. It is a good example of the method of contemporary cultural studies research in that it

actively pursues competing accounts, seeking out different bodies and categories of evidence. Where these competing accounts differ, the authors use these differences as an opportunity to explain the articulation (or, more familiarly, the connectedness) of the constitutive cultural and economic processes in the construction of a cultural object. As they describe it, their method is to analyse 'the biography of a cultural artefact' by focusing on the 'articulation of a number of distinct processes whose interaction can and does lead to variable and contingent outcomes' (Du Gay *et al.* 1997: 3). It is this recognition of the necessity of understanding the interaction of distinct, possibly contradictory and highly contingent processes that underpins the method of the book.

THE CIRCUIT OF CULTURE

At the beginning of *Doing Cultural Studies* there is an explanation of what the Open University team describes as the 'circuit of culture'. This is a model of cultural production and consumption that now occurs in a number of the Open University readers and is probably widely taught to undergraduates, and not just in the UK. What this model describes is the interaction of the five key processes 'through which any analysis of a cultural text or artefact must pass if it is to be adequately studied' (Du Gay *et al.* 1997: 3). These processes are: representation, identity, production, consumption and regulation. The diagram which accompanies the chapter makes it clear that these processes are all interconnected. When we apply the diagram to the analysis of a particular cultural text or artefact we find that even the categories themselves can overlap. Identity and representation are quite hard to separate when one is examining advertising, for instance, and the book's opening chapter, which deals with advertising, makes that quite clear too.

Despite this, however, the pedagogic value of the circuit of culture model lies in its clarification of the kinds of questions that need to be asked in a study of a cultural artefact, product or practice. These are:

- How is it represented?
- What identities are associated with it?
- How is it produced and consumed?
- What mechanisms regulate its distribution and use? (p. 3)

What these questions do is direct the research towards different locations, different cultural, industrial or social processes. Having to answer all four questions ensures that the topic will be approached from more than one perspective. It ensures that the cultural study of the 'artefact, product or practice' focuses not only on the detail of (for example) its specific representations but also on how

those representations are related to the cultural processes which structure identity, consumption, production and regulation. It is this combination of approaches, this emphasis on the articulation between relatively discrete cultural processes, which now seems to mark out this research tradition.

Indeed, I would argue that the standard form of cultural studies research today not only combines the investigation of a range of cultural or social sites for information, but also employs a range of critical and empirical methodologies. So, within an essentially theoretical essay on the cultural function of television, John Hartley's preferred method of textual analysis is reinforced by a richly historical account of the social function of television since the 1930s (1999). Richard Dyer's study of the meaning of the colour 'white' (1999) in Western contemporary media culture deals most directly with the kinds of critique we encountered in Chapter 7 – to do with the discursive construction of race and identity. However, also fundamental to his research is a history of the film industry's adaptation of technology to its economic and ideological ends, as well as a detailed analysis of how this adaptation is played out across the texts on the screen. David Morley's (2000) study of the meaning of 'home' in contemporary discourses deals directly with a critique of postmodern theories of media, belonging and identity within a context that is fundamentally informed by (in particular) European cultural history and by theoretical developments within cultural geography and sociology. His texts are television programmes, migrant memoirs, family snapshots and theories of postmodernity. Jackie Stacey's analysis of the relationship between women fans and their screen idols in postwar Britain (1994) starts out focusing on the texts provided by these fans' letters; what emerges is an ethnographic history of feminine behaviour that complicates common-sense assumptions about the social and cultural function of film stars and of the movies. I would argue that such studies (and there are obviously many more I could cite here), with their elegant and productive facility for moving across methodological and disciplinary divisions, are examples of what 'doing cultural studies' actually means today.

I am aware that the way in which this present book is structured has broken up cultural studies methods and interests into particular topics and orientations – text, audience, ideology and so on. There are good pedagogic reasons, I believe, for having presented the development of the field as a serial process. The disadvantages of such an arrangement of the material is that it exaggerates the narrative of linear development and it implies a model for cultural studies research that is simplistic or misleading. Therefore it is important to stress as I close that the best potential for cultural studies is realized in work that moves across the categories of text, audience, ideology, history and so on in order to examine the cultural relations between them. It is the capacity for such work, a

capacity I say is now routinely exploited, that marks out the most valuable attributes of doing cultural studies.

CONCLUSION

Cultural studies does present a radical challenge to the orthodoxies within the humanities and social sciences. It has enabled the crossing of disciplinary borders and the reframing of our ways of knowing so that we might acknowledge the complexity and importance of the idea of culture. Cultural studies' commitment to understanding the construction of everyday life has the admirable objective of doing so in order to change our lives for the better. Not all academic pursuits have such a practical political objective. Cultural studies' democratizing interest in the naturalization of social inequities and divisions has recovered valuable resources for the cultural analyst: disregarded evidence, subjective experiences and denigrated social practices. The retrieval and legitimation of the very subject matter of cultural studies has been a complicated and contentious task, however, and it is not yet over. There are continuing controversies as the field defines itself and as it becomes increasingly sensitive to the breadth of the material it must consider, the comprehensiveness of the processes it seeks to explain. No single method or theoretical approach can be asked to take on all of cultural studies' responsibilities.

This notion of responsibility is itself something of a defining attribute. Cultural studies has embraced the notion that it has a social function, and argues about how that function is to be understood and performed. The role of the cultural critic in the formation of cultural policy, for instance, or the political status of the cultural studies academic when speaking on behalf of other less powerful groups, or the degree to which cultural studies loses its way when it is turned into a set of analytic protocols are issues which currently are being vigorously debated within the field. The conflict, perhaps contradiction, between an outward-looking, internationalized cultural studies and a locally engaged, culturally specific cultural studies has been played out in, at least, Britain and Australia. Even the extent to which the publishing of cultural studies is enmeshed within the very processes of globalization the field has criticized has been a recurring issue as well.

It does seem that a degree of self-consciousness is unavoidable if the field is to retain its critical edge and its political commitment. While at times it seems as if all cultural studies' interests are internal – on the work of 'theoretical clarification' this book has spent so much time detailing – it is as well to remember that even the briefest acquaintance with the material covered in this book is capable of signifying that something different and important is going on. For the many

thousands of students in the UK, the US, Canada, Australasia and elsewhere, cultural studies has been dramatically enabling. It has provided them with a way of talking about contemporary culture without condescension, without over-looking the power relations which structure experience and without discounting their own experience. While we might worry that the development of cultural studies as a pedagogic activity risks dulling its critical edge, I don't believe that – in practice – this has to be the case.

The practice of cultural studies has the potential to challenge the way we think about the world. My own experience in the field has taught me rather to expect revelations, occasionally to understand suddenly what lies beneath those images, sounds, gestures I had taken for granted. If readers find that the work presented in this book has helped bring them to such moments of recognition I will be well pleased. But I would also hope that readers will follow the ideas in this book beyond its pages, particularly into appropriations of cultural studies other than the British. Theory can be culturally specific too, and there are very different inflections in the work coming out of France, the United States, Australia and Canada from those outlined in this book. This, then, has been an introduction to cultural studies; the next step is to develop the relationship and see what benefits this brings.

Notes

I The idea of cultural studies

1 This can be found in Saussure's *A Course in General Linguistics* (1960). A simple account of Saussure's work is found in Culler (1976).
2 In such formulations we can see the imperatives of the disciplines of history and sociology competing with those from literary studies.
3 See Chapter 5 for discussion of the media histories; for an example of Foucault's work, see *Discipline and Punish: The Birth of the Prison* (1979a).
4 As Morley puts it, 'The same man may be simultaneously a productive worker, a trade union member, a supporter of the Social Democratic Party, a consumer, a racist, a home owner, a wife beater and a Christian' (1986: 42).
5 For the classic location of the discussion of this split, see Hall (1981).

2 The British tradition: a short history

1 Christine Geraghty rightly points out that such a description pulls Leavis's work on mass culture unfairly 'out of the context of his own formation to serve contemporary concerns' (1996: 347).
2 Both books were first published in 1964. The latest editions are cited here.
3 Critcher's (1979: 18) critique of the book attacks this sentimental inversion of class history and points out key absences in the book, particularly the lack of any consideration of the experience of work or the function of the trade union.
4 It is instructive to compare this kind of analysis with later work on urban and youth subcultures, which, paradoxically, grew from this foundation, and a discussion of which will be presented in Chapter 4.
5 Interestingly, McCabe says the Centre was founded with the help of money donated by Penguin Books in gratitude for Hoggart's support during the obscenity trial over D. H. Lawrence's *Lady Chatterley's Lover* (1992: 29).

232

6 Eagleton (1978: 33) makes this point in his otherwise quite hostile review of Williams' career.

7 The latest edition, 1975, is the version cited throughout this book.

8 I am indebted to Patrick Buckridge for bringing this article to my attention.

9 As Hall (1990) has noted, *New Left Review* in the late 1960s and early 1970s was a key location for translations of Gramsci, the Frankfurt School and other European theorists.

10 Michael Green (1982) presents a detailed outline of these matters. Some of this information was reinforced and elaborated in a conversation with Richard Johnson during a brief visit to CCCS in 1988. I am grateful for his time and assistance.

11 Hobson, Brunsdon and Ang's work will be dealt with in Chapter 4. An example of Williamson's journalism is available in the collection *Consuming Passions* (1987) and of Coward's in *Female Desire* (1984).

3 Texts and contexts

1 This was published as a CCCS stencilled paper in 1973, but is more readily available in an edited version, 'Encoding/Decoding' (Hall 1980c), published in *Culture, Media, Language*. It is this latter version that is cited throughout this book.

2 This work was originally a CCCS stencilled paper (no. 9, 1976).

3 Bennett *et al.*'s (1981a) *Popular Television and Film* devotes a section to this debate, introducing it and reprinting the key articles, including those by Colin McCabe and Colin MacArthur.

4 The key article here, also reprinted in *Popular Television and Film* (Bennett *et al.* 1981a), is McCabe's 'Realism and the Cinema: Notes on Some Brechtian Theses' (1981).

5 'Empowerment', however, is essentially a psychological, individual effect that does not necessarily presume any wider political or structural consequence. It is an idea more widely valued in American cultural studies than in the British tradition.

6 In Fiske's (1993) most recent work, he sets out to negotiate between the Gramscianism of Hall and the Foucauldian use of discourse.

4 Audiences

1 Morley's *Television, Audiences and Cultural Studies* (1992) responds to the account of his work presented on pp. 12–15 of the first edition of *British Cultural Studies* (1990). This has influenced the revision of some aspects of this account.

2 This work will be discussed in Chapter 5.

3 I am referring, primarily, to John Tulloch and Albert Moran's work on the Australian soap opera, *Quality Soap: A Country Practice* (1986); a further article in this tradition is Tulloch's 'Approaching Audiences: A Note on Method' (1989). There is also Tulloch's most interesting, but so far unpublished, account of discussions of *Dr Who* with its fans, titled '*Dr Who*: Approaching the Audience' (n.d.). Some of this work appears in John Tulloch and Henry Jenkins' *Science Fiction Audiences* (1995).

4 This is true of much of the argument of *Television Culture* (Fiske 1987b) and of Fiske's *Understanding Popular Culture* (1989b) and *Reading the Popular* (1989a).

5 The phrase 'thick interpretation' is derived from Clifford Geertz's (1973) 'thick description'.

6 For instance, see Tulloch and Alvarado (1983), Alvarado and Buscombe (1978), and Elliott (1972). Hobson's (1982) work on *Crossroads* also falls into this tradition, of course.

7 This question is posed by Virginia Nightingale in her article 'What's Ethnographic about Ethnographic Audience Research?' (1989). Much of the following section is indebted to her article.

8 See also Ien Ang's *Desperately Seeking the Audience* (1991).

5 Ethnographies, histories and sociologies

1 Originally published in *Working Papers in Cultural Studies* in 1972, this article is available in extracted form in *Culture, Media, Language.* Subsequent citations to P. Cohen 1980 refer to page numbers in this later version.

2 To see what such a consideration might be like, see McRobbie and Garber's (1976) contribution to *Resistance Through Rituals*; it is followed by an elaboration by Powell and Clarke (1976).

3 In such statements they are representative of their tradition. One need only turn to the second issue of *Media, Culture and Society* (vol. 1, no. 2, 1979), an issue devoted to the political economy of the media, to hear the same notes struck in Nicholas Garnham's editorial. Garnham praises the empirical tradition for having at least 'recognised the mass media as economic activities', and dismisses the 'culturalist' attempt to see 'culture as opposed to the economic' (pp. 19–20).

4 This piece is entitled 'Consciousness of Class and Consciousness of Generation' (*Media, Culture and Society*, January 1979: 192–208).

6 Ideology

1 See Johnson (1979b: 230–7) for one example, but for a more extended and more sophisticated case, see Lovell (1980).

2 Hall uses the example of an industrial dispute to demonstrate this, drawing out the premises that framed the media representation of attitudes towards workers, towards the British auto firm Leyland, and towards the logic of industrial production.

3 In fact, the guide to this usage would be Althusser's notion of ideological state apparatuses (the education system, the law and so on) in *Lenin and Philosophy* (1971).

4 Readers will remember the discussion in Chapter 2 of the way Raymond Williams dealt with this problem in *Marxism and Literature* (1977), by the introduction of the residual and emergent formations of hegemony.

5 Fiske *et al.* talk about this in their analysis of Australian popular culture, *Myths of Oz* (1987: ch. 5), and Fiske further develops the idea of transgression in shopping in his *Reading the Popular* (1989a) and *Understanding Popular Culture* (1989b).

6 This rested on an account of certain traditional festivals within medieval culture that were particularly scandalous in their treatment of conventions, religious observances and other proprieties. Festivals such as the Feast of Fools were licensed moments of excess when the 'popular' could express and recognize its opposition to the classes that suppressed it.

7 This set of problems is examined in my '*Perfect Match*: Ambiguity, Spectacle and the Popular' (Turner 1987).

8 This account is necessarily brief here, but a simple application of Barthesian notions of pleasure to television can be found in Fiske (1987b: ch. 12).

9 This is a point McCabe (1992: 30–2) also makes, drawing a comparison between British engagement with popular culture and the complete absence of the popular from the work of the major European theorists.

7 Politics

1 One of the ways in which this new social terrain is discussed includes a slight rapprochement with political economy, in the admission of the importance of the phenomenon known as 'post-Fordism':

> 'Fordism' stands for the large-scale, flow processes of the modern factory, the skilled factory proletarian, the intensification of management, the rise of the corporate giants, the spread of mass consumption, the concentration of capital, the forward march of the technical division of labour, the intensification of world competition and the further spread of capitalism as a 'world system'.
>
> (Hall 1988: 275)

Having admitted the need to understand the effects of such macroeconomic processes, Hall nevertheless reminds us that Fordism was never only an economic revolution: 'it was always a cultural and social revolution as well' (p. 275).

2 There are plenty of feminist responses to Thatcherism. A particularly useful one is Jaqueline Rose's essay 'Margaret Thatcher and Ruth Ellis' (1988), which suggested that 'something about Thatcher's place in the collective imaginary of British culture calls out for an understanding of what it is she releases by dint of being a woman' (p. 4). Rose hooks Thatcher up to the revealing history of Ruth Ellis, the last woman to be hanged in Britain (in 1955), moving across to investigate the apparent paradox whereby 'Thatcher presents a femininity which does not serve to neutralize violence but allows for its legitimation' (p. 15).

3 Hall (1993), among others, has argued against this since, maintaining that nationalism is to some extent an empty vessel which does not necessarily contain the kind of ideological baggage Gilroy suggests is inevitably there. Hall puts this argument to work, suggesting that there are broader potentials for the idea of the nation.

Bibliography

Alasuutari, Pertti (1995) *Researching Culture: Qualitative Method and Cultural Studies*, London: Sage.

—— (ed.) (1999) *Rethinking the Media Audience: The New Agenda*, London: Sage.

Ali, Yasmin (1991) 'Echoes of Empire: Towards a Politics of Representation', in John Corner and Sylvia Harvey (eds) *Enterprise and Heritage: Crosscurrents of National Culture*, London: Routledge.

Allen, Robert (ed.) (1987) *Channels of Discourse: Television and Contemporary Criticism*, London: Methuen.

Althusser, Louis (1971) 'On Ideology and Ideological State Apparatuses', *Lenin and Philosophy and Other Essays*, New York: Monthly Review Press.

Alvarado, Manuel and Edward Buscombe (1978) *Hazell: The Making of a TV Series*, London: BFI.

Ang, Ien (1985) *Watching Dallas: Soap Opera and the Melodramatic Imagination*, London: Methuen.

—— (1991) *Desperately Seeking the Audience*, London: Routledge.

Armes, Roy (1989) *On Video*, London: Routledge.

Baker, Houston A. Jr, Manthia Diawara and Ruth W. Lindeborg (eds) (1996) *Black British Cultural Studies: A Reader*, Chicago: University of Chicago Press.

Bakhtin, Mikhail (1968) *Rabelais and His World*, Cambridge, MA: MIT Press.

Barker, Chris (1999) *Television, Globalization and Cultural Identities*, Buckingham and Philadelphia: Open University Press.

Barnett, Anthony (1976) 'Raymond Williams and Marxism: A Rejoinder to Terry Eagleton', *New Left Review* 99: 47–66.

Barthes, Roland (1973) *Mythologies*, London: Paladin.

—— (1975) *The Pleasure of the Text*, New York: Hill Wang.

—— (1977) *Image–Music–Text*, London: Fontana.

236

Batsleer, Janet, Tony Davies, Rebecca O'Rourke and Chris Weedon (1985) *Rewriting English: Cultural Politics of Gender and Class*, London: Methuen.

Baudrillard, Jean (1981) *For a Critique of the Political Economy of the Sign*, Paris: Telos.

Bee, Jim (1989) 'First Citizen of the Semiotic Democracy?', *Cultural Studies* 3(3): 353–9.

Bennett, Tony (1981) *Popular Culture: Themes and Issues*, Milton Keynes: Open University Press.

—— (1986a) 'Hegemony, Ideology, Pleasure: Blackpool', in Tony Bennett, Colin Mercer and Janet Woollacott (eds) *Popular Culture and Social Relations*, pp. 135–54, Milton Keynes: Open University Press.

—— (1986b) 'The Politics of "the Popular" and Popular Culture', in Tony Bennett, Colin Mercer and Janet Woollacott (eds) *Popular Culture and Social Relations*, pp. 6–21, Milton Keynes: Open University Press.

—— (1992) 'Putting Policy into Cultural Studies', in Lawrence Grossberg, Cary Nelson and Paula Treichler (eds) *Cultural Studies*, pp. 22–37, New York: Routledge.

—— (1993) 'Useful Culture', in Valda Blundell, John Shepherd and Ian Taylor (eds) *Relocating Cultural Studies: Developments in Theory and Research*, pp. 67–85, London: Routledge.

—— (1996) 'Out in the Open: Reflections on the History and Practice of Cultural Studies', *Cultural Studies* 10(1): 133–52.

—— (1998) 'Cultural Studies: A Reluctant Discipline', *Cultural Studies* 12 (4): 528–45.

Bennett, Tony and Janet Woollacott (1988) *Bond and Beyond: The Political Career of a Popular Hero*, London: Macmillan.

Bennett, Tony, Colin Mercer and Janet Woollacott (eds) (1986) *Popular Culture and Social Relations*, Milton Keynes: Open University Press.

Bennett, Tony, Susan Boyd-Bowman, Colin Mercer and Janet Woollacott (eds) (1981a) *Popular Television and Film*, London: BFI.

Bennett, Tony, Graham Martin, Colin Mercer and Janet Woollacott (eds) (1981b) *Culture, Ideology and Social Process: A Reader*, London: Open University Press.

Blackman, Shane (1998) 'The School: "Poxy Cupid". An Ethnographic and Feminist Account of a Resistant Female Youth Culture: New Wave Girls', in Tracey Skelton and Gill Valentine (eds) *Cool Places: Geographies of Youth Cultures*, London: Routledge.

Blundell, Valda, John Shepherd and Ian Taylor (eds) (1993) *Relocating Cultural Studies: Developments in Theory and Research*, London: Routledge.

Born, Georgina (1987) 'Modern Music Culture: On Shock, Pop and Synthesis', *New Formations* 1(2): 51–78.

Bourdieu, Pierre (1984) *Distinction: A Sociological Critique of the Judgement of Taste*, London: Routledge.

Bourdieu, Pierre and Jean-Claude Passeron (1977) *Reproduction in Education, Society and Culture*, London: Sage.

Bowlby, Rachel (1985) *Just Looking: Consumer Culture in Dreisen, Gissing and Zola*, London: Methuen.

Brantlinger, Patrick (1990) *Crusoe's Footprints: Cultural Studies in Britain and America*, New York: Routledge.

Bromley, Michael (ed.) (2001) *No News is Bad News: Radio, Television and the Public*, London: Longman.

Brunsdon, Charlotte (1990) 'Television: Aesthetics and Audiences', in Patricia Mellenkamp (ed.) *Logics of Television: Essays in Cultural Criticism*, London: BFI.

—— (1996) 'A Thief in the Night: Stories of Feminism in the 1970s at CCCS', in David Morley and Kuan Hsing-Chen (eds) *Stuart Hall: Critical Dialogues in Cultural Studies*, London: Routledge.

—— (1997) *Screen Tastes: Soap Operas to Satellite Dishes*, London and New York: Routledge.

Brunsdon, Charlotte and David Morley (1978) *Everyday Television: Nationwide*, London: BFI.

Buckingham, David (1987) *Public Secrets:* EastEnders *and Its Audience*, London: BFI.

Carey, James W. (1989) *Communication and Culture: Essays on Media and Society*, Boston: Unwin Hyman.

Carrington, Ben (2001) 'Decentering the Centre: Cultural Studies in Britain and its Legacy', in Toby Miller (ed.) *A Companion to Cultural Studies*, Malden, MA, and Oxford: Blackwell.

Centre for Contemporary Cultural Studies (1982) *The Empire Strikes Back: Race and Racism in 70s Britain*, London: Hutchinson.

Chambers, Iain (1985) *Urban Rhythms: Pop Music and Popular Culture*, London: Macmillan.

—— (1986) *Popular Culture: The Metropolitan Experience*, London: Methuen.

Chaney, David (1982) 'Sociological Studies of Culture', *Theory, Culture and Society* 1(1): 85–9.

—— (1994) *The Cultural Turn: Scene-setting Essays on Contemporary Cultural History*, Routledge: London.

Clarke, John (1991) *New Times and Old Enemies: Essays on Cultural Studies and America*, London: HarperCollins.

Clarke, John, Chas Critcher and Richard Johnson (eds) (1979) *Working Class Culture: Studies in History and Theory*, London: Hutchinson.

Cohen, Phil (1980) 'Subcultural Conflict and Working-Class Community', in Stuart Hall, Dorothy Hobson, Andrew Lowe and Paul Willis (eds) *Culture, Media, Language*, pp. 78–87, London: Hutchinson. (Originally published as *Working Papers in Cultural Studies* 2/1972.)

Cohen, Stanley and Jock Young (eds) (1980) *The Manufacture of News: Social Problems, Deviance and the Mass Media* (rev. edn), London: Constable.

Collins, Jim (1989) *Uncommon Cultures: Popular Culture and Post-Modernism*, New York: Routledge.

Connell, Ian (1980) 'Television News and the Social Contract', in Stuart Hall, Dorothy Hobson, Andrew Lowe and Paul Willis (eds) *Culture, Media, Language*, pp. 139–56, London: Hutchinson.

Corner, John and Sylvia Harvey (eds) (1991) *Enterprise and Heritage: Crosscurrents of National Culture*, London: Routledge.

Couldry, Nick (2000) *Inside Culture: Re-imagining the Method of Cultural Studies*, London: Sage.

Coward, Ros (1984) *Female Desire: Women's Sexuality Today*, London: Paladin.

Crisell, Andrew (1986) *Understanding Radio*, London: Methuen.

Critcher, Chas (1979) 'Sociology, Cultural Studies and the Post-War Working-Class', in John Clarke, Chas Critcher and Richard Johnson (eds) *Working Class Culture: Studies in History and Theory*, pp. 13–40, London: Hutchinson.

—— (1982) 'Football Since the War', in Bernard Waites, Tony Bennett and Graham Martin (eds) *Popular Culture: Past and Present*, pp. 219–41, London: Croom Helm.

Culler, Jonathan (1976) *Saussure*, London: Fontana/Collins.

Cunningham, Hugh (1980) *Leisure in the Industrial Revolution*, London: Croom Helm.

—— (1982) 'Class and Leisure in Mid-Victorian England', in Bernard Waites, Tony Bennett and Graham Martin (eds) *Popular Culture: Past and Present*, pp. 64–91, London: Croom Helm.

Curran, James (1990) 'The New Revisionism in Mass Communication Research – A Reappraisal', *European Journal of Communication* 5: 130–64.

Curran, James and Jean Seaton (1985) *Power Without Responsibility: The Press and Broadcasting in Britain* (2nd edn), London: Methuen.

Curran, James, Michael Gurevitch and Janet Woollacott (eds) (1977) *Mass Communication and Society*, London: Edward Arnold.

—— (1982) 'The Study of the Media: Theoretical Approaches', in Michael Gurevitch, Tony Bennett, James Curran and Janet Woollacott (eds) *Culture, Society and the Media*, pp. 11–29, London: Methuen.

de Certeau, Michel (1984) *The Practice of Everyday Life*, Berkeley: University of California Press.

Doyle, Brian (1982) 'The Hidden History of English Studies', in Peter Widdowson (ed.) *Re-reading English*, pp. 17–31, London: Methuen.

Du Gay, Paul, Stuart Hall, Linda Janes, Hugh Mackay and Keith Negus (1997) *Doing Cultural Studies: The Story of the Sony Walkman*, London: Sage/Open University Press.

Du Gay, Paul, Jessica Evans and Peter Redman (eds) (2000) *Identity: A Reader*, London: Sage.

Dworkin, Dennis (1997) *Cultural Marxism in Postwar Britain: History, the New Left and the Origins of Cultural Studies*, Durham, NC: Duke University Press.

Dwyer, Claire (1998) 'Contested Identities: Challenging Dominant Representations of Young British Muslim Women', in Tracey Skelton and Gill Valentine (eds) *Cool Places: Geographies of Youth Cultures*, pp. 50–65, London: Routledge.

Dyer, Gillian (1982) *Advertising as Communication*, London: Methuen.

Dyer, Richard (1982) *Stars*, London: BFI.

—— (1986) *Heavenly Bodies: Film Stars and Society*, London: BFI.

—— (1999) *White*, Routledge: London and New York.

Eagleton, Terry (1978) *Criticism and Ideology*, London: Verso.

Easthope, Anthony (1991) *Literary into Cultural Studies*, London: Routledge.

Eco, Umberto (1966) *The Bond Affair*, London: Macdonald.

Eliot, Thomas Stearns (1948) *Notes Towards a Definition of Culture*, London: Faber.

Elliott, Philip (1972) *The Making of a Television Series: A Case Study in the Sociology of Culture*, London: Constable.

—— (1977) 'Media Organisations and Occupations: An Overview', in James Curran, Michael Gurevitch and Janet Woollacott (eds) *Mass Communication and Society*, pp. 142–73, London: Edward Arnold.

Ellis, John (1982) *Visible Fictions: Cinema, Television, Video*, London: Routledge & Kegan Paul.

Ferguson, Marjorie and Peter Golding (1997) *Cultural Studies in Question*, London: Sage.

Fiske, John (1982) *Introduction to Communication Studies*, London: Methuen.

—— (1986) 'Television and Popular Culture: Reflections on British and Australian Critical Practice', *Critical Studies in Mass Communication* 3: 200–16.

—— (1987a) 'British Cultural Studies and Television Criticism', in Robert Allen (ed.) *Channels of Discourse: Television and Contemporary Criticism*, pp. 254–90, London: Methuen.

—— (1987b) *Television Culture*, London: Methuen.

—— (1988) 'Meaningful Moments', *Critical Studies in Mass Communication*, September: 246–50.

—— (1989a) *Reading the Popular*, Boston: Unwin Hyman.

—— (1989b) *Understanding Popular Culture*, Boston: Unwin Hyman.

—— (1993) *Power Plays Power Works*, London: Verso.

Fiske, John and John Hartley (1978) *Reading Television*, London: Methuen.

Fiske, John, Bob Hodge and Graeme Turner (1987) *Myths of Oz: Reading Australian Popular Culture*, Sydney: Allen & Unwin.

Foucault, Michel (1979a) *Discipline and Punish: The Birth of the Prison*, trans. Alan Sheridan, Harmondsworth: Peregrine.

—— (1979b) *The History of Sexuality, Volume 1: Introduction*, Harmondsworth: Penguin.

—— (1987) *The History of Sexuality, Volume 2: The Uses of Pleasure*, Harmondsworth: Penguin.

—— (1988) 'Technologies of the Self', in L. Martin, H. Guttman and R. Hutton (eds) *Technologies of the Self*, Amherst, MA: University of Massachusetts Press.

Franklin, Sarah, Celia Lury and Jackie Stacey (eds) (1991) *Off-Centre: Feminism and Cultural Studies*, London: HarperCollins.

Frow, John (1995) *Cultural Studies and Cultural Value*, London: Oxford University Press.

Garnham, Nicholas (1987) 'Concepts of Culture: Public Policy and the Cultural Industries', *Cultural Studies* 1(1): 23–38.

Gauntlett, David and Annette Hill (1999) *TV Living: Television Culture and Everyday Life*, London: Routledge.

Geertz, Clifford (1973) *The Interpretation of Cultures*, New York: Basic Books.

Gelder, Ken and Sarah Thornton (eds) (1997) *The Subcultures Reader*, London and New York: Routledge.

Geraghty, Christine (1991) *Women and Soap Opera: A Study of Prime Time Soaps*, London: Polity.

—— (1996) 'Reflections on History in Teaching Cultural Studies', *Cultural Studies* 10(2): 345–53.

Gibson, Mark and John Hartley (1998) 'Forty Years of Cultural Studies: An Interview with Richard Hoggart', *International Journal of Cultural Studies* 1(1): 11–23.

Giddens, Anthony (1990) *The Consequences of Modernity*, Stanford: Stanford University Press.

Gillespie, Marie (1989) 'Technology and Tradition – Audio-visual Culture Among South Asian Families in West London', *Cultural Studies* 3(2): 226–39.

—— (1995) *Television, Ethnicity and Cultural Change*, London: Comedia and Routledge.

Gilroy, Paul (1987) *There Ain't No Black in the Union Jack*, London: Hutchinson.

—— (1993) *The Black Atlantic: Modernity and Double Consciousness*, London: Verso.

—— (1996) 'British Cultural Studies and the Pitfalls of Identity', in J. Curran, D. Morley and V. Walkerdine (eds) *Cultural Studies and Communications*, pp. 35–49, London: Arnold.

Glasgow Media Group (1976) *Bad News*, London: Routledge & Kegan Paul.

—— (1980) *More Bad News*, London: Routledge & Kegan Paul.

—— (1982) *Really Bad News*, London: Writers & Readers.

Gray, Ann (1987) 'Behind Closed Doors – Video Recorders in the Home', in H. Baehr and G. Dyer (eds) *Boxed In – Women and Television*, London: Pandora.

—— (1992) *Video Playtime: The Gendering of a Leisure Technology*, London: Comedia and Routledge.

—— (1999) 'Audience and Reception Research in Retrospect: The Trouble with Audiences', in Pertti Alasuutari (ed.) *Rethinking the Media Audience: The New Agenda*, pp. 22–37, London: Sage.

Gray, Ann and Jim McGuigan (eds) (1993) *Studying Culture: An Introductory Reader*, London: Edward Arnold.

Green, Michael (1982) 'The Centre for Contemporary Cultural Studies', in Peter Widdowson (ed.) *Re-reading English*, pp. 77–90, London: Methuen.

Grieves, Jim (1982) 'Style as Metaphor for Symbolic Action: Teddy Boys, Authenticity and Identity', *Theory, Culture and Society* 1(1): 35–49.

Grimshaw, Roger, Dorothy Hobson and Paul Willis (1980) 'Introduction to Ethnography at the Centre', in Stuart Hall, Dorothy Hobson, Andrew Lowe and Paul Willis (eds) *Culture, Media, Language*, pp. 73–7, London: Hutchinson.

Grossberg, Lawrence (1988) 'It's a Sin', in Lawrence Grossberg, Tony Fry, Ann Curthoys and Paul Patton (eds) *It's A Sin: Essays on Postmodernism, Politics and Culture*, Sydney: Power.

—— (1993) 'The Formations of Cultural Studies: An American in Birmingham', in Valda Blundell, John Shepherd and Ian Taylor (eds) *Relocating Cultural Studies: Developments in Theory and Research*, pp. 21–66, London: Routledge.

—— (1994) 'Something is Happening Here and You Don't Know What It Is, Do You, Mr Jones?', *Southeast Asian Journal of Social Science* 22: v–x.

—— (1996) 'Identity and Cultural Studies – Is That All There Is?', in Stuart Hall and Paul Du Gay (eds) *Questions of Cultural Identity*, London: Sage.

Grossberg, Lawrence, Cary Nelson and Paula Treichler (eds) (1992) *Cultural Studies*, New York: Routledge.

Grosz, Elizabeth and Elspeth Probyn (1995) *Sexy Bodies: The Strange Carnalities of Feminism*, London and New York: Routledge.

Gurevitch, Michael, Tony Bennett, James Curran and Janet Woollacott (eds) (1982) *Culture, Society and the Media*, London: Methuen.

Hall, Stuart (1971) 'Deviancy, Politics and the Media', CCCS stencilled paper, no. 11.

—— (1975) 'Television as a Medium and Its Relation to Culture', CCCS stencilled paper, no. 34.

—— (1977) 'Culture, the Media and the "Ideological Effect" ', in James Curran, Michael Gurevitch and Janet Woollacott (eds) *Mass Communication and Society*, pp. 315–48, London: Edward Arnold.

—— (1980a) 'Cultural Studies and the Centre: Some Problematics and Problems', in Stuart Hall, Dorothy Hobson, Andrew Lowe and Paul Willis (eds) *Culture, Media, Language*, 15–47, London: Hutchinson.

—— (1980b) 'The Determination of News Photographs', in Stanley Cohen and Jock Young (eds) *The Manufacture of News: Social Problems, Deviance and the Mass Media*, pp. 226–43, London: Constable.

—— (1980c) 'Encoding/Decoding', in Stuart Hall, Dorothy Hobson, Andrew Lowe and Paul Willis (eds) *Culture, Media, Language*, pp. 128–38, London: Hutchinson.

—— (1980d) 'Introduction to Media Studies at the Centre', in Stuart Hall, Dorothy Hobson, Andrew Lowe and Paul Willis (eds) *Culture, Media, Language*, pp. 117–21, London: Hutchinson.

—— (1980e) 'Recent Developments in Theories of Language and Ideology: A Critical Note', in Stuart Hall, Dorothy Hobson, Andrew Lowe and Paul Willis (eds) *Culture, Media, Language*, pp. 157–62, London: Hutchinson.

—— (1981) 'Cultural Studies: Two Paradigms', in Tony Bennett, Graham Martin, Colin Mercer and Janet Woollacott (eds) *Culture, Ideology and Social Process: A Reader*, pp. 19–37, London: Open University Press.

—— (1982) 'The Rediscovery of "Ideology": The Return of the "Repressed" in Media Studies', in Michael Gurevitch, Tony Bennett, James Curran and Janet Woollacott (eds) *Culture, Society and the Media*, pp. 56–90, London: Methuen.

—— (1986) 'Popular Culture and the State', in Tony Bennett, Colin Mercer and Janet Woollacott (eds) *Popular Culture and Social Relations*, pp. 22–49, Milton Keynes: Open University Press.

—— (1988) *The Hard Road to Renewal: Thatcherism and the Crisis of the Left*, London: Verso.

—— (1990) 'The Emergence of Cultural Studies and the Crisis of the Humanities', *October* 53: 11–23.

—— (1992) 'Cultural Studies and its Theoretical Legacies', in Lawrence Grossberg, Cary Nelson and Paula Treichler (eds) *Cultural Studies*, pp. 277–94, New York: Routledge.

—— (1993) 'Culture, Community, Nation', *Cultural Studies* 7(3): 349–63.

—— (1996a) 'Minimal Selves', in Houston A. Baker Jr, Manthia Diawara and Ruth W. Lindeborg (eds) *Black British Cultural Studies: A Reader*, pp. 114–19, Chicago: University of Chicago Press. (First published in 1987.)

—— (1996b) 'Introduction: Who Needs Identity?', in Stuart Hall and Paul Du Gay (eds) *Questions of Cultural Identity*, pp. 1–17, London: Sage.

Hall, Stuart and Paddy Whannel (1967) *The Popular Arts*, Boston: Beacon. (First published in 1964.)

Hall, Stuart, Ian Connell and Lidia Curti (1981) 'The Unity of Current Affairs Television', in Tony Bennett, Susan Boyd-Bowman, Colin Mercer and Janet Woollacott (eds) *Popular Television and Film*, pp. 88–117, London: BFI.

Hall, Stuart, Chas Critcher, Tony Jefferson, John Clarke and Brian Roberts (1978) *Policing the Crisis: Mugging, the State, and Law and Order*, London: Macmillan.

Hall, Stuart and Paul Du Gay (eds) (1996) *Questions of Cultural Identity*, London: Sage.

Hall, Stuart and Tony Jefferson (eds) (1976) *Resistance Through Rituals: Youth Subcultures in Post-War Britain*, London: Hutchinson.

Hall, Stuart, Dorothy Hobson, Andrew Lowe and Paul Willis (eds) (1980) *Culture, Media, Language*, London: Hutchinson.

Halloran, J., P. Elliott and G. Murdock (1970) *Demonstrations and Communications*, London: Penguin.

Harland, Richard (1987) *Superstructuralism: The Philosophy of Structuralism and Post-Structuralism*, London: Methuen.

Harris, David (1992) *From Class Struggle to the Politics of Pleasure: The Effects of Gramscianism on Cultural Studies*, London: Routledge.

Hartley, John (1982) *Understanding News*, London: Methuen.

—— (1983) 'Encouraging Signs: Television and the Power of Dirt, Speech and Scandalous Categories', *Australian Journal of Cultural Studies* 1(2): 62–82.

—— (1987) 'Invisible Fictions: Television Audiences, Paedocracy, Pleasure', *Textual Practice* 1(2): 121–38.

—— (1988) 'The Real World of Audiences', *Critical Studies in Mass Communication*, September: 234–8.

—— (1992a) *The Politics of Pictures: The Creation of the Public in the Age of Popular Media*, London: Routledge.

—— (1992b) *Teleology: Studies in Television*, London: Routledge.

—— (1996) *Popular Reality: Journalism, Modernity, Popular Culture*, London: Edward Arnold.

—— (1999) *Uses of Television*, London: Routledge.

Harvey, David (1989) *The Condition of Postmodernity*, London: Blackwell.

Hawkes, Terence (1977) *Structuralism and Semiotics*, London: Methuen.

Heath, Stephen (1985) '*Jaws*, Ideology and Film Theory', in Bill Nichols (ed.) *Movies and Methods*, vol. 11, pp. 509–16, London: University of California Press.

Heath, Stephen and Colin McCabe (1971) *Signs of the Times: Introductory Readings in Textual Semiotics*, London: Cambridge University Press.

Heath, Stephen and Gillian Skirrow (1986) 'An Interview with Raymond Williams', in Tania Modleski (ed.) *Studies in Entertainment: Critical Approaches to Mass Culture*, pp. 3–17, Bloomington: Indiana University Press.

Hebdige, Dick (1979) *Subculture: The Meaning of Style*, London: Methuen.

—— (1987) *Cut 'n' Mix: Culture, Identity and Caribbean Music*, London: Comedia.

—— (1988) *Hiding in the Light: On Images and Things*, London: Routledge.

Hermes, Joke (1993) 'Media, Meaning and Everyday Life', *Cultural Studies* 7(3): 493–506.

Hobson, Dorothy (1980) 'Housewives and the Mass Media', in Stuart Hall, Dorothy Hobson, Andrew Lowe and Paul Willis (eds) *Culture, Media, Language*, pp. 105–14, London: Hutchinson.

—— (1982) *Crossroads: The Drama of a Soap Opera*, London: Methuen.

Hodge, Bob and David Tripp (1986) *Children and Television: A Semiotic Approach*, London: Polity.

Hoggart, Richard (1958) *The Uses of Literacy*, London: Penguin.

Humm, Peter, Paul Sigant and Peter Widdowson (eds) (1986) *Popular Fictions: Essays in Literature and History*, London: Methuen.

Inglis, Fred (1990) *Media Theory: An Introduction*, London: Blackwell.

—— (1993) *Cultural Studies*, London: Blackwell.

—— (1995) *Raymond Williams*, London and New York: Routledge.

Jacobs, Jason (2001) 'Issues of Judgement and Value in Television Studies', *International Journal of Cultural Studies* 4: 4.

Jameson, Fredric (1991) *Postmodernism, or The Cultural Logic of Late Capitalism*, London: Verso.

Johnson, Lesley (1987) 'Raymond Williams: A Marxist View of Culture', in Diane I. Austin-Broos (ed.) *Creating Culture: Profiles in the Study of Culture*, Sydney: Allen & Unwin.

Johnson, Richard (1978) 'Edward Thompson, Eugene Genovese, and Socialist-Humanist History', *History Workshop* 6: 79–100.

—— (1979a) 'Culture and the Historians', in John Clarke, Chas Critcher and Richard Johnson (eds) *Working Class Culture: Studies in History and Theory*, pp. 41–71, London: Hutchinson.

—— (1979b) 'Three Problematics: Elements of a Theory of Working Class Culture', in John Clarke, Chas Critcher and Richard Johnson (eds) *Working Class Culture: Studies in History and Theory*, pp. 201–37, London: Hutchinson.

—— (1980) 'Barrington Moore, Perry Anderson and English Social Development', in Stuart Hall, Dorothy Hobson, Andrew Lowe and Paul Willis (eds) *Culture, Media, Language*, pp. 48–70, London: Hutchinson.

—— (1983) 'What Is Cultural Studies Anyway?', CCCS stencilled paper, no. 74.

—— (1997) 'Reinventing Cultural Studies: Remembering for the Best Version', in Elizabeth Long (ed.) *From Sociology to Cultural Studies: New Perspectives*, pp. 451–87, Malden: Blackwell.

Jordan, Glenn and Chris Weedon (1995) *Cultural Politics: Class, Gender, Race and the Postmodern World*, London: Blackwell.

Kellner, Douglas (1995) *Media Culture: Cultural Studies, Identity and Politics Between the Modern and the Postmodern*, London: Routledge.

Laing, Stuart (1986) *Representations of Working-Class Life, 1959–64*, London: Macmillan.

Leavis, F. R. and Denys Thompson (1933) *Culture and Environment*, London: Chatto & Windus.

Leavis, Q. D. (1932) *Fiction and the Reading Public*, London: Chatto & Windus.

Lévi-Strauss, Claude (1966) *The Savage Mind*, London: Weidenfeld & Nicolson.

Lewis, Tania (2000) 'Critical Habitations: Cultural Studies and the Politics of Intellectual Location', unpublished PhD dissertation, University of Melbourne.

Livingstone, Sonia (1998) 'Audience Research at the Crossroads: The "Implied Audience" in Media and Cultural Theory', *European Journal of Cultural Studies* 1(2): 193–217.

Long, Elizabeth (ed.) (1997) *From Sociology to Cultural Studies: New Perspectives*, Malden: Blackwell.

Lovell, Terry (1980) *Pictures of Reality: Aesthetics, Politics and Pleasure*, London: BFI.

McAloon, John (1992) 'The Ethnographic Imperative in Comparative Olympic Research', *Sociology of Sport Journal* 9: 104–30.

McCabe, Colin (1981) 'Realism and the Cinema: Notes on Some Brechtian Theses', in Tony Bennett, Susan Boyd-Bowman, Colin Mercer and Janet Woollacott (eds) *Popular Television and Film*, pp. 21–35, London: BFI.

—— (1992) 'Cultural Studies and English', *Critical Quarterly* 34(3): 25–34.

McGuigan, Jim (1992) *Cultural Populism*, London: Routledge.

—— (1996) *Culture and the Public Sphere*, London: Routledge

—— (ed.) (1997) *Cultural Methodologies*, London: Sage.

McNeil, Maureen (1998) 'De-centring or Re-focusing Cultural Studies: A Response to Handel Wright', *European Journal of Cultural Studies* 1(1): 57–64.

McNeil, Maureen and Sarah Franklin (1991) 'Science and Technology: Questions for Cultural Studies and Feminism', in Sarah Franklin, Celia Lury and Jackie Stacey (eds) *Off-Centre: Feminism and Cultural Studies*, pp. 130–48, London: Routledge.

McRobbie, Angela (1981) 'Settling Accounts with Subcultures: A Feminist Critique', in Tony Bennett, Graham Martin, Cohn Mercer and Janet Woollacott (eds) *Culture, Ideology and Social Process: A Reader*, pp. 112–24, London: Open University Press.

—— (1982) '*Jackie*: An Ideology of Adolescent Femininity', in Bernard Waites, Tony Bennett and Graham Martin (eds) *Popular Culture: Past and Present*, pp. 262–3, London: Croom Helm.

—— (1984) 'Dance and Social Fantasy', in Angela McRobbie and Mica Nava (eds) *Gender and Generation*, pp. 130–61, London: Macmillan.

—— (1991) *Feminism and Youth Culture: From* Jackie *to* Just Seventeen, London: Macmillan.

—— (1992) 'Post-Marxism and Cultural Studies: A Post-script', in Lawrence Grossberg, Cary Nelson and Paula Treichler (eds) *Cultural Studies*, New York: Routledge.

—— (1994) *Postmodernism and Popular Culture*, London: Routledge.

—— (1997) *Back to Reality: Social Experience and Cultural Studies*, Manchester: Manchester University Press.

245

—— (1999) *In the Culture Society: Art, Fashion and Popular Music*, London: Routledge.

McRobbie, Angela and Jenny Garber (1976) 'Girls and Subcultures: An Exploration', in Stuart Hall and Tony Jefferson (eds) *Resistance Through Rituals: Youth Subcultures in Post-War Britain*, pp. 209–22, London: Hutchinson.

McRobbie, Angela and Mica Nava (eds) (1984) *Gender and Generation*, London: Macmillan.

Massey, Doreen (1998) 'The Spatial Construction of Youth Cultures', in Tracey Skelton and Gill Valentine (eds) *Cool Places: Geographies of Youth Cultures*, London: Routledge.

Mellor, Adrian (1992) 'Discipline and Punish: Cultural Studies at the Crossroads', *Media, Culture and Society* 14: 663–70.

Mercer, Colin (1986) 'Complicit Pleasures', in Tony Bennett, Colin Mercer and Janet Woollacott (eds) *Popular Culture and Social Relations*, pp. 50–68, Milton Keynes: Open University Press.

Miller, Daniel (ed.) (1995) *Acknowledging Consumption: A Review of New Studies*, London: Routledge.

Miller, Richard (1994) 'A Moment of Profound Danger: British Cultural Studies Away from the Centre', *Cultural Studies* 8(3): 417–37.

Modleski, Tania (1984) *Loving with a Vengeance: Mass-Produced Fantasies for Women*, London: Methuen.

—— (1988) *The Women Who Knew Too Much: Hitchcock and Feminist Theory*, London: Methuen.

—— (ed.) (1986) *Studies in Entertainment: Critical Approaches to Mass Culture*, Bloomington: Indiana University Press.

Moores, Shaun (1993) *Interpreting Audiences: The Ethnography of Media Consumption*, London: Sage.

—— (1996) *Satellite Television and Everyday Life*, Luton: John Libbey.

Morley, David (1980a) *The 'Nationwide' Audience*, London: BFI.

—— (1980b) 'Texts, Readers, Subjects', in Stuart Hall, Dorothy Hobson, Andrew Lowe and Paul Willis (eds) *Culture, Media, Language*, pp. 63–173, London: Hutchinson.

—— (1986) *Family Television: Cultural Power and Domestic Leisure*, London: Comedia.

—— (1992) *Television, Audiences and Cultural Studies*, London: Routledge.

—— (1996) 'Populism, revisionism and the "New" Audience Research', in James Curran, David Morley and Valerie Walkerdine (eds) *Cultural Studies and Communications*, pp. 279–93, London: Edward Arnold.

—— (1998) 'So-called Cultural Studies: Dead Ends and Reinvented Wheels', *Cultural Studies* 12(4): 476–97.

—— (1999) 'To Boldly Go...: The "Third Generation" of Reception Studies', in Pertti Alasuutari (ed.) *Rethinking the Media Audience: The New Agenda*, pp. 195–204, London: Sage.

—— (2000) *Home Territories: Media, Mobility and Identity*, London: Routledge.

Morley, David and Kevin Robins (1995) *Spaces of Identity: Global Media, Electronic Landscapes and Cultural Boundaries*, London: Routledge.

Morley, David and Kuan-Hsing Chen (eds) (1996) *Stuart Hall: Critical Dialogues in Cultural Studies*, London and New York: Routledge.

Morley, David and Kevin Robins (eds) (2001) *British Cultural Studies: Geography, Nationality and Identity*, Oxford: Oxford University Press.

Morris, Meaghan (1988) 'The Banality of Cultural Studies', *Block*14. (Reprinted in Patricia Mellenkamp (ed.) (1990) *Logics of Television: Essays in Cultural Criticism*, London: BFI.)

Mouffe, Chantal (1981) 'Hegemony and Ideology in Gramsci', in Tony Bennett, Graham Martin, Colin Mercer and Janet Woollacott (eds) *Culture, Ideology and Social Process: A Reader*, pp. 219–34, London: Open University Press.

Mulhern, Francis (1979) *The 'Moment' of Scrutiny*, London: NLB.

—— (2000) *Culture/Metaculture*, London and New York: Routledge.

Mulvey, Laura (1975) 'Visual Pleasure and Narrative Cinema', *Screen* 16(3). (Reprinted in Bill Nichols (ed.) (1985) *Movies and Methods*, vol. 11, London: University of California Press.)

—— (1981) 'Afterthoughts on "Visual Pleasure and Narrative Cinema" ... Inspired by *Duel in the Sun*', *Framework* 15–17: 12–15.

Murdock, Graham (1976) 'Consciousness of Class and Consciousness of Generation', in Stuart Hall and Tony Jefferson (eds) *Resistance Through Rituals: Youth Subcultures in Post-War Britain*, pp. 192–208, London: Hutchinson.

—— (1982) 'Large Corporations and the Control of the Communications Industries', in Michael Gurevitch, Tony Bennett, James Curran and Janet Woollacott (eds) *Culture, Society and the Media*, pp. 118–50, London: Methuen.

—— (1989) 'Cultural Studies at the Crossroads', *Australian Journal of Communication* 16: 37–49.

Murdock, Graham and Peter Golding (1977) 'Capitalism, Communication and Class Relations', in James Curran, Michael Gurevitch and Janet Woollacott (eds) *Mass Communication and Society*, pp. 12–43, London: Edward Arnold.

Nelson, Cary and Lawrence Grossberg (eds) (1988) *Marxism and the Interpretation of Culture*, Urbana: University of Illinois Press.

Nightingale, Virginia (1989) 'What's Ethnographic about Ethnographic Audience Research?', *Australian Journal of Communication* 16: 50–63.

O'Sullivan, Tim, Danny Saunders, John Hartley and John Fiske (1983) *Key Concepts in Communication*, London: Methuen.

Palmer, Patricia (1986) *The Lively Audience*, Sydney: Allen & Unwin.

Parker, David (1998) 'Rethinking British Chinese Identities', in Tracey Skelton and Gill Valentine (eds) *Cool Places: Geographies of Youth Cultures*, pp. 66–82, London: Routledge.

Perry, George (1975) *The Great British Picture Show*, London: Paladin.

Philo, Greg (1990) *Seeing and Believing: The Influence of Television*, London: Routledge.

Pleasance, Helen (1991) 'Open or Closed: Popular Magazines and Dominant Culture', in Sarah Franklin, Celia Lury and Jackie Stacey (eds) *Off-Centre: Feminism and Cultural Studies*, pp. 69–84, London: HarperCollins.

Powell, Rachel and John Clarke (1976) 'A Note on Marginality', in Stuart Hall and Tony Jefferson (eds) *Resistance Through Rituals: Youth Subcultures in Post-War Britain*, pp. 223–9, London: Hutchinson.

Pribram, Deidre (ed.) (1988) *Female Spectators: Looking at Film and Television*, London: Verso.

Probyn, Elspeth (2000) *Carnal Appetites: FoodSexIdentities*, London and New York: Routledge.

Radway, Janice (1987) *Reading the Romance: Women, Patriarchy and Popular Literature*, London: Verso. (First published in 1984.)

—— (1988) 'Reception Study: Ethnography and the Problems of Dispersed Audiences and Nomadic Subjects', *Cultural Studies* 2(3): 359–76.

Redhead, Steve (1990) *The End-of-the-Century Party: Youth and Pop Towards 2000*, Manchester and New York: Manchester University Press.

—— (1997) *Subcultures to Clubcultures: An Introduction to Popular Cultural Studies*, Oxford: Blackwell.

Redhead, Steve, Derek Wynne and Justin O'Connor (eds) (1997) *The Clubcultures Reader: Readings in Popular Cultural Studies*, Oxford: Blackwell.

Rojek, Chris (1998) 'Stuart Hall and the Antinomian Tradition', *International Journal of Cultural Studies* 1(1): 44–65.

Rojek, Chris and Bryan Turner (2000) 'Decorative Sociology: Towards a Critique of the Cultural Turn', *Sociological Review* 48(4): 629–48.

Rose, Jaqueline (1986) *Sexuality in the Field of Vision*, London: Verso.

—— (1988) 'Margaret Thatcher and Ruth Ellis', *New Formations* 6: 3–30.

Sanders, Claire (1992) 'Roused by the Rabble', *Times Higher Education Supplement*, 11 December: 40.

Saussure, Ferdinand de (1960) *A Course in General Linguistics*, trans. Wade Baskin, London: Peter Owen.

Scannell, Paddy and David Cardiff (1982) 'Serving the Nation: Public Service Broadcasting Before the War', in Bernard Waites, Tony Bennett and Graham Martin (eds) *Popular Culture: Past and Present*, pp. 161–88, London: Croom Helm.

Schlesinger, Philip (1978) *Putting 'Reality' Together: BBC News*, London: Constable. (Revised edition published 1987, London: Methuen.)

—— (1991) *Media, State and Nation: Political Violence and Collective Identities*, London: Sage.

Schwarz, Bill (1994) 'Where is Cultural Studies?', *Cultural Studies* 8(3): 377–93.

Seiter, Ellen, Hans Borchers, Gabriele Kreutzner and Eva-Maria Warth (eds) (1989) *Remote Control: Television, Audiences and Cultural Power*, London: Routledge.

Shiach, Morag (1991) 'Feminism and Popular Culture', *Critical Quarterly* 33(2): 37–46.

Showalter, Elaine (1987) *The Female Malady: Women, Madness and English Culture, 1830–1980*, London: Virago.

Skeggs, Beverley (1997) *Formations of Class and Gender*, London: Sage.

Skelton, Tracey and Gill Valentine (eds) (1998) *Cool Places: Geographies of Youth Cultures*, London: Routledge.

Stacey, Jackie (1994) *Star-Gazing: Hollywood Cinema and Female Spectatorship*, London and New York: Routledge.

Stedman-Jones, Gareth (1982) 'Working-Class Culture and Working-Class Politics in London, 1870–1900: Notes on the Remaking of a Working-Class', in Bernard Waites, Tony Bennett and Graham Martin (eds) *Popular Culture: Past and Present*, pp. 92–121, London: Croom Helm.

Steedman, Carolyn (1992) 'Culture, Cultural Studies, and the Historians', in Lawrence Grossberg, Cary Nelson and Paula Treichler (eds) *Cultural Studies*, pp. 613–22, New York: Routledge.

Steele, Tom (1997) *The Emergence of Cultural Studies 1945–65: Cultural Politics, Adult Education and the English Question*, London: Lawrence & Wishart.

Storey, John (1999) *Cultural Consumption and Everyday Life*, London: Edward Arnold.

—— (ed.) (1994) *Cultural Theory and Popular Culture: A Reader*, London: Harvester Wheatsheaf.

Storry, Mike and Peter Childs (eds) (1997) *British Cultural Identities*, London: Routledge.

Stratton, Jon and Ien Ang (1996) 'On the Impossibility of a Global Cultural Studies: "British" Cultural Studies in an "International" Frame', in David Morley and Kuan Hsing-Chen (eds) *Stuart Hall: Critical Dialogues in Cultural Studies*, London and New York: Routledge.

Tasker, Yvonne (1991) 'Having it All: Feminism and the Pleasures of the Popular', in Sarah Franklin, Celia Lury and Jackie Stacey (eds) *Off-Centre: Feminism and Cultural Studies*, pp. 85–96, London: HarperCollins.

—— (1993) *Spectacular Bodies: Gender, Genre and the Action Cinema*, London and New York: Routledge.

Thompson, Denys (ed.) (1973) *Discrimination and Popular Culture* (rev. edn), London: Penguin. (First published in 1964.)

Thompson, E. P. (1978a) *The Making of the English Working Class*, London: Penguin. (First published in 1963.)

—— (1978b) *The Poverty of Theory and Other Essays*, London: Merlin.

Thornham, Sue (2000) *Feminist Theory and Cultural Studies: Stories of Unsettled Relations*, London: Edward Arnold.

Thornton, S. (1995) *Clubcultures: Music, Media and Subcultural Capital*, Cambridge: Polity.

Tudor, Andrew (1999) *Decoding Culture: Theory and Method in Cultural Studies*, London: Sage.

Tulloch, John (1989) 'Approaching Audiences: A Note on Method', in John Tulloch and Graeme Turner (eds) *Australian Television: Programs, Pleasures and Politics*, pp. 187–201, Sydney: Allen & Unwin.

—— (n.d.) '*Dr Who*: Approaching the Audience', unpublished paper.

Tulloch, John and Manuel Alvarado (1983) Doctor Who*: The Unfolding Text*, London: Macmillan.

Tulloch, John and Henry Jenkins (1995) *Science Fiction Audiences: Watching* Star Trek *and* Dr Who, London: Routledge.

Tulloch, John and Albert Moran (1986) *Quality Soap: A Country Practice*, Sydney: Currency.

Tulloch, John and Graeme Turner (eds) (1989) *Australian Television: Programs, Pleasures and Politics*, Sydney: Allen & Unwin.

Tunstall, Jeremy (1971) *Journalists at Work*, London: Constable.

Turner, Graeme (1986) *National Fictions: Literature, Film and the Construction of Australian Narrative*, Sydney: Allen & Unwin.

—— (1987) '*Perfect Match*: Ambiguity, Spectacle and the Popular', *Australian Journal of Cultural Studies* 4(2): 79–94.

—— (1988) *Film as Social Practice* (rev. edn 1993, 1999), London: Routledge.

—— (1989) 'Transgressive Television: From *IMT* to *Perfect Match*', in John Tulloch and Graeme Turner (eds) *Australian Television: Programs, Pleasures and Politics*, pp. 25–37, Sydney: Allen & Unwin.

Waites, Bernard, Tony Bennett and Graham Martin (eds) (1982) *Popular Culture: Past and Present*, London: Croom Helm.

Webster, Duncan (1994) 'Pessimism, Optimism, Pleasure: The Future of Cultural Studies', in John Storey (ed.) *Cultural Theory and Popular Culture: A Reader*, pp. 531–46, London: Harvester Wheatsheaf.

Weedon, Chris, Andrew Tolson and Frank Mort (1980) 'Theories of Language and Subjectivity', in Stuart Hall, Dorothy Hobson, Andrew Lowe and Paul Willis (eds) *Culture, Media, Language*, pp. 195–216, London: Hutchinson.

Wernik, Andrew (1991) *Promotional Culture: Advertising, Ideology and Symbolic Expression*, London: Sage.

Widdowson, Peter (ed.) (1982) *Re-reading English*, London: Methuen.

Williams, Raymond (1962) *Communications*, London: Penguin.

—— (1966) *Culture and Society 1780–1950*, London: Penguin. (First published in 1958.)

—— (1974) *Television: Technology and Cultural Form*, London: Fontana/Collins.

—— (1975) *The Long Revolution*, London: Penguin. (First published in 1961.)

—— (1977) *Marxism and Literature*, London: Oxford University Press.

—— (1989) *The Politics of Modernism: Against the New Conformists*, London: Verso.

Williamson, Judith (1978) *Decoding Advertisements: Ideology and Meaning in Advertising*, London: Marion Boyars.

—— (1987) *Consuming Passions*, London: Marion Boyars.

Willis, Paul (1977) *Learning to Labour: How Working Class Kids Get Working Class Jobs*, London: Saxon House.

—— (1978) *Profane Culture*, London: Routledge & Kegan Paul.

—— (1979) 'Shop Floor Culture, Masculinity and the Wage Form', in John Clarke, Chas Critcher and Richard Johnson (eds) *Working Class Culture: Studies in History and Theory*, pp. 185–98, London: Hutchinson.

—— (1980) 'Notes on Method', in Stuart Hall, Dorothy Hobson, Andrew Lowe and Paul Willis (eds) *Culture, Media, Language*, pp. 88–95, London: Hutchinson.

—— (1990) *Common Culture: Symbolic Work at Play in the Everyday Cultures of the Young*, Milton Keynes: Open University Press.

Wilson, Elizabeth (1994) 'Fashion and Postmodernism', in John Storey (ed.) *Cultural Theory and Popular Culture: A Reader*, pp. 403–13, London: Harvester Wheatsheaf.

Winship, Janice (1980) 'Advertising in Women's Magazines: 1956–74', CCCS stencilled paper, no. 59.

Women's Studies Group, Centre for Contemporary Cultural Studies, University of Birmingham (1978) *Women Take Issue: Aspects of Women's Subordination*, London: Hutchinson.

Wright, Handel (1998) 'Dare We De-centre Birmingham?', *European Journal of Cultural Studies* 1(1): 33–56.

Wright, Patrick (1985) *On Living in an Old Country: The National Past in Contemporary Britain*, London: Verso.

About the author

Graeme Turner is Professor of Cultural Studies and Director of the Centre for Critical and Cultural Studies at the University of Queensland, Brisbane, Australia. He has published widely on media and cultural studies, and his most recent books include *The Film Cultures Reader* (2002); (with Stuart Cunningham) *Media and Communications in Australia* (2001); (with Frances Bonner and P. David Marshall) *Fame Games: The Production of Celebrity in Australia* (2000); and *Film as Social Practice* (3rd edition) (1999).

Index